# MASTERING THE ART OF ENTERTAINING

# MASTERING ᴛʜᴇ ART
# ᴏꜰ ENTERTAINING

**JOSEPH MARINI**     *Photography by* HEIDI HARRIS

Published by SparkPress, a BookSparks imprint,
A division of SparkPoint Studio, LLC
Phoenix, Arizona, USA, 85007
www.gosparkpress.com

Published 2023
Printed in Canada
Print ISBN: 978-1-68463-196-4
E-ISBN: 978-1-68463-197-1
Library of Congress Control Number: 2022912630

Cover and interior photographs © Heidi Harris
Interior design by Tabitha Lahr

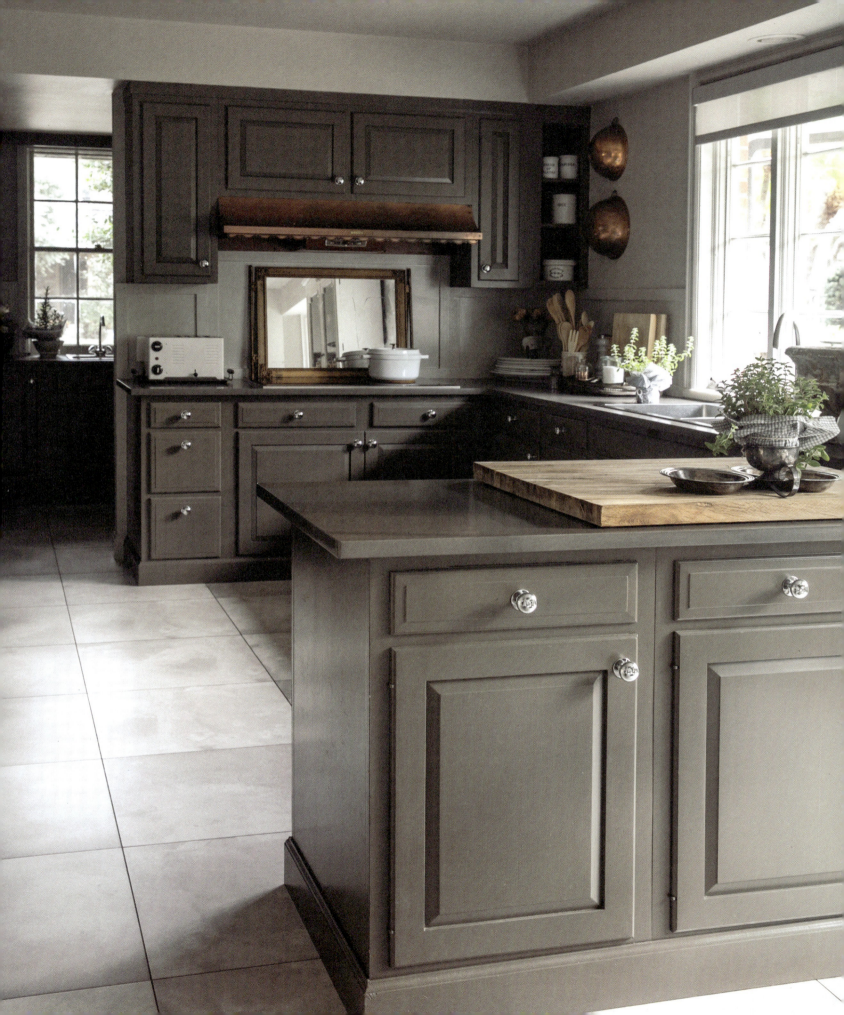

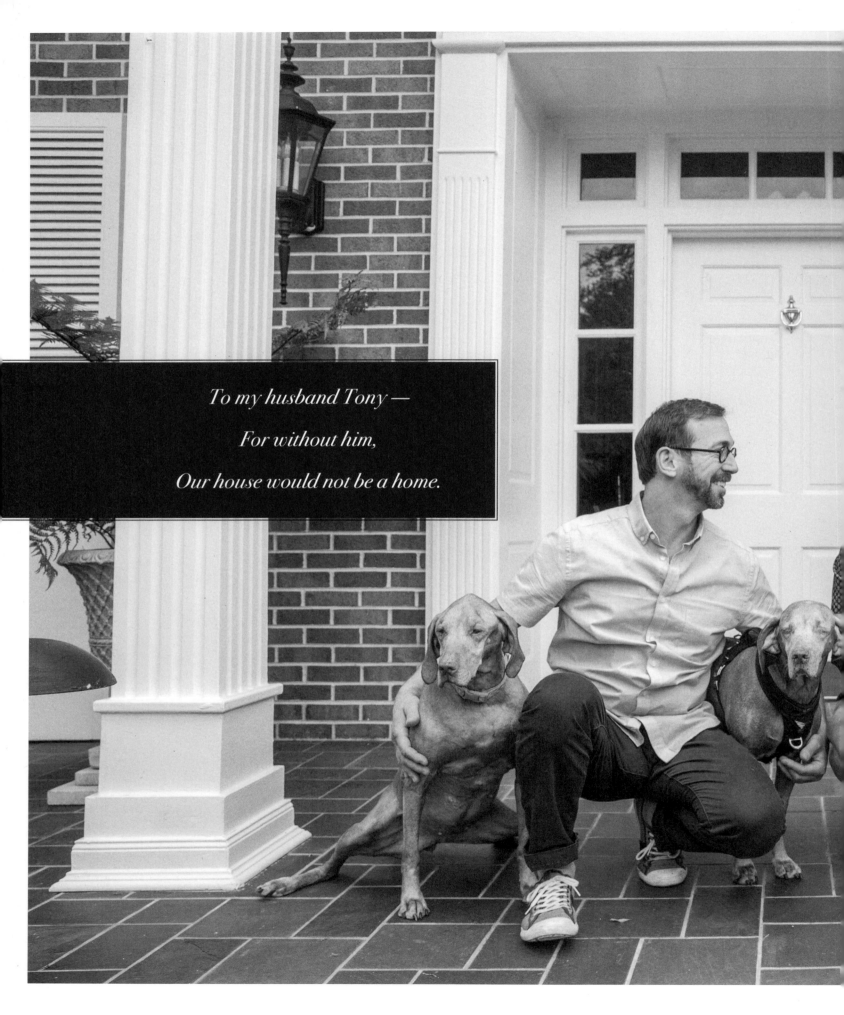

To my husband Tony —

For without him,

Our house would not be a home.

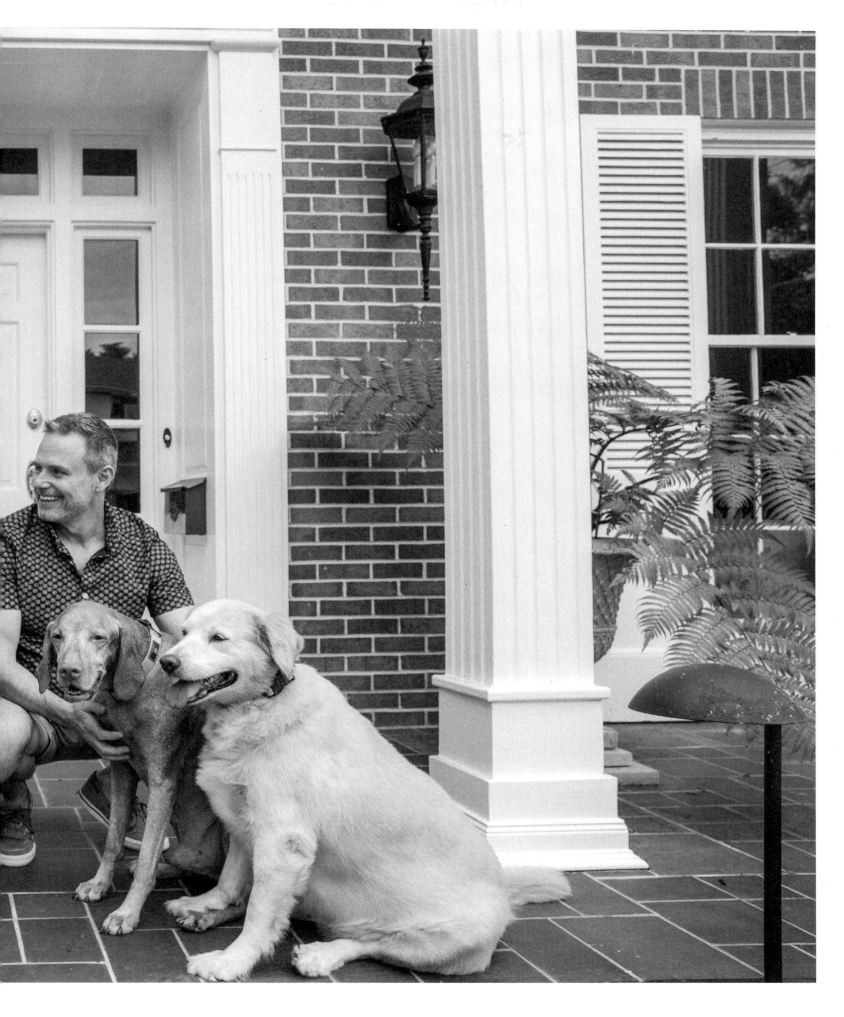

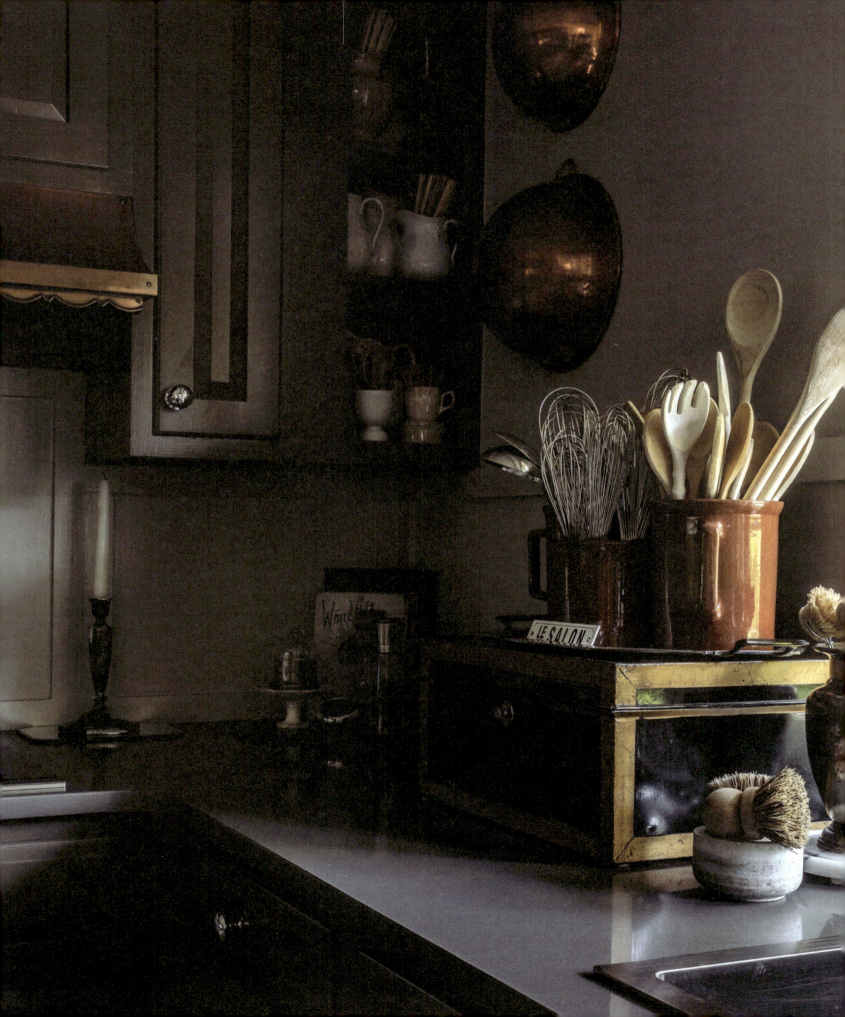

# CONTENTS

# INTRODUCTION

*I have always had an innate love for cooking,* from home economics in middle school to studying classical French cuisine in Europe. While those home economics classes taught me the fundamentals of cooking, studying under a French chef in Europe was when I really learned how to cook. I had only a French cookbook by Escoffier (one of the great masters of French cuisine), which read more like a book than a cookbook as we know it today, and an English to French dictionary to reference from. The students in my class all worked on the same predetermined menu for the day, which required translating the French recipes into a notebook the night before. We could add any notes during the lecture the next day, however, only that notebook was allowed into the kitchen to reference. Neither a dictionary nor a lesson book was allowed. If there was something we did not understand or something we failed to study the night before, we only had our intuition to rely on to create that menu. While it posed to be a challenge, it forced us to commit the recipes to memory. Then there was learning how to navigate unforeseen circumstances (like running out of propane for the stoves) while still preparing the menu of the day. I found myself wondering how it could be that we were all cooking the same menu with the same ingredients and under the same conditions, but each of our dishes looked and tasted different. I now realize that with all things being equal, what differentiated us was our intuition.

Cooking is an intuitive activity that can be learned, practiced, and honed. I learned that a recipe is not a blueprint that needs to be precisely followed to be successful, but rather a guide to assist your intuition in making the best decisions based on any number of fluid variables on any given day. Even family recipes passed down on index cards from previous generations can change for the better based on a new generation's intuition. No matter how well-tested a recipe is, I rarely follow it exactly as printed. Instead, I read the entire recipe to understand the ingredients, the proportions being used, the cooking process, and how it is served, then I will make notes on the recipe with any changes I want to incorporate based on my knowledge and intuition. I even change some of my own recipes when a thought pops into my head about how they could be improved. That's the beauty of cooking. It's an intimate experience that allows you to constantly create rather than regurgitate.

As a young kid, I was teased and called "Betty Crocker." I didn't realize or appreciate the sentiment then, as I do now. All I knew was that I loved to bake, and while it bruised my ego so many years ago, today I have come to treasure it as an accolade. I had no idea that my after-school activity of whipping up a Betty Crocker spiced cake mix with my mom would become the touchstone I would reflect on years later. I now realize it was the foundation of my life and became a key part of my happiness.

My first foray into entertaining was during a college stint in upstate New York when I was working for a prominent caterer. What I thought would be a job for extra money turned into an awakening of a love for throwing parties and making them look beautiful. The same passion and curiosity I had for baking as a child was ignited within me, only this time with a career in mind. For me, food was never about cooking in a commercial kitchen or owning a restaurant, but rather a form of creating relationships by feeding people while entertaining them. During my youth, I discovered Martha Stewart's magazine and bought my first book by her. While scrolling through the pages of the magazine, it resonated with me that I wanted to live an intentional life, create an authentic home, and entertain friends and family. As the pieces of my life started fitting together, I had an epiphany that I no longer fit into the male-dominated structure of the home-building business that had been started by my grandfather. While they "built houses," I had a different (and individual) purpose to "create homes."

With a semester left to finish my accounting degree and a plan to work in my family's business, I jumped ship and enrolled in culinary school instead. A giant leap of faith that, to my surprise, led me down a vibrant and colorful path. After graduating from school, I moved to New York City, where I would start my catering business. I met some talented food stylists, whom I had the pleasure of assisting to supplement my income at that time. Through them, I got to see how many artistic people it took to create the images that I had been admiring in the lifestyle magazines that I subscribed to. The experience of working with such creative people taught me so many wonderful things, which served to further my interest in creating immersive events for my clients, from the food to the flowers. This leap to expand my business (and my love of creating a storied home) took me to Connecticut, where I opened a small home and garden shop and went full steam ahead into event design. The blueprint of my life was not only unfolding, but it was fulfilling. Even though I was busy running two businesses, constantly decorating a home, tending to gardens, and enthusiastically venturing to Brimfield to pack my car full of goodies (usually with my friend Pat, who was so good-natured she didn't mind occasionally being buried underneath all of our treasures when I had to fit "just one more thing" in), I still took the time to entertain friends and clients. With every dinner party or cocktail party hosted, as the platters and silver

trays came out of the cupboards, I remembered how deeply gratifying it was, as a child, to help my mother set the table for the holidays. Together we'd prepare the turkey and stuffing, along with plenty of My-T-Fine pudding for her pies. I would proudly polish her silver, lay out her Italian cutlery, and arrange the stemware neatly next to her vine and floral china—all of which are family heirlooms that I still entertain with today.

I hope this book will inspire you to open your hearts, be seen, and share a piece of yourself by entertaining in your home with friends and family, new and old alike. By reading some of my tips, experiences, and recipes, allow yourself to absorb them in a way that feels helpful to you. Make it a regular thing to invite others into your home. If you feel trepidation, start simple, but be consistent. Practice the craft of entertaining and just remember, it doesn't have to be perfect, it just should be thoughtful.

I'm often asked why I love entertaining so much. It took me a long time to understand the answer to this. Fitting in, even sometimes within a family, can be difficult. By entertaining, I was allowing myself to be vulnerable enough to be seen for who I was. It allowed me to create a group of family and friends that would truly see and appreciate my authenticity. I now realize the rewards of living intentionally and opening up my home (and heart) to bring people together over food. These shared and rewarding experiences have been natural to me ever since I was dubbed "Betty Crocker."

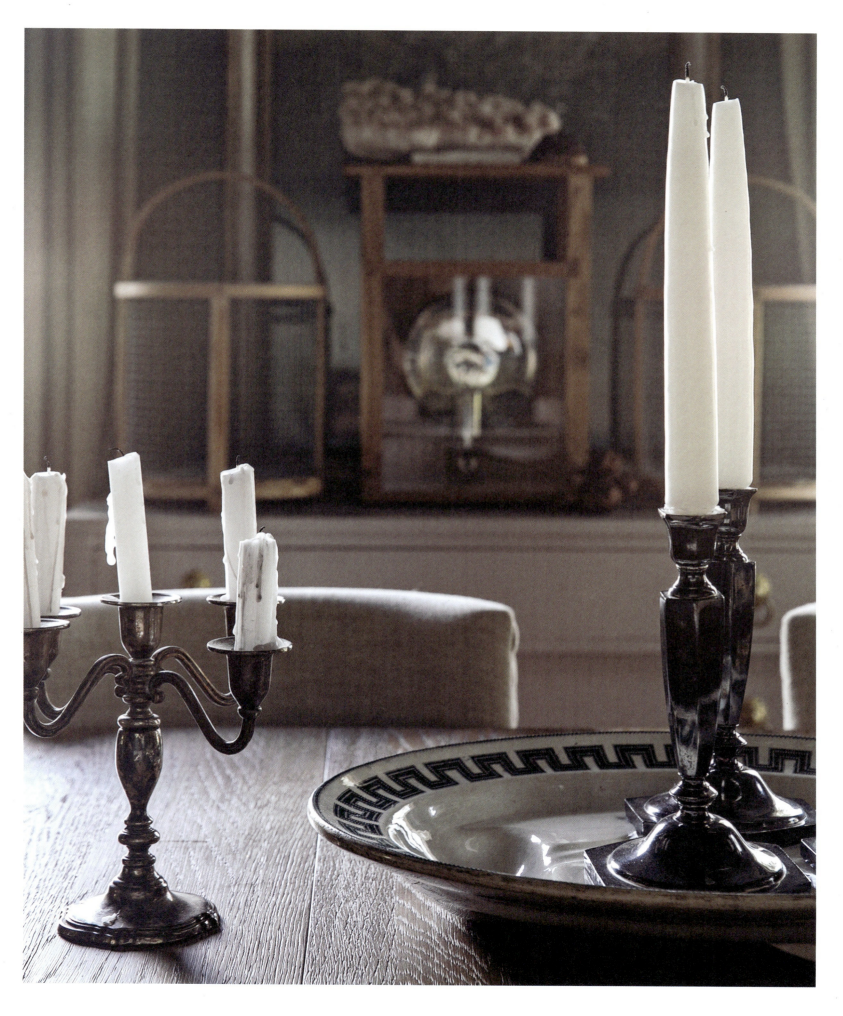

# THE IMPORTANCE OF HOME

*Every home has a story. As we imprint on it,* we become stewards forging new experiences within its walls that will become the historical makeup for the next generation that will step through its doors and further its story. This all becomes part of the DNA of a home—how it was chosen and what emotional connections were involved, the decisions made about improving it, how it was decorated, the fights within it, the make-ups, the celebrations and holidays, the moments of laughter, the occasional tears, the desires for change, the constant change of seasons, the source of comfort, and even the people who have walked through its halls. Theoretically, a home has a heart with blood running through its veins just as humans do. It has a birth and middle age, and it even experiences its golden years of life. It matures and needs face-lifts from time to time. It breaks down and needs to be repaired. Sometimes homes go through divorces and sit abandoned until someone swoops them up and shows them love again. Ones that survive the tests of time stand stoically like a well-preserved, confident, wise great-grandmother with white hair. Symbolically, homes go through many of the same life stages that we do. A home will return the same amount of love and respect that is given to it. Generation after generation, the moments shared in the company of friends and family dining on good food and appreciating the fullness of life is the reward that our homes give back for taking care of them.

Whether it is apparent or not, there is a real vulnerability that comes with inviting someone to your home. Creating a home is such a unique and personal experience, yet as humans, we find a shared interest in making a house a home because it gives us a sense of place, informs our life story, and connects us to others within our community. In the most primitive sense, it's the foundation of one's life—for one's lifetime. Our homes allow us to create meaningful lives full of feelings, experiences, memories, and imagination. Even though how we live our lives at home is different, the common bond for all of us is the desire to create a safe and loving environment that is always present. By opening your door to invite someone in, you share your personal story with them. The soul of your home is a direct reflection of how much of yourself you put into it. It is a living being inside and out that deserves as much of your attention as you can afford to give it.

My home is the center of my life. It's a gathering place to bring together all the things that I love to do: decorate, garden, collect, cook, and entertain. I am a homemaker—I constantly spend time adding to or changing things in my home to keep it fresh, new, and interesting. It evolves as I evolve—changing and maturing to become a better version of itself. My home is my laboratory for life, where I take the time to learn new skills, seek out new ideas, and discover better ways to do things. It's a sort of classroom for modern home economics where the art of domesticity inspires me to create a full and meaningful life for myself and my family. The attention given to my home shows in every corner, from the color of the walls to the flowers planted in the garden.

While entertaining is an art that involves a certain set of skills, entertaining at home is an experience shared between you and your guests that requires authenticity to make them feel included, comfortable, welcome, and wanted. Your home is the front and back cover of your book, and the pages within are the story of your life. You get to decide how much of your story you want to share. Just as you style your hair or put together your wardrobe, how you decorate your home will naturally show your personality. A home that is cared for and styled authentically will leave a lasting impression on anyone who sees it.

When I invite someone over, I want them to feel at ease the moment they walk through the door. They can see the way that I nurture and tend to my home with my own personal style, and they can sense that every detail was created with my own two hands (and the hands of my husband!). As they take in the monochromatic rooms, the textures of the furnishings, and the collection of antiques that we've accumulated, the story of our life unfolds. Each doorway becomes a portal to another chapter within our book. From the moss-encrusted birdbath perched stoically next to a window to the stacks of antique ironstone platters massed on the counters to the handmade cabinet that displays my husband's stemware collection, every detail piques the curiosity of our visitors. With each vignette that's perfectly displayed, our guests can sense that we've taken the time to be thoughtful about how we live in our home. Because of that, they usually feel safe and open to share more of themselves in return.

Whether you live in an apartment or on a sprawling farm, a home that is well-curated, cared for, and carefully kept is an ideal setting for hosting any type of gathering. Your authenticity is what you should most want to express through your home when someone comes over, not how wealthy you are or how much value you place on yourself. By filling your home with things large and small that have meaning, provoke curiosity, and tell a story about your experiences, you will create genuine interest within your guests to know more about you—the heritage you come from, your profession, the hobbies that interest you, the things that inspire you, and so on. You are allowing yourself to be seen, and with that comes the ability to build all kinds of relationships that you grow to appreciate.

While most people might find it unusual to fill their house with stone garden objects like birdbaths, statues, or footed urns, I admire their beauty, so much so that I collect them and use them all over my home, including my dining table during a party. While I have no formal training in interior design or decorating, I have learned to let my intuition guide me on what to buy and how to style it. This may seem easier said than done—I realize that—but when you understand that your intuition never puts you on the wrong path, you start to realize that rather than thinking logically about how to decorate a room, using your intuitive emotion to help you create a space that is personal to you will result in a home that you'll love to be in all the time. I can always tell when I decide with my ego. It feels like a push-or-pull deliberation—one that I never feel settled with. I question if I should buy something: *Where will I put this? What will I do with it?* If I question whether I will like the color of a wall during the day versus the night or if a window would look better with curtains, I can tell that I'm not trusting my intuition. Thinking about it logically, rather than intuitively, usually leaves me with a result that I end up changing later. But when I set my intention for how I want to use a room and what I want it to feel like, I can rely on my intuition and I can even see myself within the room, enjoying it. Every decision I have ever made based on this principle has never proven me wrong. The moment I start asking a million questions, I realize that I need to pivot from thinking with my head, to using my intuition instead.

If you use your emotional intuition from the moment you buy a home or rent an apartment to the day you decide what type of dishes you want, you'll create a home that will give you confidence and pride and bring you joy when sharing it with others. You will find that you'll want to invite friends and family over for small gatherings, host holiday parties, or even have company for dinner in front of the TV. Regardless of your level of expertise in entertaining, your home is your most important asset to living a full life and sharing it with others. Having a greater connection with your home means that you'll never feel unsatisfied with it. You will find that the fullness of life, no matter what age, begins and ends at home.

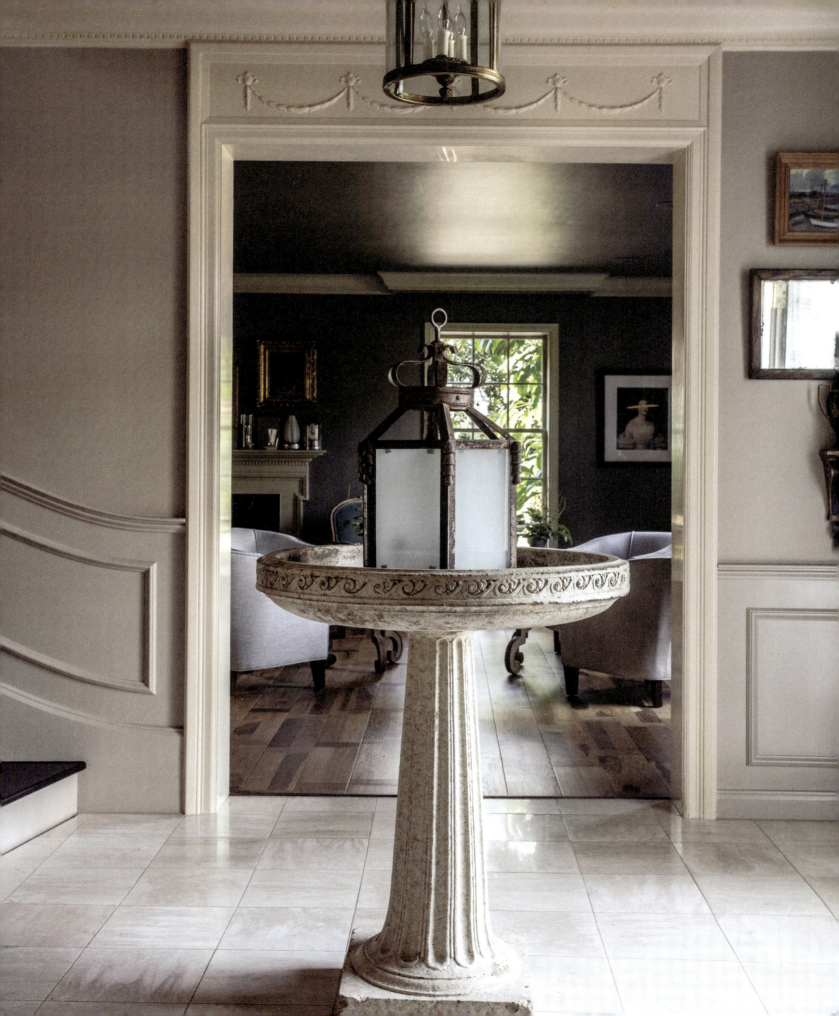

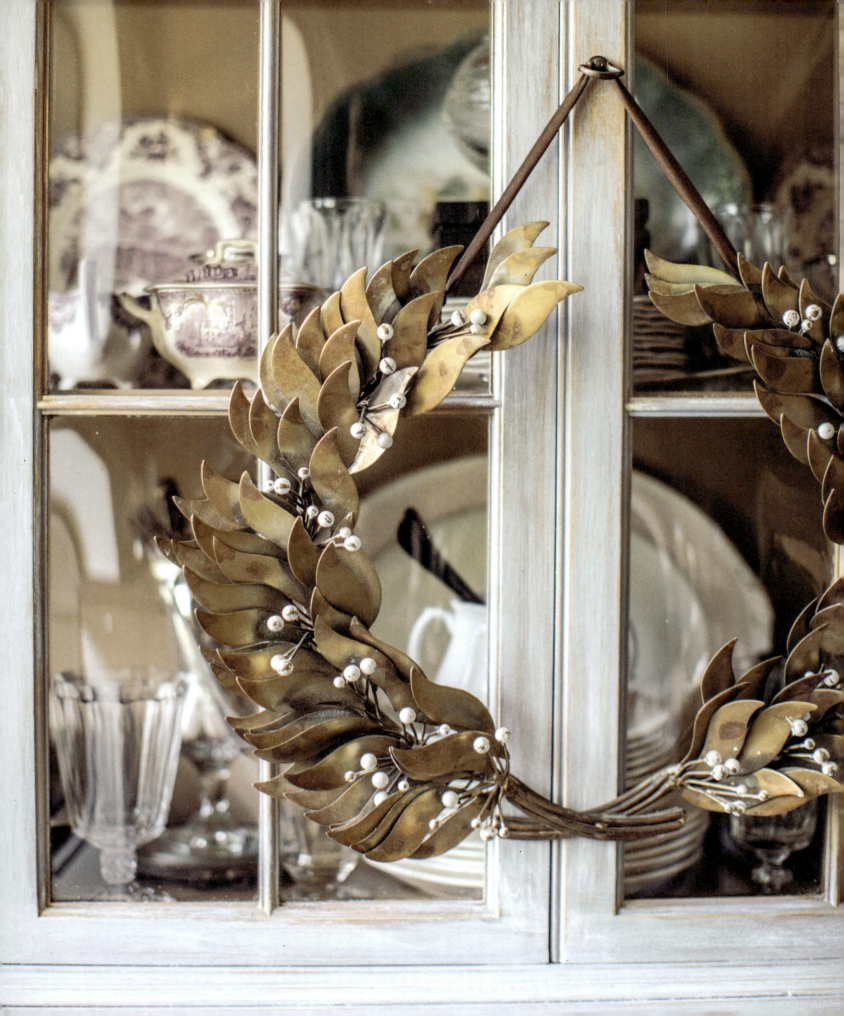

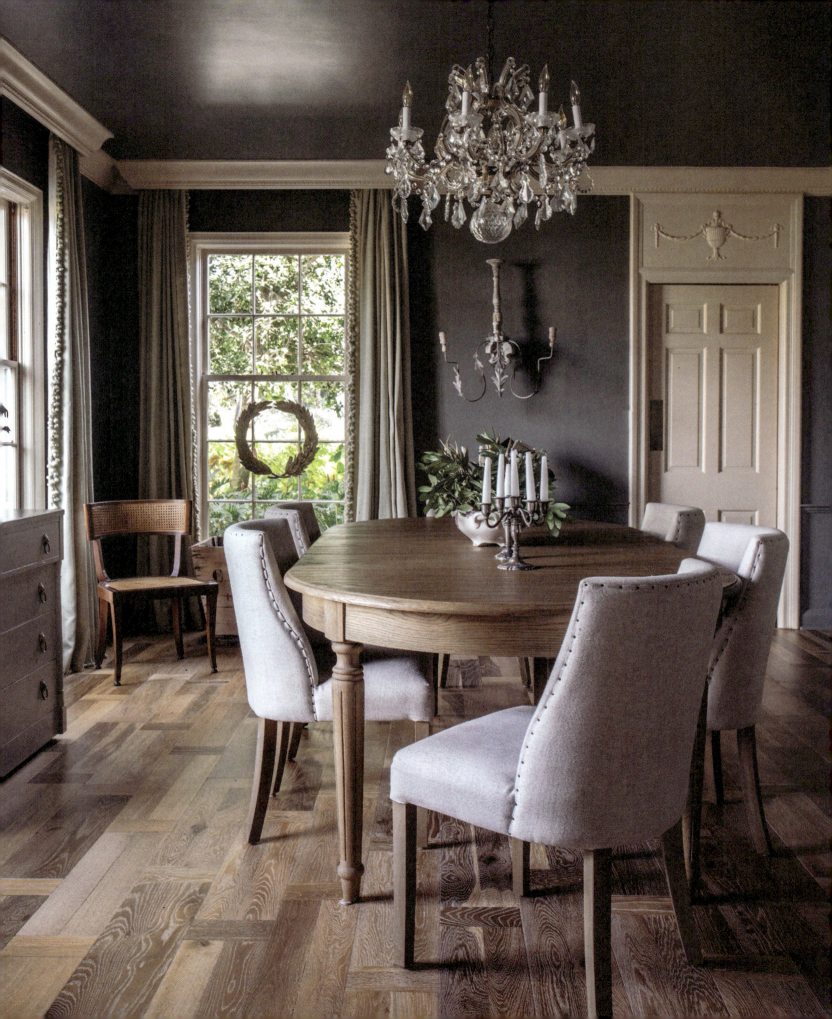

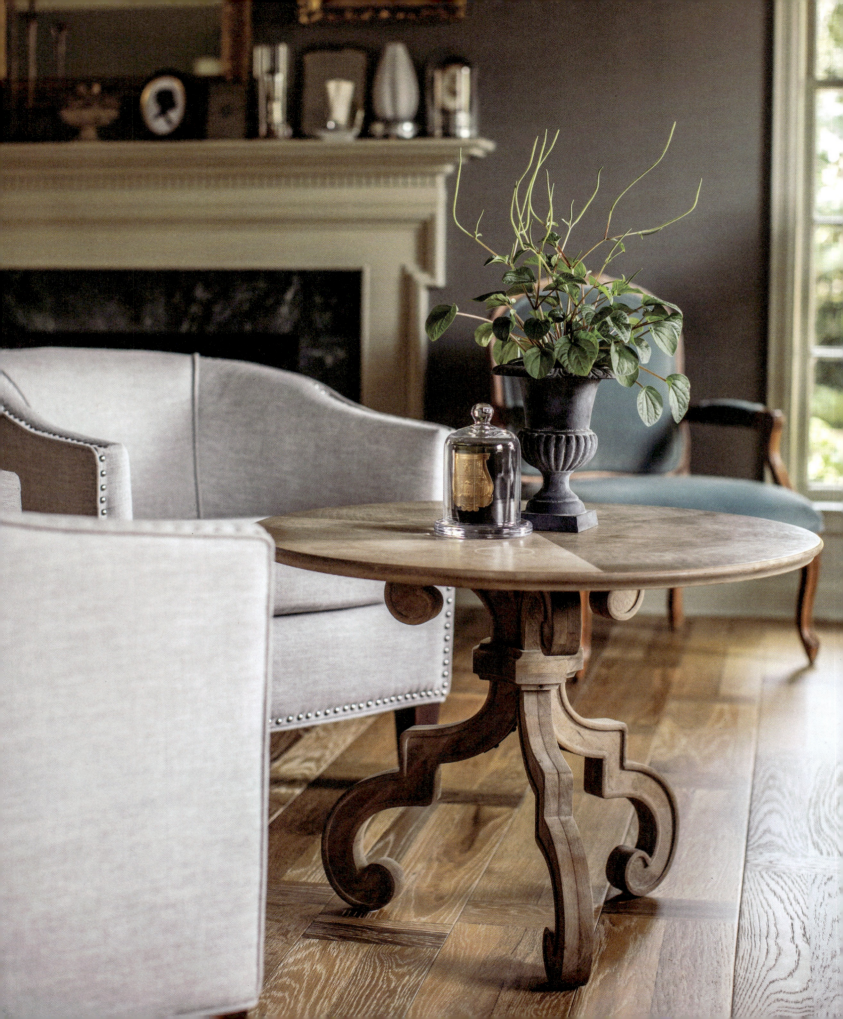

My home is layered with treasures that I've collected over the years. A mixture of items from tag sales, flea markets, and thrift shops complement garden statues, architectural pieces, and found objects. Elements from my garden like bird's nests, dried palm fronds, and harvested gourds bring a feeling of nature indoors. Just as every vignette is styled to tell a story, each room is arranged to have its own personality.

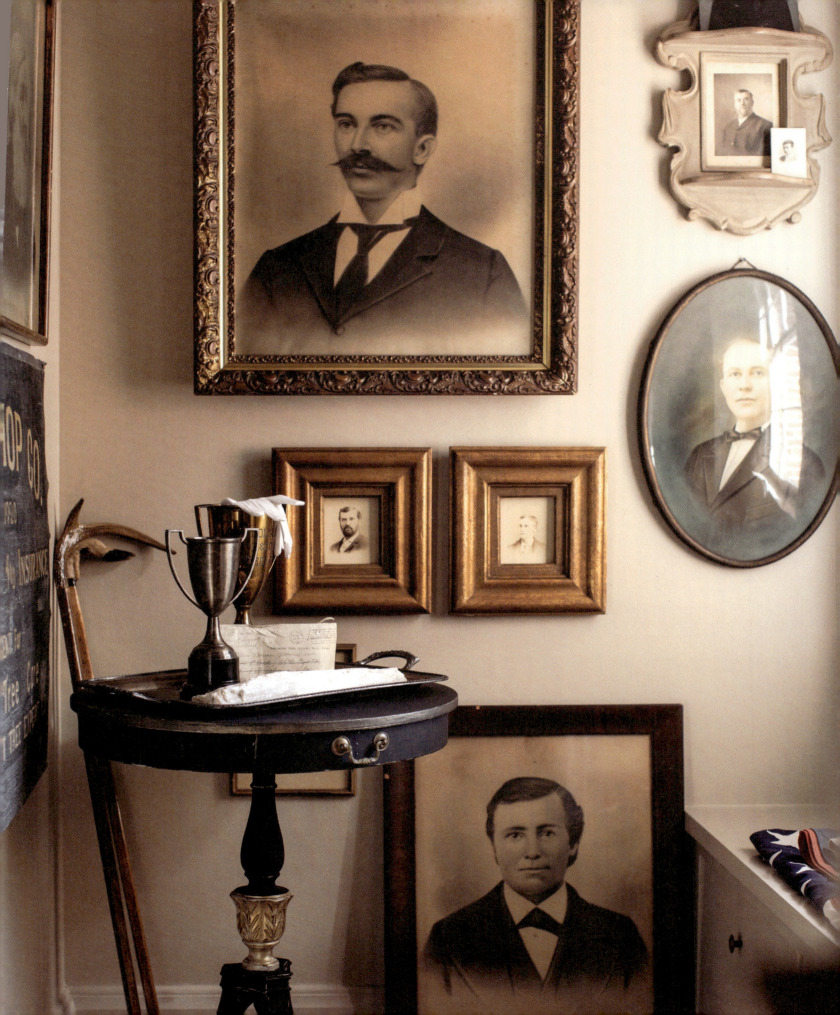

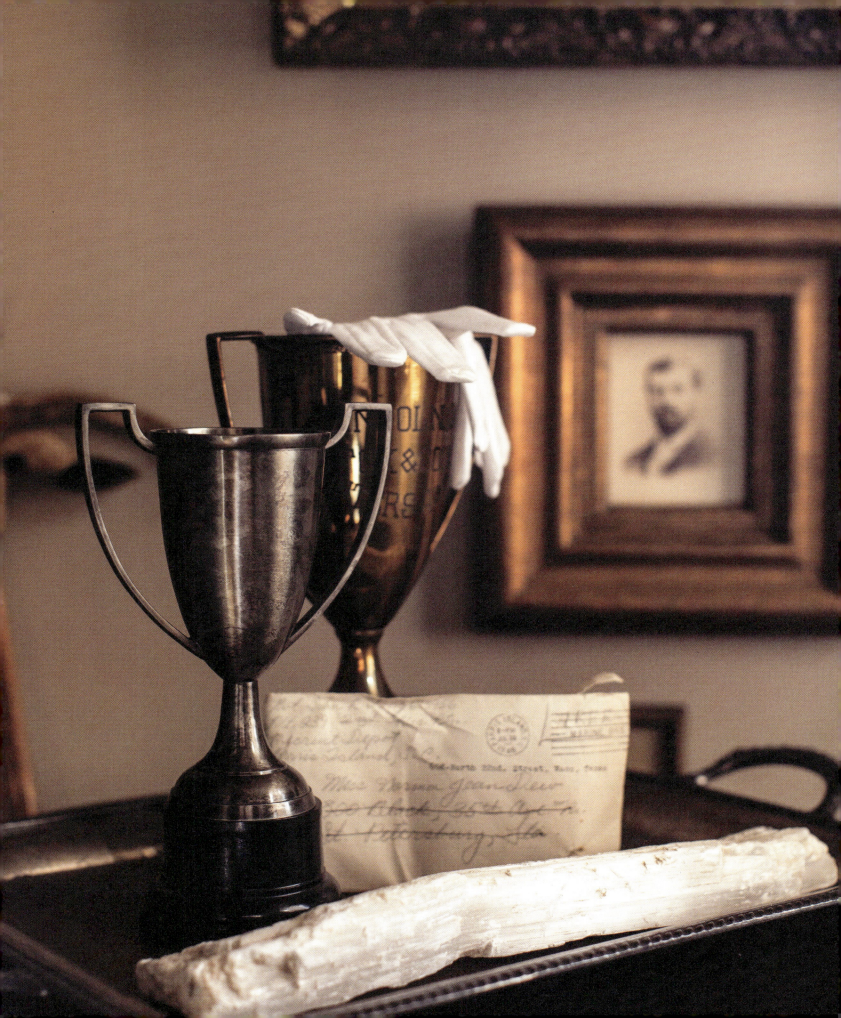

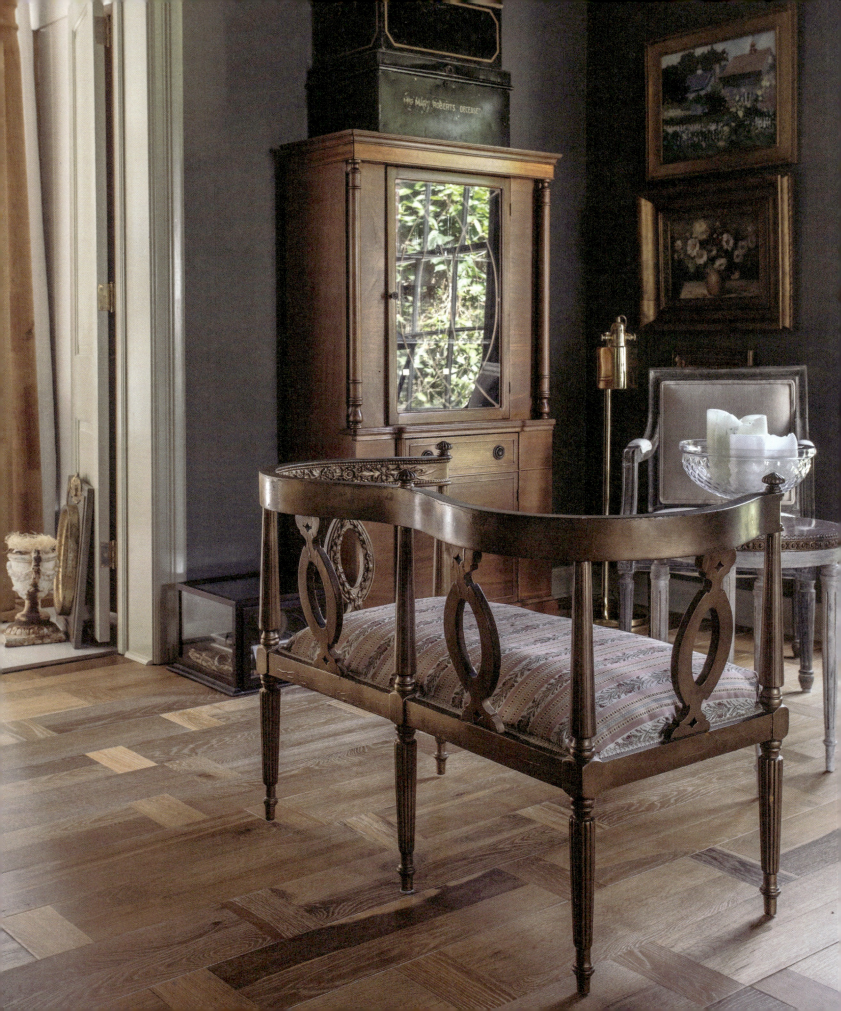

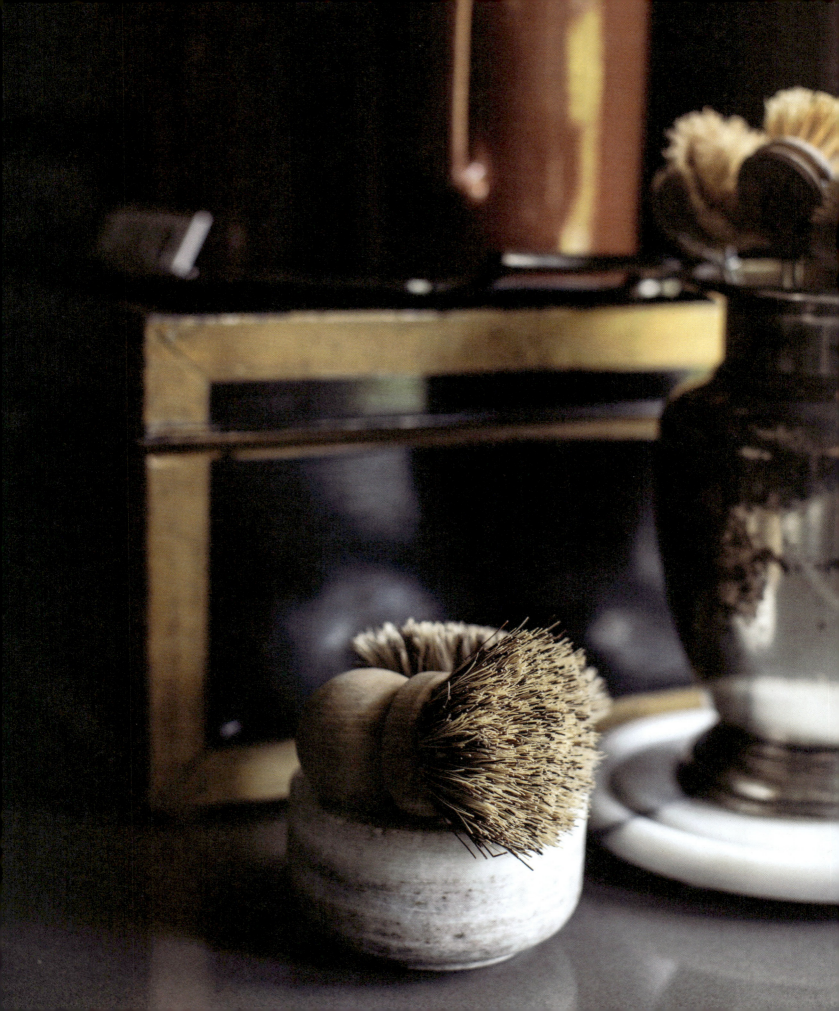

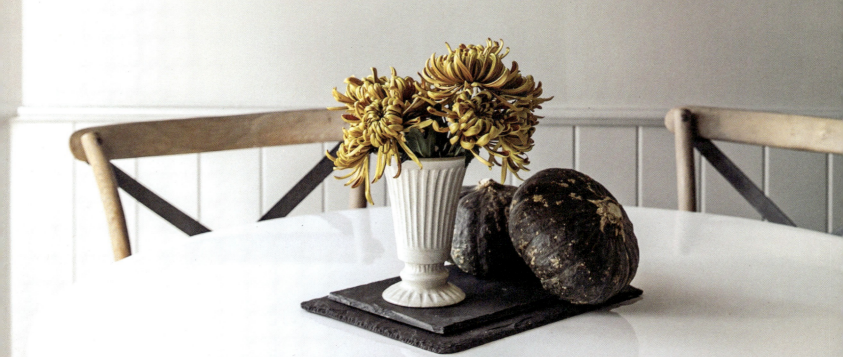

E.A.BISHOP CO.
EST. 1920
REAL ESTATE AND INSURANCE

AGENT For

Shade Tree Care
F. A. BARTLETT TREE EXPERT CO

# BEFORE *HOW* COMES *WHY*

*Before approaching the question* "How do I entertain?" one must first think about the question "Why would I entertain?" It is an art and practiced skill to be able to bring together a group of people for the common purpose of connecting and interacting over good food and drink. Entertaining can mean different things to different people. For someone new, the idea of planning a party can be overwhelming if they don't first ask themselves, "Why?" Entertaining at its core taps into the emotional nature of nurturing and connecting with others. It's not about austerity or showing off how accomplished you are. It's a way of making connections, building friendships, creating community, and sharing memories. In today's world of ongoing changes in social engagement, living environments, and connections with our homes, our reasons for entertaining continue to evolve.

Despite the ubiquity of computers, televisions, and mobile devices, we are in an era of rediscovering our genuine connection to our homes—learning that our homes are the nuclei that all life revolves around and that so much more of life should be lived fully within them. Today it is even more critical to set aside time for welcoming people into our homes and our lives. Though the ways we live our lives are endlessly diverse, the one thing that remains constant among us is the need to feel loved, cared for, happy, wanted, seen, and appreciated. How we achieve those feelings can vary from person to person. By opening your home, welcoming people, and hosting a gathering, you get right to the heart of those feelings, for you and your guests alike. Human connection is inherent in our nature, and we have learned throughout history that

we suffer emotionally, mentally, and physically when our scope of human interaction is narrowed to such a degree that we feel isolated. Engaging in the art of entertaining allows us to be filled with the prospect of creating plans with the people we surround ourselves with.

Your answer to the question "Why would I entertain?" will be unique and individual. It may be that you're extroverted and enjoy good company, or it may be that you have exceptional culinary skills and want to show them off. You may just entertain for the holidays. Some people entertain professionally, while others just have a knack for socializing. And there may be some people who don't like the idea at all because it seems overwhelming. For me, I especially enjoy the ritual of the entire process: planning, cleaning, shopping, cooking, arranging tables, serving, and spending a pleasant evening with others—sharing laughter, good conversation, the food that I've prepared, my experience preparing it, a connection over unexpected things, memories, struggles, similarities, and even differences. It seems to me that we exist in a world where we are trained to think only about ourselves. People misunderstand the notion of taking care of themselves first, often at the expense of others. Well-being doesn't exist within the ego, but in the broader sense of our energetic and emotional connection to a higher source and to each other—one that is compassionate, empathetic, and inclusive.

Giving of myself and my ability to nurture others is what brings me the most amount of joy when entertaining. Hosting also allows me to slow down and connect with myself more purposefully so that I can recenter and remember what's important in life—a sort of active meditation.

You can have a dining table that seats twenty, you can read all the best cookbooks, and you can mimic all the top event designers or content creators on social media, but without an authentic understanding of why you want to entertain, you are missing the most important aspect about the joy of entertaining. It's hard work, and with it comes a lot of responsibility—far more than just setting a pretty table. There is no such thing as "easy entertaining." If you don't have a genuine sense of what pleasure you derive from entertaining, it will merely become one more thing that you hate to do. Why does a painter paint? Why does a poet write? Why does a chef cook? Why do gardeners create lavish gardens that require an immense amount of upkeep? Not because it's easy, but because they fully understand what brings them joy in doing so. I mean, let's be honest, who in their right mind wants to spend hours shopping and prepping food, cleaning their house, setting up for a party, serving guests, and then spend several more hours cleaning dishes and recleaning their house? It sounds awful until you truly understand why you are doing it and what about it brings you joy.

When your *why* comes from your heart, all the planning and preparation becomes fun. The work before and after the party brings you just as much gratification as the party itself. It won't even feel like work, rather a string of moments that create memories to reflect on with appreciation. You'll find yourself wanting to do more of it. The mark of a good host is that they enjoy the process just as much as the event itself. And the most successful parties are those where the hosts are genuinely enjoying themselves—before, during, and after the party.

Allow yourself to try something new. You don't need a reason or a holiday to entertain; you can do it merely for the joy of bringing people together. Don't just skim the surface of hosting, but immerse yourself into the rituals of it. Start collecting pieces you can serve with, start researching recipes, and become inquisitive. Allow yourself the experience of shopping at a farmer's market for fresh, flavorful ingredients. Go meet your local wine merchant and learn how to pair wines. Play with flowers, polish silver, arrange a room for company, and bake the best damn cookie you can. The experience of entertaining will be just as much fun for you as it will be for your guests.

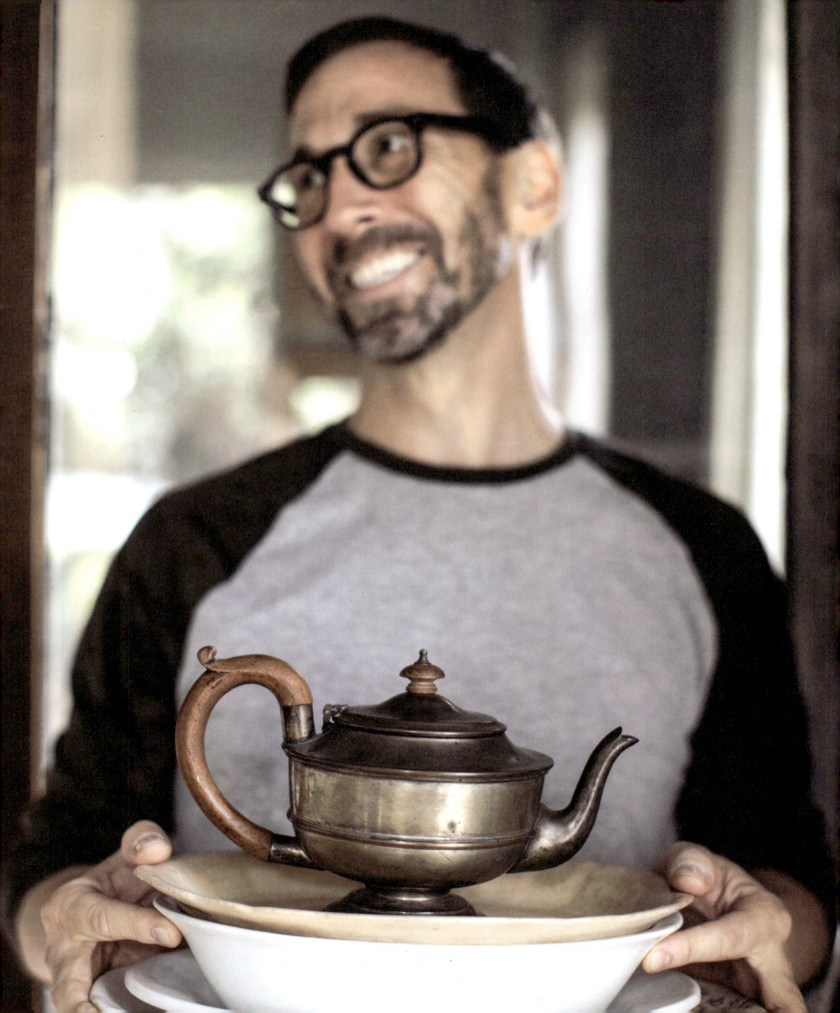

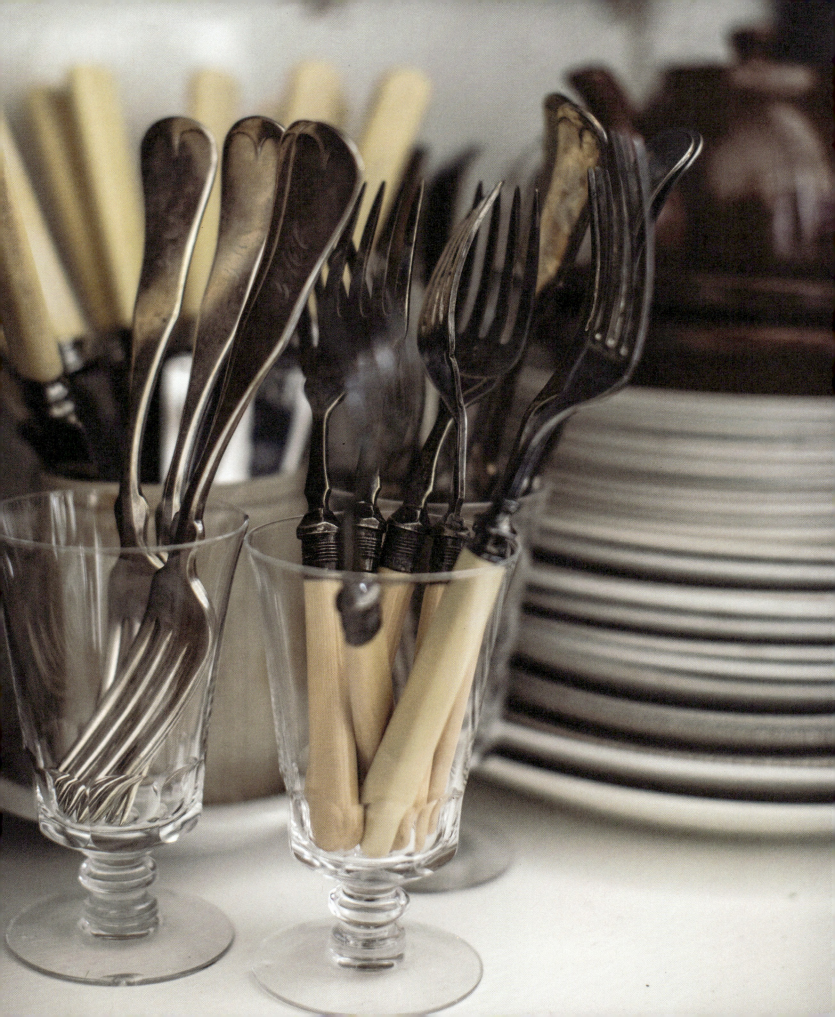

Antique cutlery and serving pieces that are rich with patina can have a significant impact on a table when paired with new or modern dishes. Adding etched or colored glassware found at thrift shops lends a three-dimensional interest to an otherwise flat surface.

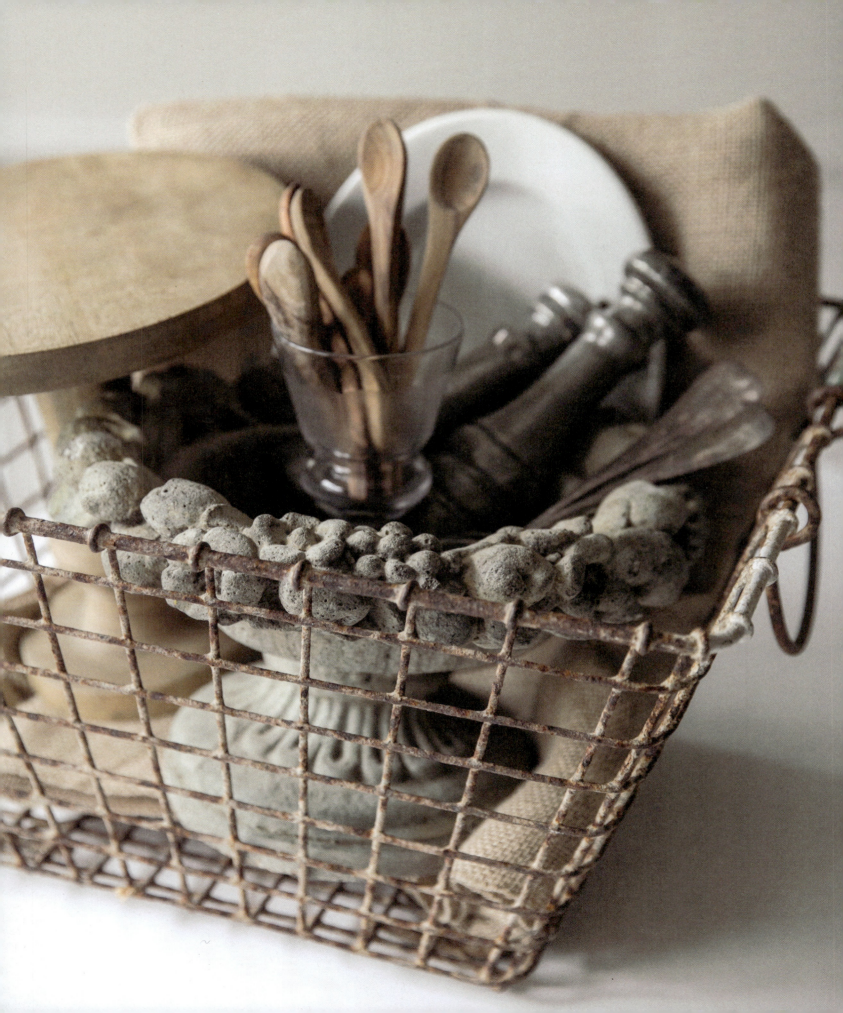

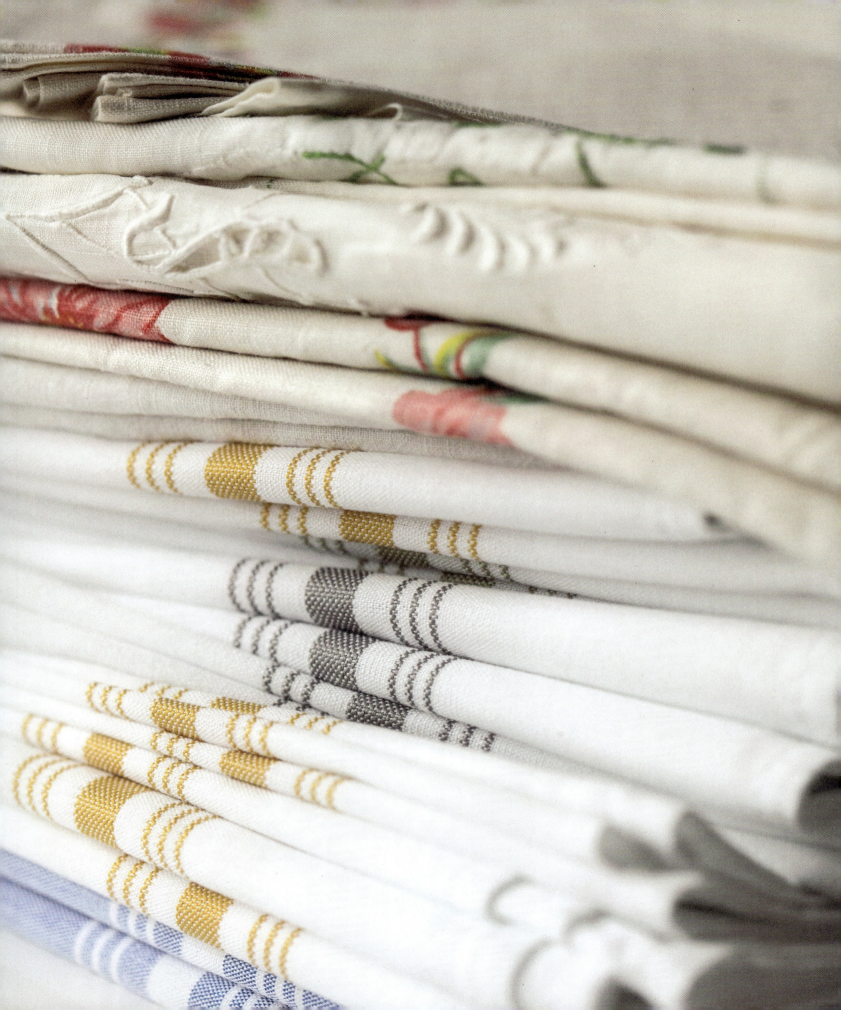

To welcome guests, food is prepared
from scratch, linens are chosen, platters
are gathered and stemware is organized.
Every detail is carefully considered—right
down to the icing on the cookies.

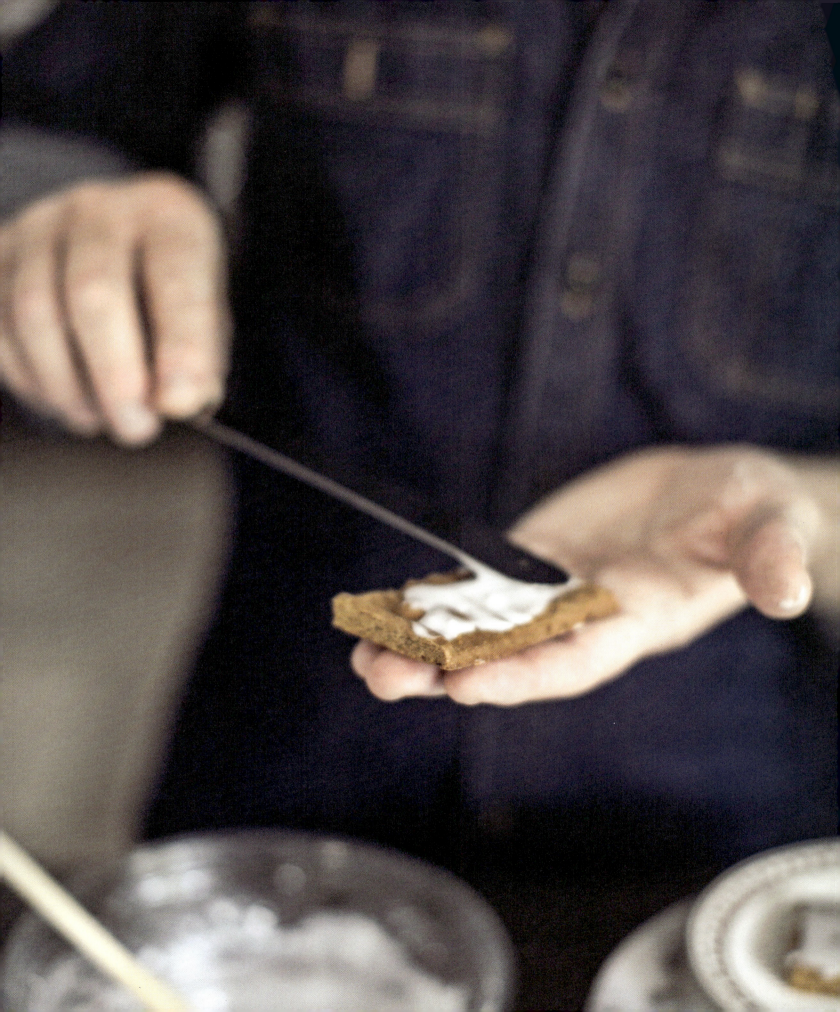

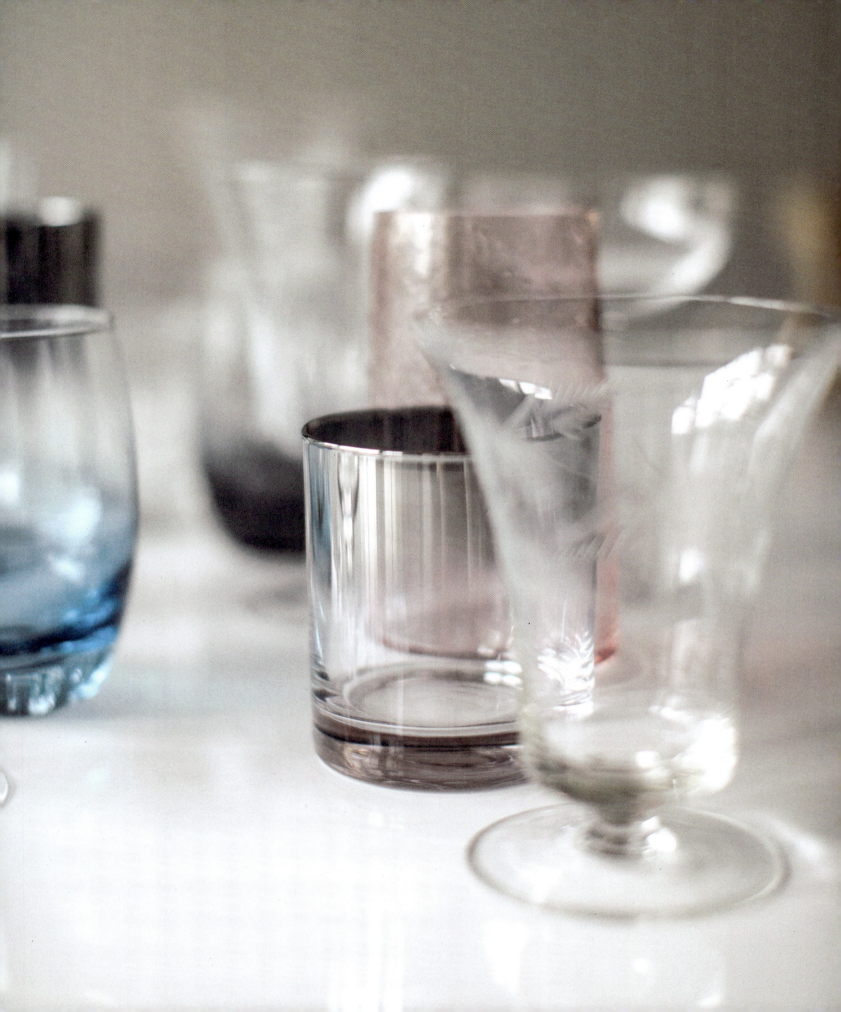

# THE MARK OF A GOOD HOST AND THE MERIT OF A GRACIOUS GUEST

*Events, celebrations, and gatherings can* take infinite shapes and forms—from the location to the music to the food, there are endless options to consider. But two elements that are an essential part of every single party, no matter its size: every party needs a host, and every party needs guests. At some point in your life, you are going to be the host of a gathering, just as you'll be invited to be a guest in someone's home. Both of these roles come with various responsibilities to consider.

## ON BEING THE HOST

Some people are naturally inclined to host parties. It's in their DNA, but that doesn't mean entertaining is reserved exclusively for them. Practice and experience through trial and error can turn you into a commensurate party planner. A good host enjoys entertaining not because they want to show off or claim their position in society but because they genuinely like bringing people together. Before opening your home to others, there are some important rules of etiquette that you should know.

The evolution of etiquette has seen its ups and downs with each generation. Over the past several years, life, in general, has become more relaxed, and many rules of etiquette that once were commonplace have been modified to reflect a

more relaxed lifestyle. Even though conventional rules adapt and change, etiquette continues to be a basic science of living. It remains an important guide for acceptable personal, social, and professional behavior to allow us to live together in harmony.

As a host, your most important role of the evening is prioritizing the interests of your guests in everything that you do. In doing so, you will demonstrate your good nature, and your guests will follow your example, which in turn will result in the display of appropriate social conduct within your home. Some may question whether conventional etiquette should also be adhered to at gatherings that only include immediate family. While the setting may be more relaxed than a formal affair, proper behavior, good taste, charm, manners, and a pleasant demeanor are just as important, both for the host and the guest. Considerations of etiquette should begin the moment you decide to have a party.

You will have a lot of details to attend to in the days and hours leading up to your gathering, so before a guest list can be assembled or a menu planned, it is important to make sure that your home is clean, organized, in good repair, and ready to invite guests into. The last thing you need is to feel stressed that there is unfinished business with the impending arrival of your guests.

Planning a guest list ahead of time helps to keep a structure for the rest of the details of your party. Your list might include friends, relatives, business associates, neighbors, or new acquaintances. Inviting people that you're sure will be compatible with one another will take some of the pressure off you and keep your party flowing smoothly while you are tending to food preparations. It's also good to invite a few people that you know are outgoing and good conversationalists on their own.

While some gatherings like cocktail parties thrive with a large guest list, it's not always necessary to have a large group of people, especially if you are new to entertaining. If you're just getting your feet wet, plan for a pared-down gathering you'd feel comfortable with, and build up as you gain confidence and experience. Remember, too, that budget and space factor into your planning. It is always better to do less and to do it the best that you can than to spread your budget too thin.

Always create your budget first. Some small and impromptu gatherings may not need much thought financially, but the costs for bigger parties can add up quickly. Critical thinking and proper planning are skills that every host must learn, especially when it comes to finding creative solutions to maximize one's budget. Depending upon the type of event, your budget might include the printing of invitations along with postage, floral arrangements, linens, waitstaff, and live music, or it might primarily consist of food and drinks, thank-you notes, and bags of ice. No matter, there will be unexpected expenses that arise with each party, so plan in a buffer as well. Once your budget is established, you can confidently determine if you can successfully put on the type of event that you want with the guest list that you have anticipated.

The type of invitations you send should be commensurate with the formality of the party that you plan to host. A written invitation is not always required; however, whenever it's fitting, a written one is always preferred. Be concise and clear about the party details in your invitation so your guests will understand how to prepare for the occasion. Details as minute as a special guest being honored or a new friend that you want to introduce should not be overlooked. These details are just as important as the time and date of the party. Also, consider the time of year you are entertaining to ease scheduling conflicts for your guests. Consider your guests' lifestyles, regularly scheduled obligations, and daily agendas before deciding. If you want your party to be a success, you want to make attending it as easy as possible for everyone.

A good host always considers their neighbors when setting out to have a gathering. Immediately informing

An invitation might include the following details:

- the name of the host
- the type of occasion (holiday, cocktail, birthday party, etc.)
- if the party is in someone's honor, the first and last name of the honoree
- the date the party will be held (including the day, month, and year)
- the time the party will begin (and end, if applicable)
- the location where it will be held (likely your address)
- the date guests should RSVP by and instructions for how they should do so (the RSVP date should give you plenty of time to prepare, but it should not be so far ahead that it makes it difficult for your guest to commit)
- any short, quick information that you think will be prudent (black tie requested, light hors d'oeuvres served, theater to follow, casual attire, don your most creative hat, etc.)

any neighbors that might be impacted by your party shows that you're thoughtful. Let them know the details of your event, and encourage them to contact you immediately if there is any inconvenience that is too grave for them to handle. Perception is individual—what may not seem like a big deal to you might be to someone else. You can inform neighbors in person, over the phone, or with a handwritten note left at their door. Text or email might come across as passive-aggressive. If it's the type of gathering that permits, consider inviting them for a cocktail. A good deal of proper etiquette relies on intuition as well as goodwill, so approach an unusually difficult neighbor ahead of time with a token of appreciation to bolster an amicable and respectful relationship.

Have a plan, be prepared, and be flexible. Creating a schedule for the day of your event helps to keep you focused. A feeling of calm preparedness from you makes an imprint on your guests, just as a frantic, flustered feeling does. Commit your schedule to memory, but always have it written down behind the scenes so you can refer to it in private. Write down every detail you can think of. My schedule even includes the times I should light the candles, turn on the music, and check the thermostats. There is a

feeling of accomplishment that comes with knowing you are prepared when the first guest arrives. While creating structure is important, stay flexible. Sometimes things will throw you off schedule, and that's OK. Use your intuition and critical-thinking skills to work around those unforeseen circumstances and get yourself back on track as soon as possible. Also, after each party, a good host takes note of things that could have been done better to ensure that the next party goes more smoothly.

Set the scene ahead of time. Consider every detail you can think of for warmly welcoming your guests into your home. Use your senses to determine if something will feel good or not. Even when every detail is well thought out, there will be last-minute adjustments. Make sure your table is perfectly set, your home is clean, your serving dishes are prepared, the lights are appropriately ambient, candles are laid out, flowers are placed, the guest bathroom is properly prepared, doors are unlocked, the coat closet is cleared out, the porch lights are on, the bar is ready to go, appropriate music is playing—and at just the right volume. These are all details that individually may not amount to much, but when put together in perfect orchestration, the impact on your guests will instantly put them at ease and ready to mingle.

## — IN PERFECT TIME —

The timing for sending out invitations is very important. Here is a general guide for when to make an invitation:

*formal dinner:* two to three weeks in advance

*informal dinner:* four days to one week in advance

*cocktail party:* two to four weeks in advance
(during the holidays, it should be closer to four weeks)

*formal luncheon:* one week in advance

*casual lunch:* two to four days in advance

*casual gathering:* one to three days in advance

*birthday:* three weeks in advance

*bridal or baby shower:* three to four weeks in advance

*wedding:* two to three months in advance

*graduation or religious milestone:* three to four weeks in advance

*holiday dinner:* four to five weeks in advance

**TIP:** A not-so-commonly-known standard of etiquette: You would not address the envelope of an invitation (especially a formal invitation, such as for a wedding or a formal dinner) to the invitee "and guest" (i.e., Janet Smith and Guest). You should address the invitation to the person you know (Janet Smith). If you would like to extend the opportunity for them to bring a guest, enclose a handwritten note welcoming them to do so. In the case of a wedding invitation, you would address the inner envelope to your invitee "and guest."

Master the art of greetings and introductions. Cordiality, charm, and graceful demeanor are imperative when welcoming someone to your home, even if it is your closest family. You should always be there to greet your guests at the door, even if you must politely excuse yourself from another conversation. It's more than just a hello; it's a moment to express your gratitude for their attendance. It can even be a moment to flatter your guest with a compliment in whatever way is appropriate. Make it a positive, loving exchange, but know that it's not an appropriate time to lead into a lengthy conversation. They want to get settled, and you still have work to do. Welcoming someone into your home is also a good time to make an introduction to someone else. Even if you know someone has met before, reiterate their first names so that they aren't caught off guard or left feeling uncomfortable in case they don't remember the other person's name. Find a common topic of interest to foster a conversation so that you can return to the party. Greetings and introductions should always be short and sweet because you will have to serve drinks, tend to other guests, and serve food. If a guest presents a hostess gift, politely thank them but do not open it at that moment. Bring it into the kitchen or another room to open after the party. Should a guest bring a bottle of wine (unless you requested that they bring it for the party), it is a hostess gift for you to enjoy later, not for you to serve at the party (except when you've run out and need to use it).

Be the leader and be visible. You oversee the party, from the food to the conversation. Your eyes and ears must be in many places at one time. Your intuition should also be finely attuned. Whether you are having a large cocktail party, an intimate dinner party, or a backyard barbecue, you will need to know how to scan a room or a table and interject when needed—in fact, often *before* something is needed—whether to refill a glass or offer more food. Never assume the role of a guest at your party, and never spend more time behind the scenes than needed. You must be there to tend to your guests as well as mediate the occasional accident or provide a boost when a conversation fizzles.

Too often, someone will get on a sensitive topic that's inappropriate for a social gathering, or an inebriated guest will become difficult. You may have to privately approach a delicate situation and handle it the best way that you can as quickly as possible. There are three really good ways to divert the attention of a difficult guest that I've used at various times. The first is what I call the "shiny new object" approach. Gently get the attention of your difficult guest and tell them you want to show them something in the other room—maybe something new that you've purchased. The second is the "ask for advice" approach. After getting their attention, ask your disruptive guest if they could give you their advice about something while leading them off in the other direction away from the rest of the group. I call the third approach "ask for help." Guide the difficult guest away from others by asking if they would assist you with something in the kitchen. With any of these approaches, once you have the guest alone, you can diffuse the situation. Never challenge a guest in a tense moment, and always remain composed and gracious.

Cell phones should be put away. You've invited your guests to spend some one-on-one time with you. This is a moment to have face-to-face connections. Allow this to be a time to disconnect from mobile devices and appreciate the company that you have in your presence. As the host, you can keep your phone in the kitchen if you need to periodically check it, otherwise, don't have your phone out. If a guest is too reliant on their mobile device, be polite and ask them (in private) to kindly put it away and be in the moment with the other guests at the party. Sometimes a parent or a professional is required to be on call. Be polite but proactive and softly suggest that they take their call privately in another room.

An inevitable situation that every host encounters at some point is a guest who arrives late without giving prior notice or, better yet, the guest who arrives too early. Both have their drawbacks and can potentially cause frustration.

It is important to observe but not absorb the actions of a less-than-considerate guest so that you can approach either situation with calmness and composure. Be attuned to your body language during these situations as well. A guest who arrives too early should not expect to take up your time until the party starts. You can welcome them in, offer a drink, and politely tell them you have a few things to finish up and that you will be with them shortly. If it's a close friend, you can elicit their help, but generally don't ask guests to help at a party you are hosting. In contrast, a guest who arrives unusually late should be welcomed to join at whatever stage the party is at. Arriving late to a cocktail party may not cause that big of a ruckus; however, when a dinner is planned, it would be impolite of you to inconvenience the other guests with an unreasonable delay. I give a grace period of fifteen minutes, and then I simply rearrange the seating to reserve a seat next to me for my late guest. When they do arrive, I can quietly usher them to the table for a seat next to me without disrupting the other guests. The late guest may feel embarrassed, so help them to quickly integrate into the conversation as effortlessly as possible and serve them whatever course the others are eating.

Be attentive to your guests, clear up throughout the evening, engage in conversation, offer refills on beverages, and make sure everyone has had enough to eat. Aside from an occasional guest bringing a dirty dish into the kitchen, refrain from allowing anyone to help with any cleanup. Be conscious of removing dirty dishes and glasses before they add up. Have a dedicated spot in your kitchen to stack them so that you can return to your guests. It is never polite to wash dishes while you have guests in your house. Often you will have a persistent guest who will want to offer help, which is very polite of them; however, you invited them to your home to enjoy themselves. Acknowledge their offer with appreciation, and unless there is an extenuating circumstance, let them know that you have it covered.

A good host prepares for the small (sometimes seemingly insignificant) details in advance—even those that are not related to food. For every gathering, I have two very important things prepared ahead of time. One is a kit of travel-sized personal items to keep in the loo. It includes items a guest can use in private for any number of reasons—such as Band-Aids, deodorant spray, mouthwash, floss, a sewing kit, an eyeglass kit, nail polish remover, a nail file, nail clippers, a stain stick, feminine hygiene supplies, safety pins, bobby pins, and aspirin. Kept neatly in a basket by the vanity, it is something that your guests will notice and be so appreciative of. The second, for my sanity, is what I call a 911 kit. I prepare a bucket of soapy water and put it in a broom closet with a mop, several towels, a roll of paper towels, spray cleaner, club soda, stain remover, salt, and a hand broom with a dustpan. When the inevitable happens, I am ready for it without causing a fuss or commotion among my guests. You wouldn't want to be caught in a situation where your party suddenly turns into a mad search for cleaning products.

Seated dinner parties are a lot of fun, and thinking outside the box for a seating arrangement has benefits. I always put considerable thought into it. This is one area where the old-fashion rules of etiquette can be bent. My style deviates from the traditional norms of alternating men and women at the table, largely because my husband and I have a diverse community with same-sex couples, but also, I find that old style of seating too stuffy. I do not believe in separating couples at different ends of the table either. I find that couples can add to the vibrancy of a dinner party because they can keep a conversation flowing as a team. As the host, you would seat yourself in the most commanding position of the table, usually at the end closest to the kitchen and with the ability to view the entire room. Plan the seating around you by putting the shyest people closest to you, and intersperse talkers evenly around the table. If you are entertaining outdoors

## — BUFFET-STYLE ETIQUETTE —

Hosting a buffet-style meal? Once you have presented the food, casually walk around the crowd and quietly invite everyone to help themselves to the buffet. While you keep an eye on the buffet, offer wine to anyone who has sat. Always serve yourself last during a buffet dinner.

If seating is casual and scattered about, then it is OK for guests to start eating as soon as they are seated. If there is only one main dining table, then it is polite for the guests to wait until you have seated yourself. In this case, it would be wise to welcome your guests to start eating once half of the table has been seated, as you will be busy serving drinks and making sure platters are replenished as needed.

with a beautiful view of the garden or sunset, seat your guests with the best view possible. Let them appreciate what you get to see every day. Be mindful of anyone who is left-handed and seat them at an end of the table so they don't feel constricted sitting next to a right-handed person. Most importantly, if you have a special guest or a guest of honor, be sure to seat them next to you.

It's common during a dinner party for a host to signal that it's OK to start eating by being the first to lift their fork. If you don't have help serving, be mindful to sit as quickly as possible after serving the last person. You don't want your wonderful meal getting cold. If you do need to quickly excuse yourself, at least your guests will be eating. If you have a spouse or a very close friend, allow them to assist you with refilling drinks while you are serving the meal.

When it's time to wrap up the party, you want to suggest it without being rude or crass. You will need some time to yourself to unwind and clean up. There are a few signals that you can give to let your guests know it is time to wind down. Typically, during a seated dinner, one

hour after dessert is plenty of time to start wrapping up. Offering a tray of mints or small chocolates accompanied with a statement that you've enjoyed having the company is a gracious way to end an evening. Try turning down any music until it is just barely audible or close the bar and remove any food into the kitchen. Slowly start to clear any extra dishes or glassware. If you're offering small parting gifts as a token of your appreciation for coming, start handing them out. Giving a polite expression of thanks for a lovely evening to a group helps get a large crowd to say their goodbyes. If a guest yawns, capitalize on it. Elicit the help of a friend to be the first to say they are going to leave. And, if all else fails, flicker the lights and announce, "Last call!" (Jokingly, of course. I would only use this tactic with very close friends who would get the humor!) However you decide is best, be sure that your final goodbyes are brief and genuine.

Make your guests' departure as special as their arrival. I like the idea of giving a small takeaway to each guest as they leave. It is not expected, but that's exactly why I do it. It doesn't have to be anything fancy or expensive—something homemade is especially nice. It could be some chocolate bark, roasted nuts, a Chinese fortune cookie, caramels, or a small clay pot and a package of seeds—be creative. No matter how your party turns out, it puts a finishing touch on the night.

## ON BEING THE GUEST

A seasoned host knows the value of having well-mannered friends and family join their parties. Even if you never take the opportunity to host your own party, you will certainly be invited to one. Aspire to be an engaging guest. From responding to an invitation to sending a thank-you note, you should exhibit your best behavior. Attention to etiquette should not be misconstrued for snobbery. Striving for it doesn't mean you must be stiff and robotic; it just means that you should reciprocate the gracious gestures that you hope for as a host. By doing so you help to make someone's party a success.

When you receive an invitation, respectfully reply promptly. It may not seem like a big deal, but for the host, so much planning hinges upon your response. If you're unsure about your ability to attend, be polite and telephone or email as soon as possible to state your interest in attending and explain what's holding up your ability to commit. Usually, the host will make a concession and reserve a tentative spot for you until you can let them know with certainty. If time passes and you're still unsure, politely decline altogether and ask to be included in the future. Texting a response to an invitation should be avoided— unless you received the invitation via text. If an invitation is made within a group text, it's probably been done for ease. It's prudent to respond to the host individually as well as within the group. A host receiving responses in a group text could get confused and miss something.

If you neglect to reply by an RSVP date and the party is within a few days of being held, it's best not to contact the host and ask to be added to the guest list. Rather, send them a note or an email apologizing for your lapse of duty and wish them all the best success with their party. If the host feels you're sincere and they can manage, they may continue to extend the invitation, but this decision is rightfully up to them.

If you do need to decline, you shouldn't go into detail about why unless specifically asked. It's polite and thoughtful, however, to follow up with a handwritten note thanking the host for the invitation, and that is when you can elaborate on your absence. If you decline an invitation to a celebration at someone's home, be it a birthday, graduation, or wedding, sending a card acknowledging their celebration is a kind and thoughtful gesture.

If you've accepted an invitation, be sure to arrive on time—especially if you've been invited to a seated dinner. For me, on time constitutes a fifteen-minute grace period from the time stated on the invitation. If you'll be attending a cocktail party, you may have a bit more flexibility.

Either way, if you know you're going to be late, let the host know at the time of responding. If you find yourself in an unexpected situation that's keeping you from arriving on time, a quick call to the host can put their mind at ease. It would be impolite (unless the host is a close friend) to send a text regarding your impending late arrival. With proper communication, a good host will understand and can manage their planning around it.

Just as important, avoid arriving early at someone's house. They are likely finishing last-minute preparations, and you wouldn't want to cause them any undue stress. While it may seem respectful to be early, it's difficult for a host to tend to you while still getting ready. If you do arrive early, park your car at the top of the street or in a nearby parking lot and wait until the invitation time has arrived. This advice goes for attending simple gatherings and elaborate weddings alike (even if the event is being catered). The time you should arrive is the time on the invitation.

Be mindful when parking at someone's home. When attending a large party, you should not park in the host's driveway. You won't know if they'll have staff needing to get in or out. And you wouldn't want to disrupt the flow of the party by asking guests to shuffle their cars because you need to get out.

Be considerate of neighbors, and don't park in a manner that blocks their driveways. If you're arriving with someone with impaired movement, a host will understand your need to park in the driveway for the safety of the guest. However, once the guest is welcomed in and settled, politely excuse yourself and go move your car.

If the host lives in an apartment or condo, navigate the hallways quietly. Hallways in buildings can be a conduit for sound. Should there be a doorman, be extra polite to him or her under any circumstance.

Leaving on time is just as important as arriving on time. Even if you find yourself engrossed in a conversation, you can politely offer to continue it at another time. The host may want to have some time to clean up before he or she retires to bed. Try not to extend your stay too long, unless asked by the host. If you're aware that people are lingering, be the one to signal your departure. You'll be doing the host a service, as most people will follow suit and say their goodbyes as well. If there isn't a predetermined end time on an invitation, take the host's subtle cue when they signal that their party is ending. They're not being rude—they're probably tired from a full day of preparation. During a seated dinner party, an appropriate time to depart would be thirty to sixty minutes after dessert. If the host has retired you to another room for an after-dinner drink, allow yourself thirty minutes to enjoy it, and then thank your host for a wonderful evening.

Never leave a party without saying goodbye to at least one of the hosts. If you are attending a large party and cannot find them, be sure to follow up the next day with a phone call. Goodbyes are not a time to linger in conversation. You shouldn't hold your host up at the door if they have others to send off. With all the work a host has done to entertain you, he or she will appreciate the accolades and praise in a well-written thank-you note. I make it a practice to buy a card ahead of time and have it sitting on our table, ready to inscribe the next morning during breakfast. Even if you feel compelled to send a text or an email, you should still follow up with a handwritten note.

When you attend a party, it's always appropriate to bring a hostess gift—even for your closest friends. The exception to the rule would be a casual get-together with a very close friend or family member that you see daily. The gift doesn't need to be expensive or elaborate. It's a thoughtful way to show your appreciation for receiving an invitation. You can gauge your gift on the type of event you're attending. You wouldn't want to bring a bottle of champagne to a barbecue, just as you would not want to give a bottle of barbecue sauce at a fancy dinner party, unless you made it.

Your gift should be something that reflects you, and it should say that you took the time to think of the host. While wine has become the default hostess gift, try to put some extra thought into what you present to the host.

A reasonable amount to spend on a gift is between twenty and twenty-five dollars. The thought means more than the price tag. Fresh flowers, jams, soaps, candles, something found at a flea market, mustards, something homemade, a plant, packets of seeds, lotion, and even chocolates make for thoughtful hostess gifts. Keep in mind that the host will open your gift after all the guests have departed, so enclose a gracious note.

## — TIPS FOR PARTY TIME —

- Be entertaining. If the host makes an introduction, be engaging and help take over the conversation so they can continue greeting other guests. Be outgoing and introduce yourself. Extend a hand to others, especially if you see someone by themselves—a host relies on their guests to get to know one another.

- Steer clear of controversial topics of conversation, such as politics or religion. In today's political climate, we must strive harder to find meaningful connections with people. Your host has brought you together in hopes that you can find topics to discuss to make for a pleasant evening. If you find yourself ensconced in a difficult conversation and are unable to pivot to something less emotional, politely excuse yourself to the bar or the loo.

- Be helpful, but not overly helpful. A host doesn't mind a helpful guest, but there are limits. They've invited you to come and have a good time, not to work. If they ask for your help, whether clearing a dish or pouring a glass of wine, do so, and then seamlessly return to the party. Doing more than asked may make your host feel as though they can't handle it on their own.

- Allow the host to guide the timeline. If there's a transition, say from cocktails to dinner, politely be seated when prompted. Don't linger in conversation and keep the host waiting.

- Many hosts have private areas in their home. Be conscious—if you see a closed door or if the lights are off, it probably means they don't want people entering. Asking to use a bathroom in a private area of their home, unless it's an emergency that requires extra privacy, is impolite.

- Always take a cocktail napkin when it's offered to you, especially when taking an hors d'oeuvre from a tray.

- Look for a designated or discrete area to set down items in your hands that you don't need—an empty glass, a used napkin, or a toothpick. Placing these things on a buffet table or a tray with food is unsanitary and unsightly to other guests.

- Eating an hors d'oeuvre over a tray that is being passed is impolite. Place the hors d'oeuvre on a napkin and wait for the server to walk away.

- Don't bring an empty cocktail glass to the dining table. Leave it on a coaster or a napkin on a side table in an adjoining room. If you're still enjoying a cocktail when dinner is called, it's customary to stand at your chair, put your drink at your place setting, and wait until you're invited to take a seat.

- Upon entering someone's home, unless you have extenuating circumstances, remove your hat and coat. If you get cold easily, bring a light sweater or wrap; do not use your coat.

- Don't start eating until everyone is served. Place your napkin on your lap and wait for the host to be seated. You may begin once they lift their fork or invite you to start eating.

- If something on the table is beyond your reach, ask someone who's close to pass it. Don't shout to the other side of the table. Quietly ask your neighbor if they can reach the desired item. If they can't, they can ask the next closest person.

- If the silverware is arranged on top of your napkin, rest one hand over the silverware and hold it firmly while you slide the napkin out. You want to prevent excessive clanking or the potential drop of silverware.

- When being served family-style, food will generally flow, platter by platter, in one direction. It is proper to hold the platter for the person that you are passing to.

- When you get up from your chair at a dinner party, simply lay your loosely folded napkin to the left side of your dish. Never set your dirty napkin on the chair where you're sitting.

- When you finish eating, set your fork, knife, or spoon across the length of your dish in the middle. This will help the host or server remove your dish and silverware in one motion.

- Remember to say "Please" and "Thank you," even if you're addressing hired help.

- Sometimes a host may strike out when it comes to the whims of your palette. If something has been served that you don't enjoy, don't draw attention to it. Simply eat around it, and when asked if everything was OK, politely say it was delicious and that you may have filled up on too much cheese and crackers. Do not start listing off ingredients that you don't enjoy.

- If you spill something in a host's home or at the dinner table, remain calm and discreetly pick up as much as you can. If something has broken, like a glass or a dish, find a napkin that can cover the area so no one puts their foot or hand in it, and set about to find the host to help clean up completely. Don't take on cleaning up without alerting the host.

- If you encounter a bone or piece of fat in a dish or hors d'oeuvre, cup one hand over your mouth and remove it with the other hand. Place it discreetly on the side of your dish or fold it in your napkin.

- Don't drink too much. Know your limit and stick to it. If you've had too much to drink and the host feels it's unsafe for you to drive, concede and consider an alternative. This would be a good time to go the extra step and bring them a small bouquet of flowers the next day, thanking them for keeping you and countless others safe.

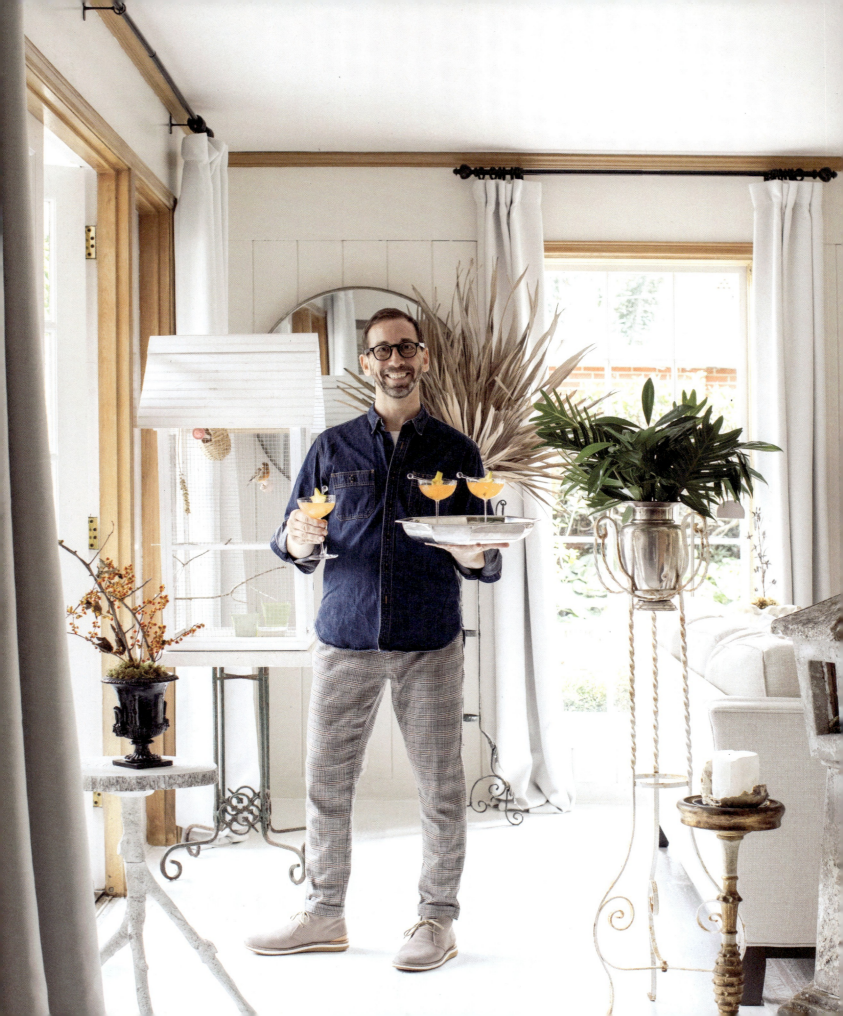

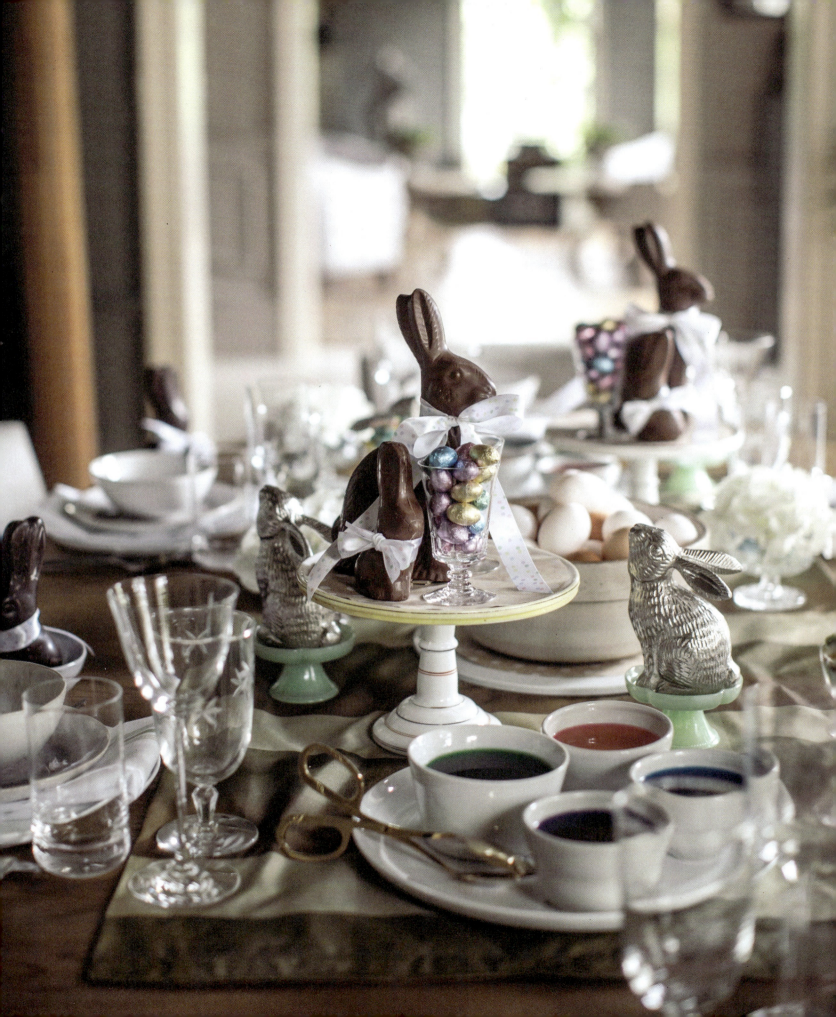

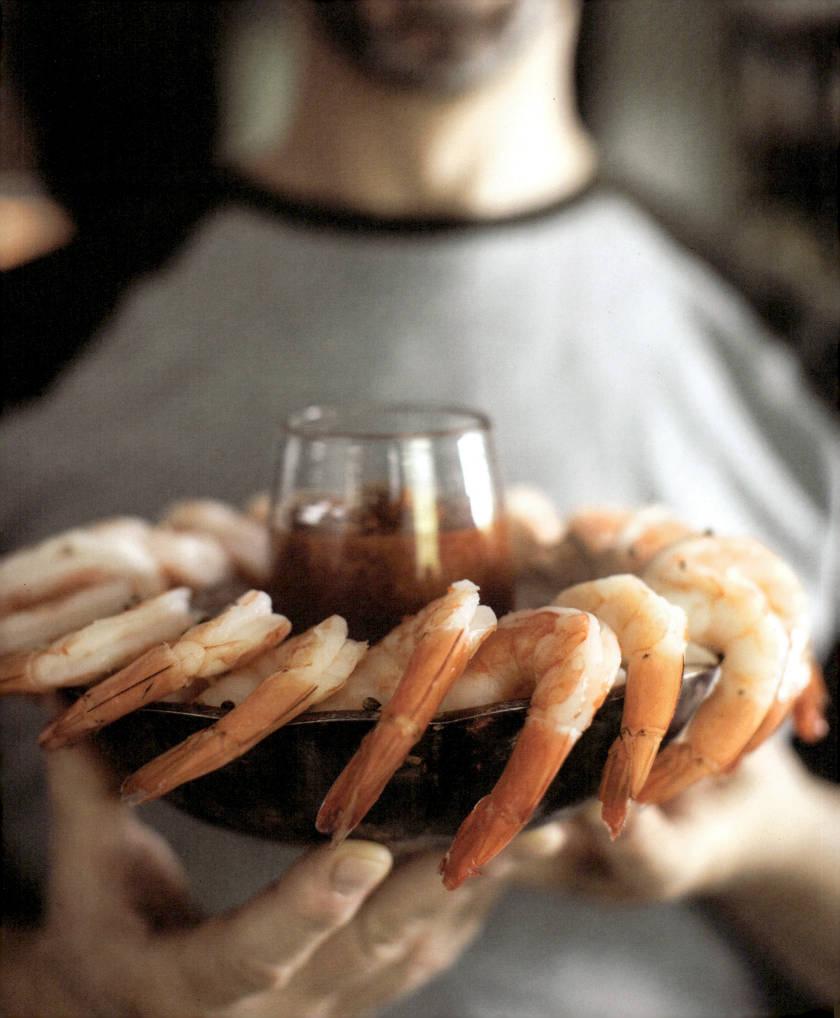

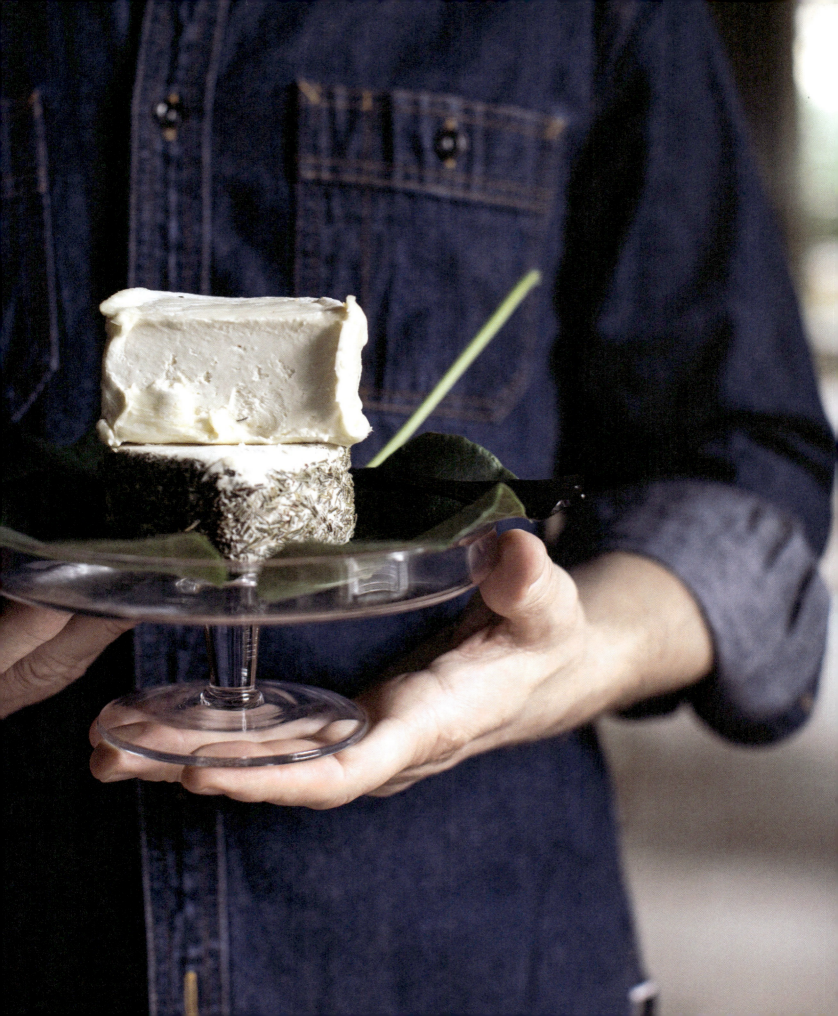

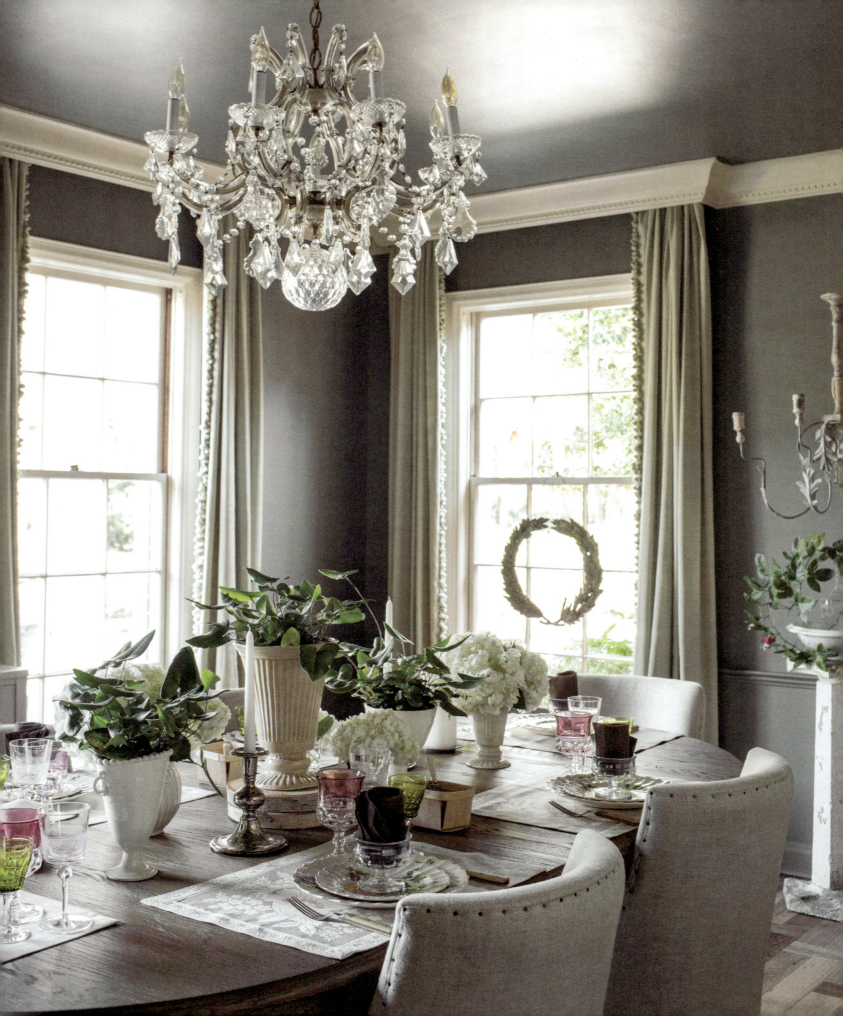

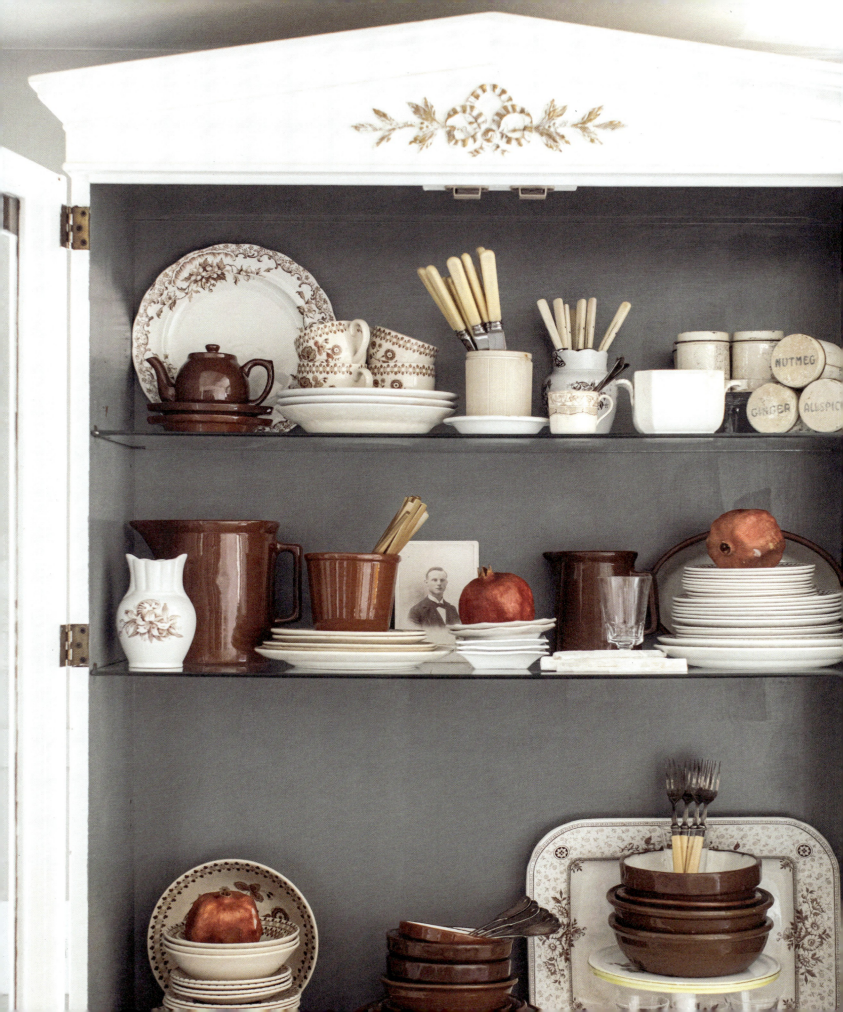

It's the small details that make a gathering memorable—from the invitation to the garnish on a platter. Expressing your authenticity is most important—it doesn't have to be perfect, it just should be thoughtful.

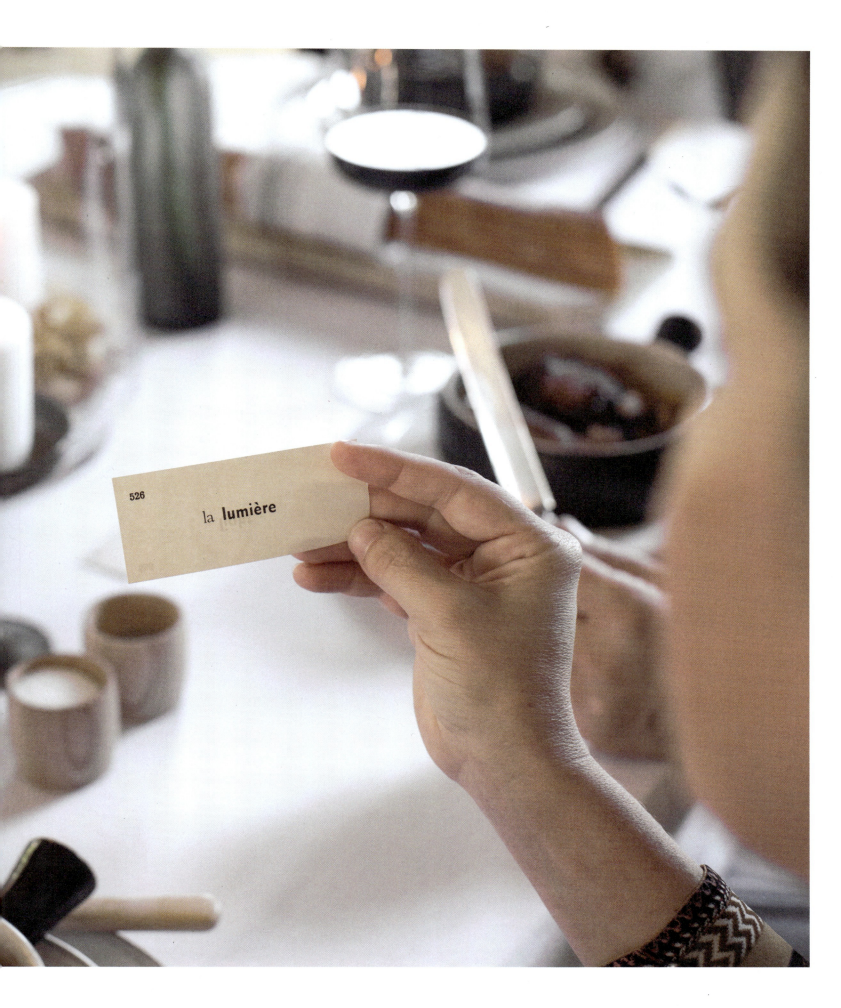

526

la **lumière**

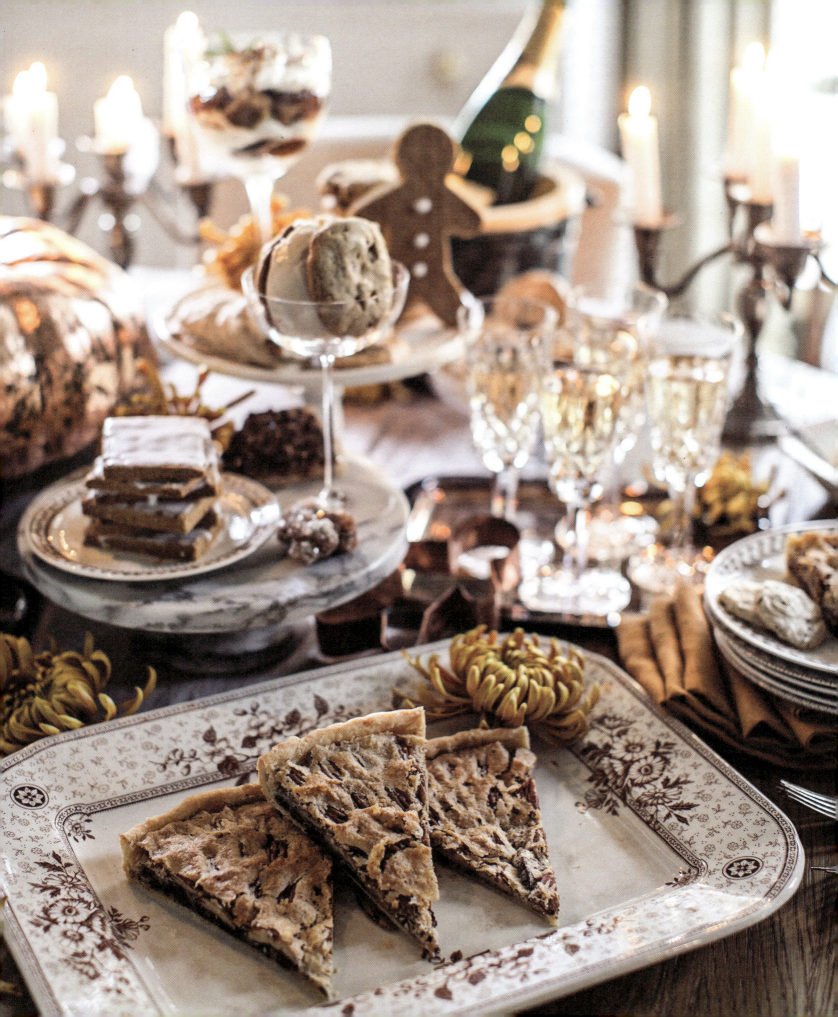

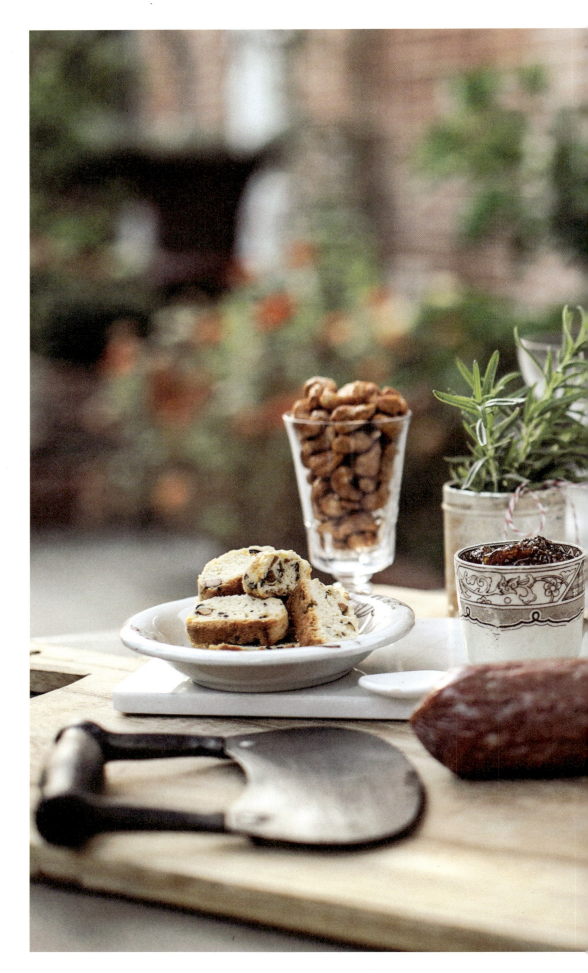

Whether just learning or seasoned, a good host takes the time to flatter their guests by making any gathering a little bit special. Serving a rosé in chilled glasses costs nothing extra yet makes a simple charcuterie extraordinary.

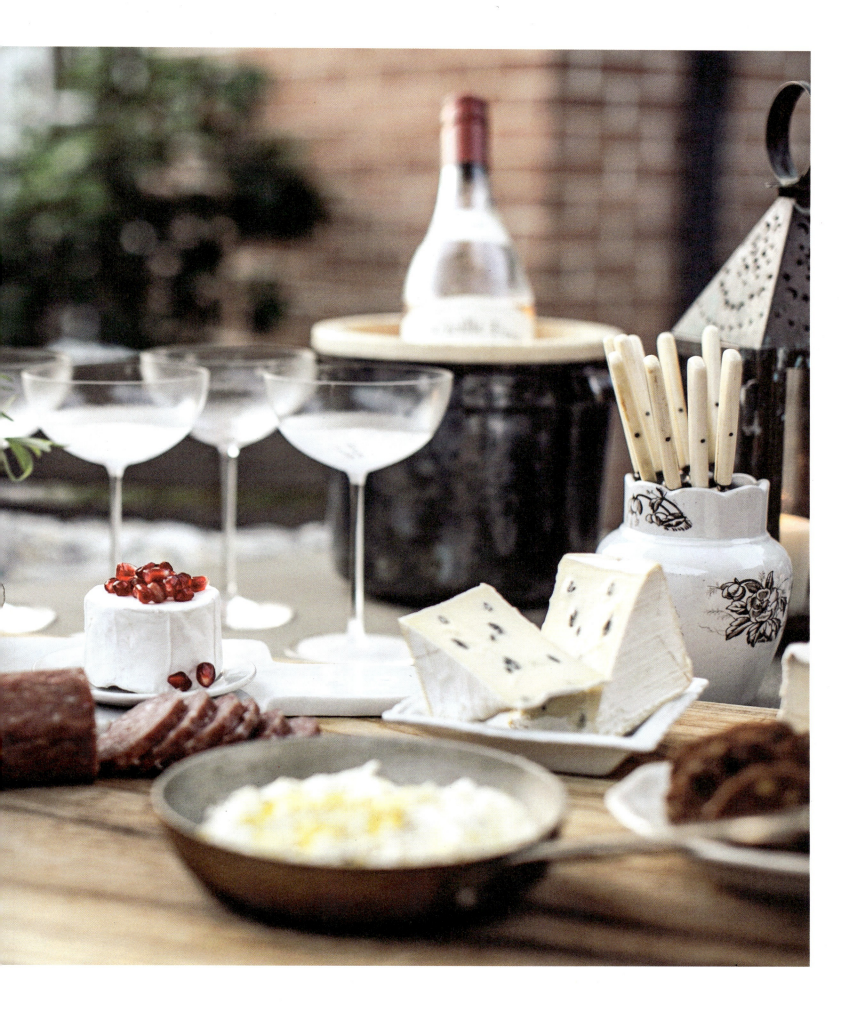

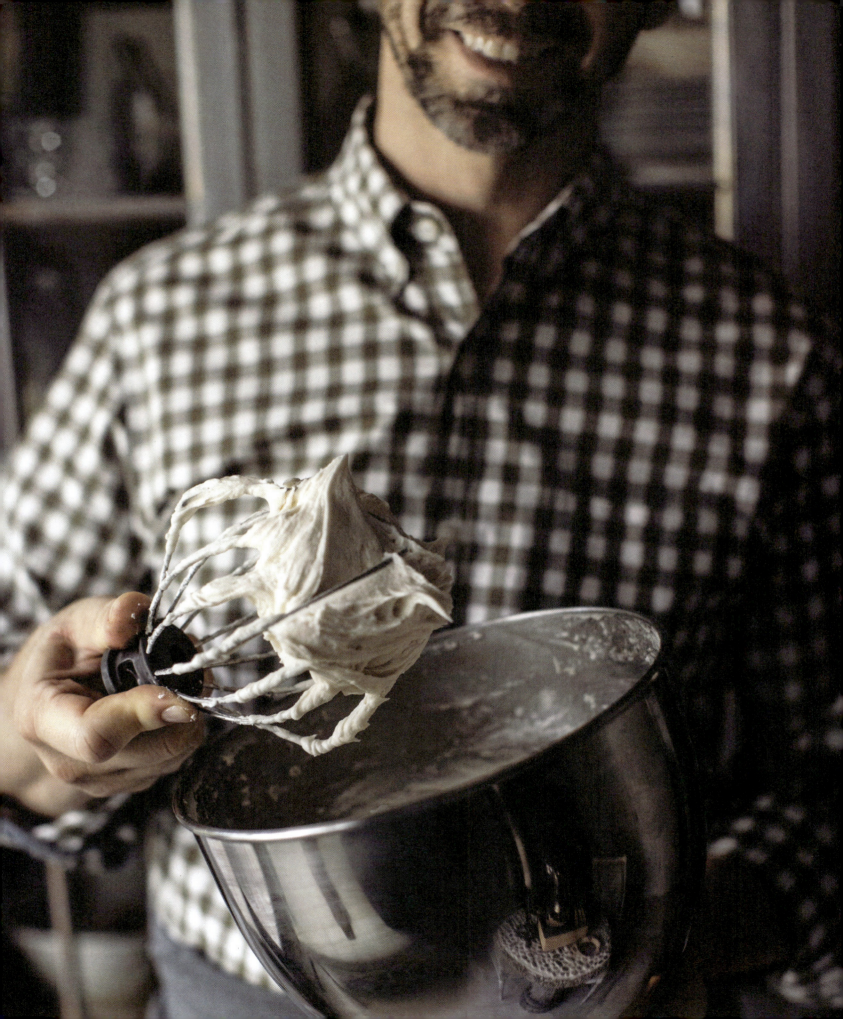

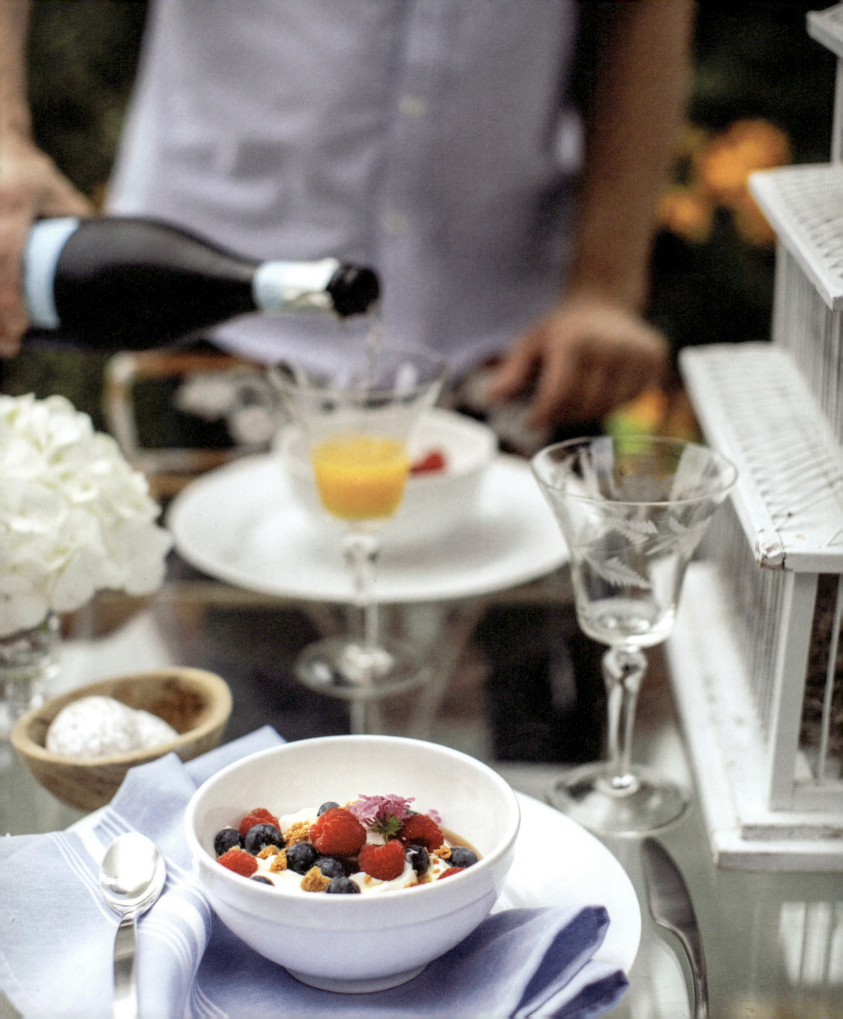

# THE ART OF THE TABLE

*One thing that many hosts share is the* desire to be creative—to put on a good party and make it visually appealing. Whether it's a buffet, a seated dinner, or simply an impromptu luncheon, having people over becomes that opportunity to express your creativity and make a memorable impression. The opportunity to make something look beautiful and feel special for someone else is gratifying. We've all been influenced by our past, come from different heritages, and have different traditions, which culminate in a wide range of personal tastes and styles. Defining yours can feel daunting when you are first getting started. Authentic expression is the most valuable trait that someone can possess, especially a gracious host.

Whether you want to go over-the-top for a festive celebration or have a simple get-together, the decoration of your tables should reflect your personality. Continuity with the serving pieces and tableware that you collect will provide a solid foundation for building a beautiful table for any occasion. Hosting an elaborate masked Halloween party would require much more detail than a seated three-course dinner, just as a barbecue buffet would be more relaxed than an executive luncheon, but if you've been diligent in selectively collecting your props, you'll be able to use the same pieces over and over. Any opportunity to entertain is an opportunity to show your creativity, so have fun with it.

The artistry of developing a beautiful table comes with an understanding that our senses are not two-dimensional. When we look at a table, its impression is not only visual; what we see also makes an impression on how we feel. In every situation, whether you want an elaborately artistic table or a simple setting, using decoration and serving pieces that are pleasing visually (and tactilely) will add to the ambiance of the evening. Use the best that you can for any occasion and refrain from cutting corners. Plastic plates never seem to give quite the impression that ceramic plates do. More often than not, we are tempted to do what we can to save on the amount of work that will need to be done, but it's never advised. You want to give the impression to your guests that they are valued and appreciated, so it matters what you're serving with. It's rare that I ever recommend using any type of disposable items when entertaining, except for cocktail napkins. From serving pieces to dishes and glassware, the cumulative effect of using real tableware shows that you are committed to entertaining your guests with style.

Entertaining at home is not always ideal for having themed events (like "Hawaiian luau" or "'70s disco"). While popular in the early part of the 2000s, I find that themes add a great deal of stress when it comes to achieving a particular look with a fussy menu to match. Rather, strive just to host a beautiful event. You can do this with fresh flowers, candles, wonderful condiments, well-prepared food, props pulled from around your home, well-pressed linens, comfortable rooms, and great guests.

So what makes a beautiful table? Layering, consistency, repetition, and simplicity. These four components can be applied to a formal seated five-course dinner as well as a simple low-key evening with friends. Whether you're arranging a buffet table or setting out TV trays for movie night, the same considerations can be made.

Every table requires some type of layering, from tablecloths or placemats to flowers and candles; it's what makes a table inviting. By adding texture, height, depth, and interest, it won't feel flat or uneventful. Layering can also be achieved by using color as well. While I tend to favor tables that are simpler in nature, you might enjoy layering with different patterns of linens or dishware that contrast in color. Through layering, you get to showcase your style and immerse your guests in a unique experience. Whether I am setting a table for a dinner party or creating a table for hors d'oeuvres, I pull a mix of new and old dishware and props from my prop closet. I have collected English ironstone and antique dishware for years, as well as silver pieces with patina, wood serving pieces, white marble, etched glassware, and antique French cutlery. Many of my pieces were purchased at flea markets and thrift stores or during my trips to Paris, while others are cherished family heirlooms. I encourage you to take an interest in keeping heirlooms that are passed down from generation to generation and use them for entertaining. There's no glory in letting them sit behind glass collecting dust.

By layering porcelain, stone, wood, silver, and iron (usually with age and patina) on a table paired with our collection of fine stemware and crisp linens, I create a storied table that feels luxurious without being pretentious. It's a style that's unique to my husband and me. Oftentimes I add interest by including pieces from my gem collection, antique books, flowers from the garden, potted plants, old photographs, or even antique candelabras. Our table is never set the same way twice.

Consistency is key to achieving a balanced and good-looking table. Take the time to ensure each place setting is equally spaced around your table—regardless of what you're setting it with. At the White House, a ruler is used to make sure every item at each place setting around the table is set the same.

Here are a few tips for creating a consistent table:

• Make sure that your tablecloth is draped evenly around all sides of the table. The ideal overhang

for a tablecloth is a minimum of six inches on all sides and never longer than just touching the tops of your chairs.

- When using placemats, chargers, or large dishes to anchor a place setting, set them so the bottom is in line with the edge of the table. Placing your finger vertically at the edge of the table to align your dishes and cutlery will ensure that every place setting is the same distance from the edge of the table.

- Any cutlery flanking a place setting should be placed with the bottom edge of their handles flush with the edge of the table for a clean, crisp look.

- Provide sixteen to twenty inches of space between each chair for your guests' comfort.

- Chairs should be pushed in only halfway to the edge of the table. If you are combining different styles of chairs, be sure to balance them evenly in height and style around the table.

- Glassware is arranged to the top right of the dish (just over the knife). The water glass should be placed closest to the charger or dish with the wine glass to the right and slightly above it.

- Forks are arranged on the left side of the place setting in order of course, starting farthest from the dish. The knife is placed on the right side of the place setting with the blade facing the charger. A spoon, if needed, is placed to the right of the knife. A dessert fork or spoon would be placed above the dish, with the handle of the fork to the left or the handle of the spoon to the right.

- A napkin is typically placed on the left side of the place setting. It is best laid to the left of the forks to prevent unnecessary commotion by trying to wrangle it free from the forks or, worse yet, accidentally causing a fork to drop. The napkin can also be placed folded on top of or draped over the charger or base plate. Napkin rings can give an extra-special touch to a table.

- Everything on the table should be meticulously laid out the same way for every place setting.

Repeating shapes, colors, and patterns will help to bring a table together visually. First and foremost, use the shape of your table to guide you in which shapes to repeat in your place settings. Consider the following:

- *Tablecloths and placemats:* A square or rectangular table is better suited to a square or rectangular tablecloth than a round or oval one. Similarly, a round or oval table would look out of place with a square or rectangular cloth on it. If you are setting a table with placemats, use round ones for a round table and square ones for a square or rectangular table.

- *Florals:* A long rectangular centerpiece looks better on a rectangular table, just as a single round vessel will complement a round table. When buying flowers, repeat one to three colors in the arrangement that coordinate with the other colors on your table. Do not do more than that until you become more skilled at floral arranging. If several arrangements are being placed on the table, use the same type of vessel for each one to ensure the arrangements match.

- *Dishes and glassware:* Even when setting a table with mixed and matched items, find some common elements that repeat, whether it's the shape, pattern, coloration, or material.

Above all, remember that simplicity is always preferred when entertaining at home. That doesn't mean that your table must be boring by any stretch of the imagination. Even a formal table set for a seven-course dinner can feel simple by creating a casual centerpiece with a mass of antique bottles filled with single stems of flowers. If making floral arrangements is too much, a grouping of candles makes just as beautiful a centerpiece. Even the use

of greenery cut from your yard in a few simple vases can be beautiful.

Set your table with only those things that you will use for dinner service. While a stack of graduating dishes in different patterns topped with a beautiful bowl and an intricately folded napkin looks fantastic at each place setting, extra items become cumbersome when you need to remove them while your guests are being seated.

When your table is thoughtfully curated, your guests will naturally take the time to notice how beautiful it looks. You will have shown them that you made an effort to put your best foot forward.

## — BEAUTIFUL BUFFETS —

- A buffet table should be dressed with linens draped to the floor on all four sides unless it is arranged on a beautiful piece of furniture, sidebar, or counter.
- A buffet table should have layers to it. Food should not be displayed only on flat serving pieces; rather, cake stands, three-tiered plate racks, and perhaps baskets with big handles should be mixed in.
- Do not use boxes or milk crates that are draped with linen cloths to elevate your food. This takes away from the appeal of the food by making the arrangement in which it is displayed feel unnatural and "too staged."
- A tall arrangement should anchor a buffet table. The bouquet should be well elevated above the food to help draw the eye to the table. I sometimes prefer to place my arrangement toward one side of the table. This can help to distinguish where the plates, silverware, and napkins end and the food begins.
- For the ease of your guests, have silverware wrapped in the napkins and tied with twine or maybe encased in napkin rings.
- Set a small bread-and-butter-type dish next to each food item as a place to set down a used serving utensil to avoid risking the table getting dirty from food.
- A great way to make a sparse-looking buffet table feel lusher and more intimate is to garnish the table with greenery and hearty flowers that won't wilt out of water (such as boxwood, pittosporum, viburnum, sunflower heads, zinnia heads, or orchids).
- A buffet can benefit from some creative layering of fabrics to create texture, such as a runner, a swag of lace, a draping of antique trimming, or some patterned fabric that is ruched around the arrangement and studded with votive candles.

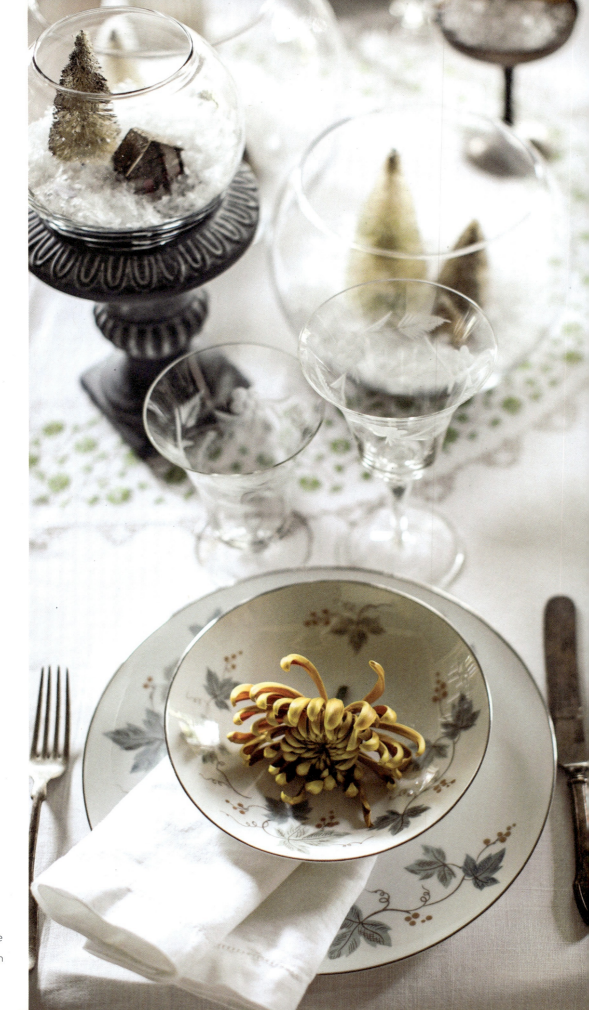

A Christmas table is set with an embroidered table cloth found at an estate sale. The vine motif in my mother's wedding china is complemented by the etched floral pattern in the antique stemware. A collection of hand-dyed bottle brush trees are transformed into "snow globes" and set around the table to create a winter wonderland theme. The colors in the dining room have been carefully considered to coordinate with the soft colors that dress our vintage aluminum trees scattered around the house.

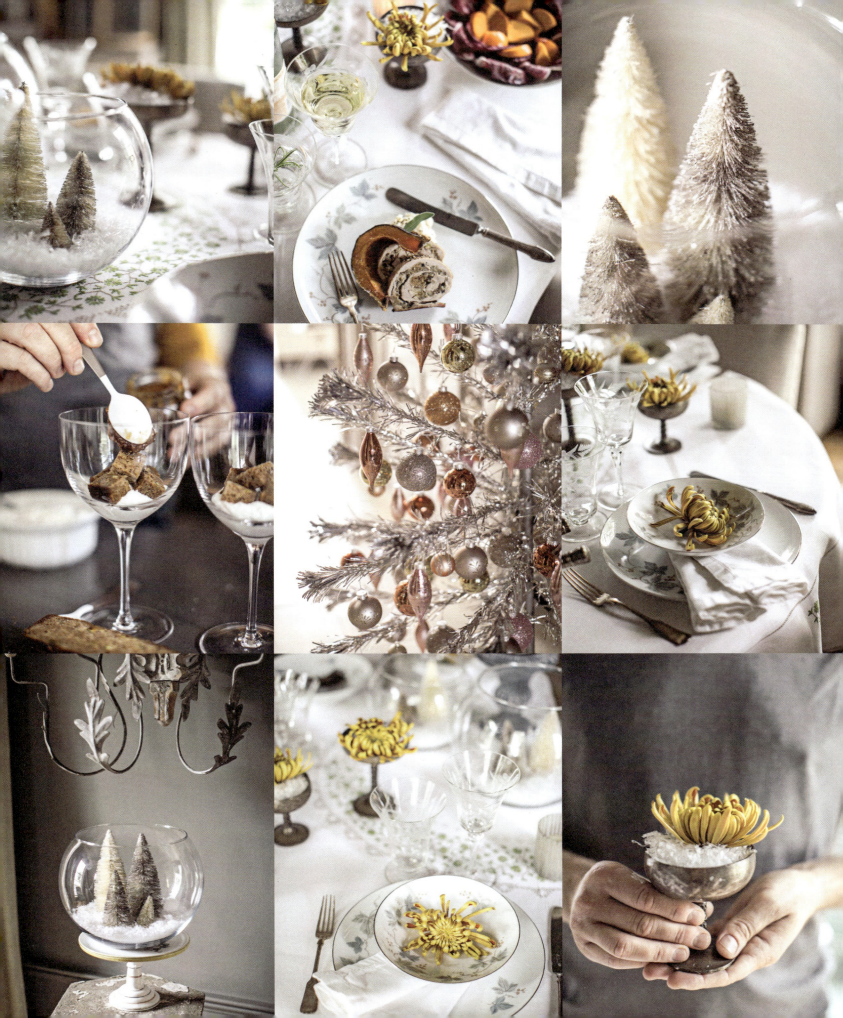

The richness of Thanksgiving is interpreted by a simple, yet elegant table that is ladened with texture. Each year I hand-gild a collection of gourds in the fall. Here, gold and copper take center stage. Stacked down the center of the table with tarnished silver candlesticks, they are brought to life amongst the glow of candlelight. The colors and textures are repeated in the place settings, where a mid-century modern dish in a gold floral-leaf pattern is layered with a copper linen napkin and an antique, brown transferware dish in a cloverleaf pattern.

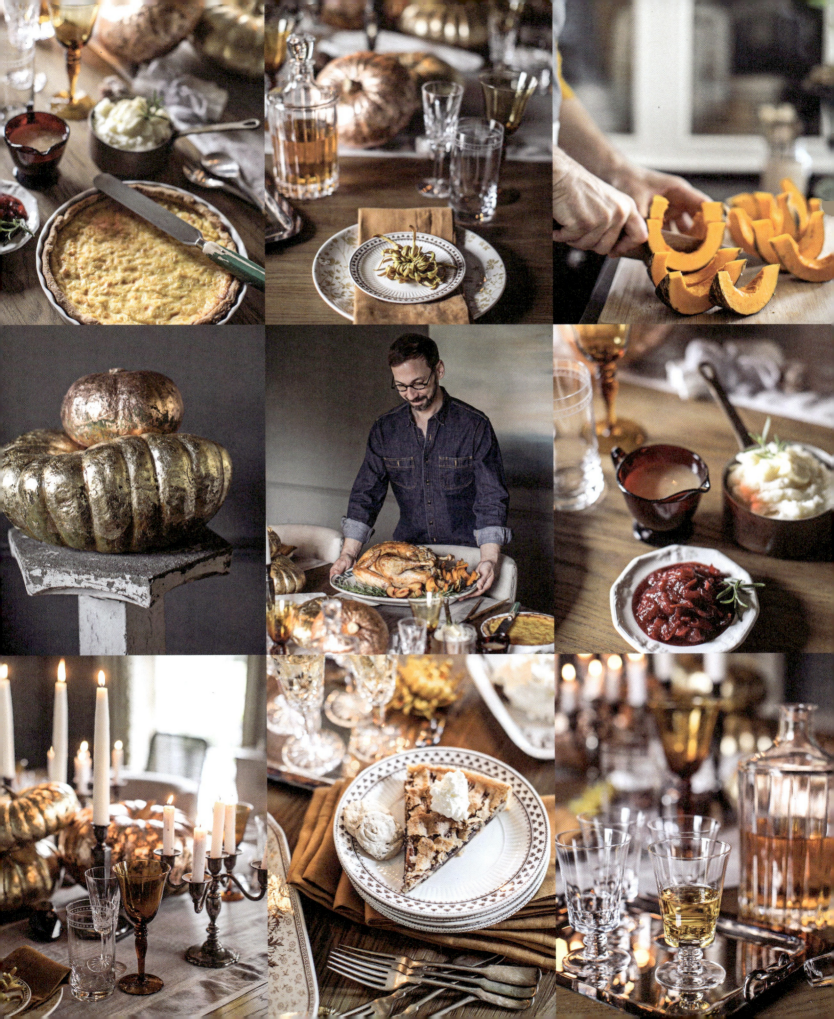

The living room is transformed for a French-inspired dinner for friends. A stark white table is set with modern, earthenware dishes and clean, simple stemware. Antique bone-handled cutlery compliments the color of dried white rose petals in glass hurricanes. I like to add something personal and unique to my tables—a vintage French to English flashcard placed at each place setting gets the conversation going. Even the color of the dessert was carefully chosen to blend in with the table.

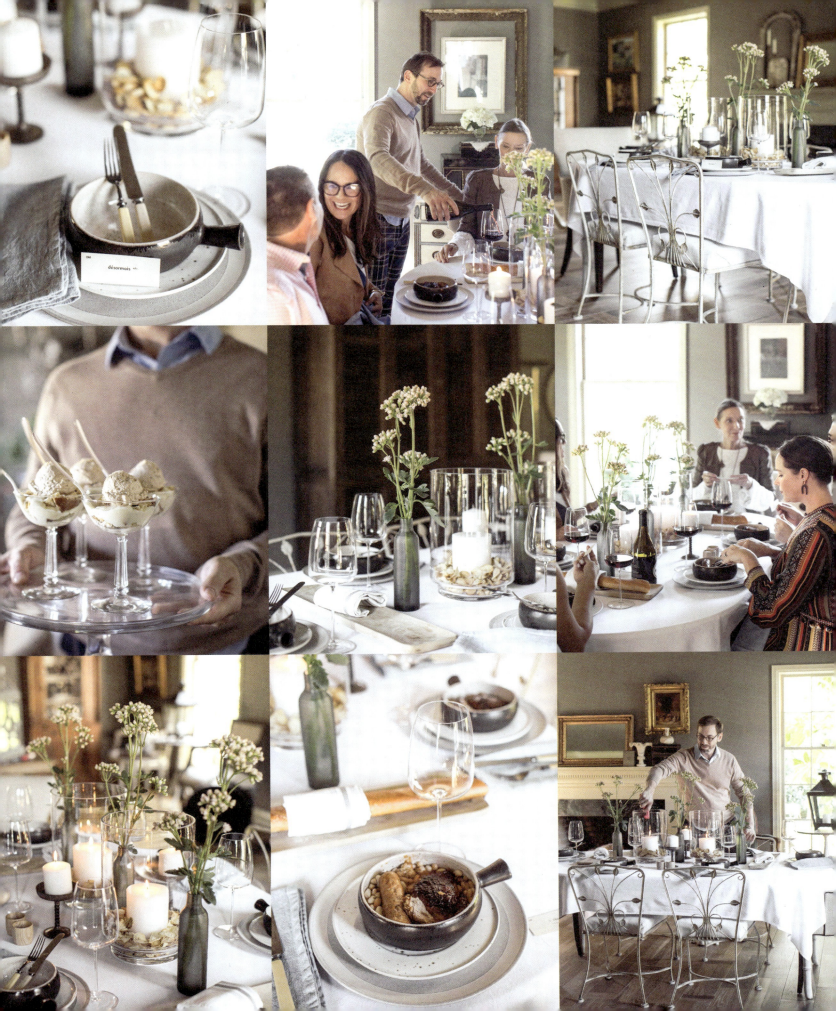

Bright, festive color is displayed in this backyard barbeque by draping one of my antique flags over a table dressed with a white tablecloth. Rather than using flowers on the buffet table, which would only compete with the boldness of the flag, pots of herbs are used to accentuate the greenery found in the garden. By wrapping the pots in gingham tissue, I was able to give them to my guests at the end of the evening. Stark white platters and bowls highlight the beauty of each dish. The lack of flowers was mimicked at the dining table by arranging pots of ferns down the middle.

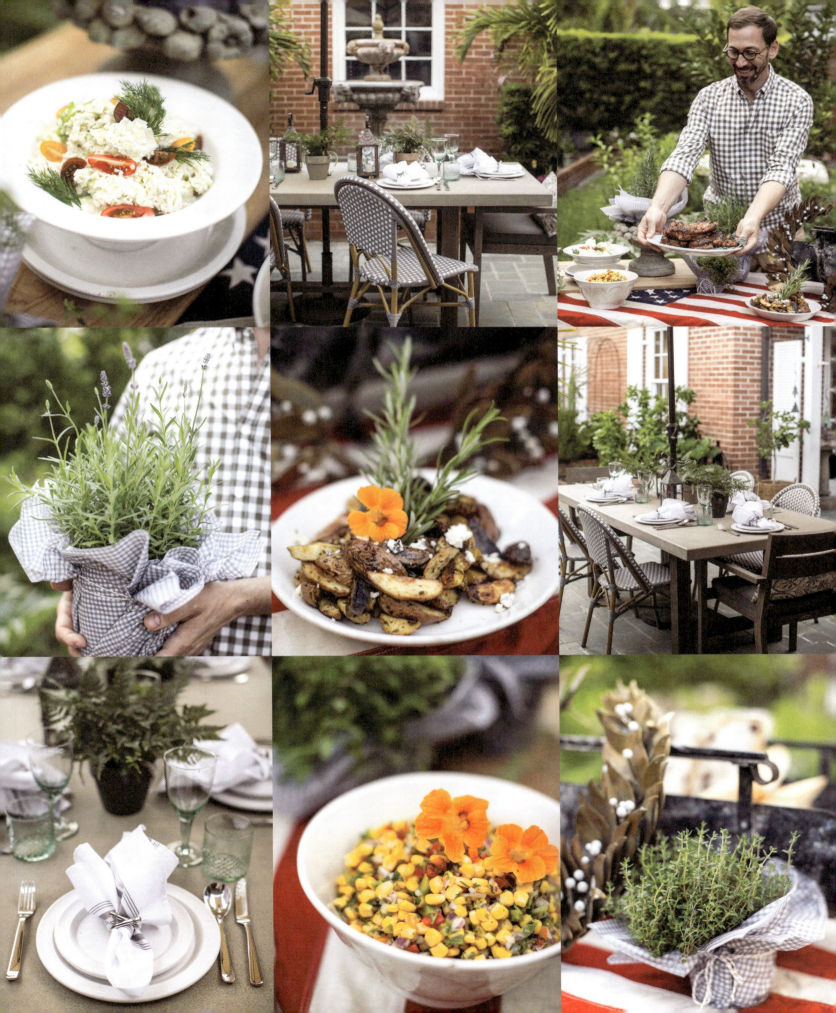

Inspired by my travels to France, a casual and effortless table was set with a striped linen cloth purchased in Provence. A table set entirely with flea market finds doesn't have to look old and dated. A wooden dough bowl filled with small antique books and giant lemons from my garden serves as a quick "thrown-together" centerpiece. Light filters through the bougainvillea to cast a reflection of the etched stemware on the embroidered linen napkins. The easiness of the day called for the food to be casually laid on the table for guests to help themselves.

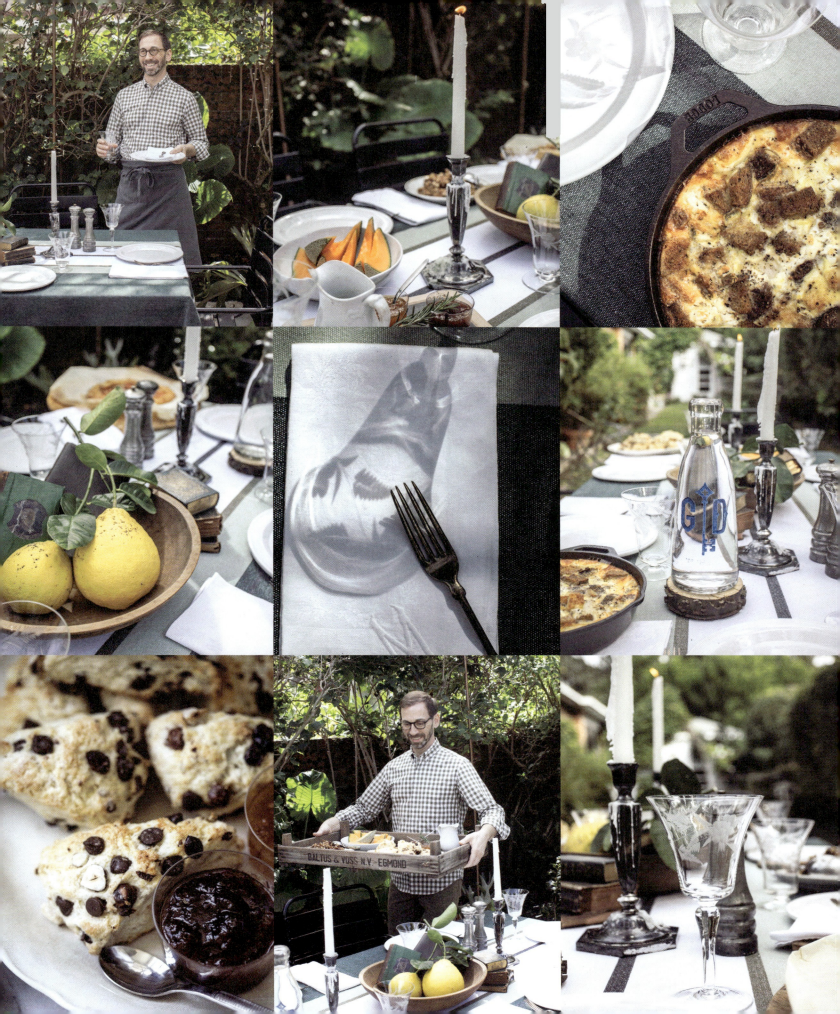

The beauty of this formal table is that its elements stand out on their own—without competing with each other. Modern, handmade dishes in black anchor the table without overpowering it. Sleek gray-lucite cutlery softens the boldness of the black dishes. The natural twine that wraps the monogrammed napkins gives a bit of whimsy to the seriousness of the place settings. My husband's best crystal stemware is selected for its shape and size, and looks as though they're dancing around the table. The flowers in shades of melon, peach, and orange lend a softness to the stark contrast of black and white.

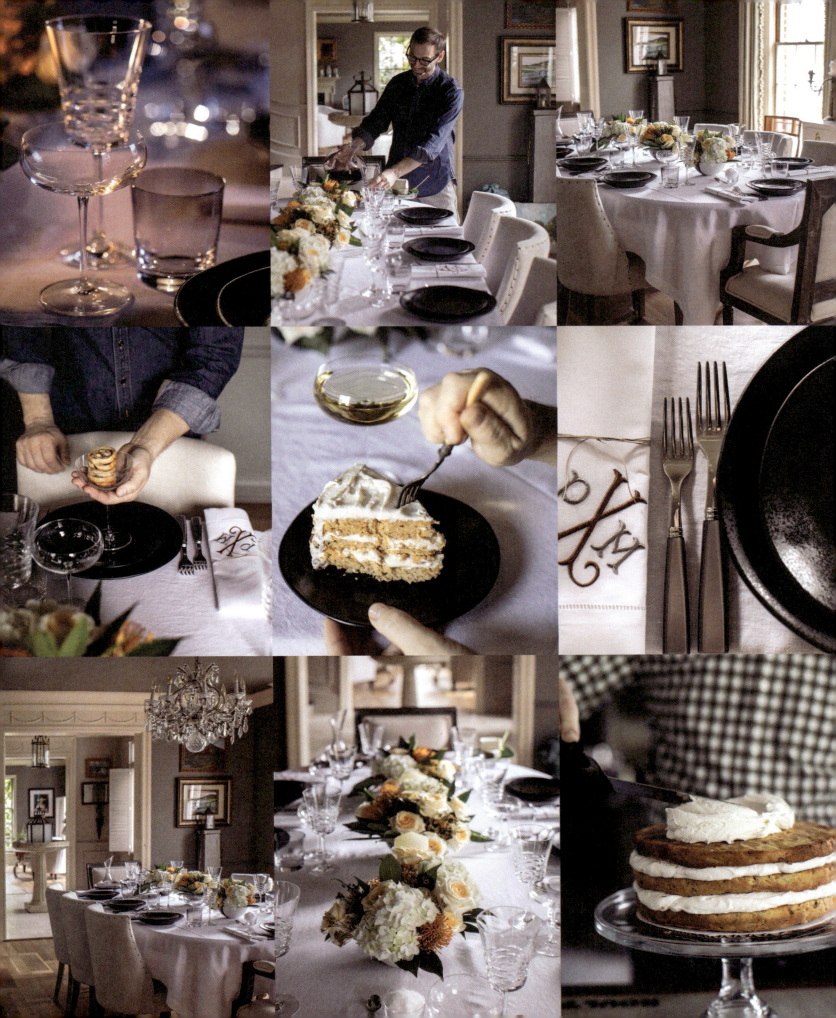

# CREATING A "PROP CLOSET"

*My love for props started at a young age,* in New York City when I was assisting food stylists for photoshoots. I had the pleasure of visiting some prop houses and browsing through aisle after aisle of serving pieces, linens, glassware, dishes, vases, and anything else related to food and entertaining, all neatly organized by type, color, and size. Anything you wanted for throwing a party could be found there. While my budget at that time didn't afford me the luxury of amassing my collection, my event-design business did allow me to rent many of these items for clients' parties. I eventually began to source and accumulate my own props inexpensively from flea markets, antique shops, estate sales, and thrift stores.

If you are hoping to entertain regularly, it is smart to have a dedicated spot to store your collection of props and tableware. There are endless kinds of dishware, glassware, linens, serving pieces, and more for entertaining and an infinite number of items one can buy to put on a party. Breaking it down and choosing what's necessary is not easy. If you aren't careful, you could find yourself overloaded with things that will never get used.

My biggest dilemma while living in a small New York apartment was storing my collections. Frustrated at having things scattered about my apartment, I decided to "renovate" one of the closets so it could be dedicated to organizing and storing my

entertaining wares—my *prop closet*. I realized then that everyone, including myself (someday!), should have a room dedicated to housing all their entertaining needs. Since that first closet, I've made it a priority in each home I've lived in to create a space to do just that. To this day, I still call it my "prop closet." Fortunately, with each new house, that space got larger as my collection grew. It began with that original reconfigured coat closet, and since I've used an oversized French armoire, a spare bedroom closet, an old china hutch, a converted food pantry in an 1850s farmhouse, rows of stainless steel racks in a basement, and—my favorite— an actual room akin to a scullery with floor-to-ceiling cabinetry in our current home. It was the defining feature that sold me on the house (aside from the fact that it was perfect for entertaining). When I opened the door to what I thought was a closet just off the butler's pantry, to my delight, I discovered what would become my best prop closet to date. I was told this was where the previous owner, who built the house fifty-three years earlier, stored all her entertaining items. Like me, she had collected quite a bit of stuff over the years and knew the importance of organizing it in one location. My prop closet houses all my essentials for entertaining, from my mother's heirloom dishes to Ziplock bags filled with whimsical hors d'oeuvre picks.

Just as with accessorizing one's wardrobe, the age-old adage "stick with the classics" can be applied to the pieces that you buy for entertaining. The classics never go out of style, and they can be used repeatedly while accessorizing with trendy, occasion or holiday-themed pieces. The bulk of the dishes and serving pieces I collect are vintage or antique and consist of white ironstone or European white porcelain as well as brown-glazed redware. It's very easy to set a table that always looks in style with these pieces, even if I am interspersing some modern, colored, or patterned dishware or glassware. Have a foundation of props you can build around for any type of occasion. Whatever you start with as the foundation for your collection, do so

thoughtfully, keeping it monochromatic and without decoration so that you can have the flexibility to weave in some whimsical pieces to spruce up your table. Be open-minded about where to shop for your collections. Keeping to a certain color doesn't mean that you must keep to one type of material or that all serving pieces should be from one manufacturer. Finding one-off pieces at thrift stores, estate sales, and flea markets in varying shades of your foundation color or varying shapes, sizes, and materials adds to the fun and interest of creating a collection to build your prop closet with. I've even repurposed dozens of glass yogurt jars to use as votives rather than going out and buying them. I always make it a point when traveling, especially to Paris, to hit the flea markets for inexpensive bone flatware, silver cutlery, ironstone, embroidered linens, or etched glassware to add to my collection. Sometimes I come across a great vintage water bottle, antique candlesticks, or some other type of French ephemera that can be used to decorate a table. Adding to my collection motivates me to plan a party, and our travel stories always make for good conversation.

Most importantly—and I can't stress this enough— use everything that you have for your parties. No matter the cost or the history of something, having it just to look at does not add value to a well-lived life. Yes, one of your grandmother's dishes could break or your expensive crystal stemware could shatter, but the point of owning these things is for them to add to your experience of life. Use them, enjoy them, and share them with others. Let their story enrich your guests' experience.

**WHAT'S OLD IS NEW AGAIN:** Finger bowls were placed at each place setting for guests to dip their fingers in to rinse before wiping them on a napkin. They are a welcome addition to any table when serving foods that may be eaten with the hands, such as corn on the cob, seafood, or ribs.

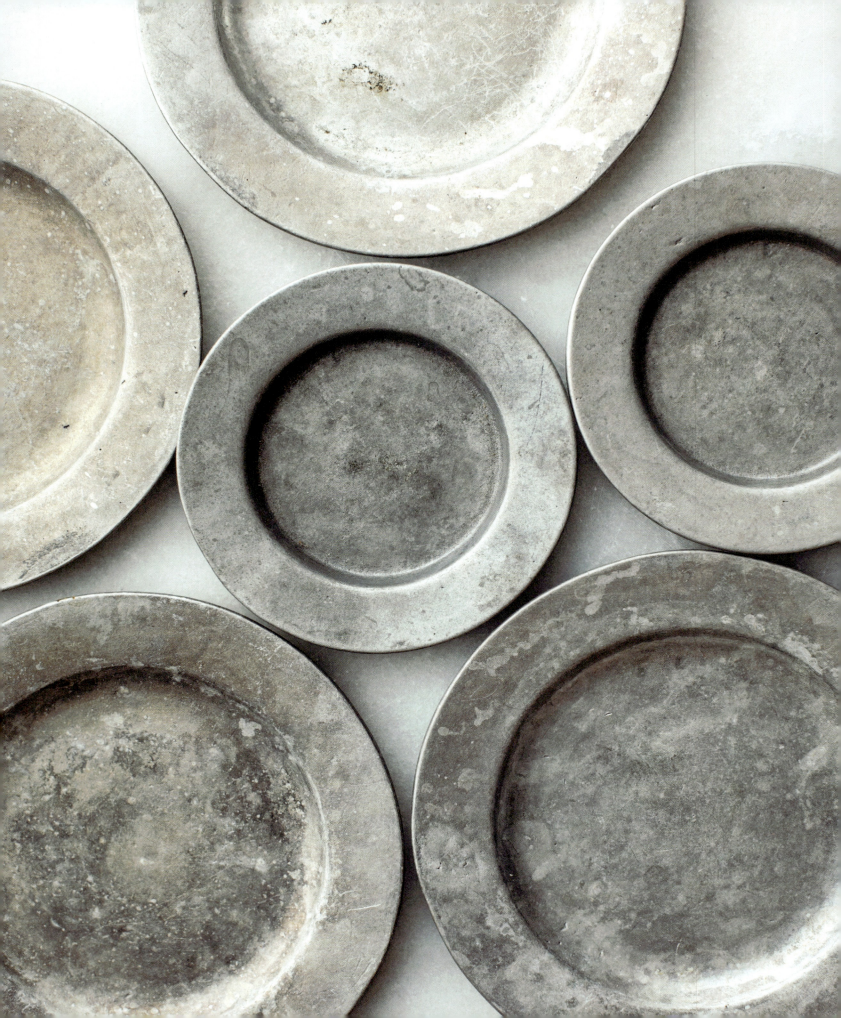

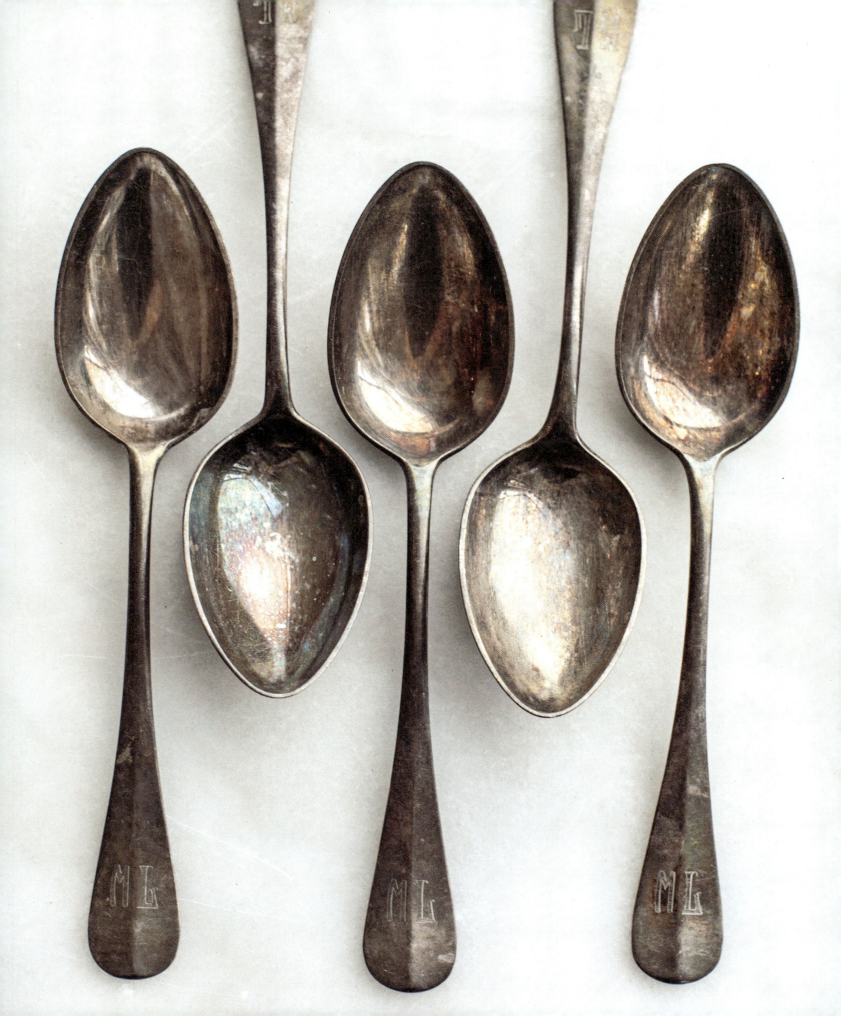

# TAKING STOCK

Suggestions for populating your prop closet
(Consider keeping items in sets of six, eight, or twelve)

### Dining Accessories:

- dish sets (dinner plates, salad plates, bread plates, and bowls)
- large high-sided bowls for pasta
- soup or chowder bowls (thick-walled)
- linens sized appropriately for your table
- placemats and chargers for place settings
- linen or cotton napkins
- water glasses (thin-rimmed and unfooted)
- all-purpose stemmed wine glasses (thin-rimmed and with a capacity of twenty to twenty-three ounces)
- cutlery (it should feel balanced in weight and comfortable in the hand)
- knife rests (glass, wood, or metal)
- finger bowls (large enough to hold four ounces of water with room to dip fingers)
- wine bottle coasters (wood, metal, or stone)

### Serving Accessories:

- a set of matching graduating platters (the largest big enough to hold a turkey)
- a set of matching graduating deep bowls (able to hold hearty side dishes)
- a set of matching graduating shallow bowls (able to hold salad-type items)
- small ramekins or bowls for holding dips and sauces
- wood cutting boards in various sizes for display purposes
- utensils for serving (small spoons, large spoons, forks, a cake server, tongs, spatulas)
- salt and pepper wells or shakers
- cheese knives (a combination used for hard and soft cheeses)
- graduated cake plates in three sizes
- cocktail plates (small bread-and-butter-sized plates)
- wooden bowls in varying sizes
- baskets in varying sizes

### Bar Accessories:

- serving ice bucket (glass, crystal, silver, or earthenware)
- chilling ice buckets (varied sizes for beer, wine, soda, and champagne)
- ice tongs and ice scoop
- cocktail shaker with strainer (metal or glass)
- wine openers and bottle openers (captain's knives are best)
- shot glass (glass or metal)
- muddler (wood or metal)
- cocktail napkins (paper or linen)
- decorative picks and skewers for cocktail garnishes
- bar glassware (double old-fashioned, highball, martini, champagne)

### Centerpiece Accessories:

- small bud vases (glass, ceramic, or metal)
- glass hurricanes for florals or candles
- glass votives (filled with wax or with votive inserts)
- centerpiece vessels
- taper-candle holders (glass, silver, or ceramic)
- taper candles and pillar candles in varying heights
- good-quality floral shears
- floral tape, floral frogs, and clear glass pebbles
- risers to create levels, such as cake stands, books, marble slabs, and wooden discs

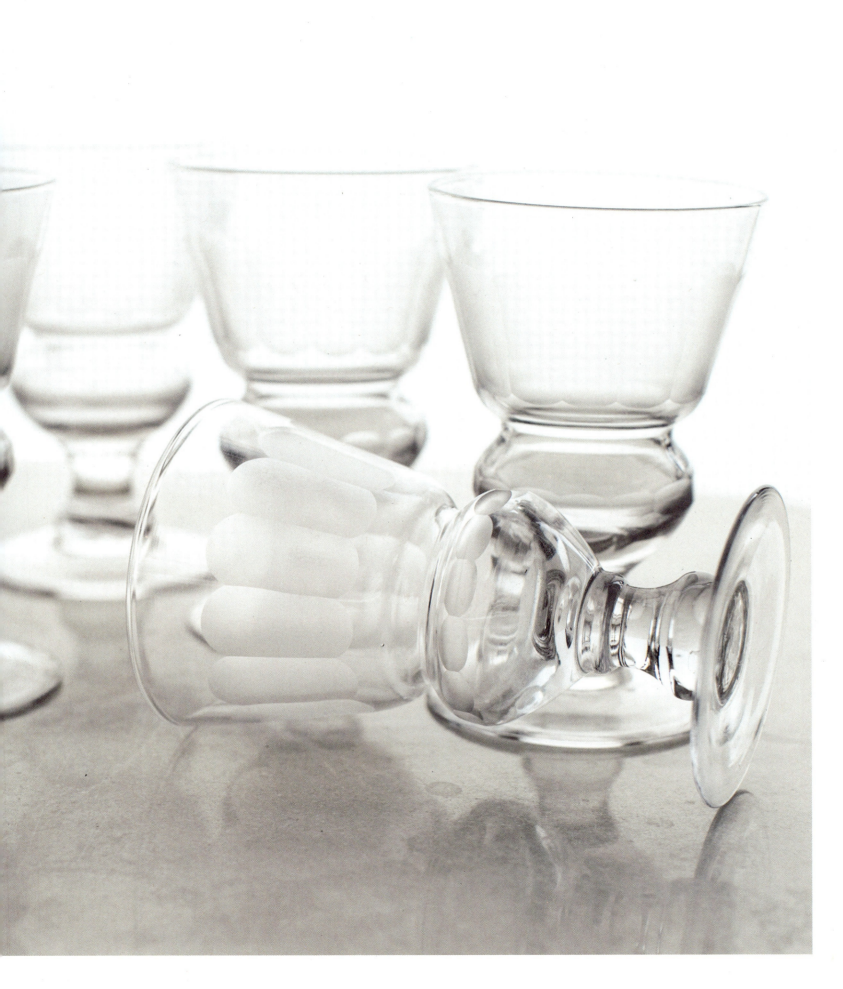

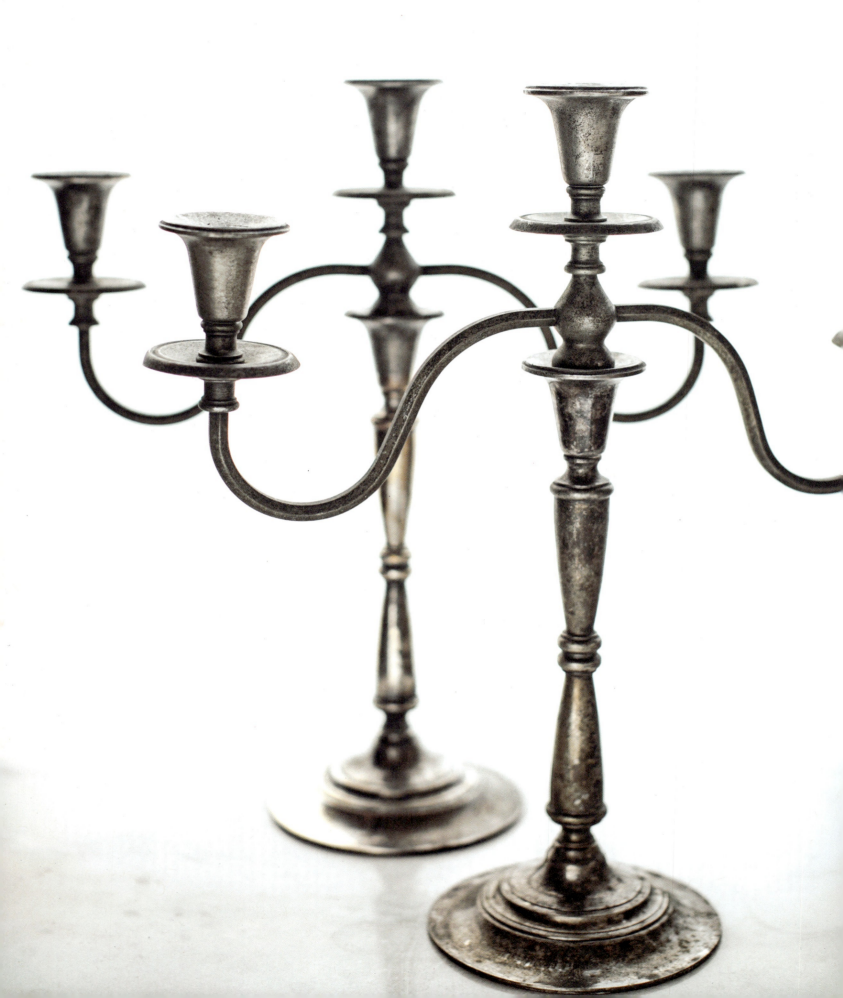

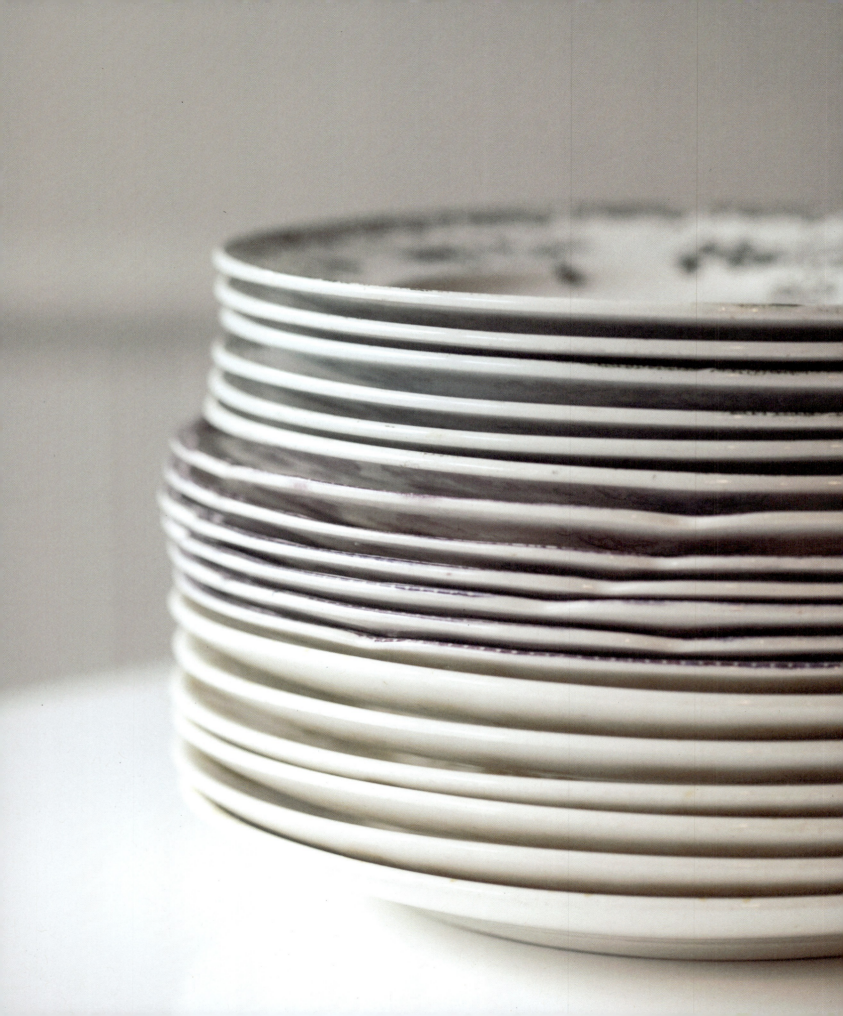

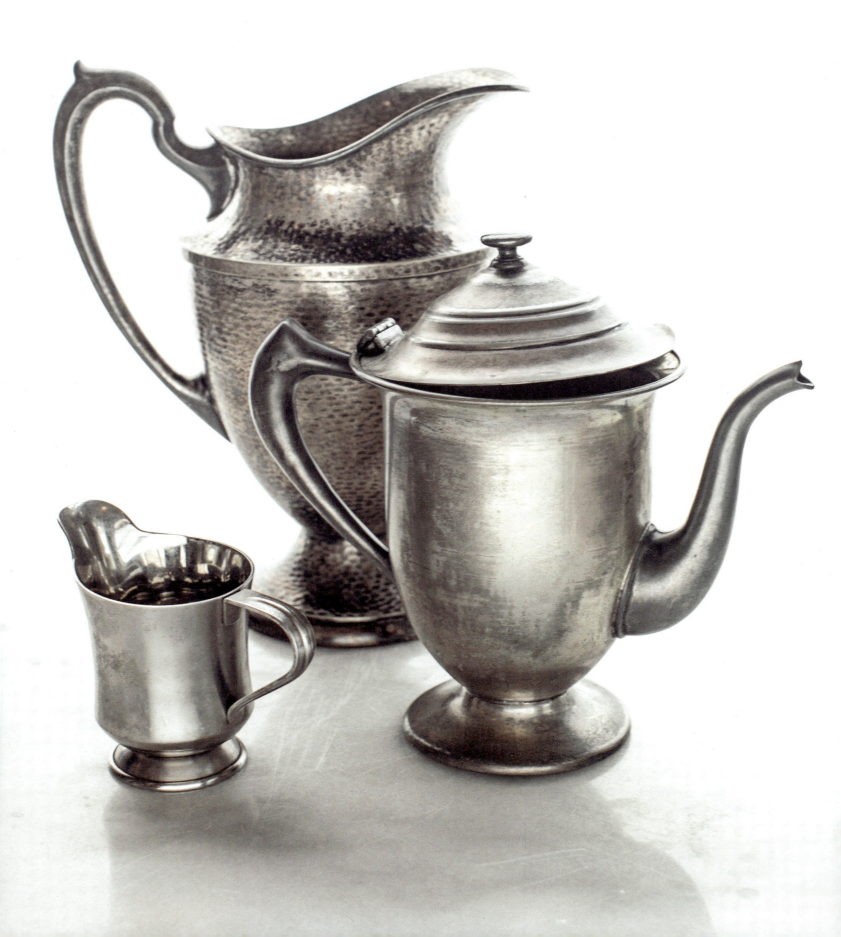

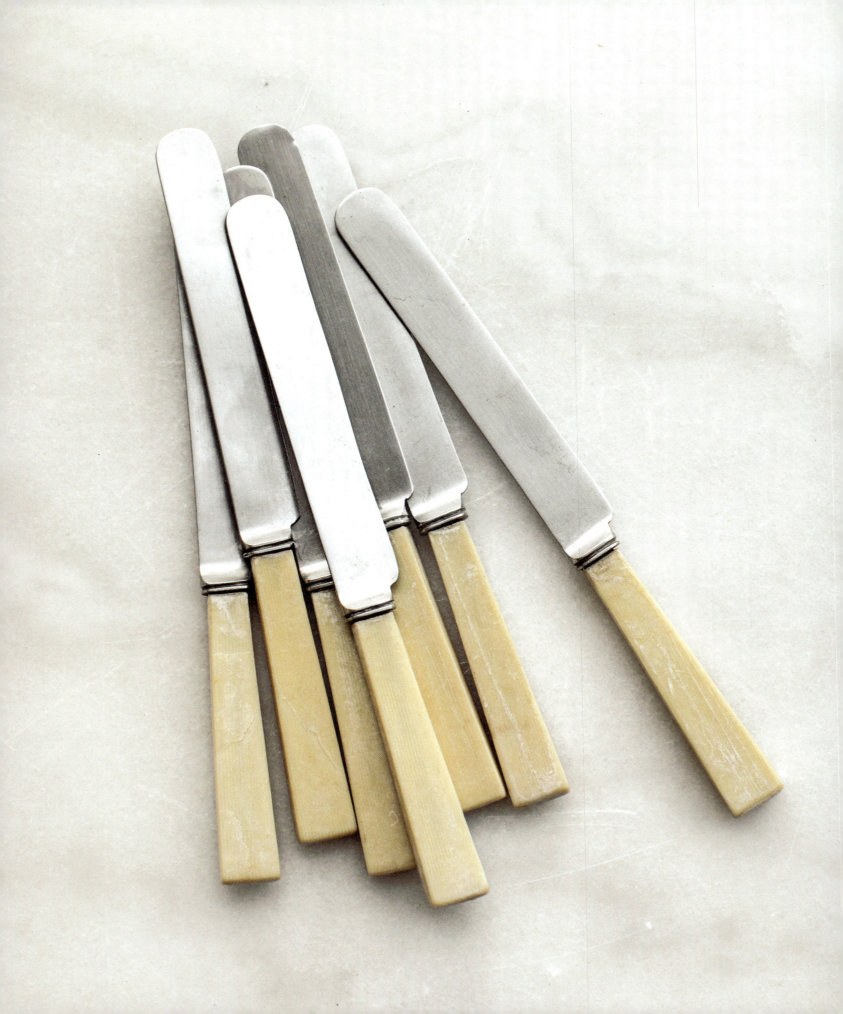

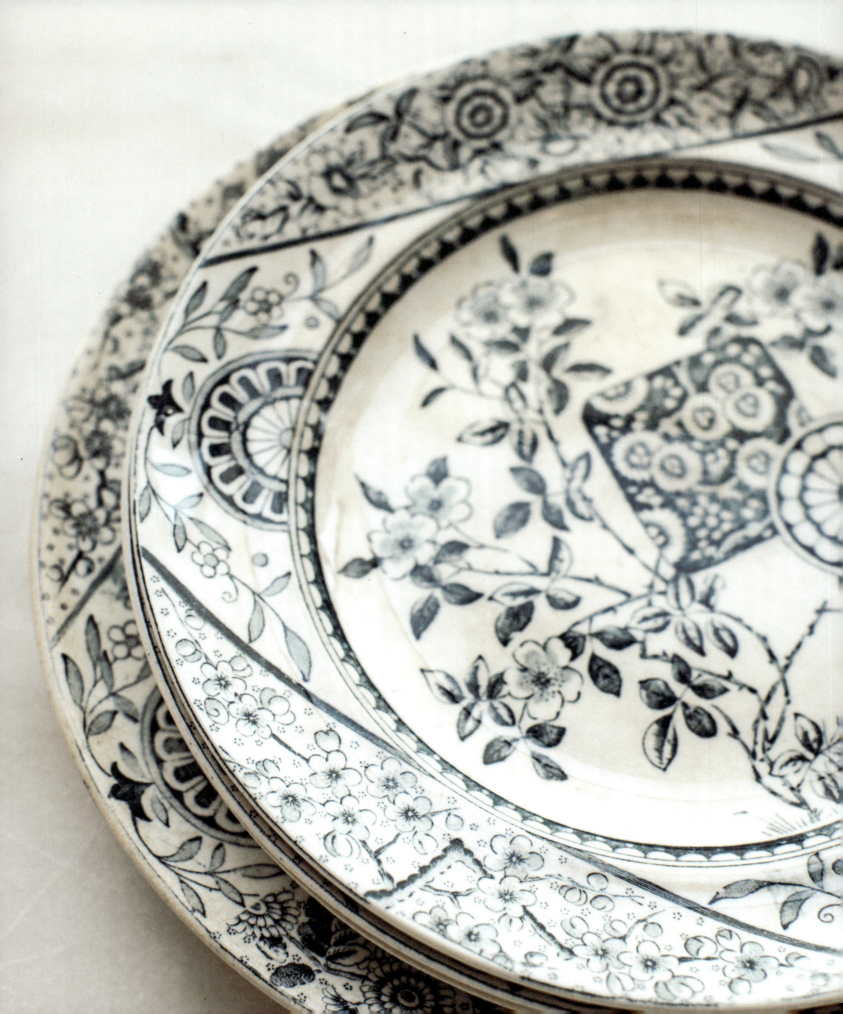

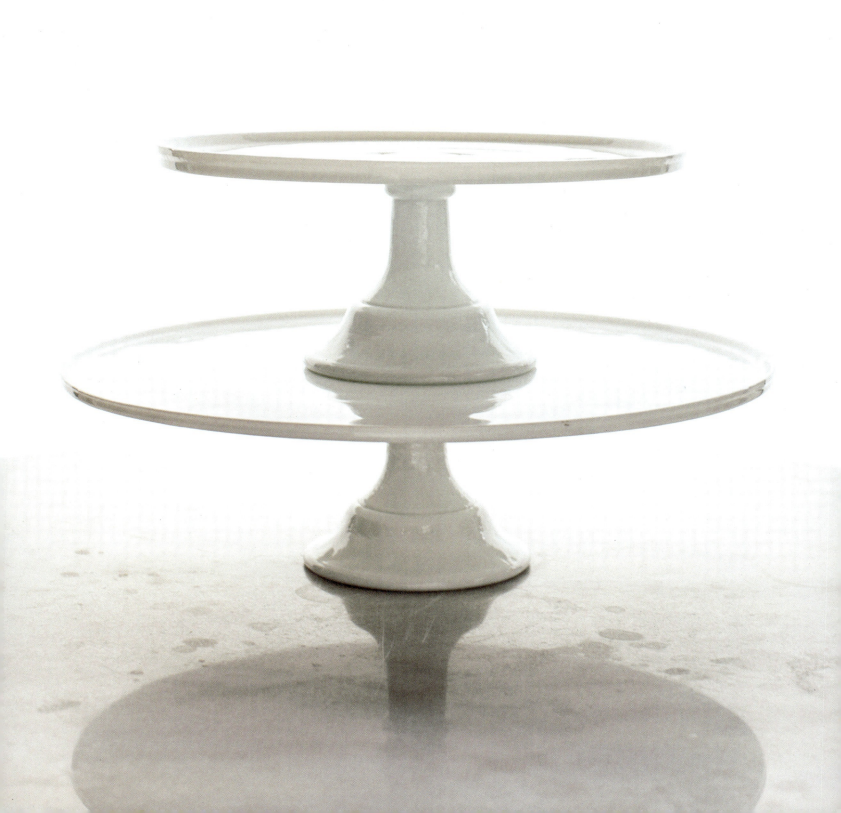

# WORKING WITH FLOWERS

*A beautiful centerpiece is the crowning glory* for a stylish dinner table. A tall arrangement can also be an eye-catching anchor for a buffet table. A simple bud vase can elevate a charcuterie tray and even a few blooms as garnish on a dessert platter can cause guests to take a moment to pause and admire. Beyond the table though, flowers placed around your home add life and texture to a room. They have the power to change your mood in an instant. Everyone notices a beautiful bouquet, so it's helpful to learn how to make one. With a few key suggestions, you can quickly become a floral artist.

Your favorite flowers can easily be sourced from a florist, wholesale market, flower farm, farmers market, grocery store, or even your backyard. Because I'm an avid gardener, I plant perennials, shrubs, and annuals that will give me a selection of seasonal flowers to cut at a moment's notice. At times, if flowers are hard to come by, I opt for cutting greenery from the many interesting plants around my yard. It could be a handful of tall branches from a tree, a single giant monstera leaf, a trailing vine of ivy, or even clippings from a fragrant

rosemary bush. A big bouquet of greenery can be just as beautiful as a vase full of colorful blooms. I encourage you to look around your yard at the different types of plants you could forage for an arrangement. If you want to feel inspired, create an area in your yard for a cutting-flower garden. Aside from benefiting wildlife, including pollinating insects, you will be able to practice working with flowers purely for the enjoyment of it.

Unless you're cutting a handful of wildflowers, it's a good practice to limit the type and color of flowers used in your arrangement to a maximum of three. Ideally, choose different shades of the same color to create a monochromatic bouquet until you get comfortable exploring with different color options. Using a sixty-thirty-ten rule will guarantee a beautiful and balanced arrangement every time. The idea is that 60 percent of your bouquet should consist of the main color (or type) of the flower, 30 percent should consist of a secondary color (or type), and 10 percent should consist of a third color (or type). Once you're comfortable making arrangements with a monochromatic tone, try using the same formula with colors that create an analogous color scheme (three colors found side by side on a color wheel) for a more spirited-looking arrangement. Other color combinations can be selected, but I find monochromatic and analogous are the simplest combinations to work with. A singular type of greenery added to an arrangement can enhance it and bulk it up. Tuck greenery in last to add volume or to fill in any empty spots you may notice.

In addition to the colors of the flowers, the texture and movement of the flowers also determine the style of an arrangement. Some have a rigid and stiff nature, such as roses, mums, lilies, small sunflowers, and carnations (often the types of flowers that can be found in a grocery store). Others (often found in a garden setting) have movement to them by the way they naturally bend or undulate, such as tulips, hydrangeas, zinnias, or peonies. Stiff flowers can

provide the needed structure to an arrangement, while softer flowers with movement give an arrangement a more naturalistic feel. It's not unusual for me to combine store-bought flowers with fresh flowers cut from my garden when I'm preparing for a party. Keep your arrangement interesting by using a mixture of sizes and types of blooms. In nature, most flowers grow naturally in groupings, creating a density within a garden. You can achieve a similar density in your arrangement by creating informal groupings of the same type of flower rather than spacing them individually around the arrangement.

Properly cutting and hydrating flowers is vital for them to thrive and open to their full potential. Hydrating them a day or two in advance of making your arrangements will guarantee bigger and more beautiful blooms, along with an increased vase life so they can be enjoyed longer. Don't make the common mistake of rushing to make an arrangement by hacking off the stems of your newly purchased flowers, which have been out of water for an extended period, and hastily shoving them into a vessel. Often the buds are still tight and the stems have not had a chance to soak up enough water, which could lead to your arrangement prematurely wilting right on your table. Purchase your flowers a day or two in advance. Clean the stems of their lower leaves, give a fresh cut at an angle, and submerge them in a bucket of tepid water that covers at least eight inches of stem. Allow them to relax undisturbed at room temperature, away from the sun. If you've purchased flowers with very tight buds that need to be forced open, soak them in a separate bucket with lukewarm water. Once hydrated, pull each stem individually from the bucket and give it a fresh cut at the desired length before adding it to the vase.

Choosing the right vessel for your arrangement can take some practice. Almost anything can be used depending upon the kind of flowers you have and the size of the arrangement you want. Make sure it is watertight, or at least have a watertight container that can be set into a

## ARRANGEMENT ALTERNATIVES

Be creative, and keep in mind that centerpieces don't strictly have to be floral arrangements. A grouping of seasonal gourds or a swag of greenery makes a beautiful presentation, just as a collection of potted ferns or small clay pots of pansies add a simple charm to even the most ornate table. And if the ease of using potted flowers isn't enough to convince you, consider that they can also be given to each of your guests at the end of the evening as a token of appreciation.

vessel that cannot hold water. The smaller the mouth of the vessel, the less material that will be needed. My preference is to use vases that have a wide, voluptuous body with a smaller neck, unless I'm working with very large blooms such as hydrangea, which can easily fill a large urn. For very wide containers, such as a porcelain bowl or an antique soup tureen, you may need to incorporate the use of floral frogs or chicken wire that's been balled up. Either can be submerged in the water to support the stems without being seen once the arrangement is finished. Floral foam, although commonly used commercially, is not suggested and is frowned upon for its hazard to the environment.

For a balanced-looking arrangement, make the bouquet one and a half to two times the height of the vase and two to three times the diameter of the mouth. Oftentimes greenery can help fill in larger arrangements. Keep in mind that arrangements aren't strictly vertical; they are three-dimensional and spherical. Think of side to side

as much as you think of up and down. Balancing the scale and proportion of an arrangement takes some practice. Centerpieces on a dining table should not exceed the height of the guests' eyesight from either side of the table. If, after seating your guests, you find your arrangement hampers easy conversation (which happens to the best of us) simply remove the arrangement without too much fuss and rearrange some candles to take up the empty space.

Removing all or most of the greenery from a flower's stem prevents an arrangement from becoming overcrowded and looking messy. Additionally, any leaves that become submerged will quickly stagnate and create murky water, causing the arrangement to smell rotten. While a drop of bleach in the water can help prevent it, it's best to have clean stems altogether.

Most stems can simply be cut at an angle before placing them into a vessel; however, some will need special attention in order to thrive. Two of the most common that you will encounter are those that bleed when cut and those that are hard and woody. Flowers that ooze a sappy substance (usually a milky white color) when cut need to be cauterized with a flame before putting the stem into water. Neglecting to do so will cause the flower to wilt. Woody stems and branches, cut either from a tree or a bush, will benefit from having the end smashed with a mallet or having a three-to-four-inch incision made up the branch to allow for more surface area to absorb water.

Now that you are armed with some basic knowledge of putting together an arrangement, practice regularly. As the old saying goes, "We can't allow the perfect to be the enemy of the good." Get comfortable with making mistakes so that when the time comes to have a party, you have the confidence to show off your skills.

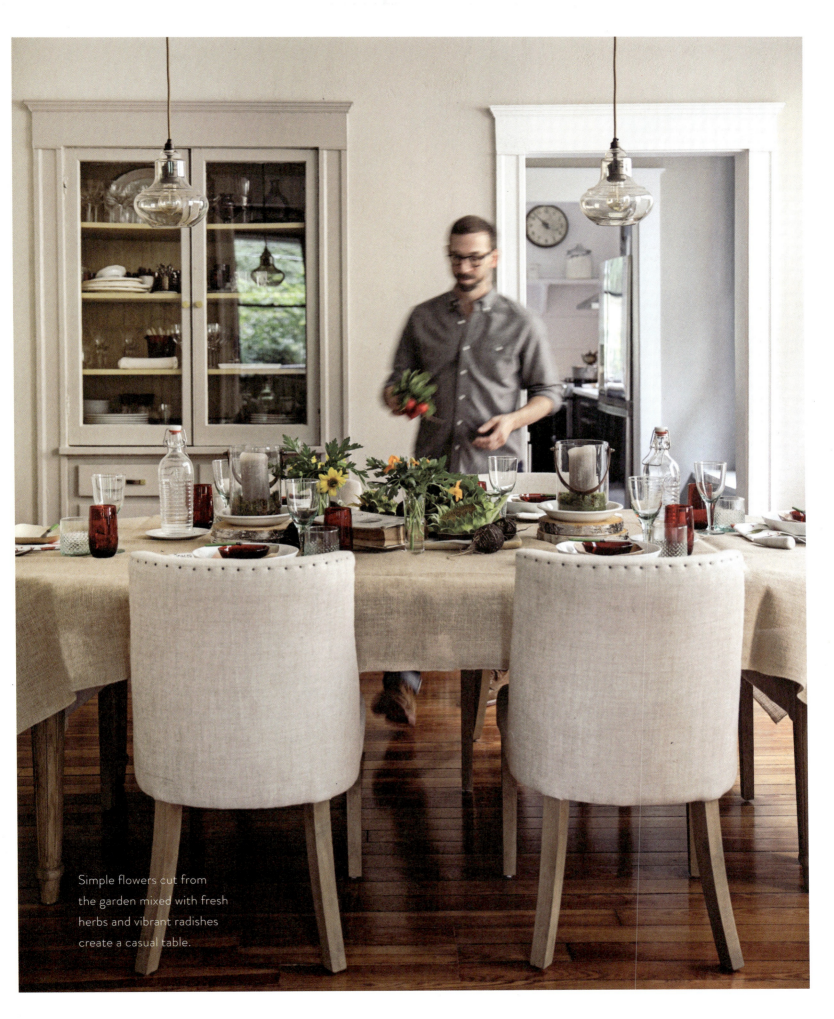

Simple flowers cut from the garden mixed with fresh herbs and vibrant radishes create a casual table.

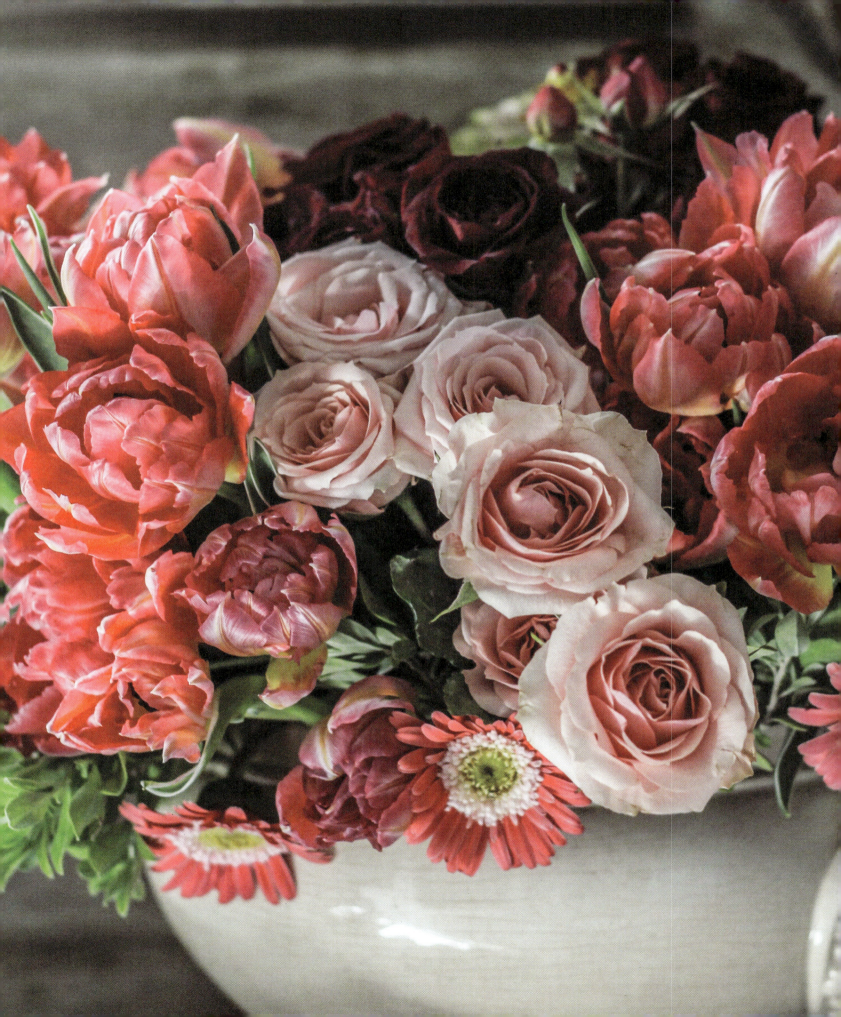

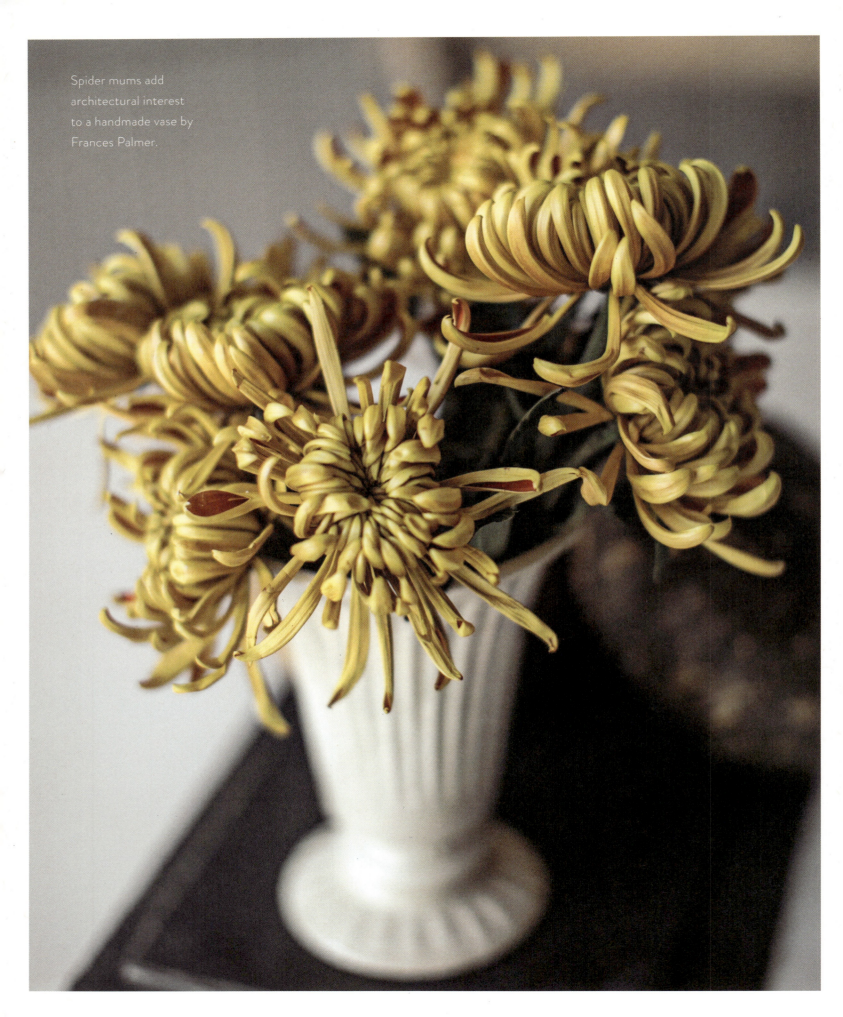

Spider mums add architectural interest to a handmade vase by Frances Palmer.

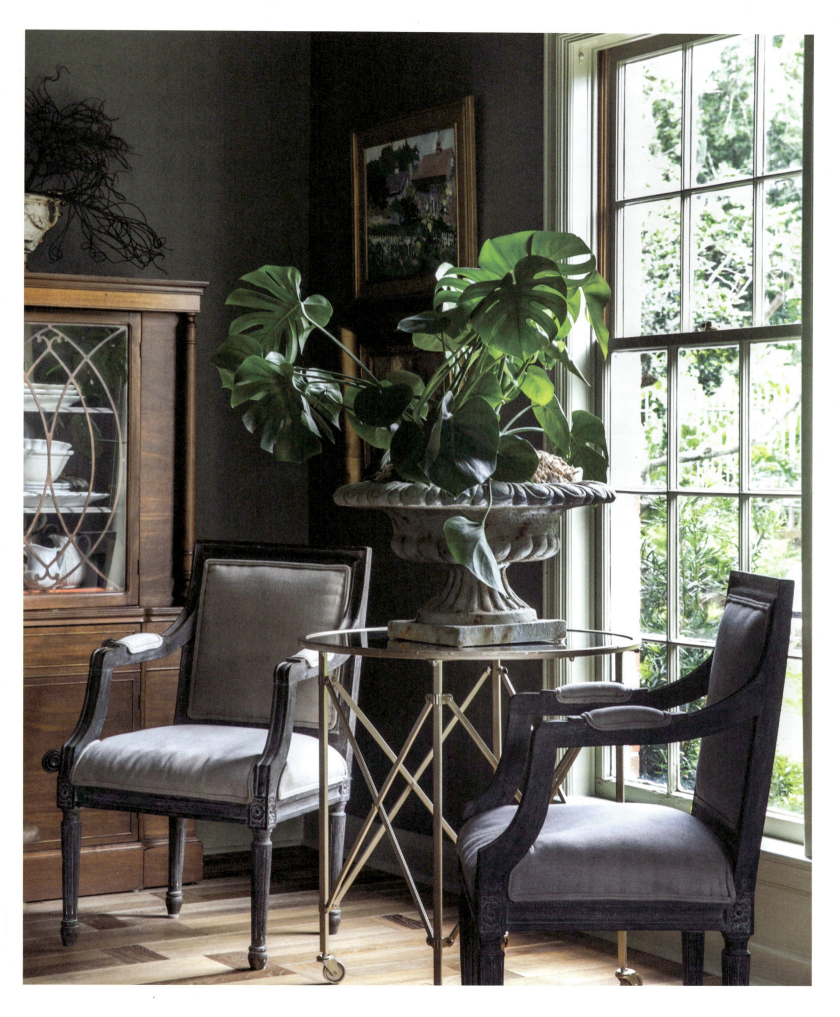

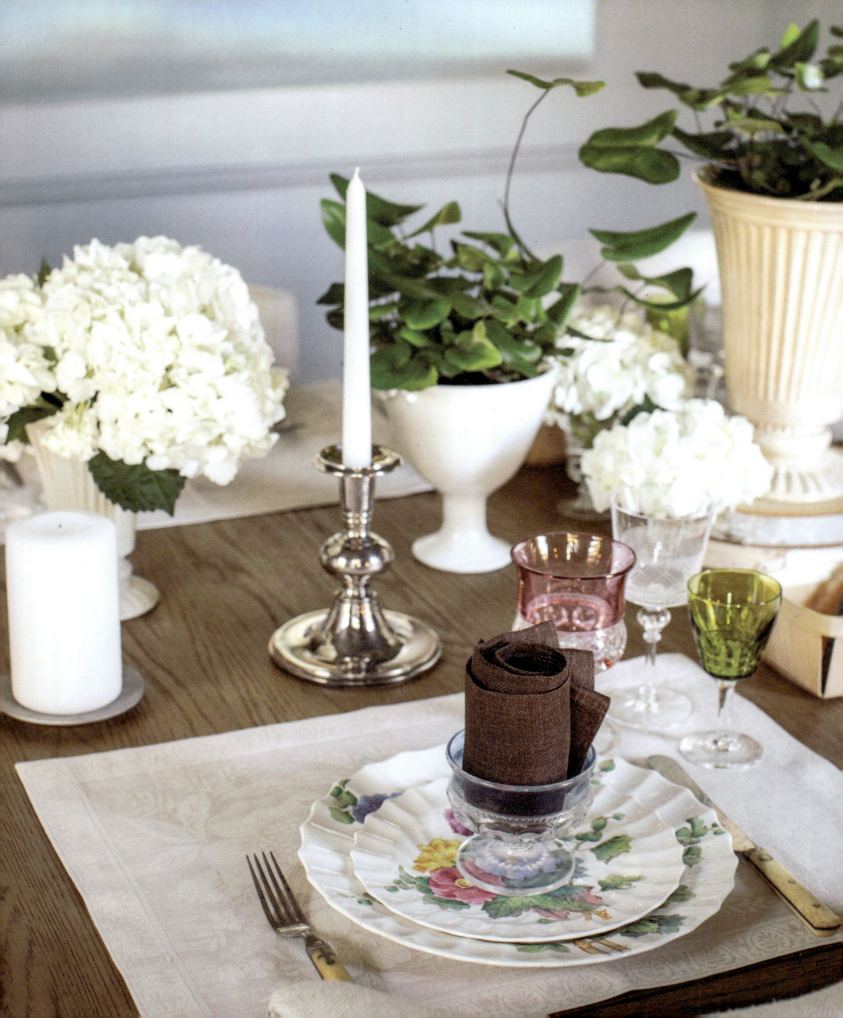

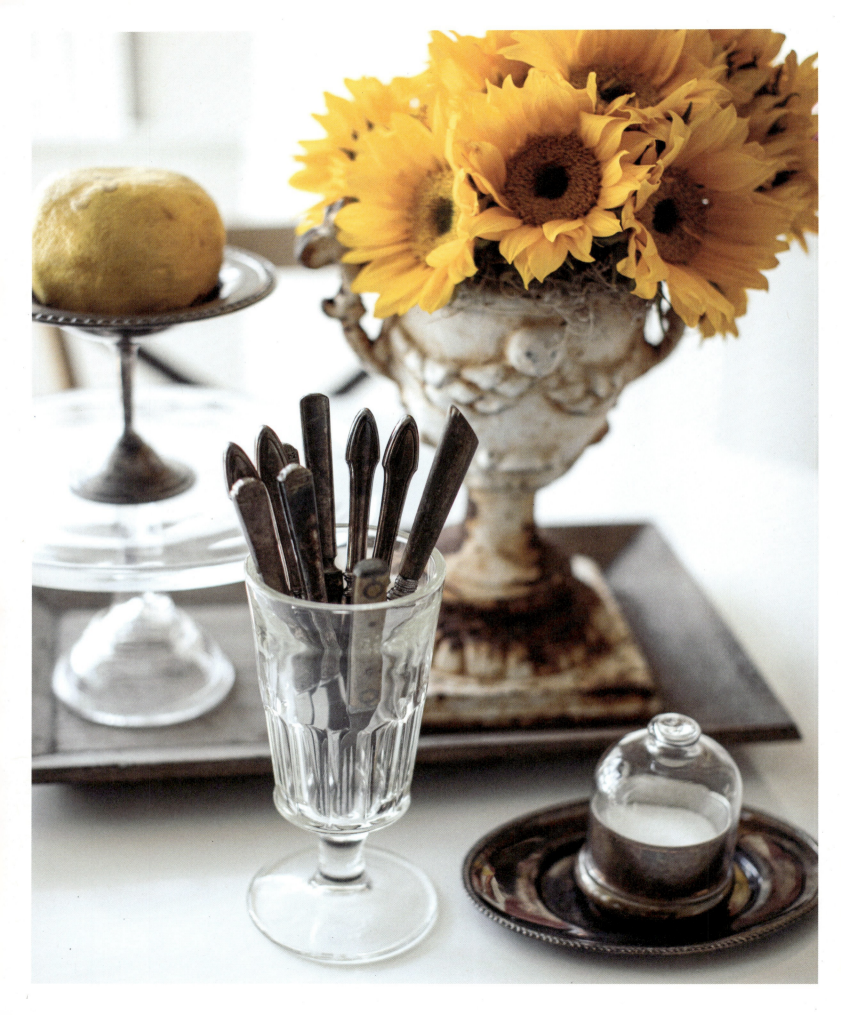

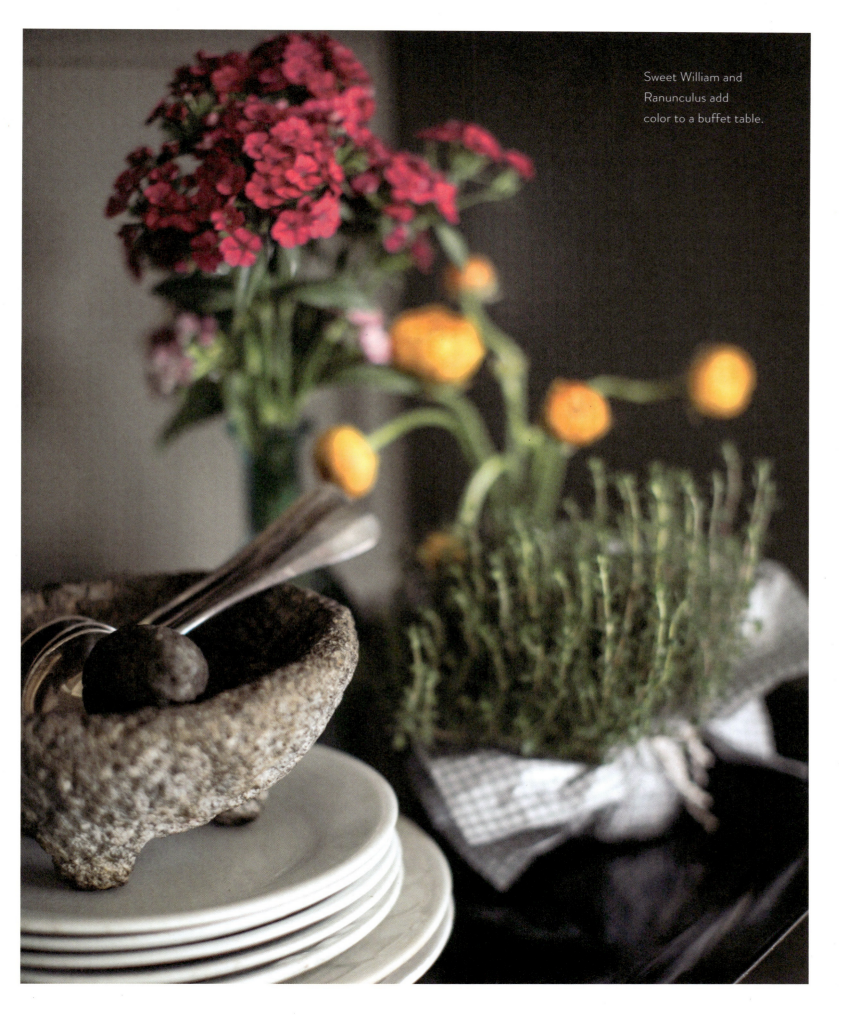

Sweet William and
Ranunculus add
color to a buffet table.

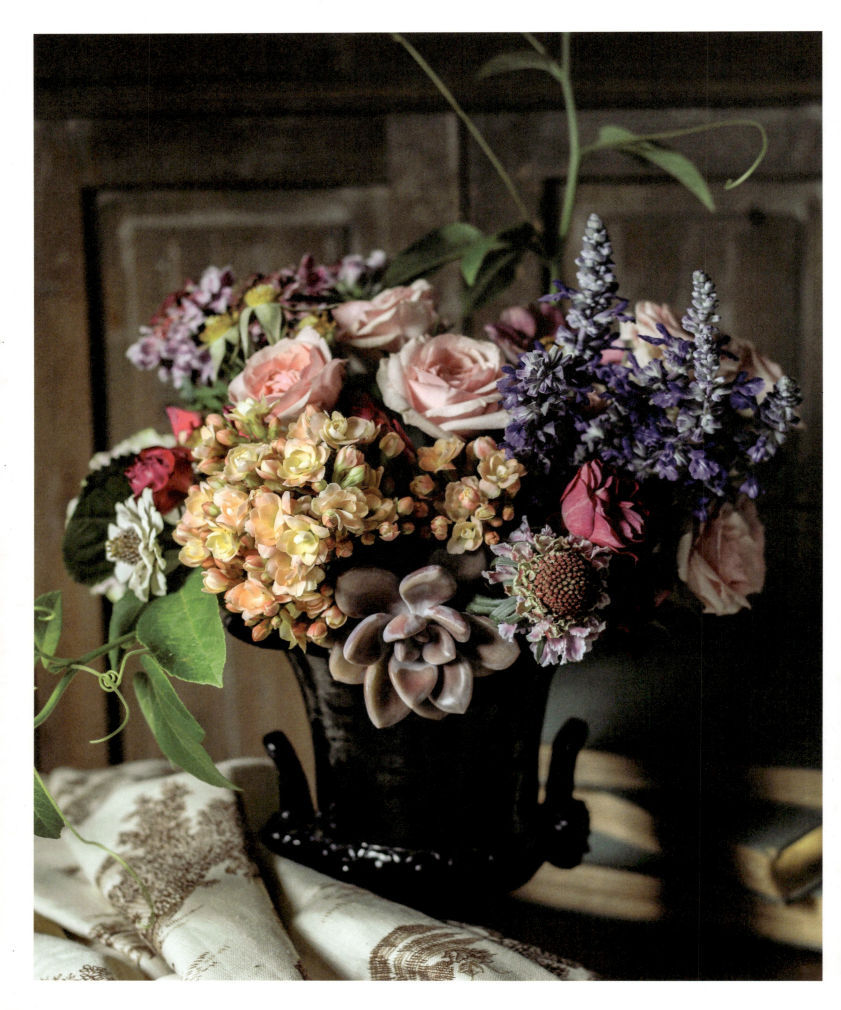

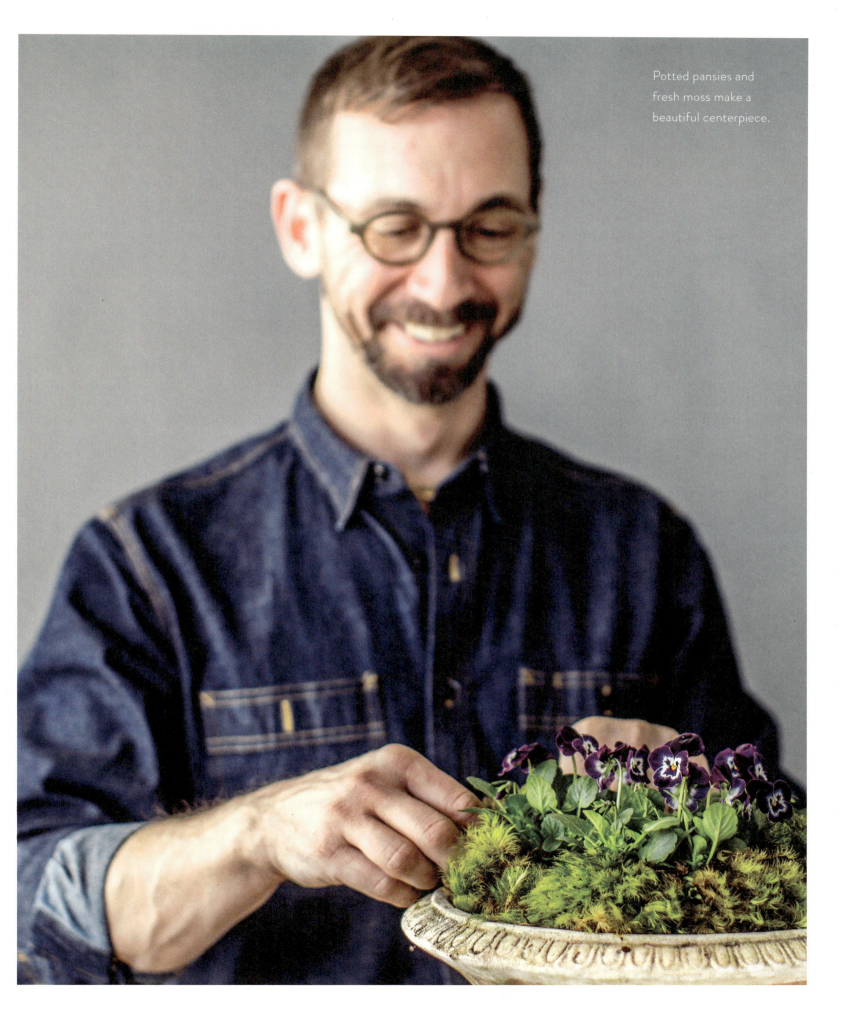

Potted pansies and
fresh moss make a
beautiful centerpiece.

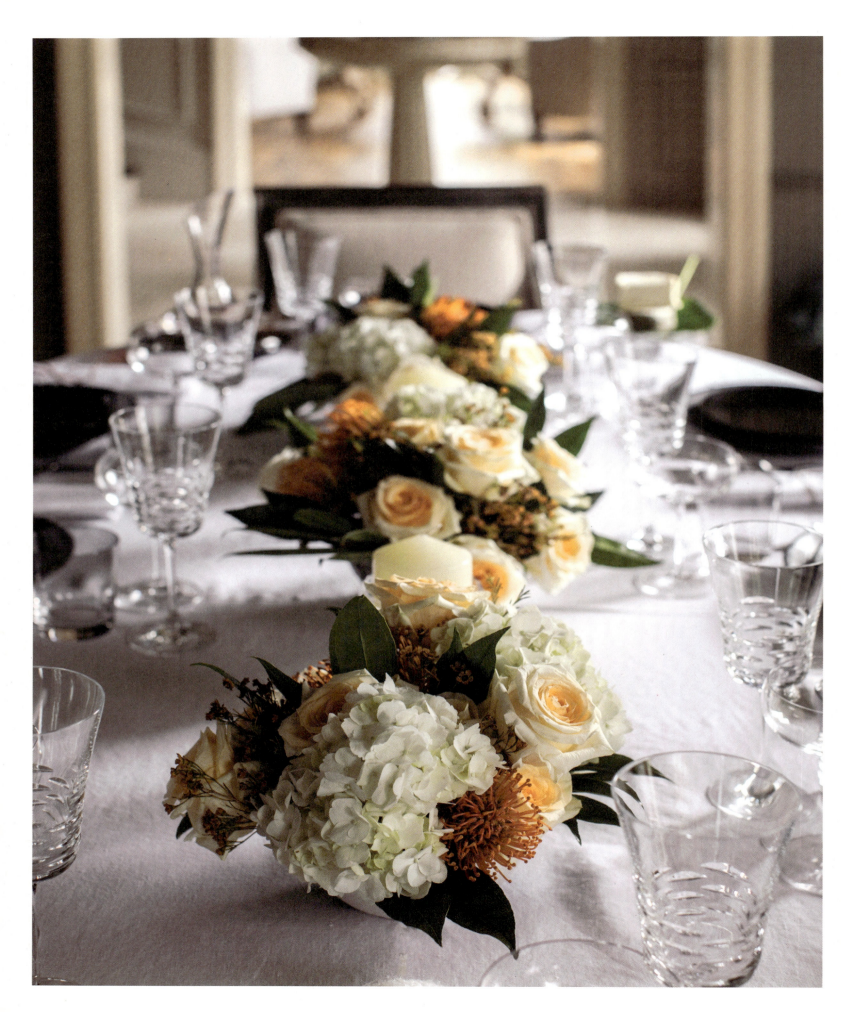

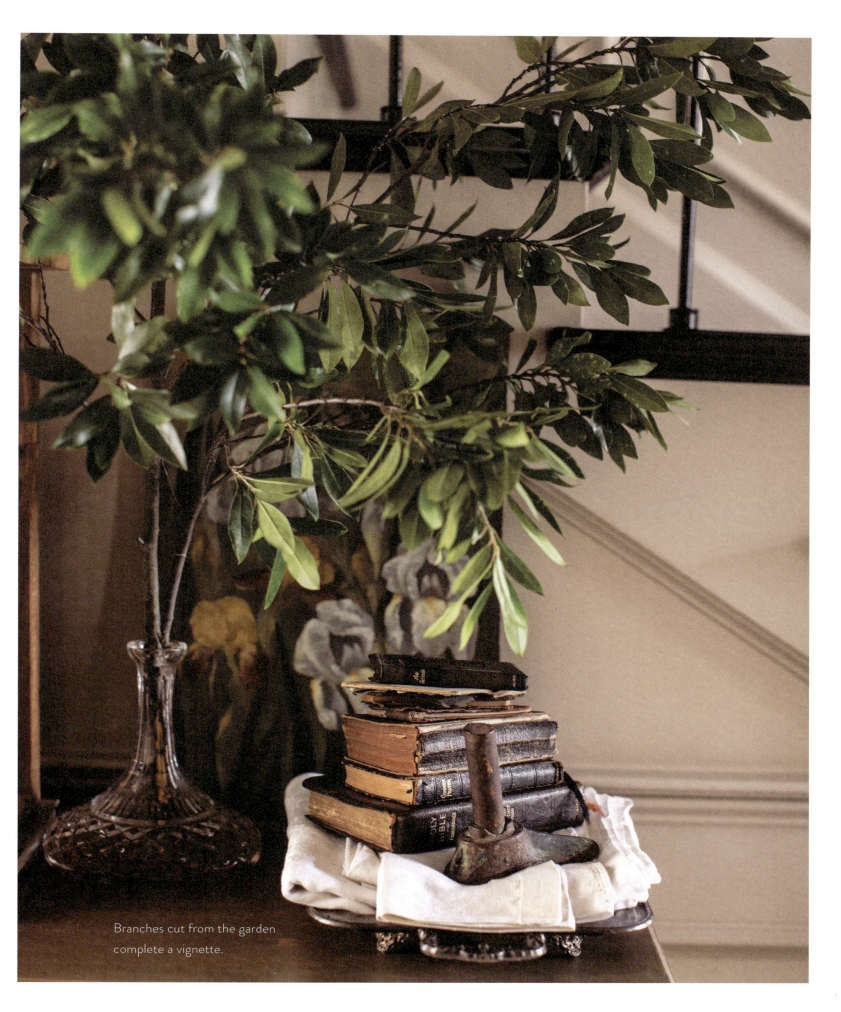

Branches cut from the garden
complete a vignette.

# SHAKEN, STIRRED, AND STRAIGHT UP

*Everyone loves the appeal of a chic bartender* covered in tattoos blending potions that smoke and taste of burned wood which are chilled by a single giant ice cube or one who's preparing tall mojitos jammed with bright green, fresh, organic mint and perfectly crushed ice. But unless you're skilled at making these concoctions or unless you're hiring a professional bartender trained in the art of craft cocktails, setting up a classic bar at home is usually preferred. While almost any drink can be served in a double old-fashioned or a highball (including beer), what creates a memorable experience is sipping a cocktail from a unique and interesting glass. Whether it's a fancy crystal goblet or a stylishly etched coupe found at a flea market, a well-chosen glass can become the main event of the party. That first impression goes from ordinary to extraordinary the moment you hand someone a beautiful glass. You can keep a collection of basic glassware in your prop closet, but hunt for unusual glasses that you can entertain your guests with. I am always on the lookout for polished, smart-looking glasses in sets of six or more at thrift stores. When I find unique ones for less than a dollar a piece, I purchase them and store them for my next party.

As with all other details of your party, the bar should not be neglected. It should be easy for the guests to understand and navigate. Have it organized so they

could get their drinks quickly to prevent others from waiting too long. By grouping items like glassware, liquor, mixers, sodas, and condiments on individual trays, your bar stays tidy throughout the evening. Consider adding a small floral arrangement and some candles to make it look beautiful and inviting. In order to minimize the barrage of labels on the bar, I prefer to decant all juices into nice glass pitchers. I also set out cocktail condiments like olives, onions, cherries, and citrus in small matching bowls. It's even a nice touch to place a bowl of nuts or chips at the bar for quick snacking while waiting to make a drink.

The placement of the bar is often the least considered detail, but I find it to be of great importance—it's the first place your guests will go upon arrival. It's also the first spot in your home that could cause a bottleneck; therefore, it should be well placed to allow for the easy flow of guests throughout your home. You could consider using a counter in a butler's pantry, a desk in a library, the surface of a built-in bookshelf adjusted to a comfortable level, or even a collapsible table with a cloth draped to the floor— but only if it's out of the way of foot traffic. Bar carts have become a trendy option, but they're one of my least favorite to use. I find them unpractical, precarious, and very difficult to navigate. In my opinion, they are best reserved for a premade cocktail, a punch bowl, or an after-dinner aperitif.

Remember: you want to have the best party with what you can afford. The bar is not the place to skimp if you're stretching your budget. If you have a limited budget, consider having a pared-down bar with one or two good-quality liquors along with wine or beer. If you can't afford top-shelf liquor, prepare a premade signature cocktail or punch with inexpensive alcohol and spend the extra money to upgrade the wine or beer.

Most importantly, have plenty of ice on hand. It seems like ice is the one thing a host (including myself) is frantically dialing someone for at the last minute. There must be something ingrained in our psyches that makes us

## — COCKTAILS ALFRESCO —

Find a shaded area for the bar when entertaining outside. Not only will the ice melt faster in the sun, but the alcohol and mixers will be so warm that they'll quickly melt the ice in your glass—watering down a perfectly good cocktail. Large tin utility tubs provide a great option for icing down beverages rather than having coolers strewn about. Be mindful: if you have iced buckets sitting on the bar in the heat, be sure to set them on something that can absorb the condensation, like an old cutting board.

go blank when it comes to ice. My solution: it's the very first item I put on my organization list (in capital letters and highlighted).

The makings of a proficient home bar for any occasion include the following: vodka, gin, bourbon, scotch, sweet and dry vermouth, wine, beer, club soda, cola, diet cola, ginger ale, tonic, orange juice, cranberry juice, pineapple juice, Rose's lime juice, and sparkling water, along with cocktail olives, cocktail onions, cherries, lemon wedges, and lime wedges. If you want to impress, try adding single malt whiskey, brandy, cognac, Grand Marnier, tequila, rum, aged port, Lillet, and Cointreau, as well as POM pomegranate juice, homemade Bloody Mary mix, stalks of celery, sliced cucumber, and even Angostura bitters.

Even with a fully stocked bar, it can be fun to also offer a signature cocktail. Trying something new and different will create camaraderie among your guests. Do some research and choose a cocktail that compliments the hors d'oeuvres or amuse-bouche you plan to serve. While I enjoy a classic vodka gimlet shaken so hard there are ice crystals in the drink, my guests have enjoyed some beautiful and delicious cocktails which I've provided recipes for. Consider choosing one of the following recipes and mix yourself a delicious cocktail.

# — CHEER-FULL HINTS —

People generally consume two beverages per hour for cocktail parties and one to two cocktails before a dinner party.

- You can pour five to six glasses from a bottle of wine.

- You can pour six glasses from a bottle of champagne or prosecco.

- Usually, ½ to ¾ of the guests will drink wine at a party.

- Usually, ¼ of the guests will drink beer and the other ¼ will drink a mixed cocktail.

- A signature cocktail can be popular, so most guests will be apt to try at least one glass.

- Two to three glasses of wine are typically consumed during a sit-down dinner.

- If you are not pairing wine with a specific dish, red is usually preferred in the evening and white in the afternoon. A crisp, dry rosé is great for a hot summer gathering.

- Soda and juices are best served out of small cans or bottles so they are not wasted.

- A 750 ml bottle of liquor has 16 shots in it; a liter has 22.

- A standard neat drink is 2 oz of alcohol served on the rocks.

- Purchase 1 pound of ice per person for drinks during a 4-hour cocktail party, in addition to the ice used for chilling.

- Most traditional cocktails are made with vodka or gin.

- Always offer a choice of light or dark beer, like an IPA and an amber lager.

- Some people do not drink. Offer sparkling water or club soda with a splash of juice as a nonalcoholic option.

- Refer to "Creating a 'Prop Closet'" (page 89) for the utensils needed for a bar.

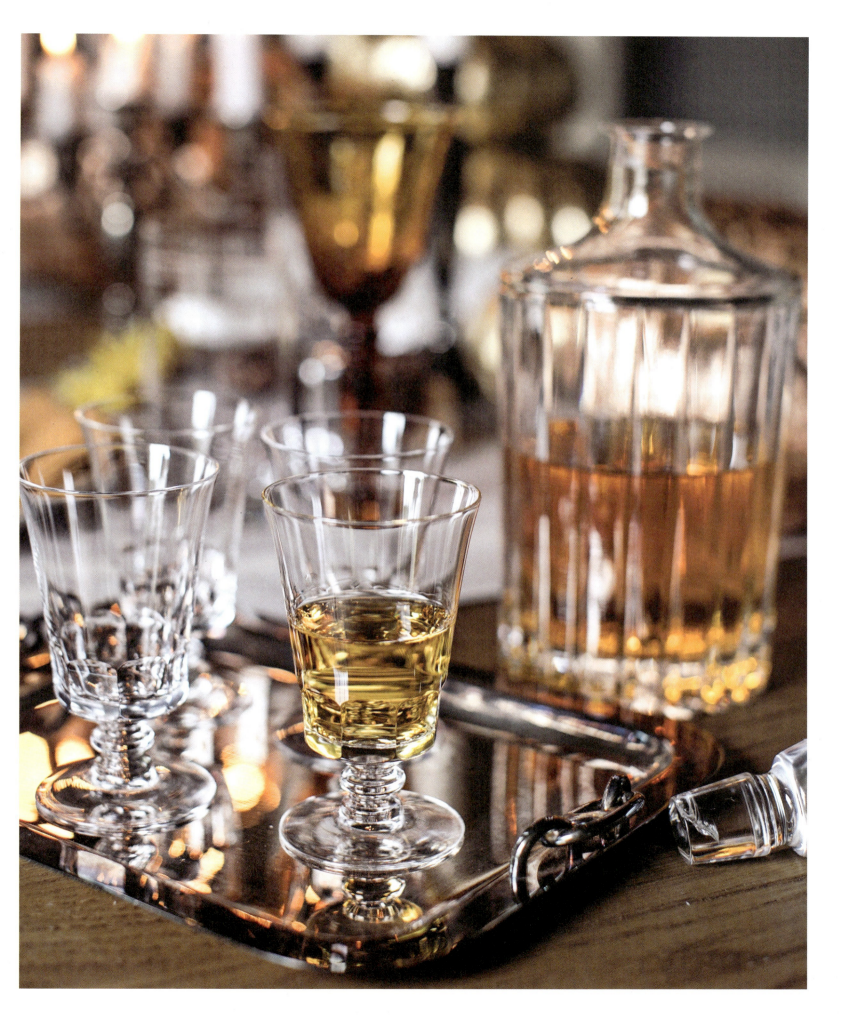

# POMEGRANATE AND PROSECCO

*Makes 6 glasses*

This is an incredibly easy recipe for a colorful cocktail. I'm not even sure I can call it a recipe, although it is my go-to for easy and quick entertaining.

1 bottle dry prosecco, chilled
1 bottle Pom pomegranate juice, chilled

Pour ½ teaspoon pomegranate juice into a champagne flute then fill ¾ of the way full with very cold prosecco. Serve immediately.

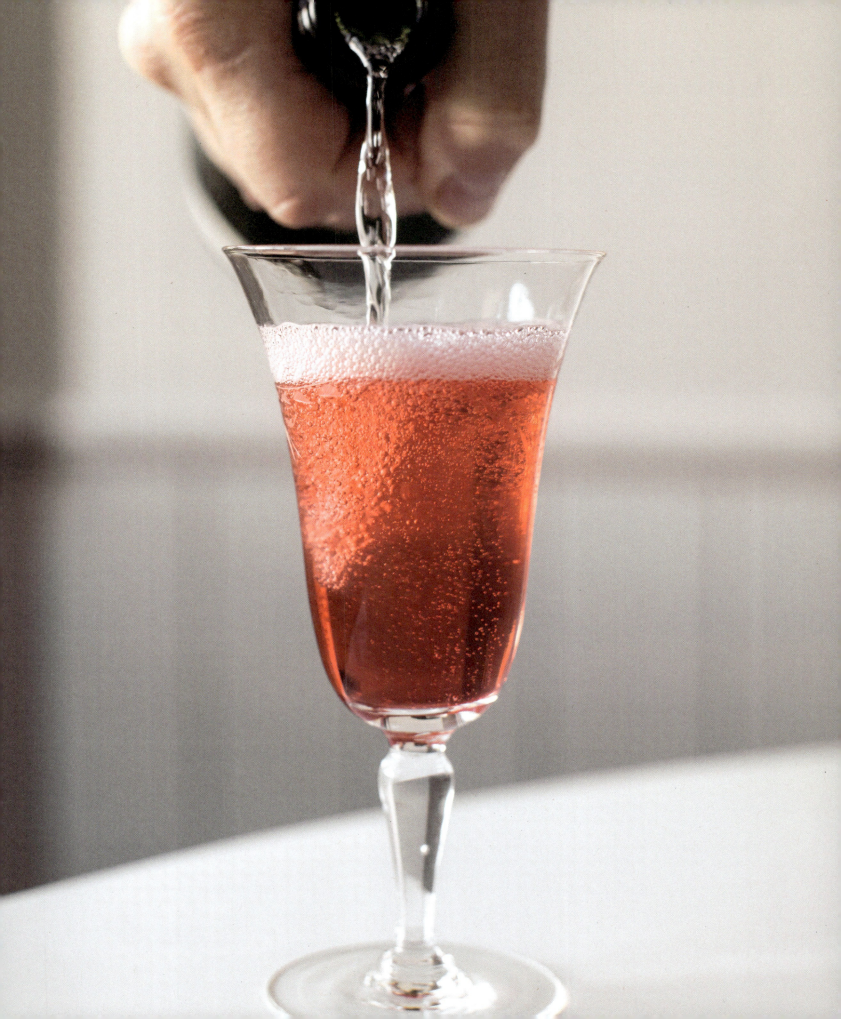

# THE STARGAZER

*Makes 1 cocktail*

Aperitifs are becoming a popular staple on the home bar once again. This moody-looking drink pairs the slightly bitter flavors of Pimm's with the sweet, floral undertones of St. Germain. It's a great cocktail to serve for a mid-afternoon summer affair or an evening cocktail before dinner. I love to serve this drink in an old-fashioned coup-style glass.

2 shots of Pimm's
1 shot of St. Germain
Cold ginger ale
1 starfruit

Chill a coup-style martini or champagne glass with ice. Combine the Pimm's and St. Germain in a cocktail shaker, then fill halfway with ice. Shake vigorously for 1 minute until very cold. Dump the ice from the coup and pour in the mixture from the shaker. Top off the glass with cold ginger ale. Garnish with a slice of starfruit. Serve immediately.

# ROSEMARY LIMONCELLO SPRITZER

1 shot of chilled vodka
¼ cup chilled dry prosecco
½ teaspoon Rose's lime juice
¼ teaspoon Pom pomegranate juice
½ teaspoon pineapple juice
Fresh cranberries for garnish
1 lime, cut into wedges
1 grapefruit, cut into wedges

In a shaker that has been filled halfway with ice, combine vodka, pomegranate juice, Rose's lime juice, and pineapple juice. Shake until cold. Strain into a tall glass and top off with chilled prosecco. Squeeze the juice from a wedge of grapefruit over the prosecco. Finish by garnishing with fresh cranberries, a lime wedge, and a wedge of grapefruit.

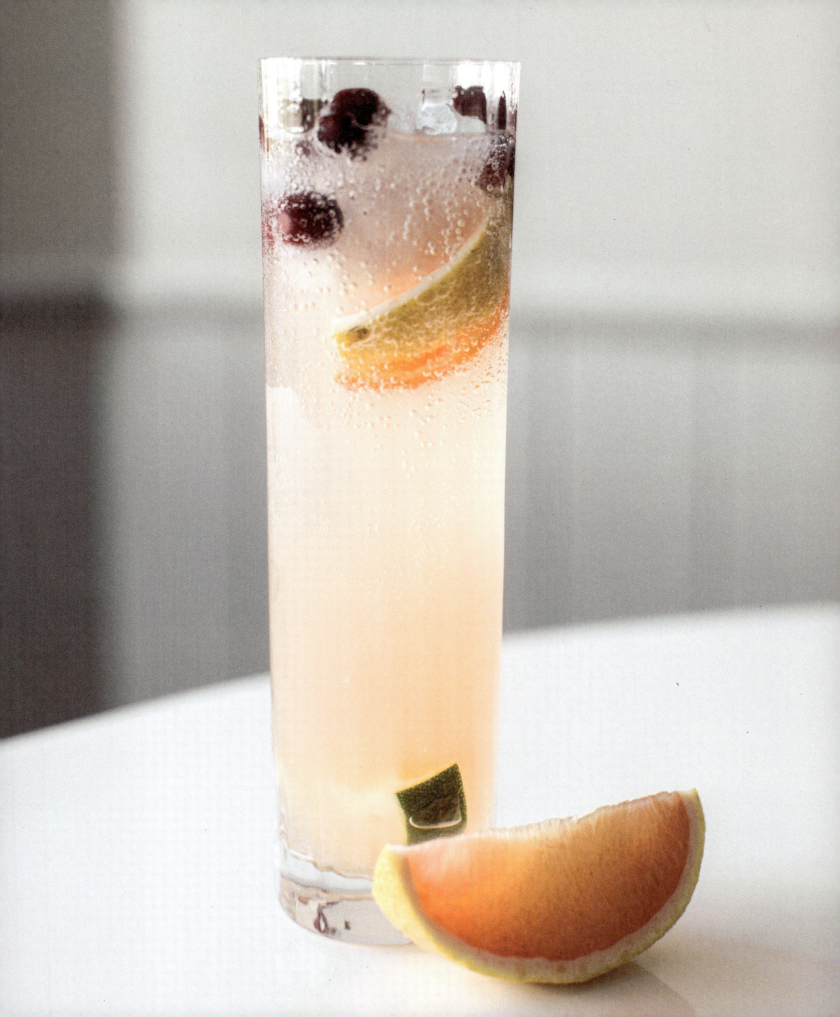

# BLOODY MARY MIX

*Makes a 34-ounce pitcher*

For a fresh-tasting Bloody Mary mix that packs a punch, this is it. Say "no more" to tomato juice and vodka. Served in a beautiful glass garnished with kosher salt and chili powder, your guests will think they've died and gone to heaven, trust me.

24 ounces passata (tomato puree)
6 scallions, thinly sliced
1 tablespoon black pepper
¾ teaspoon kosher salt
½ cup white vinegar
⅛ cup dill pickle juice
1 clove garlic, mashed to a paste

½ teaspoon tabasco sauce
1 teaspoon chili powder
4 teaspoons prepared horseradish
1 teaspoon fish sauce
1 lime cut into wedges for garnish
1 bunch celery with nice leaves for garnish

## FOR THE GLASS GARNISH
¼ cup kosher salt
1 tablespoon chili powder

Combine all the ingredients and mix thoroughly. Decant into a glass pitcher.

Mix the salt with the chili powder and spread it into a thin, even layer on a small dish. Fold up a few paper towels into a square big enough for the glass and soak it with water. Gently ring it out, leaving it moderately wet, and place it on another small dish next to the salt mixture. Before the guests arrive, dip the rims of the glasses into the paper towel then dip them into the salt mixture.

Arrange the glasses, bloody mary mix, and vodka on a tray with wedges of lime and stalks of celery that have been cut 3" longer than the body of the glass. Serve and enjoy.

> **TIP:** If you or someone you know is allergic to fish, simply leave out the fish sauce.

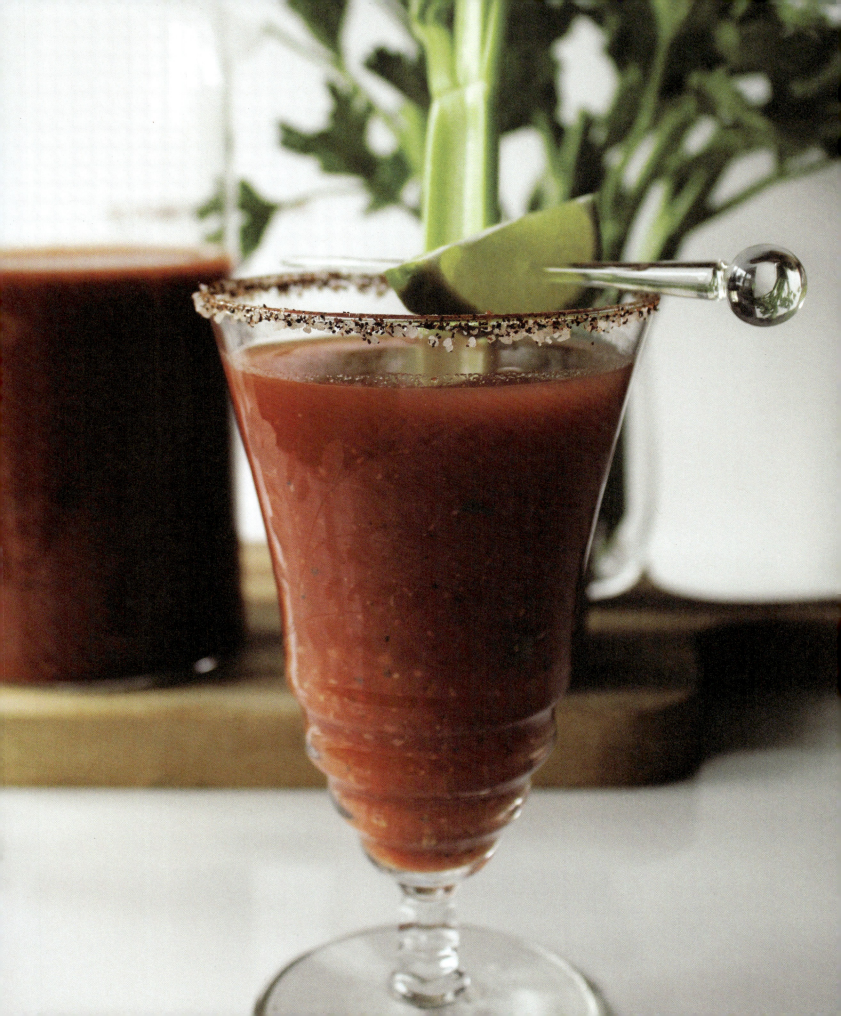

# CLASSIC VODKA GIMLET

For a modern spin on a classic gimlet, serve this refreshing cocktail in a vintage-style "coup" martini glass. Because vodka is lighter in flavor than gin, cutting down on the simple syrup lends to a perfect balance of spiciness and sweetness.

    3 ounces of vodka
    2 teaspoons Rose's lime juice
    Juice of 1 lime wedge

In a metal shaker, combine the ingredients and fill with ice. Shake hard for 30–45 seconds. Strain into a chilled glass and garnish with a skewered lime wedge.

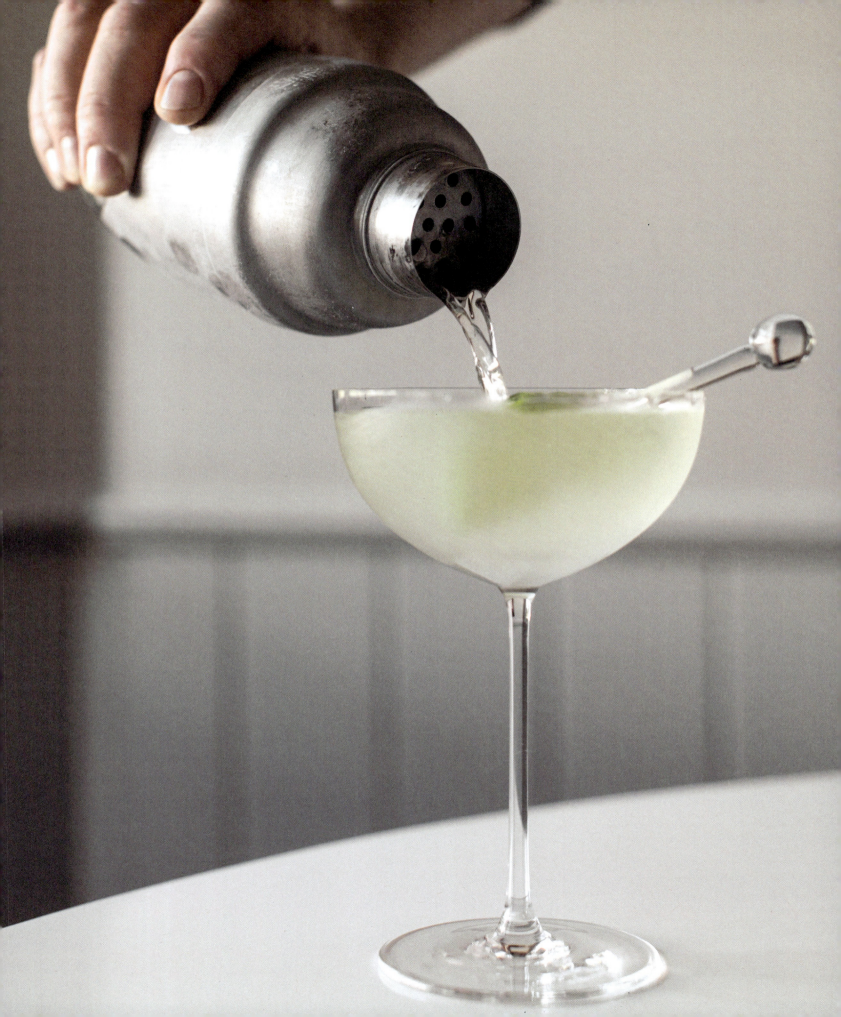

# THE FRENCHMAN'S CITRUS

*Makes a large punch bowl*

Homemade rosemary syrup adds a warm sweet touch to this signature cocktail. Rather than adding ice to the punch bowl, have an ice bucket handy to fill each glass with ice at the time of serving.

    1 bottle dry prosecco
    1 cup vodka
    1 cup Limoncello
    ¾ cup rosemary syrup
    ½ cup pomegranate juice
    1-liter bottle of club soda, cold

### For the rosemary syrup

Combine 1 cup of sugar with ½ cup water and 4 sprigs of rosemary in a small saucepan. On medium heat, boil for 6–8 minutes. Turn off the heat and allow the rosemary to steep until cool. Discard the rosemary.

### For the punch

Combine all the ingredients, except the club soda, in a punch bowl and stir until combined. Just before your guests arrive, pour the cold club soda into the punch bowl. Serve over ice and garnish with a sprig of rosemary and an orange wedge.

> **TIP:** Try substituting fresh-squeezed blood orange juice for the pomegranate juice.

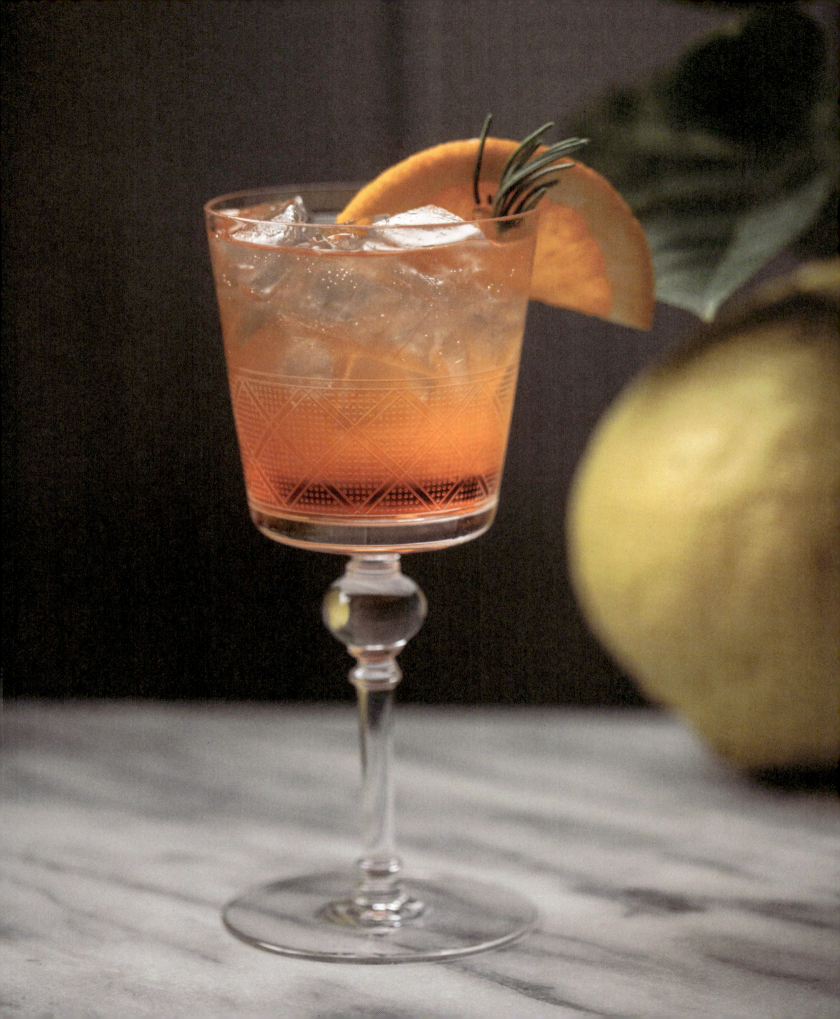

# PLANNING A MENU

*Planning a menu can have its challenges,* especially because we are so accustomed to practicing ways to shorten our time in the kitchen. Balancing quick, easy recipes with ones that require more involved preparation is the key to creating a successful menu that can be easily pulled off during your party. Once again, this process requires a fair amount of planning. Thoroughly researching recipes ahead of time will give you a good idea of the kind of cooking equipment you'll need, how much cooking you'll be doing in advance versus the day of, the storage space it will require, the types of storage containers you will need for holding prepared foods, and all the serving pieces that will be needed. Rather than constructing a crafty menu based on a theme, and instead of using ingredients or preparations that you might not be accustomed to, choose recipes that are simple to prepare and easy to reinterpret. Invest in cookbooks that have simple recipes. Make notes—lots of notes—to perfect your recipes. Even the most thoroughly tested recipes may not translate in your kitchen. Don't be afraid to revise a recipe to make it better. I like recipes that can be used in different applications—from changing a pesto into a dip to

If you are someone that enjoys the comradery of a potluck gathering, here are a few tips to ensure a successful party:

Make a list of everything that is needed, from drinks to desserts. Envision a specific menu in your mind. Even though other people are participating, you are still in charge as the host and will guide the way the event will turn out. Being too vague, such as planning only for a "potluck barbecue," won't help with deciding what you should be setting your table with.

Oftentimes a potluck can cause stress for the guest who doesn't know what to bring and doesn't want to disappoint the host. Be specific about what you are asking them to bring. For instance, don't just suggest that they bring "dessert." Ask them instead to bring "a chocolate dessert, like cake or brownies." Or if you want them to bring a "side dish," ask them instead for a "side dish of green beans" and allow them to use their creativity to decide how to prepare that dish. This ensures that you have a balanced and fulfilling menu to set out on your table.

So that your table looks beautifully styled and cohesive, set aside your own matching serving pieces, such as all-white platters or silver trays and wood bowls. Transfer the food that is provided onto your serving pieces before serving.

Remember that your guests took time out of their busy schedules to participate, so endeavor to send them individual thank-you notes the day after the party commending them for their participation and put forth how valuable they were to the success of the party.

---

making large meatballs small enough to serve as hors d'oeuvres. Entertaining at home should be an extension of who you are and what your authentic capabilities are. Rather than dreaming up difficult menus that end up being stressful, rely on your instincts and your established skills to be creative. Many of the recipes contained in this book can be reinterpreted and used in various ways. The planning and preparation should be just as fun as the party itself, so enjoy a glass of wine while researching recipes and making your preparation notes.

Learning fundamental cooking skills is not only a hallmark of home economics; it's also an investment in yourself. Knowing a basic life skill for survival is irreplaceable. Even though we exist in a world full of conveniences, they should supplement our skills rather than replace them. I ascribe to the notion that cooking for a party should largely be done from scratch. The nurturing that goes into preparing delicious food for company far outweighs store-bought food that is mass-produced. Prepared foods that are purchased for a party should supplement your menu rather than replace it.

Whether you're planning for platters full of hors d'oeuvres or inviting friends to a candlelit supper, your menu should be rich with texture, flavor, and variety. Food allergies should be a consideration of every host, and there are simple ways to plan so that everyone at your party can be accommodated. For large cocktail parties, I try to construct a menu with hearty vegetarian dishes alongside dishes that have meat, poultry, or seafood. Be knowledgeable about the ingredients in every one of your dishes in the event a guest alerts you to a medical sensitivity. Be extra prepared for the rare occasion that you haven't been alerted in advance by having some extra fresh ingredients in your refrigerator so you can quickly pull something together.

An integral part of planning a menu is understanding the amount of preparation it will require before and during the party. Proper time management would minimize your time in the kitchen while your guests linger in another room. Choose recipes that can be made ahead and that only require last-minute finishes or assembly at the time

of service. Entertaining is not like making dinner for your family. Making a sauce at the last minute or dressing a salad is acceptable during a party, but if you're pan-searing a bunch of meat to be perfectly medium-rare, your guests will be wondering where you've gone. The added pressure it imposes on you is not worth it. Have the food be simple, but the experience extraordinary. When I choose recipes for a party, I ask myself the following questions: Do the dishes complement one another? Is the mise en place (preparation) relatively easy? Is the cooking process easy? Will the dish hold its texture and moisture until it is served? Is the dish, and its ingredients, recognizable to my guests? Will it present beautifully on a dish or platter?

The more you can plan ahead, the smoother your event will go. With each recipe, make a sheet of notes to reference during your party. List the cooking temperature, duration, how it gets served, the portion size, the type of garnish or sauce that accompanies it, and the utensils to put with it. You'd be surprised how much hustle and bustle happens when it comes time to serve, which could lead to a host feeling unprepared and flustered. Being able to quickly glance at notes will help to assure that you have a handle on things. If you have help in the kitchen, they can refer to your notes for instructions rather than guessing. When I have recipes that need to be finished at the last minute, I will have the ingredients measured and prepared on a baking sheet lined with parchment paper and my page of notes on the same tray. Each recipe would have a dedicated tray to keep me organized and focused on the task at hand. If I must quickly reposition where I'm working, I need only to pick up one tray full of ingredients rather than shuffling bowls one at a time, risking confusion or mistakes.

Most importantly, the recipes I choose allow me to prep everything one or two days in advance so that all I will need to give my attention to on the day of my party is cooking the food and finishing last-minute details. Even the simplest tasks are sometimes overlooked, and this unexpectedly becomes time wasted on the day of the event. For instance, say you're serving a big salad for ten: you might not think that pulling apart the lettuce and washing it would take up too much time on the day of your party, but consider how much time would be saved if you had done it the day before so that all you had to do was take it out of the fridge, tear it, and toss it with dressing. Planning these details ahead of time will allow you to find ways to lessen the work needed on the day of the party, which is indispensable for your sanity.

How does one calculate how much food to buy? Let's say you're cooking stuffed pork loin for eight: How many loins should you purchase? It's a common question, and you shouldn't feel defeated if it confuses you. These calculations are necessary when creating a budget as well as when shopping for ingredients. Portion sizes would be based on the menu as a whole. Serving a sliced roast à la carte would require a larger portion than when offering a vegetable and a starch alongside it. Alternatively, a buffet table with many dishes to choose from can accommodate

smaller portions per person. Most recommended portion sizes in a recipe are stated in ounces. Whether by weight or by volume, it's just a matter of mathematics when you learn to convert ounces to pounds or cups. This will be essential when endeavoring to create a shopping list. When in doubt, plan for the higher end of a portion size.

Generally, dishes that are served family-style should be padded by a couple of ounces per dish per person because you don't have control over how much each guest will take. In contrast, seated dinners and passed hors d'oeuvre portions can be calculated with a bit more precision. I make it a rule, however, to have an additional serving or two prepared in the event of an accident or in case an unexpected guest joins at the last minute. As with any situation during a party, if you've prepared properly, being able to think on your feet will be much easier.

# — PLANNING FOR HORS D'OEUVRES —

An Evening of Hors d'oeuvres and Cocktails Only
Plan for a variety of 6–8, calculated at 1.5–2 pieces of each per person.

❦

Hors d'oeuvres with Cocktails and Tabled Appetizers
Consider a variety of 5–6 hors d'oeuvres, calculated at 1.5 pieces of each per person

and

2 oz. per person for dips with crackers or bread

and

a variety of 2–3 tabled finger foods, calculated at 1–2 pieces of each per person

❦

Hors d'oeuvres with Cocktails and Dinner
Plan for 2–3 types, calculated at 1–1.5 pieces of each per person.

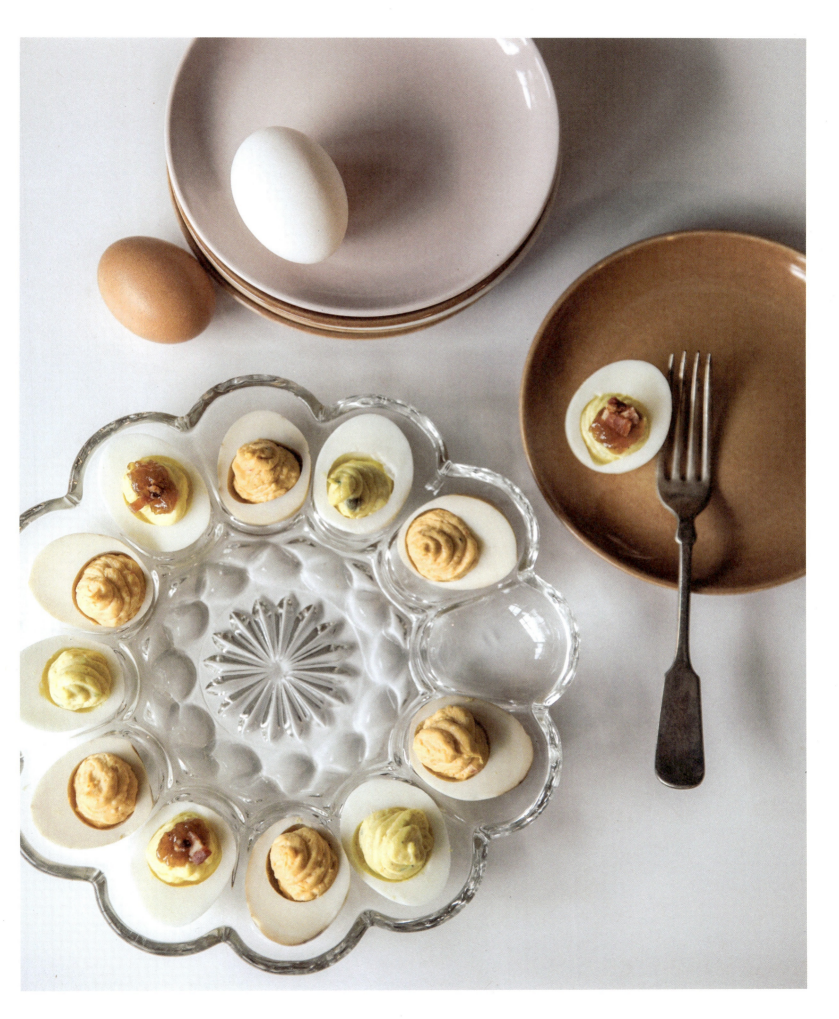

# — COCKTAILS AND CHARCUTERIE —

**4–20 people:**

- 2–4 types of cheese, 2 oz per person for each variety
- A variety of 1–2 types of cured meat 2–3 oz. per person per type
- A variety of additions below

**20+ people:**

- 4–6 types of cheese, 2 oz per person for each variety
  (Choose a balance of hard, soft, semisoft, salty, nutty, and buttery)
- A variety of 2–3 types of cured meat, 3–4 oz. per person per type
  (salami, speck, coppa, finocchiona, prosciutto, saucisson, lomo)
- A variety of additions below

My favorite additions to a charcuterie display include:

- a mixture of olives
- roasted artichokes
- high-quality crackers
- French baguette
- dates
- fig jam and fine Dijon mustard
- kettle-cooked potato chips
- one or two prepared salads, such as chicken salad or farro salad
- petite kosher dill pickles
- pickled vegetables
- Italian breadsticks
- pâté
- one type of fresh fruit (grapes, strawberries, oranges, melon, or figs)
- roasted or prepared nuts
- Marcona almonds
- tapenade or caponata

# — LUNCH, DINNER, AND BUFFET PORTION SIZES —

| Food Item | Lunch Portion | Dinner Portion | Buffet Portion |
|---|---|---|---|
| • beef, lamb, pork, veal | | | |
| (whole or ground, boneless) | 4–6 oz | 8 oz | 6 oz |
| (whole with bone) | 8–10 oz | 12–14 oz | 10–12 oz |
| • poultry and game | | | |
| (whole or ground, boneless) | 4–6 oz | 8 oz | 6 oz |
| (whole or pieces with bone) | 8–10 oz | 12 oz | 10 oz |
| • fish and seafood | 6 oz | 8 oz | 5 oz |
| • sauces | ½–1 oz | 1–1 ½ oz | ½–1 oz |
| • pasta | 1 lb/5 people | 1 lb/4 people | 1 lb/6–8 people |
| • rice or starch, cooked | 2 oz | 3–4 oz | 3 oz |
| • vegetables or side dish | 3 oz | 4 oz | 2–3 oz |

# — THE PERFECT DINNER PARTY —

A modern format for a seated dinner that I've found successful and enjoyable is serving a three-to-four-course dinner that starts with an amuse-bouche preset on the table. Whether it's a small dish at each place setting or several small platters around the table, presenting small bites (such as olives, roasted nuts, or crostini) kicks off a stylish evening in the warm glow of flickering candlelight that's dancing to ambient music. As your guests settle in and wine is poured, they can nibble on these delicacies while you're plating the first course.

## AMUSE-BOUCHE

small bites that whet the appetite
sometimes served with a taste of champagne

## STARTER COURSE

soup, salad, or a small dish of pasta

## MAIN COURSE

the star of the evening
it's stylish to choose either a starch or a vegetable for presentation on a dish

## DESSERT COURSE

if baking is your thing, then do it up
otherwise, keep the dessert simple and delicious

---

### Optional Courses

adding either of these two courses to your dinner party
requires little preparation, but makes a big impact

#### *Intermezzo*

a small tasting of citrus sorbet
served before the main course as a palate cleanser

#### *Cheese Course*

a small sampling of exceptional-quality cheese served with a crostini
usually served just before dessert

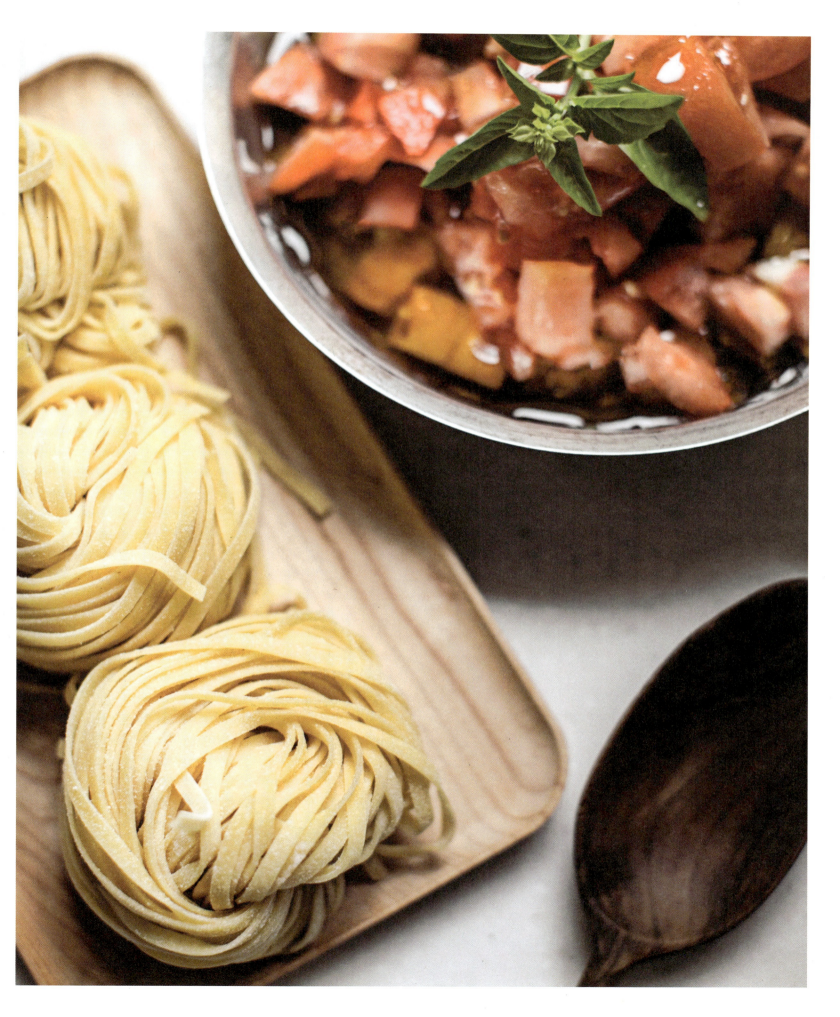

## CRASH COURSE IN COOKING

Now that you've settled on a menu for your party and determined the appropriate serving sizes, I want to give you some basic information and suggestions that will make a marked difference in your cooking. This is by no means an exhaustive lesson in cooking; rather, these are some handy tips and practices that you can use to further develop your skills in the kitchen.

## FOUR MUST-HAVE KNIVES FOR EVERY KITCHEN

- 8" or 10" chef's knife—ideal for heavy chopping
- 4" paring knife—ideal for finer tasks, such as peeling fruits and vegetables
- 8" boning knife—ideal for slicing fat from meats, carving out bones, and fileting meat
- Serrated knife—ideal for slicing through delicate items like bread or tomatoes

Invest in good-quality knives. A knife should feel good in your hand with a balanced weight between the handle and the blade—ideally with a full tang (a blade which is a single piece of metal that also extends into the handle). In addition to good-quality knives, have a honing steel and a sharpening stone. Sharpening your knives before each use will make food preparation safer and easier.

## FIVE BASIC TYPES OF CUTS

- dice: *small dice:* ¼" x ¼"; *medium dice:* ½" x ½"; *large dice:* ¾" x ¾" (cut uniformly)
- mince: a very small, nonuniform chop that leaves the ingredient in tiny little pieces
- julienne: thin strips precisely sliced into ⅛" x ⅛" thickness and 2"–3" long
- chiffonade: a leaf that has been tightly rolled like a straw and then very thinly sliced into strips
- bâtonnet: same as julienne but larger (½" x ½" thickness and 3" long)

## MIREPOIX

A mixture of diced vegetables sautéed (without browning) in fat to create a base flavoring for dishes. It typically consists of 2 parts onion, 1 part celery, and 1 part carrots.

## BOUQUET GARNI

A bundle of herbs tied together and used to flavor soups, stews, stocks, and roasts. Typically made with a bay leaf, thyme, sage, and/or parsley. Some dishes benefit from the addition of citrus rind. The bouquet is removed and discarded at the end of cooking.

## SEASONINGS

From salt to spices, seasonings enhance the flavor of a dish and should be used moderately so as not to overpower the natural flavors of a dish. Consider using them in their most singular form rather than buying spice mixes or seasoning blends. Many pre-made seasoning blends contain salt and preservatives. Most herb blends contain the same herbs you likely already have in your possession.

### SALT

Arguably the most important seasoning of all. Food in its simplest form doesn't need the addition of flavorings if a proper amount of salt is used. Whether used during the cooking or baking process or added before serving, salt is a flavor developer. If there's one seasoning you should master, it's salt. I keep three different kinds of salt in my kitchen. Kosher salt for cooking, fine sea salt for baking, and Maldon salt for finishing a dish. I rarely, if ever, use iodized table

salt. Usually, recipes don't use enough salt, but err on the side of caution; start with listed measurements and add more as needed (except for baking recipes). Adding salt in small amounts requires patience, but it is essential in achieving proper flavoring. Too much salt will quickly ruin a dish, whereas too little will leave a dish tasting flat and disappointing. Just remember: you can always add more, but you can't take it away. Salt, unlike water, does not evaporate. Caution should be exercised when adding salt to dishes that require long cooking times where the liquid will evaporate.

## Salt before cooking

- Seasoning meats before cooking with kosher salt will draw proteins and juices out to the surface, so they can caramelize during cooking to create a delicious crust. Usually, ½ to ¾ teaspoon is used to season an 8-ounce piece of raw meat. As you become comfortable using salt, gauge the amount by pinches, rather than measurements. It can be used on any type of raw meat (except for fish) about two hours before cooking. Fish should only be salted at the time of cooking. Anytime I make a mixture of ground meat, I season the mixture with salt little by little until I can taste all the flavors in the mixture. (Note: any meat that has been smoked or cured, such as ham, has already been salted and therefore does not need additional salt.)

## Salt during cooking

- Whether boiling, blanching, or flavoring a sauce, salt will be used at different times during the cooking of a recipe.
- Salting water for boiling or blanching vegetables brings out their natural flavor. It speeds up the cooking process without breaking down their fibers. Be cautious, however: water evaporates but salt does not. If you expect any evaporation, cut back on the salt to compensate. Ideally, the water should taste like weak seawater.
- Salt permeates the starch of pasta and potatoes and develops their flavor. It also reduces the amount of starch they release. The water should taste well-salted, like mild seawater, before adding pasta.
- Grains (such as rice) only need a couple of pinches of salt for each cup of dry grain. As the water evaporates, the salt concentrates; don't overdo it.
- Salt also helps to deepen the flavor of last-minute sauces, especially those that are thickened with flour or cornstarch. This is done to taste, so add a pinch at a time while constantly tasting. You'll taste the flavors slowly intensify as you add more. If you think something tastes perfectly salted but you're unsure if it needs more, stop at that moment and let your palette rest. Come back to it and taste before adding that last pinch—chances are you won't need it.
- Again, it should be used very judiciously for anything that will cook for long periods and reduce in volume, such as soups, stocks, and stews. As the liquid evaporates, the salt concentrates and intensifies. It's best to add a small amount of salt for cooking and then finish with more at the end for flavoring. Something that's been overly salted will be "stinging" to the tongue.

## Salt after cooking

- When a dish is fully cooked, a final addition of salt can make the flavors pop—add in small increments and constantly taste until the desired flavor is achieved. Maldon salt is a wonderful finishing salt, and a final pinch over food just before serving will prolong the flavors of the dish on the palette.

### Salt for baking

- Iodized salt is commonly used for baking, but I prefer fine sea salt. Its pureness will help to intensify the sweetness and depth of flavor in baked goods when used properly.
- Caramel and chocolate are greatly enhanced by salt.
- Maldon salt is commonly used for sprinkling on baked items—like chocolate chip cookies, just as they are fresh out of the oven and still piping hot. Again, a little pinch goes a long way.

### PEPPER

Rather than a flavor enhancer, the way salt is, pepper is a spice. Peppercorn is commonly available in black, white, pink, or green. Each variety has a unique and wonderful flavor to it, though white and black are most common in recipes. Peppercorns that are freshly cracked from a grinder have more freshness and flavor than pepper that has been commercially ground. Black pepper develops a depth of flavor in a dish by adding a sharp, woody aroma with a complimentary warm, piney, sometimes spicy flavor. White pepper in contrast is less complex and is preferred when making potato dishes and cream-based sauces or soups.

### HERBS AND SPICES

- Use fresh herbs as often as possible, especially when preparing a dish that doesn't require cooking and for cold salads. Dried herbs are reserved for dishes that will be cooked down. The cooking process will render the flavor from the herb. Most recipes stipulate whether to use fresh or dried herbs. If you're unsure, opt for fresh whenever possible. If you must substitute a dried herb for fresh in a recipe, you'll want to reduce the amount by half. Dried herbs are more concentrated than fresh and are therefore stronger. Herbs commonly found in cooking are parsley, sage, rosemary, thyme, dill, oregano, tarragon, mint, basil, and bay leaves.
- Spices can be purchased whole or already ground. For the freshest flavor, grind your spices as needed. Buy ground spices in small quantities for optimum freshness. While spices are commonly found in most baking recipes, it is not unusual for them to be used in savory preparations, especially cream-based sauces. The most commonly used spices are allspice, cardamom, cayenne, cinnamon, clove, cumin, curry, ginger, turmeric, nutmeg, paprika, and saffron.

### GARLIC

Garlic is a vegetable, but it is used for flavoring food. Raw garlic has a bite and lingers unpleasantly. Cooking garlic sweetens and mellows it. Use raw garlic sparingly and mash it rather than chopping it. For cold dishes or salads, temper the bitter sting of raw garlic by blanching a whole clove in boiling water for a minute before grinding it into a paste. Sautéing garlic will extract its sweet flavor and should be done so on moderate heat to keep it from burning and turning bitter.

## PREPARING MEAT

It's crucial to bring raw meat to room temperature before cooking it. Doing so will help it retain its moisture and cook evenly and more quickly. Often meat (especially turkey) becomes dry and tough because it hasn't fully come to room temperature before cooking. Even ground meats should come to room temperature within an hour of cooking. Thick cuts of meats such as pork chops, steaks, or chicken breasts will usually require about one to two hours to come to room temp. Larger portions—roasts and whole birds—can take two to three hours until they've come to room temp. A large turkey that wasn't previously

frozen should sit out of the fridge for about four hours, depending on its size. A frozen turkey should be thawed in a refrigerator for two days before bringing it to room temp. Fish only takes anywhere from thirty minutes to one hour, depending upon its thickness.

Thoroughly dry the meat before seasoning. Applying salt to dry meat will extract its natural juices for a wonderful sear.

Ideal internal temperatures for the best-tasting meat:

- **whole poultry:** 160 degrees
- **ground poultry:** 165 degrees
- **whole beef:** 140–145 degrees
- **ground beef:** 160 degrees
- **whole pork:** 140–145 degrees
- **ground pork:** 160 degrees
- **whole lamb:** 140–145 degrees
- **ground lamb:** 160 degrees
- **fish:** 145 degrees or until flesh is opaque, firm, and separates easily when pressing on it

For shrimp, lobster, crab, and scallops: Cook until the flesh is pearly white, firm, and opaque. For clams, oysters, and mussels: They're done when the shells open.

Allow any meat to rest after cooking—never carve it right away. Doing so allows the juices to redistribute and reabsorb back into the meat, rather than bleeding out. For burgers, meat loaves, steaks, chicken breast, chicken thighs, and pork chops, allow the meat to rest a minimum of five to ten minutes. For larger roasts like a leg of lamb, whole chicken, rump roast, pork loin, or pork butt, allow a minimum of fifteen minutes. Large turkeys should sit tented for a good twenty to thirty minutes. Don't cover the meat while it's resting—loosely tent it with foil to keep it warm while allowing any steam to escape.

When the meat is finally ready to serve, always cut across its natural grain for the most tender results.

## COOKING METHODS

**Searing:** Mostly done with meat, poultry, fish, and some seafood. It creates a depth of flavor by using very high heat—in a flat pan with low sides—to quickly caramelize the protein to a deep brown, crisp texture without entirely cooking the food. First, always make sure your hood fan is turned on high. The meat should be dried and then seasoned. A small amount of fat (about 1 tablespoon) that can withstand high heat (safflower oil or avocado oil) should be used. Just at the point the oil starts to shimmer, glisten, and spread out, lay the meat facedown, and do not touch it until the surface is a nice deep brown. Resist the temptation to push on it or move it around the pan. Take caution not to let the oil get so hot that it smokes. If it does, it's best to discard that oil in a metal bowl set on a heat-proof pad and start over again. Do not overcrowd the pan when searing several pieces of meat. Allow air to circulate between the pieces; otherwise, you'll end up steaming them. It's best to sear in small batches. Adding several pieces at once will cool a pan down slightly, so adjust the heat to keep it consistently hot.

**Sautéing:** Food that's cooked with dry heat in a pan using just a small amount of fat such as butter or olive oil while consistently tossing it. When sautéing vegetables, your objective is to "sweat" the vegetables to develop their flavors while maintaining their texture. Use a pan that's slightly bigger than you will need. Adding too many vegetables at once can create excess liquid in the pan, causing the ingredients to simmer rather than sweat. Keep your pan hot enough the entire time for the cooking to be active and brisk but not so hot that your food will caramelize.

**Braising:** A combined cooking method using both dry and wet heat that's typically used with whole cuts of meat or poultry. The meat is first seared at very high heat until properly caramelized. The temperature is reduced, and a liquid is

added to the same pot (along with vegetables and flavorings) to cover about ⅔ of the meat. Once it comes to a slow boil, the heat is reduced, and the pot is covered and kept to simmer at a low temperature. If stovetop space is needed for other preparations, braising can be finished in a 275-to-300-degree oven (as long as the pot does not have plastic handles).

**Blanching:** A process of submerging vegetables in rapidly boiling water for a very short period and then plunging them into ice water to stop their cooking. This process helps preserve their bright color, crispness, and flavor.

**Simmering:** A gentle technique in which food is cooked in liquid that's kept just below a boil. The liquid should first be brought to a slow boil, then lowered to a very slight bubble in the middle of the pot and left to cook for a long period so the flavors develop, and proteins tenderize.

**Deglazing:** Adding a liquid—usually wine, acid, or stock—to a very hot pot to reconstitute the caramelization of meats or vegetables left on the bottom. Be sure your hood fan is set to high before starting. Scrape the bottom of the pot while the liquid reduces and allow any potential alcohol to burn off. The reduced liquid creates a "fond"—a base that will enrich the flavor of the dish or sauce being made.

## FRESH STOCK

Stock is used as a cooking liquid and is the foundation for creating exceptional sauces. One that's properly made has a gelatinous quality that produces thicker, richer stews and sauces. Most store-bought "stock," while OK, is more like a broth. It lacks the gelatinous consistency that stock does. Making stock is time-consuming but highly rewarding. If you can't make your own, look for a good-quality bone broth in your grocer's refrigerated or freezer section. While these tend to be heavier in flavor, they contain the gelatin necessary for making a good dish. A great way to save stock is to freeze it in ice cube trays; the cubes can then be emptied into freezer bags, ready to be used at a moment's notice. I especially like the silicone molds used to make large cocktail ice cubes.

## ACID

Acid can bring a mouthful of fresh flavor to a dish. Sometimes it's added during the cooking process and other times it'll be added at the end of cooking to intensify the flavor. Typical acids used during cooking or for flavoring are lemon juice, lime juice, vinegar, and wine. But acids also have other beneficial uses. Vinegar or lemon juice hampers the oxidation of some sliced fruits and avocados. It can tenderize meat and keep fish and seafood firm during cooking. When whipping cream for a dessert, a few drops of lemon juice will give the final whipped cream more body. Stiff egg whites for a soufflé or meringue benefit from rubbing a few drops of white vinegar on the inside of your mixing bowl before whipping. Also, a few drops of lemon juice or white vinegar will help to soften the gluten when working with pastry dough.

These tips and techniques are great tools to have in your arsenal of cooking skills, and all of them will help you build a delightful menu. But perhaps the most important practice of all when it comes to hosting a dinner party is preplanning. Once I have settled on what I'm going to serve, I prepare anything on the menu that will keep well in advance—such as condiments, salad dressings, spice mixes, and croutons. I also make things that I can put in the freezer—like dough, stock, and pesto—so they'll be ready for me when I need them.

The following recipes in this chapter are commonly used in my kitchen as I prepare for a party. They will help you in the preparation of many of the other dishes found in the recipes section as well.

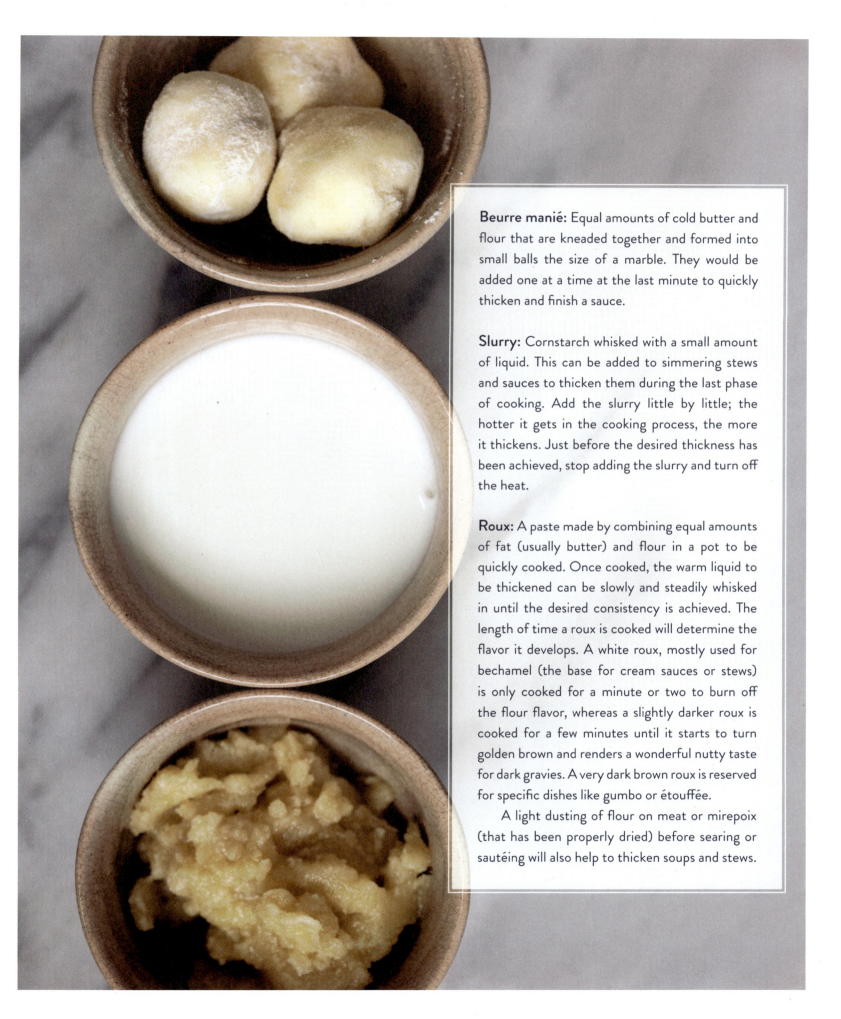

**Beurre manié:** Equal amounts of cold butter and flour that are kneaded together and formed into small balls the size of a marble. They would be added one at a time at the last minute to quickly thicken and finish a sauce.

**Slurry:** Cornstarch whisked with a small amount of liquid. This can be added to simmering stews and sauces to thicken them during the last phase of cooking. Add the slurry little by little; the hotter it gets in the cooking process, the more it thickens. Just before the desired thickness has been achieved, stop adding the slurry and turn off the heat.

**Roux:** A paste made by combining equal amounts of fat (usually butter) and flour in a pot to be quickly cooked. Once cooked, the warm liquid to be thickened can be slowly and steadily whisked in until the desired consistency is achieved. The length of time a roux is cooked will determine the flavor it develops. A white roux, mostly used for bechamel (the base for cream sauces or stews) is only cooked for a minute or two to burn off the flour flavor, whereas a slightly darker roux is cooked for a few minutes until it starts to turn golden brown and renders a wonderful nutty taste for dark gravies. A very dark brown roux is reserved for specific dishes like gumbo or étouffée.

A light dusting of flour on meat or mirepoix (that has been properly dried) before searing or sautéing will also help to thicken soups and stews.

# — A BAKER'S DOZEN, PLUS A FEW MORE —

## *Helpful Tips for Baking*

- Work with eggs, dairy, and liquid ingredients at room temperature when making batters or for recipes that require creaming ingredients together.

- Work with very cold ingredients when making doughs, such as pie crusts, scones, and biscuits.

- Be exact when measuring ingredients. Do not eyeball it—even for additions such as chocolate chips or blueberries. Adding more than called for in a recipe could create too much fat or liquid, and your goods will not bake as intended.

- Use only pure extracts. Be aware that they do contain alcohol, which aids in extracting their flavor when they're made. It's best to add extracts toward the end of a recipe or cooking process. Heat will burn off the alcohol, thereby causing some amount of flavor loss to the recipe.

- Anytime a dough becomes noncompliant— meaning it snaps back, will not hold its shape, or starts to look stringy—don't overwork it. Allow it to rest, covered in the refrigerator, for 15–20 minutes.

- Ovens should be well preheated. Usually, when an oven is preheating, it does not automatically stop at the desired temperature. It usually heats beyond it, turns off, and then adjusts itself to the proper temperature. Keep a temperature gauge in your oven to ensure a proper and consistent temperature.

- Baking pans—like cake pans or pie dishes— should not be placed on cookie sheets in the oven. If you think something risks overflowing, place the cookie sheet on the rack below to catch incidental spillovers. For an even bake, air needs to circulate under the pans.

- Baking is not a set-it-and-forget-it experience. How something reacts in an oven depends upon its temperature fluctuations, what rack it is placed on, if it's towards the front or back of the oven, what the humidity is like, the age and quality of the oven, etc. Always start baking at the stated temperature on a recipe, but be mindful through the process; if something is cooking too quickly around the edges, adjust the temperature down a few degrees (5 to 10 degrees usually helps) to slow it down so it bakes evenly. Baking takes constant participation, especially when things are in the oven.

- Follow the procedure in a recipe exactly. If a recipe requires creaming ingredients for several minutes, there is a reason for it. Likewise, follow the order in which ingredients are added. Something as seemingly insignificant as adding sour cream to a cheesecake batter last can make all the difference: If it was added at the

beginning, it would suffer from overbeating, which would produce a spongy cake.

- Consider spending the extra money to use European butter—especially when making pastry doughs. Most contain a higher percentage of butterfat and less water content than cheaper American varieties.

- Allow freshly baked items to cool and properly set before removing them from their pans.

- Have your ingredients premeasured in bowls before working through a recipe.

- Use a small ice cream scooper or a baking scale when portioning out cookie dough to achieve uniform cookies every time.

- Set your timer five to ten minutes before the recommended time in a recipe. You can always add more time, but you can't ever subtract it.

- Darker baking pans absorb heat and cook faster than lighter ones. When you're using dark pans, adjust your oven temperature down by 10 degrees after 10 minutes.

- Use dry measuring cups for dry ingredients and wet measuring cups for wet ingredients; do not interchange them.

- Learn the difference between ounces and fluid ounces: Ounces are measured by weight, whereas fluid ounces are measured by volume. Dry ingredients are only measured by weight (ounces). They have different weights by volume: 8 ounces of flour in a recipe is not equivalent to 1 measuring cup, just as 8 ounces of sugar would not fill the same measuring cup to the same level. If a recipe lists dry ingredients in ounces, they need to be weighed, not measured. If a recipe lists dry ingredients in cups, then use dry measuring cups. Liquid, however, has the same weight per volume; therefore, 8 fluid ounces of water would have the same weight as 8 fluid ounces of milk. That's why liquid ingredients can be measured in a liquid measuring cup.

# CHICKEN STOCK

A good stock is the foundation of all cooking, from soups to sauces. While they take a little bit of time to make, the results far exceed anything that can be store-bought. Traditionally, the ingredients used in making a stock come from the trimmings and discarded pieces that are leftover from the prior week's cooking. This recipe is for a 7-quart stockpot.

1 whole chicken
1 shallot, including skin
1 onion, including skin
2 carrots, washed
2 stalks of celery, washed

Green tops of 1 leek
6 cloves garlic, skin on
2 bay leaves
A small handful of parsley
A small handful of thyme

Remove the meat and skin from the chicken and reserve them for another use. Add the carcass to a 7-quart stockpot. Chop the onion, carrots, shallot, leek, and celery into ½" chunks and add to the pot along with the other ingredients. Fill the pot within one inch from the top with tepid water. Set it on the stove on medium heat until the pot starts to come to a very mild simmer. Keep the heat so that a light simmer is maintained. You should only see a few bubbles bubbling up. Adjust the pot on the burner as needed to regulate the heat. Allow it to simmer uncovered for five to six hours. During the first 20 minutes, skim any white impurities from the top regularly.

In a sink, place a medium-sized bowl into a larger bowl filled with ice. Strain the stock into the bowl in the water bath via a colander lined with a paper towel or cheesecloth. Using the back of a spoon, push out as much stock liquid as possible. Discard the contents of the colander. When the stock has cooled, cover and refrigerate overnight to allow the fat to rise to the top and solidify. Scrape off the fat and discard. The stock can stay refrigerated for five days or frozen for future use.

# BEEF STOCK

The key to a hearty beef stock is to achieve a good caramelization of the bones before simmering. I prefer to use marrow bones, however, any type of beef bones from a butcher will work. This recipe is for a 7-quart stockpot.

2 pounds of beef marrow bones
1 shallot, including skin
1 onion, including skin
2 carrots, washed
2 stalks of celery, washed
Green tops of 1 leek
6 cloves garlic, skin on

2 bay leaves
A small handful of parsley
A small handful of thyme
5 tablespoons tomato paste
1 tablespoon black peppercorns
1 cup dry red wine

Chop the onion, carrots, shallot, leek, and celery into 1" chunks and set aside. In a preheated 400-degree oven, roast the marrow bones for 30 minutes. Flip the bones and add the onion, shallot, and carrots. Smear the tomato paste on top of the bones. Roast for an additional 30 to 40 minutes until the bones and tomato paste are caramelized. Remove from the oven. Transfer the bones and vegetables to a 7-quart stockpot. Set the roasting pan onto the stovetop on medium-high heat and deglaze the pan with the red wine, constantly scraping the bottom to release any caramelized pieces. Allow the wine to reduce by half. Transfer that to the stockpot and add the rest of the ingredients. Fill the pot within one inch from the top with tepid tap water.

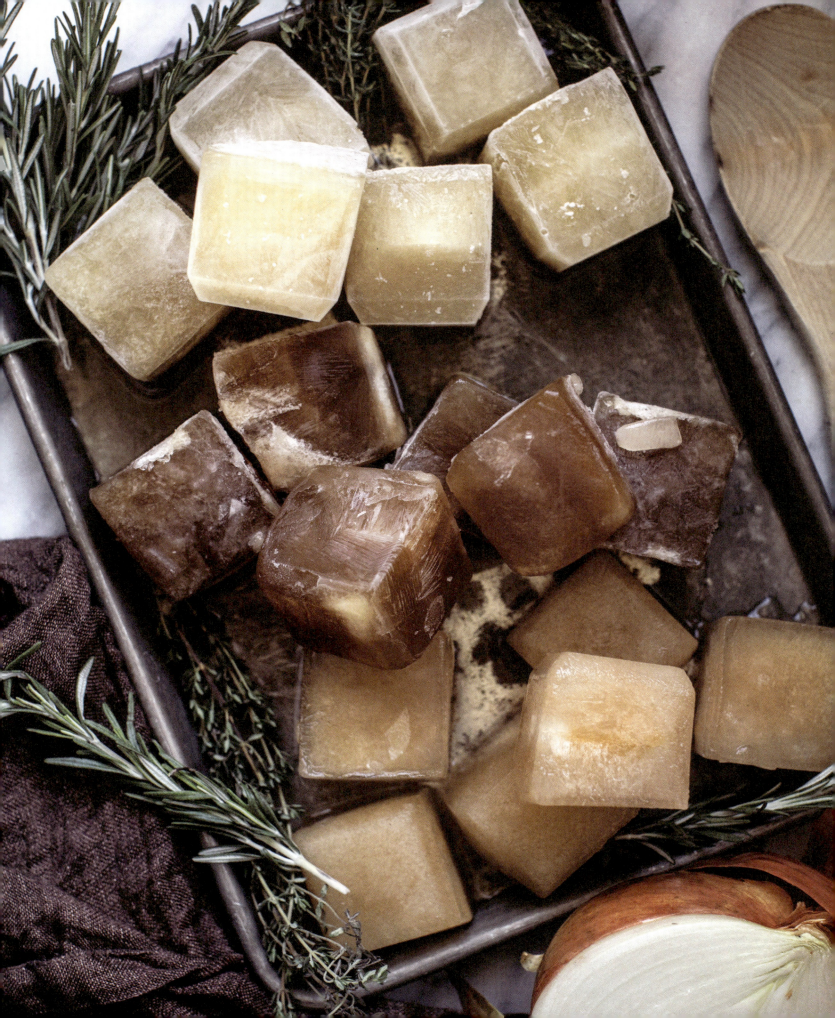

Set the pot on the stove on medium heat until it comes to a very mild simmer. Reduce the heat to maintain a light simmer. You should only see a few bubbles bubbling up. Adjust the pot on the burner as needed to regulate the heat. Simmer for seven to eight hours uncovered. For the first 20 minutes, skim any impurities from the top regularly.

In a sink, place a medium-sized bowl into a larger bowl filled with ice. Strain the stock into the bowl in the water bath via a colander lined with a paper towel or cheesecloth. Using the back of a spoon, push out as much stock liquid as possible. Discard the contents of the colander. When the stock has cooled, cover and refrigerate overnight to allow the fat to rise to the top and solidify. Scrape off the fat and discard. Refrigerate your stock to use within five days or freeze for future use.

## VEGETABLE STOCK

Vegetable stock is a great way to use up all leftover vegetable trimmings and discarded pieces during the previous week's cooking. It is versatile enough to be used in almost any dish in place of water for extra flavoring. This recipe is for a 6-quart stockpot.

| | |
|---|---|
| 1 shallot, including skin | 6–8 white mushrooms |
| 2 onions, including skin | 4 cloves garlic, skin on |
| 3 carrots, washed | 1 bay leaf |
| 3 stalks of celery, washed | A small handful of parsley |
| Green tops to 1 leek | A small handful of thyme |

Chop the shallot, onions, celery, leeks, mushrooms, and carrots into small to medium dice and add to a 6-quart pot, along with the rest of the ingredients. Fill the pot within one inch of the top with tepid tap water.

Set the pot on the stove on medium heat until it starts to simmer. Reduce the heat to maintain a light simmer. You should only see a few bubbles bubbling up. Adjust the pot on the burner as needed to regulate the heat. Simmer for 3–4 hours uncovered.

In a sink, place a medium-sized bowl into a larger bowl filled with ice. Strain the stock into the bowl in the water bath via a colander lined with a paper towel or cheesecloth. Using the back of a spoon push out as much stock liquid as possible. Discard the contents of the colander. When the stock is cooled, refrigerate to use within five days or freeze for future use.

**TIP:** Use the skins of your vegetables for a darker, richer stock.

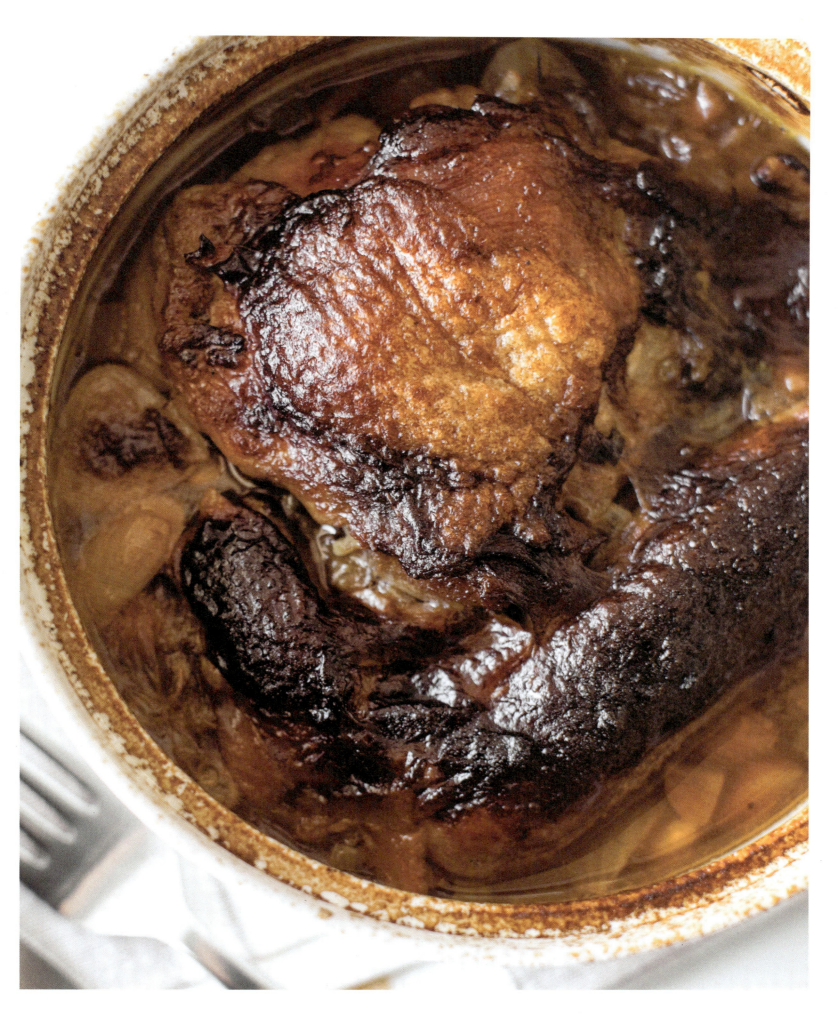

# ARTICHOKE PESTO

*Makes 4½ cups of pesto*

Aside from being a wonderful condiment, the fresh, bright flavors in pesto make it such a wonderful base for flavoring so many dishes that I keep some stocked in my freezer to use when needed. The basic construction of pesto combines the main ingredient (most commonly an herb) with parmesan cheese, garlic, oil, and nuts. While pesto is commonly made with a fresh herb like basil or parsley, it can also be made with other ingredients such as artichokes, roasted red peppers, arugula, or sun-dried tomatoes. Pesto of any variety adds wonderful flavor to stuffing, soups, stews, salad dressings, and sauces. It can even be made into a wonderful compound butter for steaks or grilled fish. My favorite and most used is Artichoke Pesto. It is so versatile that I use it in many of my entertaining recipes from Warm Artichoke Dip to Artichoke Hush Puppies.

2 14-ounce cans of artichoke quarters
1 bunch parsley, stems removed
¾ cup walnuts
½ cup grated parmesan cheese
5 garlic cloves, smashed

½ teaspoon salt
¼ teaspoon pepper
¾ cup olive oil
2 tablespoons lemon juice

Drain and rinse the artichokes. Squeeze out any excess water. Wash the parsley and pat dry. In the bowl of a food processor, add the artichokes, walnuts, garlic, and parmesan cheese. Pulse to chop all the ingredients. Remove the lid and add the parsley, salt, pepper, lemon juice, and olive oil. Process on high speed for about 45 seconds until a smooth-ish paste is formed. If the pesto is a little too stiff, additional olive oil can be added 1 tablespoon at a time. Store refrigerated in an airtight container. It can also be frozen for up to one month.

# ARUGULA-PARSLEY PESTO

*Makes 2½ cups*

This bright green pesto has a nutty, peppery taste. Even though it is wonderful as a pesto, it makes a flavorful base for a flavored mayonnaise or a bright, herby addition to a salad dressing.

1 cup parsley leaves, washed
2 packed cups of baby arugula
4 cloves garlic
½ cup parmesan cheese
½ teaspoon pepper
½ cup olive oil
½ cup walnuts, toasted
1 lemon

**TIP:** Add 4 tablespoons of this pesto to ⅓ cup of mayonnaise for a wonderful condiment to a burger or sandwich.

Squeeze the juice from the lemon and set it aside. In the bowl of a food processor, combine the ingredients along with the lemon juice and process until smooth and fully combined, about 2 minutes. Store refrigerated in a sealed container for up to five days. This pesto can also be frozen in ice cube trays for up to one month.

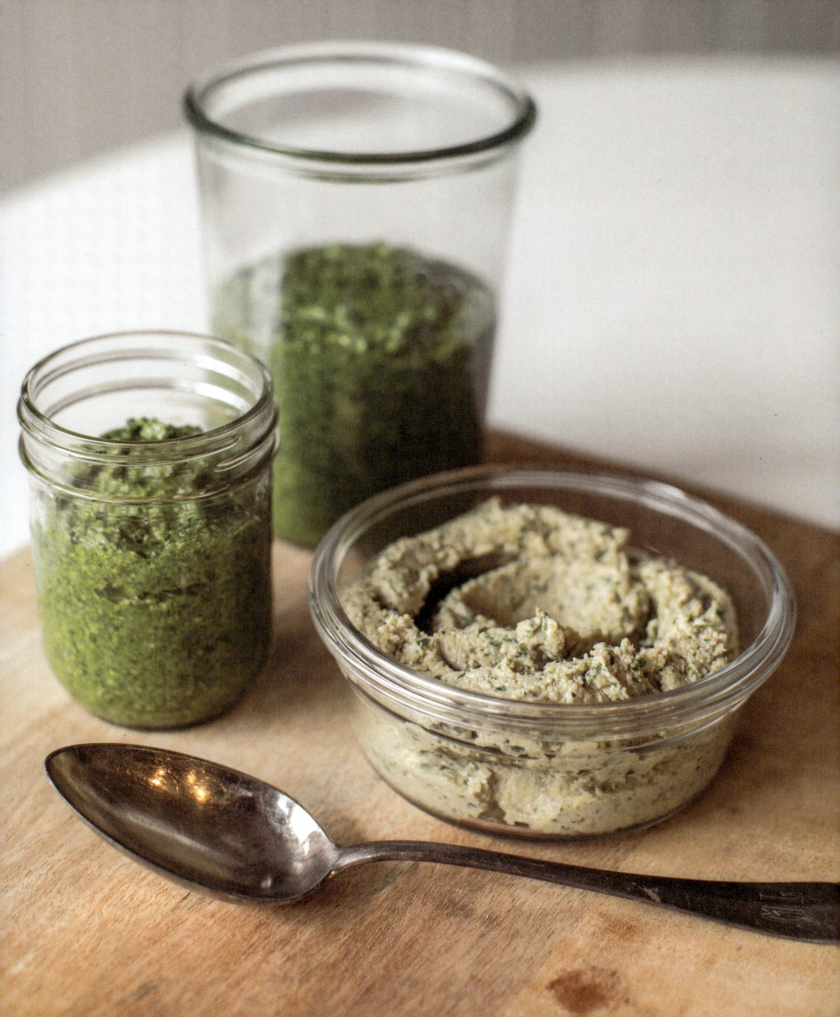

# BASIL PESTO

*Makes 2½ cups*

The success of this pesto comes from the pungent, peppery flavor of basil which is tempered by the salty richness of the cheese, and it blends perfectly with the grassiness of a hearty olive oil. Whether tossed with fresh tomatoes, al dente pasta, or simply used as a dip for crusty bread, it's the perfect way to take advantage of a summer's fragrant bounty.

  3 cups packed basil leaves, washed
  4 cloves garlic
  ½ cup parmesan cheese
  ½ teaspoon pepper
  ½ cup olive oil
  ½ cup pinenuts, toasted
  1 lemon

Squeeze the juice from the lemon and set it aside. In the bowl of a food processor, combine the ingredients along with the lemon juice and process until smooth and fully combined, about 2 minutes. Store refrigerated in a sealed container for up to 4 days. This pesto can also be frozen in ice cube trays for up to 1 month.

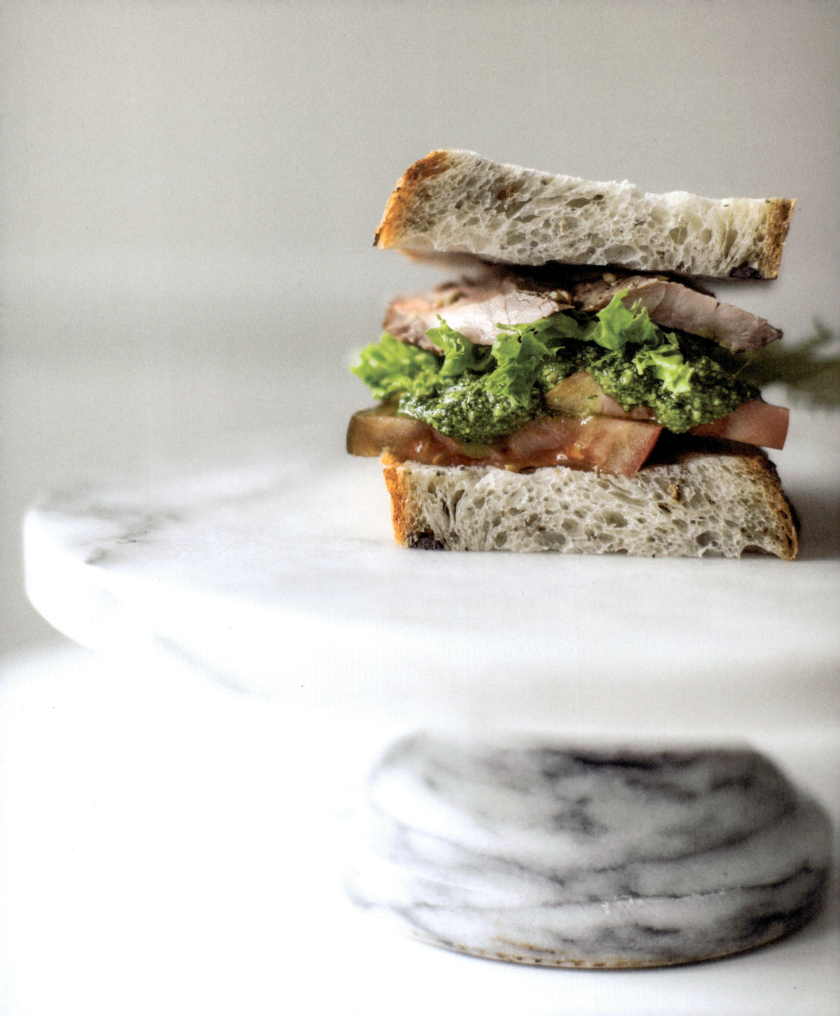

## LEMON CAPER REMOULADE

*Makes 1 cup*

Tangy and lemony, this remoulade makes a perfect
condiment to any sandwich.
It is also wonderful for dipping fried chicken or fried fish into.

1 cup mayonnaise
1 teaspoon capers, chopped
1 teaspoon fresh dill, chopped
1 teaspoon fresh parsley, chopped
1 lemon, juiced
A pinch of cayenne
⅛ teaspoon kosher salt
⅛ teaspoon black pepper

Combine all ingredients in a bowl and mix until combined.
Store in a sealed container in the refrigerator for up to 1 week.

## LEMON CUMIN VINAIGRETTE

*Makes 1 cup*

¾ cup olive oil
¼ cup lemon juice
½ teaspoon Dijon mustard
2 tablespoons rice wine vinegar
1 teaspoon cumin
½ teaspoon kosher salt
¼ teaspoon white pepper

Combine the lemon juice, Dijon, vinegar, cumin, salt, and
pepper in a mixing bowl. Whisk together. Continue whisking
and drizzle in the olive oil, allowing it to emulsify. Store
refrigerated in a sealed container for up to 1 week.

## WARM TOMATO VINAIGRETTE
*Makes 1½ cups*

¾ cup salad oil
⅓ cup ketchup
¼ cup cider vinegar
¼ cup sugar
1 tablespoon Worcestershire sauce
1 tablespoon onion powder

Combine all ingredients in a saucepan and whisk until combined. Heat until hot, but not boiling. Allow to cool and store in a sealed container in the refrigerator.

## BUTTERMILK DRESSING
*Makes 3 cups*

1 cup buttermilk
¾ cup mayonnaise
½ cup Greek-style yogurt, full fat
1½ tablespoons capers, chopped
1 tablespoon Dijon mustard
½ bunch of fresh parsley
1 clove of garlic, crushed
⅛ teaspoon kosher salt
⅛ teaspoon black pepper

Combine all ingredients in the bowl of a food processor and mix on high speed until fully combined, about 1 minute. Store refrigerated in a sealed container for up to 5 days.

# MEYER LEMON RELISH

*Makes about 1½ cups*

Meyer lemons have a tender skin, unlike regular lemons. They are a cross between a lemon and an orange, which explains their addictive, sweet, florally perfumed citrus scent. They add a bright flavor to almost any dish. This relish is versatile enough to be used as a dressing for salads or vegetables, but it's also wonderful to roast a chicken or fish that's been bathed in it.

3 Meyer lemons
1 regular lemon
1 shallot, julienned very thin
1 scallion, thinly sliced on a bias
2 tablespoons parsley, chopped
1 tablespoon sherry vinegar
½ cup olive oil
¼ teaspoon black pepper
¼ teaspoon kosher salt

In a small bowl, toss the julienned shallots with the sherry vinegar and set aside. Using a vegetable peeler, peel the rind off the Meyer lemons, being careful to have as little pith as possible. Julienne the rind as thinly as possible. The thinner the better. Squeeze the juice from the pulp of the Meyer lemons along with the juice from the regular lemon, being sure to strain any seeds. Combine the Meyer lemon rind, juice from all the lemons, shallots, scallion, parsley, salt, pepper, and olive oil in a bowl. Mix well and allow the ingredients to macerate in a covered container at room temperature for 1 hour. Chill until ready to use.

**TIP:** It is best prepared fresh and used right away.

# HOMEMADE BARBEQUE SAUCE

*Makes 1½ cups*

This barbeque sauce has the perfect balance of tang and flavor. It's the perfect complement to spareribs or a pulled pork butt.

6 ounces tomato paste
½ cup white wine
½ cup cider vinegar
¼ cup molasses
¼ cup light brown sugar
1 teaspoon kosher salt
1 teaspoon Worcestershire sauce
½ teaspoon cumin
⅛ teaspoon cinnamon

1 teaspoon paprika
1 teaspoon onion powder
¼ teaspoon garlic powder
1 teaspoon chili powder
1 teaspoon dry mustard
¼ teaspoon smoked paprika
¼ teaspoon ground oregano
1 teaspoon ground celery seed

Combine all the ingredients in a small saucepan and whisk them together. Set the saucepan on medium heat and bring to a boil. Reduce to medium-low heat, partially cover with a lid and allow to boil for 10 minutes, whisking often. It should be actively bubbling the entire time. Allow to cool and store in the refrigerator for up to 2 weeks.

# HOMEMADE COCKTAIL SAUCE

*Makes 1 cup*

¾ cup ketchup
2 tablespoons prepared horseradish
1 tablespoon lemon juice
1 teaspoon Worcestershire sauce

Combine all ingredients in a bowl and serve with an iced shrimp cocktail. Add an additional tablespoon of horseradish if you would like it spicier.

# RICH QUICHE DOUGH

*Makes one 9" deep dish quiche*

Years ago, my friend Helen Couloufacos had a wonderful shop in Brooklyn, New York, where we would spend days cooking endlessly for her devoted customers. Her shop had a true spirit of home cooking—everything was made from scratch using the highest quality ingredients. Helen and I, along with her daughter Selena, shared a love of food, so much so that we would spend hours dissecting recipes and finding ways to make them better. Even the mayonnaise was homemade. Her quiche was in such high demand that every day the neighborhood would be filled with fragrances of garlic, mushrooms, leeks, herbs, cheese, and the warm scent of fresh baked crust. This sturdy, flaky crust is rich with flavor, easy to work with, and very forgiving. It perfectly elevates an otherwise ordinary, typical quiche to extraordinary.

- 2 cups all-purpose flour
- 1 tablespoon sugar
- ½ teaspoon fine sea salt
- Zest of 2 lemons
- 6 ounces cubed unsalted butter, very cold
- 3 hard-boiled egg yolks, crumbled
- 2 egg whites

In a large mixing bowl, combine the flour, sugar, salt, and egg yolks.

Work the cold butter into the mixture until it resembles coarse cornmeal with some larger pieces of butter throughout the dough. Whisk the egg whites and add to the mixture. Combine with a spoon until it starts to form a dough. Gently and quickly knead the dough until it comes together into a smooth pliable ball. Turn the dough onto a lightly floured surface and give it two to three more kneads making sure it is smooth. Flatten into a thick disc, wrap in parchment paper and refrigerate for 1–2 hours before rolling out. Although it is best made fresh, this dough can be frozen for up to one month.

# CORNMEAL—BUTTERMILK GALETTE DOUGH

*Makes 2–3 galettes*

Rich and nutty, this dough makes the perfect savory galette.

- 6 tablespoons buttermilk
- ⅔ cup very cold water
- 2½ cups all-purpose flour
- ½ cup white cornmeal
- 2 teaspoons sugar
- 1 teaspoon fine sea salt
- 14 ounces cubed unsalted butter, very cold

In a large mixing bowl, combine the flour, cornmeal, sugar, and salt. Using your fingers, work the butter into the flour mixture quickly so that it resembles the texture of cornmeal with some larger pieces of butter remaining.

Add the buttermilk and ¾ of the cold water to the mixture. Stir until incorporated. Using your hands, knead the dough until it just comes together. Turn it onto a floured surface and continue to knead until the dough is combined, smooth, and pliable. Only add the rest of the water as necessary to help bring the dough together.

Divide the dough in half or thirds, shape it into a disk, and wrap it with parchment and saran. Refrigerate for 2 hours before using. This dough can be frozen for 1 month.

## PÂTE À CHOUX

*Makes about 30 small puffs*

Choux paste is a versatile French dough used to make small puffs for savory hors d'oeuvres, as well as miniature pastries such as éclairs or Paris-Brest. They make the perfect foil for filling with a variety of salads to serve as finger foods.

½ cup whole milk
½ cup water
7 tablespoons unsalted butter
1 teaspoon sea salt
1 tablespoon sugar (use only for sweet profiteroles)
1½ cups all-purpose flour
5–6 large eggs for the dough
1 large egg for the egg wash

**TIP:** Make sure the butter is fully melted before bringing the liquid to a boil.

Preheat the oven to 425 degrees. Whisk the one egg for the egg wash in a small bowl and set it aside. Set up a mixer fitted with a paddle attachment on the counter, ready to go. Line two baking sheets with parchment.

In a medium-sized saucepan, combine the milk, water, butter, salt, and sugar (optional). On medium heat, melt the butter into the liquid without boiling. Once fully melted, turn the heat to high and quickly bring it to a full boil. Immediately remove from the stove and add the flour all at once, stirring briskly with a wooden spoon until fully incorporated. Put the pot back on the burner, set it on low, and cook the dough for about 1–2 minutes, constantly stirring. It is cooked when a hazy film forms on the bottom of the pot.

Immediately transfer the hot paste to the bowl on the mixer. On low speed, mix the dough for about 45 seconds to let out a bit of heat and steam. With the mixer still running on low to medium-low speed, proceed to add your eggs one at a time—making sure each one is incorporated before adding the next. Only use 5 eggs and test the dough. It should not be too wet. It should leave a stiff trail when you run your finger through it, or it should form a peak at the end of your paddle when raised out of the dough. If the dough is still too dry, quickly whisk the final egg in a bowl and add one half at a time until desired consistency is achieved. You may not need the whole egg.

Immediately transfer the dough to a piping bag fitted with a metal tip. Pipe the dough in a circular motion about the diameter of a half-dollar onto a parchment-lined baking sheet and build up with three full turns of the bag. Stop piping, give the bag a quick turn of the wrist, and pull up to create a small peak. Once all the dough has been piped out, give each a gentle brush of egg wash, being sure not to push down on the dough.

Immediately place the tray(s) in a 425-degree oven for 12 minutes. Without opening the oven, lower the temperature to 350 degrees and continue to bake for another 15 minutes or until the puffs are golden brown and stiff. Do not open the oven door at any time in the first 20 minutes of baking. Once baked, remove the puffs and quickly poke a hole into the side of each one with a small knife or wooden skewer to release any steam. Place the baking tray(s) back in the oven for 5 minutes to crisp up. Remove from the oven and allow to cool completely before using. If you are using the profiteroles the day they are baked, let them sit out uncovered to keep their crispness, otherwise gently cover them with a clean cotton cloth until ready to use the next day. Putting them in a sealed container will cause them to soften.

# HONEY CURRY DIJON

*Makes 1¾ cups*

This spread is the perfect dip to elevate the crudités at your next party. It also makes a great condiment for a variety of sandwiches.

1¼ cups mayonnaise
3 tablespoons curry powder
¼ cup honey
1 tablespoon Dijon mustard

Combine all the ingredients in a mixing bowl and stir until fully combined. Store in an airtight container in the refrigerator for up to 2 weeks.

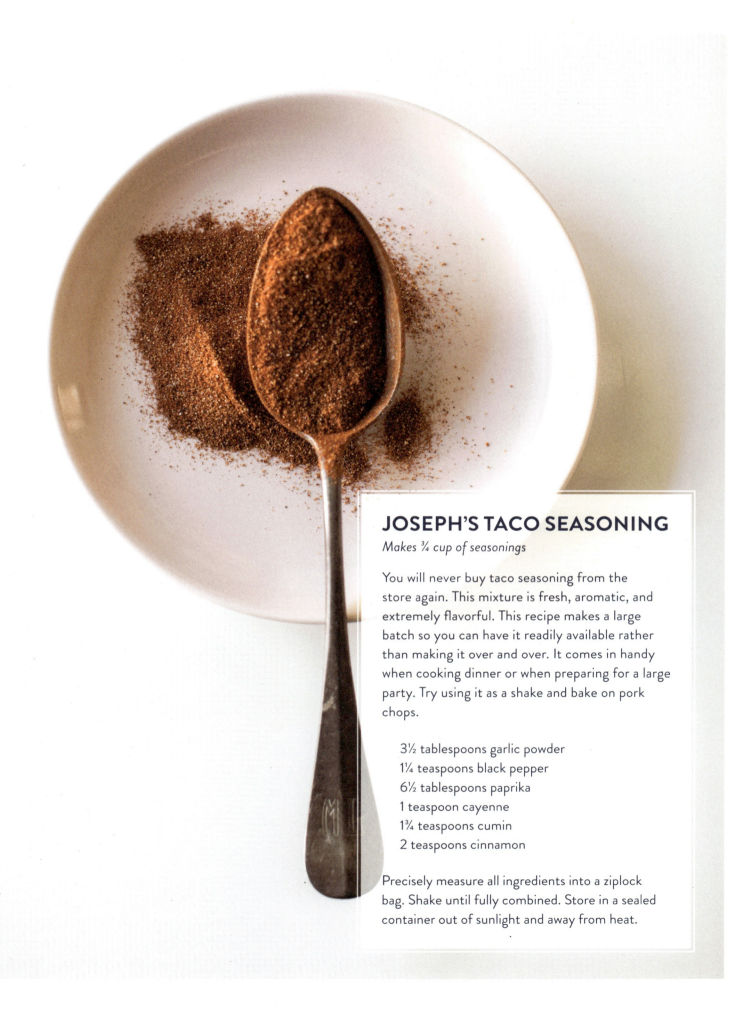

## JOSEPH'S TACO SEASONING

*Makes ¾ cup of seasonings*

You will never buy taco seasoning from the store again. This mixture is fresh, aromatic, and extremely flavorful. This recipe makes a large batch so you can have it readily available rather than making it over and over. It comes in handy when cooking dinner or when preparing for a large party. Try using it as a shake and bake on pork chops.

3½ tablespoons garlic powder
1¼ teaspoons black pepper
6½ tablespoons paprika
1 teaspoon cayenne
1¾ teaspoons cumin
2 teaspoons cinnamon

Precisely measure all ingredients into a ziplock bag. Shake until fully combined. Store in a sealed container out of sunlight and away from heat.

# SOURDOUGH CROUTONS

Za'atar is a Middle Eastern herb (hyssop) that is not commonly known. It also shares the same name with a spice mix that can be used in anything from roasts to soups to sauces to dips. It has a bright, earthy fragrance from the many combinations of herbs and spices found in it. Different regions in the middle east prepare it differently, but I prefer the Lebanese variety that commonly contains sumac. It is widely used in the Middle East as a dip for bread, so it's no surprise why it's so delicious when used on croutons for salads and stuffings.

1 loaf of sourdough bread
4 teaspoons za'atar spice
6 tablespoons olive oil
2 big pinches of Maldon salt

Preheat the oven to 350 degrees. Trim the skin off the loaf of bread and discard. Slice the loaf into 1½" cubes. In a large bowl, whisk together the olive oil and the za'atar. Toss the bread in the oil mixture so that it is fully coated. Crushing the Maldon salt with your fingers, sprinkle it on the bread, and toss again. Lay the bread in a single layer on a baking sheet covered with parchment. Place in the oven for 10 minutes. Turn the croutons over with tongs and place them back in the oven for another 5–10 minutes until they are golden brown. Let cool on the tray and store in an airtight container.

# RECIPES FOR ENTERTAINING

# CITRUS MARINATED OLIVES

*Makes 1-pint container*

Whether as an amuse-bouche set on a table as your guests are being seated or on a charcuterie, these marinated olives are simple to make and full of flavor. Opt for good quality, unpitted olives that have been stored in water rather than oil. A Spanish mix works well. If you are mixing your own, try Kalamata, Castelvetrano, Arbequina, Gordal, and Gaeta.

2 cups of mixed olives
1 orange
1 lemon
¼ cup olive oil
2 pinches of kosher salt
1 pinch black pepper, fresh cracked is best
1 teaspoon fresh rosemary or thyme, chopped fine

Grate the rind of the orange and lemon into a mixing bowl. Add the olives, olive oil, salt, pepper, and fresh herb of your choice and mix until evenly coated. Allow to sit for 30 minutes, stirring often. Best when served freshly prepared, but can be kept in a sealed container in the refrigerator for up to 2 weeks.

# LEMON-CUMIN HUMMUS

*Makes 3½ cups*

Hummus is a versatile dip that is a welcome addition to any charcuterie or table of hors d'oeuvres. It's so simple to make, and homemade far surpasses that which you can buy in a grocery store. I prefer to have mine with some slight texture to it. I do not process it until it is completely smooth, but that is just a personal preference. To present this, I spoon it into a shallow bowl and with the back of a spoon, I smooth it out in a circular motion leaving an indentation with each rotation. Drizzle some olive oil over the top and sprinkle with za'atar.

30-ounce can chickpeas

2 garlic cloves, mashed

1 cup olive oil

2 tablespoons cumin

1 hearty pinch Maldon salt

¼ cup lemon juice

2 tablespoons tahini

Drain and rinse the chickpeas. Add them to the bowl of a food processor. Add the additional ingredients and process on high speed until a smooth paste is formed, about 2–3 minutes. If it seems a little too thick, it is best to loosen it with warm water—1 tablespoon at a time. Adjust the flavor with additional Maldon salt if needed. Store in an airtight container for up to three days. Serve with toasted pita wedges.

# BABA GHANOUSH

*Makes about 3½ cups*

Charred eggplant gives this dip its smoky flavor. It is generally served as a meze in Levantine cuisine, along with its cousin hummus. While not commonly found in America, sumac added to this dish gives it a tangy, lemony taste with just a little hint of spiciness from fresh mint.

3 whole eggplants, large

3 cloves garlic

8 leaves of fresh mint

½ teaspoon kosher salt

4 tablespoons tahini

2 lemons, juiced

¾ teaspoon sumac

4 tablespoons olive oil

Using a fork, poke holes in the eggplant all around. Adjust the rack in your oven to 6" below the broiler element. Preheat the broiler to high. Place the eggplant on a baking sheet lined with foil. Broil for about 30 minutes, turning the eggplant every 10 minutes. The skins should be charred all over and the eggplant extremely soft. Do not remove it from the oven until the skins are charred. If the eggplant is not completely soft, but the skin is fully charred, lower the broiler to low and move the baking sheet down to the bottom rack. Remove from the oven and let the eggplant cool. Slice it lengthwise and scoop the flesh out into a fine sieve colander lined with cheesecloth. Discard the skins. Using a potato masher, gently press down on the eggplant to expel any water and allow it to sit while you prepare the rest of the recipe. In a mortar and pestle or with the back of a chef's knife, grind the garlic, mint, sumac, and salt into a smooth paste. Stir in the lemon juice and combine. When the eggplant has drained, transfer it to a mixing bowl and add the lemon juice mixture. Stir to combine. Add the tahini to the bowl and stir the mixture vigorously with two forks until the eggplant breaks down and the tahini is fully combined. While whisking with the forks, slowly add the olive oil in a steady stream. Whisk vigorously to emulsify. The mixture will become pale and creamy. Taste for salt and adjust as needed. To serve, place the baba ghanoush in a shallow serving bowl, drizzle with a little olive oil and sprinkle some sumac on top to garnish. Serve with toasted pita.

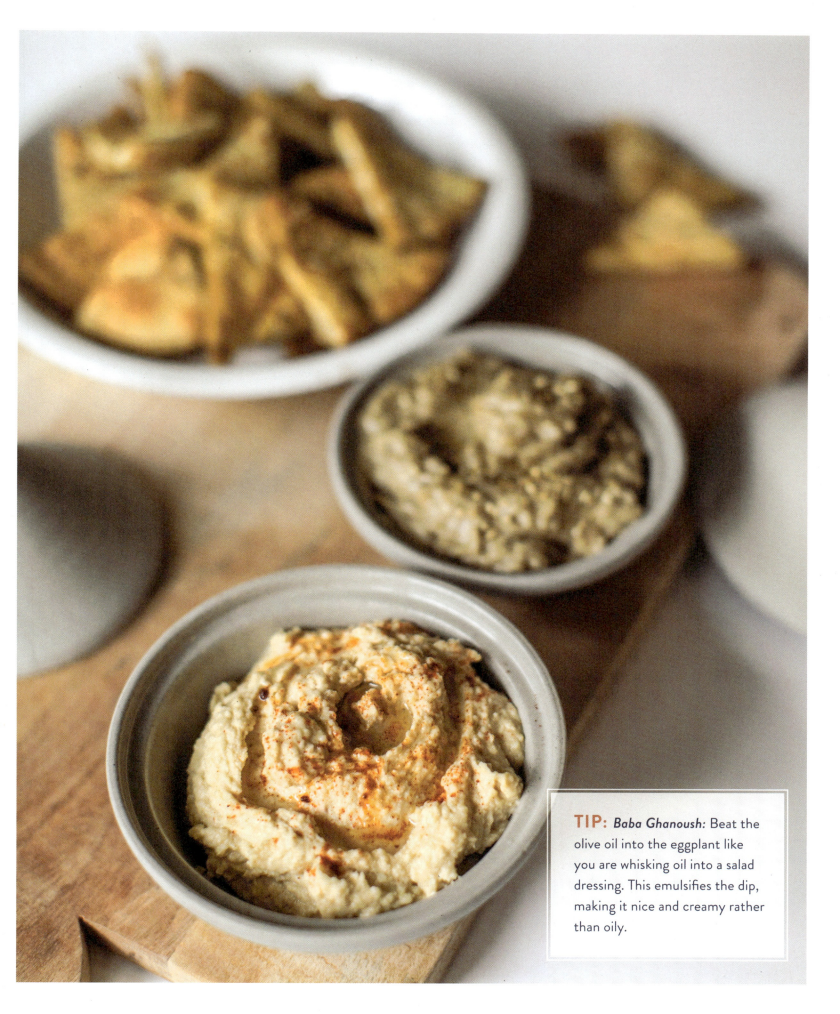

**TIP:** *Baba Ghanoush:* Beat the olive oil into the eggplant like you are whisking oil into a salad dressing. This emulsifies the dip, making it nice and creamy rather than oily.

# GORGONZOLA PARMESAN STRAWS

*Makes 16*

These flaky, salty puff pastry twists are easy to make and can be made in advance. Stack them in a stemmed glass on your hors d'oeuvre table or cut them in half and serve them as an amuse-bouche as your guests are sitting down to dinner.

1 package of frozen puff pastry
¼ cup parmesan cheese
3 ounces gorgonzola, finely crumbled

1 tablespoon fresh thyme
⅛ teaspoon black pepper
1 large egg

Preheat oven to 375 degrees. Before working with your dough, have all of your ingredients ready. Make an egg wash with the egg by whisking 1 tablespoon of water into it. Line two baking sheets with parchment and set them aside.

On a lightly floured surface, unfold the cold puff pastry and lightly flour the top. Roll the dough until you have a 12" x 12" square. Brush the top of the dough with the egg wash, being sure to get the ends to help seal them. On half of the dough, sprinkle on the parmesan, gorgonzola, thyme, and pepper evenly. Fold the other half of the dough onto the cheese and seal the edges with a slight press of your finger. Gently roll the dough to seal in the ingredients and shape the dough into an 8" x 10" rectangle. Lightly rub some flour on the top of the dough, then using a sharp knife, slice ½" wide strips through the entire dough. I like to slice the dough along the 10" side so that I have longer straws. If your dough feels hard to work with at this point, place it in the refrigerator for 10–15 minutes to firm up. Twist each strip 3–4 times and lay it on your baking sheet, keeping each one about 2" apart so they don't bake together. Press the ends of each straw down firmly onto the parchment to keep them twisted. Brush each one with egg wash and bake for 10–12 minutes until they are puffed and golden brown. Rotate the baking pans halfway through to evenly bake.

# PROSCIUTTO PINWHEELS

*Makes about 40 pinwheels*

These bite-sized pinwheels are swirled with the iconic flavors of Italy. They are the perfect finger food to serve as an hors d'oeuvre or alongside a crisp, tender salad. They can be made in advance and frozen until ready to use at your next party.

1 sheet frozen puff pastry
4 ounces Prosciutto di Parma
¾ cup Parmesan cheese

1 tablespoon fresh thyme
3 tablespoons pine nuts, toasted
1 large egg plus 1 tablespoon water to make an egg wash

Preheat the oven to 375 degrees. Line two baking sheets with parchment and set them aside.

Lightly flour your surface and unfold 1 sheet of cold puff pastry. Roll out the dough to an 8" x 11" rectangle. Egg wash the top of the dough and sprinkle the Parmesan cheese in an even layer over the entire dough. Rough chop the pine nuts and scatter them evenly. Sprinkle on the thyme. Lay the prosciutto flat along the entire surface, leaving a ½" edge on one of the 11" sides. Starting at the opposite end of the 11" side, tightly roll the dough until you reach the ½" edge. Give it an egg wash and continue to roll the dough to seal it. Egg wash the entire log and place it in the refrigerator for 15 minutes to stiffen. Using a serrated knife, slice the entire log into ¼" slices. Lay each round flat onto the parchment of your baking sheet, leaving a 2" space between each one. Bake for 20 minutes or until golden brown. Let cool slightly before transferring to a serving platter.

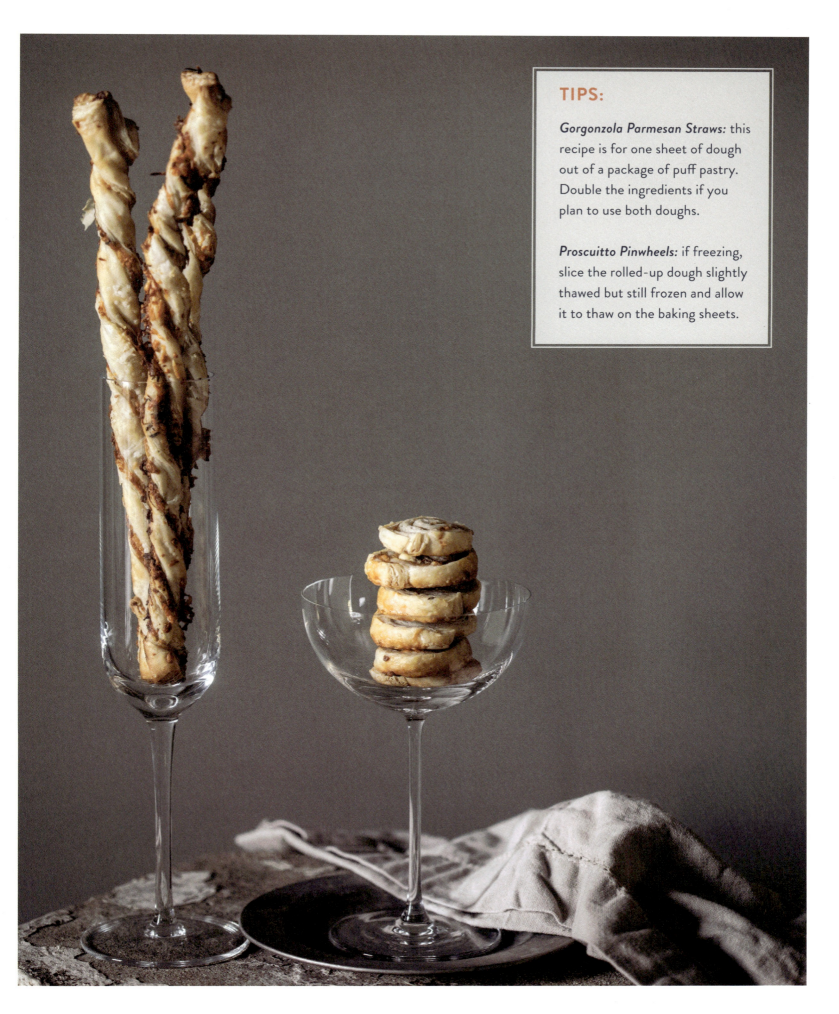

**TIPS:**

*Gorgonzola Parmesan Straws:* this recipe is for one sheet of dough out of a package of puff pastry. Double the ingredients if you plan to use both doughs.

*Proscuitto Pinwheels:* if freezing, slice the rolled-up dough slightly thawed but still frozen and allow it to thaw on the baking sheets.

# WARM ARTICHOKE DIP

*Serves 25*

What's not to love about the taste of artichokes, garlic, and cheese. The enticing aroma of this dip, served piping hot, will have your guests running to the table. Since it doesn't last long, I like to divide it into two or three separate baking dishes to bake in succession during a party so that it's always fresh and always hot.

1 recipe for Artichoke Pesto on page 172
1½ cups grated Parmesan cheese
1 cup mayonnaise
Zest of 1 lemon
½ cup gruyere cheese, grated

Combine all the ingredients and divide into 2–3 baking dishes. Bake in a 350-degree oven for 20–25 minutes, until it's a light golden brown and bubbling. Serve with slices of toasted baguette or toasted pita.

> **TIP:** This dip can be portioned and frozen right in its baking dish for future use.

# CUMIN SPICED CASHEWS

*Makes 4 pounds of nuts*

I make this recipe in large batches because the cashews never seem to last that long. I like to put small bowls of these nuts around the house during a party. My guests always compliment how delicious they are—little do they know how easy they are to make. Package some in a small cellophane bag tied with ribbon for a beautiful hostess gift the next time you are a guest at someone's house.

  4 egg whites
  4 tablespoons water
  4 pounds of cashews (whole, salted, and roasted)
  1⅓ cups sugar
  4 teaspoons cumin
  8 teaspoons kosher salt
  1 teaspoon cayenne pepper

Preheat the oven to 250 degrees. Line two baking sheets with parchment paper.

In a medium bowl, whisk the egg whites with water until very foamy. Add the cashews and toss to coat. Strain the cashews in a colander for 2–3 minutes to allow any excess liquid to drain off. Combine the sugar, salt, cumin, and cayenne in a medium bowl. Add the nuts and toss to fully coat. Spread the nuts in a single even layer on the two baking sheets and bake for 40 minutes. Pull the nuts from the oven, stir them on the baking sheet, and evenly spread them out again. Reduce the oven to 200 degrees and bake for an additional 30 minutes until dry. Cool to room temperature on the trays and break up any pieces that have stuck together. Store in an airtight container.

**TIP:** Simply cut the recipe in half for a smaller batch.

# SLICED RADISHES WITH SALTED BUTTER

If there was ever a classic French snack, this would be it. Not only is it delicious, but the only cooking required is toasting the baguette. This version makes a great passed hors d'oeuvre, however it can be presented on a platter or wooden cutting board with whole fresh radishes, a mound of flakey sea salt, fresh whipped butter, and sliced baguette—a sort of variation of a charcuterie.

   1 French baguette
   1 bunch radishes
   1 pound unsalted European butter, softened
   3 tablespoons fresh cracked black pepper
   Flakey sea salt like Maldon Salt

Slice the baguette ½" thick on a slight diagonal and very lightly toast in the oven. They should barely be light golden brown in color. Using a sharp knife or a mandolin, slice the radishes thin, place them in a bowl, cover with a wet paper towel, and keep them cold. In a mixer fitted with a paddle attachment, whip the butter with 3 hearty pinches of the flakey sea salt. Taste to see if it is salty enough. Don't make it too salty because it's nice to finish the hors d'oeuvre with a sprinkling of Maldon salt before serving.

To serve, spread a generous amount of butter onto a slice of baguette and lay 3 slices of radish on top. Sprinkle with some black pepper and a touch of Maldon salt. Garnish with a sprig of a fresh herb.

> **TIP:** I like to use European butter and whip my own flakey salt into it. If you feel adventurous, you can quickly whip a pint of heavy cream into fresh butter using a mixer with a whisk attachment—add the salt at the end.

# HEIRLOOM TOMATO GAZPACHO CUPS

*Makes 2 quarts*

Using za'atar spiced croutons in this recipe rather than plain bread brings an earthy flavor to the bright taste of a pureed soup made from raw, fresh ingredients.

6 ripe heirloom tomatoes in varied colors
6 Scallions, white and green portion
3 tablespoons Basil Pesto, recipe found on page 174
3 cloves garlic
¾ cup olive oil
¼ cup fresh parsley
1 large cucumber

1 lemon
1 teaspoon kosher salt
1 tablespoon white vinegar
1 teaspoon chili powder
2½ cups Sourdough Croutons, recipe found on page 188
Feta cheese for garnish

Score the skins of the tomatoes in a large "X" pattern. Dunk them into a pot of boiling water along with the whole garlic cloves for 30 seconds, then remove and allow to sit for a few minutes. Reserve the garlic. Gently peel the skin from the tomatoes and remove the core. Rough chop the tomatoes, place them in a bowl, and sprinkle with half of the salt. Toss and allow to sit for 10–15 minutes. Peel and seed the cucumber. Rough chop, place in a bowl, and salt with the remaining salt. Allow to sit for 10–15 minutes. Zest and juice the lemon and set aside. Pour out the liquid from the tomatoes and cucumbers into a bowl, and add the lemon zest, lemon juice, vinegar, and chili powder. Toss with the croutons and allow them to soak up the liquid.

In the bowl of a food processor, add the tomatoes, garlic, cucumber, pesto, scallions, parsley, and croutons with any remaining juice from the tomatoes and cucumber. Process on high until smooth. With the machine running, slowly drizzle in the olive oil to emulsify it. Adjust salt if needed. If it needs to be loosened a bit, drizzle in hot water with the food processor running until your desired consistency is reached. Chill for 30 minutes and serve in small glass cups. Garnish with some crumbled feta cheese.

# CURRIED CHICKEN SALAD PUFFS

I have been using this recipe for decades, and it is always a crowd-pleaser. Full of flavor and texture, each bite begs for another. Curry and pineapple meld deliciously with fresh fragrant dill while the palette lingers between the sweetness of the grapes and the tang of the Dijon. This is the perfect recipe to serve inside of profiteroles at a cocktail party.

## FOR THE PROFITEROLES
See Pâte à Choux recipe on page 185

## FOR THE CURRIED CHICKEN SALAD

4 boneless breasts of chicken
1 teaspoon capers, chopped
½ cup red grapes, quartered
¼ cup scallions, sliced
1 small shallot, small dice
3 tablespoons fresh dill, chopped
¼ cup slivered almonds

1 cup celery, small dice
3 tablespoons curry powder
1 tablespoon Dijon mustard
¼ cup blonde raisins
10 ounce can of crushed pineapple, well-drained
1–1¼ cup mayonnaise

In a pot of well-salted water, boil the chicken breast until fully cooked. Remove and set aside to cool. Chop the chicken into small dice and place it in a large mixing bowl. Mix 1 cup of mayonnaise, Dijon, and curry powder in a small bowl and set aside. Combine all the other ingredients with the chicken and toss to incorporate. Add in the mayonnaise mixture and toss to combine. Add the additional ¼ cup of mayonnaise if desired. Carefully add salt to taste if needed. Refrigerate until ready to use.

When assembling the puffs—slice the profiterole in half to create a top and a bottom. Use a small ice cream scoop to create clean, uniform portions of chicken salad to place on the bottom of the profiterole. Apply the top of the profiterole over the chicken salad and serve. These are best assembled within thirty minutes of your guest arriving.

**TIP:** Using fresh pineapple in this recipe turns it bitter. Only use canned.

# ICED SHRIMP COCKTAIL

*Plan for 3–4 shrimp per person for a cocktail party*

While most frozen shrimp is packaged and sold with a label of medium, extra-large, jumbo, or extra-jumbo, it is better to become familiar with recognizing the size of shrimp by their classification in weight. Shrimp labeled as 16/20 means you will get 16 to 20 pieces of shrimp per pound. These will be bigger in size than, say, 21/25. While you get more shrimp per pound with 21/25, the shrimp will be markedly smaller.

3 pounds 16/20 shrimp, peeled and deveined, tails-on
½ cup pickling spice
2 lemons, sliced
3 stalks of celery, cut in half
5 quarts water
4 tablespoons kosher salt
1 tablespoon black peppercorns
For the cocktail sauce, see recipe on page 180

In an 8-quart pot, add all of the ingredients except the shrimp. Bring to a boil, cover, and simmer for 15 minutes. While that simmers, peel and devein the shrimp if needed, leaving on the tails. Bring the liquid back up to a boil and add the shrimp. Boil for 3 minutes, until the shrimp are bright pink and firm to the touch. Stain in a colander and toss in a bunch of ice to cool quickly. Do not rinse the shrimp. Once cooled, keep chilled in a refrigerator until ready to platter. To platter, fill a silver bowl with ice and arrange the shrimp on top in a circular fashion. Add a small bowl of cocktail sauce in the middle. Garnish with lemon slices.

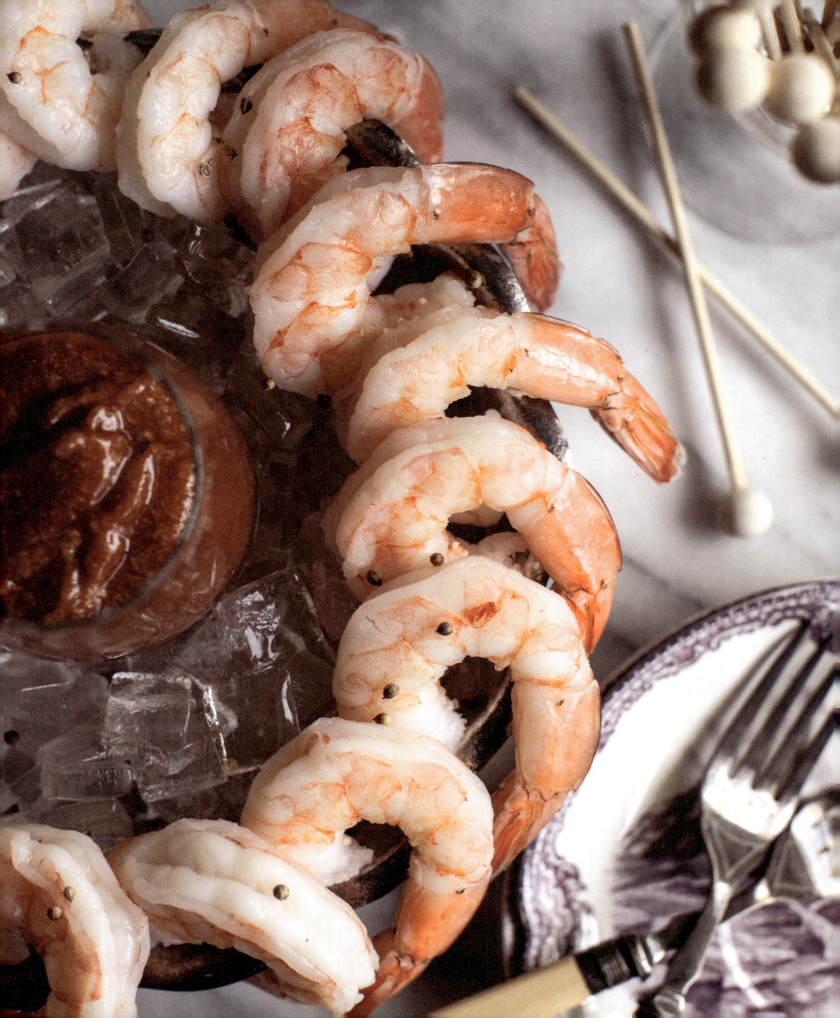

# AGED CHEESE AND PLUM TOMATO GALETTE

*Makes 1 galette*

A crusty, rich cornmeal dough creates a free-form tart that envelops the flavors of melted cheese and roasted tomatoes. The gruyere is essential for this galette, but feel free to experiment with adding an alternative cheese to it, such as feta, goat, or ricotta.

  1 disc of Cornmeal–Buttermilk Galette Dough from page 182
  8 ounces gruyere cheese
  4 ounces fresh mozzarella cheese
  4 semi-ripe plum tomatoes
  8 basil leaves, chiffonade
  ⅛ teaspoon black pepper
  ⅛ teaspoon kosher salt
  1 large egg plus 1 tablespoon water for an egg wash

Preheat the oven to 400 degrees. Shred both kinds of cheese with the large holes of a cheese grater and set them aside. Slice the plum tomatoes about ⅛" thick and lay flat on a double layer of paper towels to absorb their moisture. On a well-floured piece of parchment paper, roll out the galette dough until it is round and ⅛" thick. The dough will feel wet, so don't be afraid to keep it well floured to make it easy to work with. Slide the parchment with your dough on it onto a baking sheet. Sprinkle both kinds of cheese on the dough leaving the outer 1½" to 2" edge empty. Sprinkle the basil on top of the cheese evenly. Lay the tomatoes on top in a circular fashion so they are flat but close to each other. Sprinkle with salt and pepper. Fold the edges of the dough up and over the tomatoes creating a free-form edge. Egg wash the edges and bake for 35–45 minutes until the crust is golden brown and crisp. Allow the galette to rest for 10 minutes before cutting.

**TIP:** Placing a layer of cheese on the dough keeps it from getting soggy during baking.

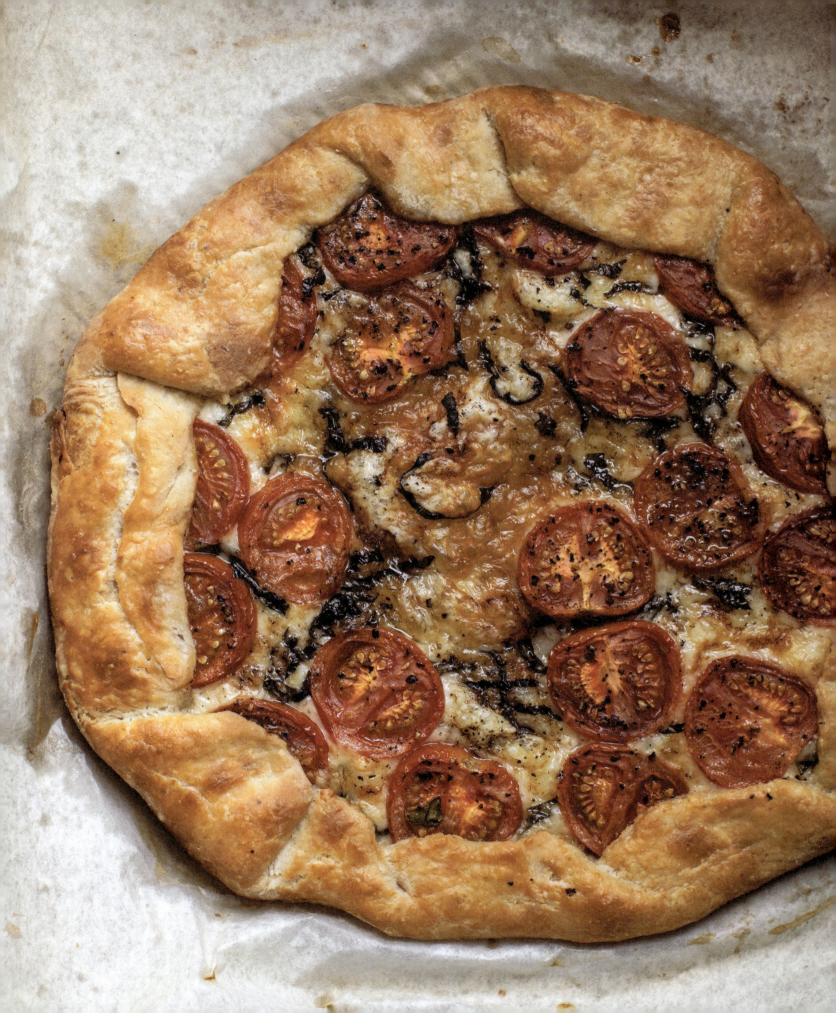

# CHICKEN SCHNITZEL SLIDERS WITH CELERY SLAW

*Makes 48 sliders*

Schnitzel is a regular dinner item in our house, and because I love it so much, I thought it would make a great hors d'oeuvre for our parties. What better way to serve it than as a slider. I make use of frozen parker house rolls for this recipe. The dough can be found in the freezer section of any large grocer. They bake up nicely and make the perfect bite-sized hors d'oeuvre. I prepare the chicken about an hour before our guests arrive.

24 pieces of frozen parker house style dough

5 boneless breasts of chicken

Grapeseed oil

1 cup all-purpose flour

4 large eggs

8 teaspoons Dijon mustard

4 teaspoons kosher salt

4 tablespoons water

2 cups plain bread crumbs

2 cups plain panko

4 stalks of celery

1 lemon, juiced

1 teaspoon honey

1 shallot, minced

½ teaspoon kosher salt

4 tablespoons olive oil

½ cup Lemon Caper Remoulade— recipe found on page 176

## For the rolls

These are best baked fresh the morning of your party. Line a baking sheet with parchment and brush with a little olive oil. Cut each frozen piece of parker house dough in half. Place the cut side down on the parchment being sure to keep about 2" between each piece of dough. Brush the tops with olive oil and loosely place another piece of parchment on top. Allow to sit on the counter to thaw and rise for about 3 hours. Once doubled in size, remove the top layer of parchment. Brush again with olive oil and lightly sprinkle some Maldon salt over the tops while crushing it in your fingers. Place into a preheated oven according to the package directions. Bake according to the package, until the tops and bottoms are a nice, rich golden brown. Cool on the baking sheet. Do not cover. Once cooled, slice each roll in preparation for the chicken.

## For the celery slaw

In a bowl, whisk together the lemon juice, honey, and 2 teaspoons of dijon mustard. Using a mandolin, thinly slice the celery at an angle and add it to the bowl. Toss and allow to sit for 15 minutes, then add in the olive oil and kosher salt. Stir to combine, cover, and set aside.

## For the chicken

Butterfly each piece of chicken and pound out until thin and even. Cut each breast into 1½" pieces so that you have 48 pieces total (you may end up with more than 48 pieces). It may seem small, but once the coating is fried on the chicken, it will be just big enough to fit the rolls. In a large bowl, mix the flour, eggs, 6 teaspoons of Dijon mustard, salt, and water until a batter forms. Add the chicken pieces and toss to coat. Set aside. On a large dish, combine the breadcrumbs and panko so it's evenly mixed and distributed. Fill a cast-iron Dutch oven with grapeseed oil until it is about 1½" deep. Clip a candy thermometer to the side and place it on medium-high heat. While the oil is heating, gather your chicken, breadcrumbs, tongs or a large slotted spoon, a cooling rack lined with paper towels, and some Maldon salt. As the temperature approaches 350 degrees, dredge several pieces of chicken in the breadcrumbs being sure to push down into the bread on both sides. Once the temperature reaches 350 degrees, slide those pieces carefully into the hot oil and fry for about 1–2 minutes on each side or until the coating is a medium golden-brown color. You will need to keep an eye on

the temperature so that it does not exceed 350, nor should it go too far below it. The chicken will cool the oil down to about 300 degrees so you can adjust the temperature up slightly to get the oil back to 350 degrees as it cooks. As each batch is frying, dredge another batch in the breadcrumbs and fry once the previous batch has been removed from the oil. Lightly sprinkle each batch while hot with a little Maldon salt crushed in your fingers.

Assemble each roll with a piece of chicken, a small dollop of remoulade, and a few slices of celery. Platter and serve at room temperature.

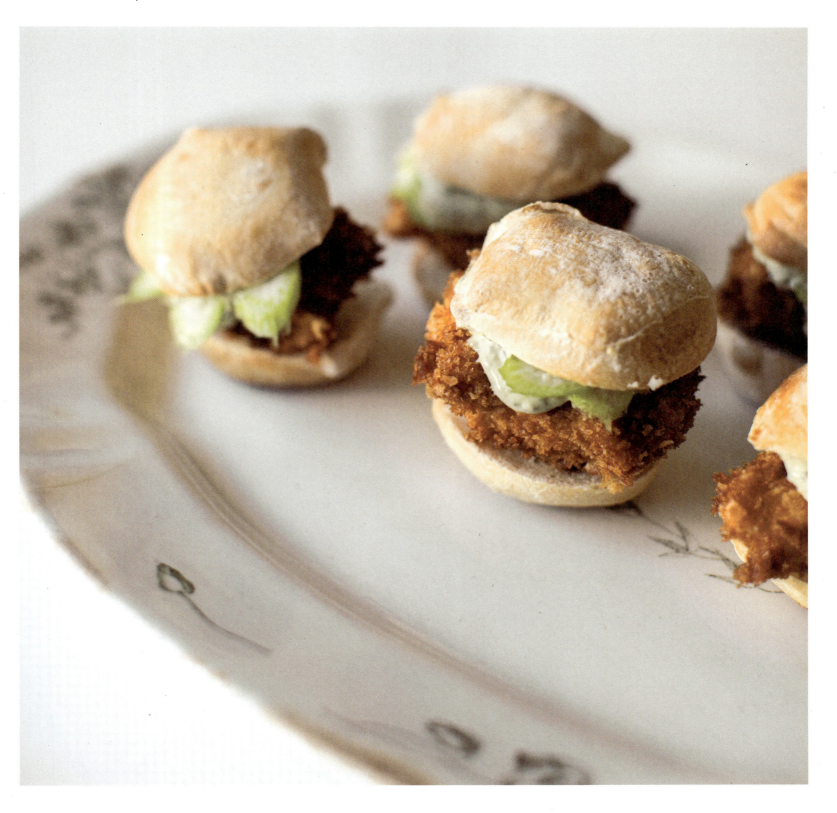

# TURKEY TACO CUPS

*Makes 20–24 cups*

A cinch to put together and even though it's made with turkey, it's brimming with flavor. Even the young kids will love diving into these.

  1 pound of ground turkey meat
  1 shallot, minced
  2 cloves garlic, minced
  1 tablespoon olive oil
  ¼ cup chicken stock
  2 tablespoons Joseph's Taco Seasoning, recipe found on page 187
  ½ teaspoon kosher salt
  2 scallions
  1 16-ounce container of sour cream
  1 15½-ounce can of black beans
  1 bag tortilla scoops

Sprinkle the salt on the ground turkey and allow it to come to room temperature. Drain and rinse the black beans. Slice the scallions at an angle and set them aside. In a non-stick frying pan, heat the olive oil and sauté the shallot and garlic until translucent. Add the turkey meat and the taco spice. Break up the meat as it sautés, being sure to mix in the taco spice. Add the chicken stock and continue to sauté until the liquid is just absorbed. Let the meat cool.

To assemble, add a spoonful of the turkey meat to the tortilla cup, top with some sour cream, a black bean, and a sliver of scallion. You could also add a sliver of avocado that's been coated with lemon juice for some additional color and flavor.

> **TIP:** Look for ground dark meat or at the very least 93% lean turkey. The 99% lean white meat will dry out quickly.

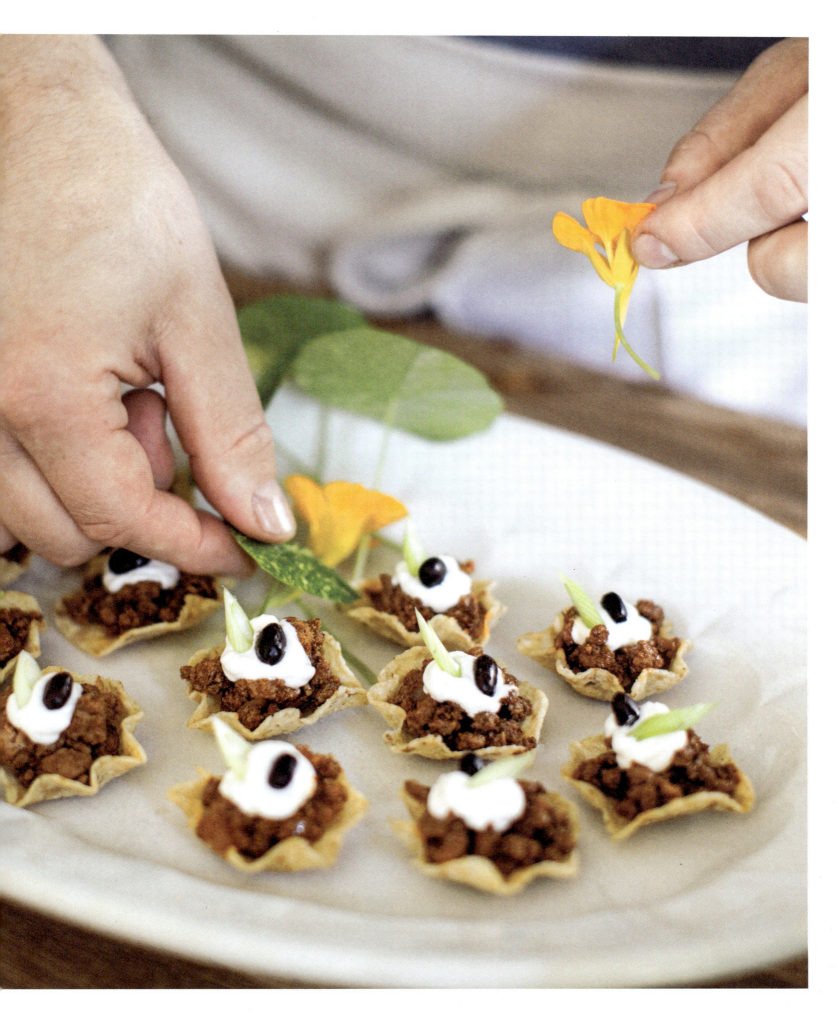

# ARTICHOKE HUSH PUPPIES

*Makes 24–28*

A hush puppy like you've never had before. Crispy on the outside, tender and warm on the inside. Dip them in a lemon-caper remoulade and you've got the quintessential finger food.

These are best served fresh, whether warm or at room temperature, and look great stacked on a white platter.

1 cup white cornmeal
½ cup all-purpose flour
½ cup cake flour
2 teaspoons baking powder
¼ teaspoon baking soda
1 teaspoon kosher salt
½ cup buttermilk

2 large eggs
½ white onion, minced
8 ounces Artichoke Pesto on page 172
6–8 cups grapeseed oil
Maldon Salt
Lemon Caper Remoulade—recipe found on page 176

Sift together the cornmeal, both flours, baking powder, baking soda, and salt.

Whisk the eggs into the buttermilk, then whisk in the artichoke pesto and onion.

Combine the artichoke pesto mixture with the flour mixture and stir until incorporated.

In a cast iron Dutch oven, add enough grapeseed oil to be 1½–2" deep. Clip-in a candy thermometer and bring the oil to 350 degrees. Using a 1-ounce ice cream scoop, place 7–8 individual scoops into the hot oil and allow to fry to a nice golden brown, about 3–4 minutes. Adjust the temperature of the stove to maintain the oil at 350 degrees. The temperature will lower when you put the batter into the oil. Transfer the hot hush puppies to a rack lined with paper towels and repeat until all the batter is used. Sprinkle a little crushed Maldon salt onto the hush puppies when they come out of the oil.

# SKEWERED TUNISIAN MEATBALLS WITH PAPRIKA SAUCE

*Makes 32 1-ounce meatballs*

These are the perfect bite sized hors d'oeuvres. Skewer and serve on a bed of steamed, riced cauliflower to keep them sturdy on a platter. Be sure to make extras because these will be a hit.

FOR THE SAUCE
- 2 tablespoons olive oil
- ½ cup onions, small dice
- 3 cloves garlic, minced
- 1 28-ounce can of fire-roasted whole tomatoes
- 4 ounces tomato paste
- 1 tablespoon fresh oregano, minced
- 1 teaspoon smoked paprika
- ½ teaspoon kosher salt
- ½ teaspoon black pepper

FOR THE MEATBALLS
- 1 pound ground turkey
- 1 pound ground pork
- ½ cup onion, small dice
- 2 cloves garlic, mashed
- ¼ cup green olives, pitted and minced
- ½ teaspoon fresh thyme
- ½ teaspoon fresh parsley
- 1 teaspoon ground fennel
- ¾ teaspoon kosher salt
- ¼ teaspoon red pepper flakes

## To make the sauce

On medium heat, sauté the onions and garlic in olive oil in a saucepan until translucent. Add the tomato paste and cook, stirring for 3 minutes. Add the tomatoes, oregano, paprika, salt, and pepper. Simmer for 30 minutes, stirring occasionally. Adjust the flavor with additional salt if needed. The sauce can be kept refrigerated for up to 4 days.

## To make the meatballs

Preheat the oven to 375 degrees. Combine all the ingredients in a large mixing bowl and mix using your hands. Taste the meat for salt and adjust as needed. Form the meat into 1-ounce meatballs and place on a baking sheet lined with parchment. Bake the meatballs for 15–20 minutes. They can be kept refrigerated in a covered container for up to 3 days.

On the day of your party, combine the sauce and the meatballs in a large pot and set on the stove on medium heat until the meatballs are heated through. Skewer each meatball and place on a bed of steamed, riced cauliflower and serve hot.

# EGG SALAD ON PUMPERNICKEL TRIANGLES

*Makes 24 hors d'oeuvres*

A spin-off of a classic tea sandwich, this flavorful, light egg salad is juxtaposed against the dark, dense, tangy rye flavor of pumpernickel bread. Pumpernickel is available in a cocktail-sized loaf which is thinly sliced. The sturdiness of the bread makes it a good stiff base for serving as a finger food.

  1 loaf pumpernickel cocktail bread
  2 dozen eggs
  ⅓ cup capers, rinsed and chopped
  ¼ cup dill, chopped
  3 tablespoons Dijon mustard
  ⅔ cup mayonnaise
  1 teaspoon black pepper

For the perfect hard-boiled egg, carefully place the eggs in a pot with just enough tepid water to cover them. Add 2 teaspoons of salt to soften the water. Bring to a low boil uncovered and set a timer for 15 minutes. While the eggs are boiling, prepare a large bowl of water with lots of ice. You will need a bowl big enough to hold all the eggs plus the water. When the timer goes off, quickly drain the eggs into a colander and turn them into the ice water bath to shock them. Allow them to sit in the ice bath for 2–3 minutes. Peel immediately. The eggs can be stored whole in a sealed container for up to 2 days before use.

To make the egg salad, roughly mash the cold hard-boiled eggs into a large bowl. Add the additional ingredients and mix well. If the egg salad is too stiff and dry, add additional mayonnaise a little at a time. Season with Maldon salt if needed. Store the egg salad in a sealed container until you are ready to assemble the triangles just before your party.

To assemble the triangles, cut each piece of cocktail bread in half at a diagonal to create a triangle. Lay them out on a cookie sheet and using a small ice cream scoop, carefully scoop a dollop onto each triangle. Garnish with some dill fronds or a sliver of scallion. Keep cold until ready to serve.

> **TIP:** Pumpernickel bread is on the dry side so be sure that your egg salad is nice and moist.

# CURRIED RED LENTIL SOUP

Comforting, simple, and easy to throw together. Serve this filling soup as the main event. Paired with a simple salad, it makes the perfect fall dinner. It can also be served in small cups as an hors d'oeuvre at a cocktail party.

1 onion, small dice
1 leek, trimmed, washed, and diced small
4 carrots, small dice
3 stalks of celery, small dice
2 red peppers, seeds removed, small dice
8 cloves garlic, minced
4 tablespoons olive oil
3 ounces tomato paste
2 tablespoons curry powder

2 cups red lentils
2 bay leaves
2 tablespoons fresh thyme
1 tablespoon fresh sage, chopped
1 teaspoon kosher salt
½ teaspoon white pepper
⅛ teaspoon cayenne
8 cups of hot water

In a stockpot, sauté the onion, leek, carrots, and celery until translucent. Add the red pepper and garlic—sauté until the red pepper softens. Add the tomato paste and curry powder and cook for 2 minutes while stirring. You want the tomato paste to caramelize slightly, but not burn. Add the hot water, lentils, salt, pepper, sage, thyme, bay leaves, and cayenne. Let simmer for 30–40 minutes. Don't worry that the red lentils are falling apart. Remove from the heat, remove the bay leaf and puree ¾ of the soup in a food processor until well blended. Return it to the pot and stir. Add an additional cup of hot water to loosen the soup. It should have thickness enough to coat the back of a spoon but still have a pureed soup consistency. Season with an additional teaspoon of salt and taste. Add extra salt as needed to bring out all the flavors.

# CORN CHOWDER

*Makes 5 quarts*

Corn chowder is delicious served plain, but the addition of Italian sausage, crab meat, or shrimp can make it a meal all on its own. I have served this as a soup course as well as the main dish served with a chunk of toasted baguette and butter. I use chicken stock in mine, but you can create a vegetarian version by eliminating the bacon and substituting the chicken stock for vegetable stock.

7 slices of bacon, cut into small pieces
1 onion, small dice
5 cloves garlic, minced
1 tablespoon curry powder
⅛ teaspoon red pepper flakes
5 tablespoons butter, unsalted
¼ cup flour
8 cups chicken stock

1 teaspoon kosher salt
½ teaspoon black pepper
4 large russet potatoes, cut into ½" cubes
1 tablespoon fresh thyme
6 ears of corn
1 cup whole milk
50 ounces of white cheddar cheese
Fresh dill for garnish

Heat the chicken stock in a saucepan and keep it warm. Grill the ears of corn over an open flame until they are lightly grilled all around (you don't want a lot of charring). Slice the corn from the cob and set it aside in a bowl. Reserve the corn cobs. In a large stockpot, fry the bacon until crispy, then remove and reserve. With the remaining grease in the pot, sauté the onions and garlic until translucent. Add the curry and the red pepper flakes and sauté for an additional 2 minutes. Add the butter, and once melted, add the flour, whisking until combined—making a roux. Cook for 1 minute, then slowly add in the warm stock while whisking constantly. Add the salt, pepper, thyme, and the reserved corn cobs and bring to a boil. Simmer for 30 minutes. Add the corn kernels and cook for 10 minutes. Add the potatoes and simmer for another 20 minutes, until the potatoes are fork-tender without falling apart. Remove the cobs from the soup and discard them. Into the one cup of milk, slowly drizzle in ½ cup of liquid from the hot soup while whisking to temper it. Add that mixture back to the soup and let it simmer for an additional 5 minutes. Add the grated cheese and stir to combine. Adjust the flavor with salt as needed. Garnish with crumbled bacon and chopped fresh dill.

# POTATO LEEK SOUP

*Serves 6–8*

The abundance of leeks and garlic in this soup makes it very silky and rich with flavor. It's a simple soup that leaves the soul feeling nourished and enriched.

8 russet potatoes
1 bunch of leeks (2 large stalks)
½ cup garlic cloves
¼ cup olive oil
3 cups vegetable stock
8 cups water
5 tablespoons kosher salt
3 teaspoons white pepper

Peel the potatoes, cut into 1" cubes, and set aside in a bowl with enough water to cover the potatoes. Trim half of the green part from the leeks and remove the bottom, then slice them in half lengthwise. Wash the leeks in water very well to remove all the sand. Chop the leeks and set them aside. Crush the garlic with the back of a knife and set it aside. In a large stockpot on medium heat, sauté the leeks and garlic in olive oil until the leeks are soft. Add the stock, water, and potatoes along with 3 tablespoons of kosher salt and 2 teaspoons of white pepper. Allow the soup to simmer until the potatoes are very soft and easily fall apart when poked with a fork. Set up a food processor and an empty bowl for transferring the soup. Remove the soup from the stove and place it next to a food processor. Using a ladle, scoop the cooked potatoes and leeks along with the liquid into the food processor and blend until smooth. Transfer the puree to the clean bowl and repeat until all of the cooked potatoes and liquid has been processed. With the additional salt and pepper season to taste. The pureed soup should be thick enough to coat the back of a spoon, but not so thick that it resembles loose mashed potatoes. Adjust by adding a little hot water if needed until the desired consistency is reached. Serve hot or allow it to cool and store in a refrigerator for up to four days.

# SALAD OF PEARS, ENDIVE, WALNUTS, AND MIXED GREENS

*Serves 6*

1–2 heads of little gem lettuce
1 head red leaf lettuce
1 small red onion, sliced thin
1 head of endive
½ cup walnuts, toasted and chopped
1 bartlett or red Anjou pear
Juice of 1 lemon in a bowl of water
Maldon salt
1 recipe for Lemon Cumin Vinaigrette, on page 176

Wash the lettuce under cold water and pat dry with paper towels. Tear the lettuce and store it in a bowl in the refrigerator to stay crisp. Slice the endive into strips. Core the pear and slice it into thin strips and soak them in a bowl of water with lemon juice to keep them from browning.

Arrange the different types of lettuce on a dish, garnish with slices of pears, red onion, and walnuts. Drizzle with dressing and finish with a sprinkle of Maldon salt.

# ARUGULA AND BOSTON LETTUCE WITH FRESH FIGS

*Serves 6*

The simplicity of this salad can't be overstated. Fresh, ripe ingredients lend a feeling of elegance—the sweetness of figs cuts against the bitterness of tangy arugula. When enveloped in a creamy buttermilk dressing with fresh herbs, it's just pure heaven.

2 heads of Boston lettuce
6 ounces baby arugula
1 pint of fresh, ripe figs, quartered
Maldon salt
1 recipe for Buttermilk Dressing, on page 177

Wash and dry the Boston lettuce. Tear it into pieces and place it in a bowl with the arugula. Toss with buttermilk dressing. Garnish with figs and give a generous sprinkling of Maldon salt to finish.

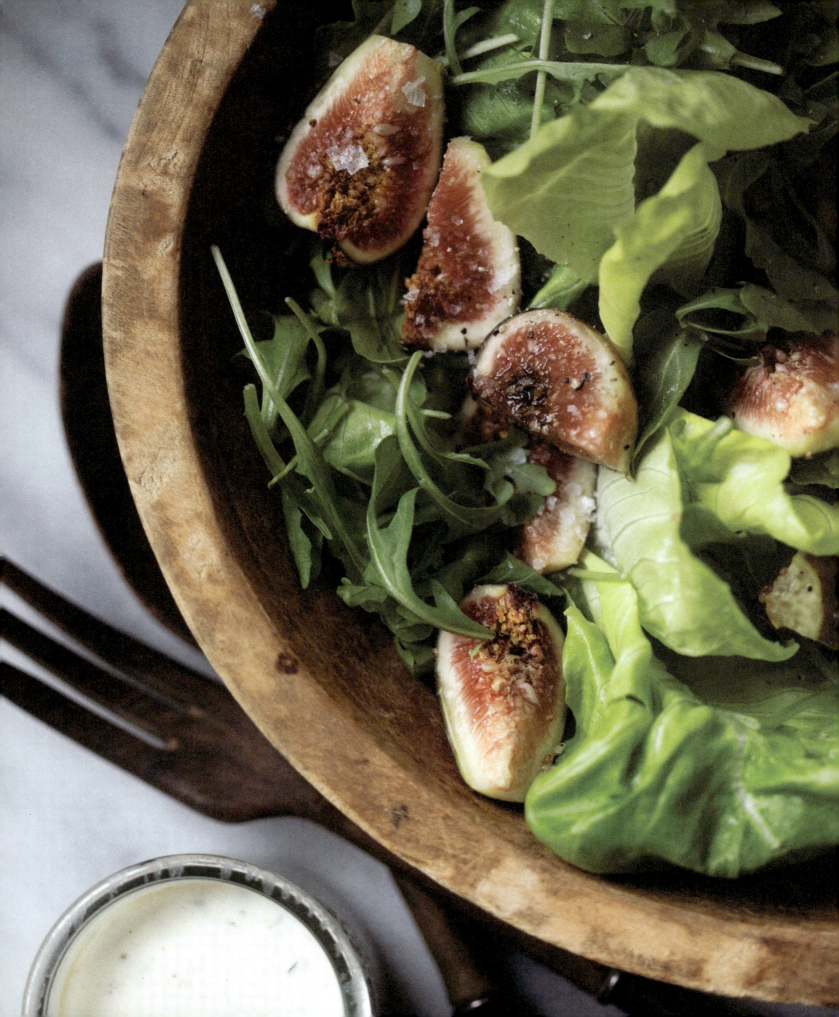

# PANZANELLA SALAD

*Serves 6*

This salad has bright colors and fresh flavors of ripe tomatoes, spicy basil, lemon zest, and croutons baked with za'atar spices. I prefer the flavors of heirloom tomatoes, but any kind of ripe tomato can be used.

    4 large ripe heirloom tomatoes
    5 cups Sourdough Croutons, recipe on page 188
    3 scallions
    1 lemon
    ¼ cup Basil Pesto, recipe on page 174
    ½ cup olive oil
    ⅛ teaspoon black pepper, fresh cracked
    ½ teaspoon kosher salt

Cut the tomato into 1" cubes. Place in a bowl, gently toss with salt, and allow to sit for 10 minutes. Slice the scallions on a diagonal and set them aside. Zest the lemon and add to the scallions. Juice the lemon and add to a small bowl with the pesto and olive oil. Add to this the strained liquid from the tomatoes. Whisk until combined. In a large mixing bowl combine the croutons, scallions, lemon zest, and tomatoes. Drizzle over the dressing and gently toss to coat. Serve on a big platter or individual servings. Sprinkle on some black pepper and a pinch of Maldon salt then garnish with fresh basil leaves.

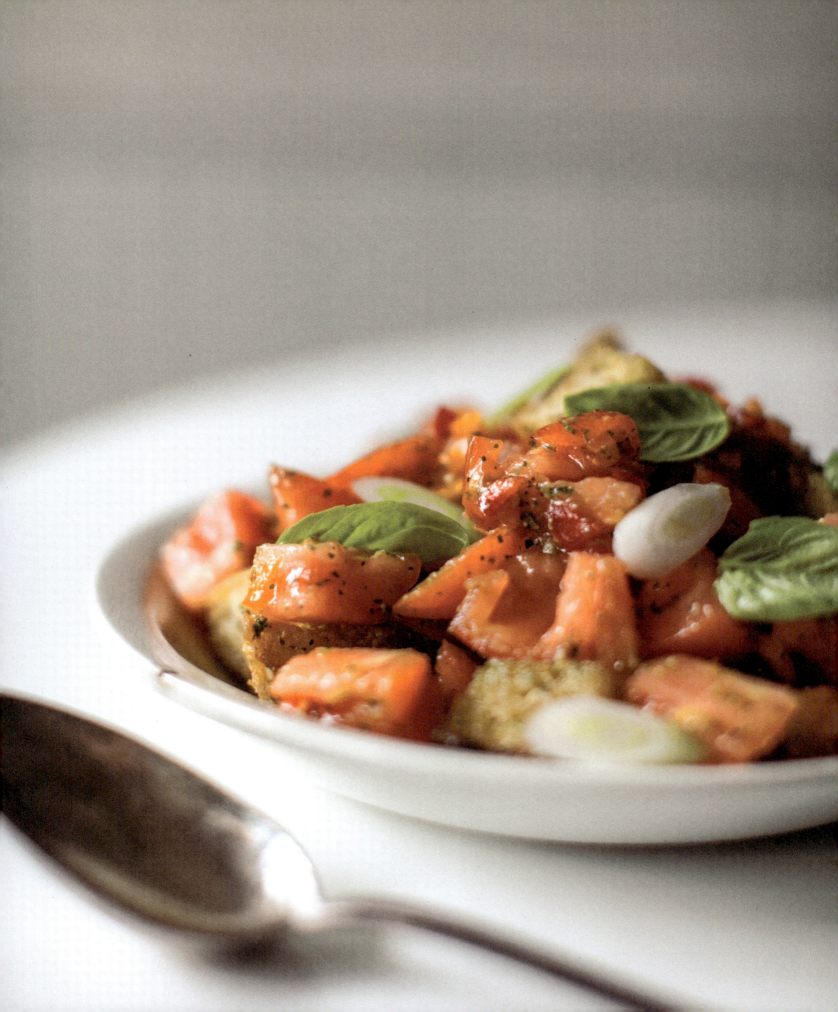

# ROASTED VEGETABLE PASTA SALAD

*Serves 12–14 as a side dish*

This colorful pasta salad is packed full of roasted vegetables and makes the perfect dish for a summer picnic or a casual luncheon. It is best served at room temperature.

1 pound Rotelle pasta

1 small shallot, small dice

1 eggplant

2 small yellow summer squash

1 large zucchini

½ red pepper

½ orange pepper

¼ cup sun-dried tomatoes

¼ cup oil-cured black olives or kalamata olives pitted

½ cup artichoke hearts

½ cup olive oil

½ teaspoon kosher salt

6 fresh basil leaves, chiffonade

Preheat the oven to 375 degrees. Slice the sun-dried tomatoes into thin strips. Rinse and drain the artichoke hearts and give them a rough chop. Give the olives a rough chop. Combine the artichokes, sun-dried tomatoes, and olives in a bowl and set aside.

Trim the skin from the eggplant, cut into 1" cubes and spread out onto a baking sheet lined with a piece of parchment. Cut the summer squash and zucchini into ½" cubes and add to the baking sheet. Chop the red and orange pepper into medium dice and add to the baking sheet. Add the diced shallot. Sprinkle the vegetables with the kosher salt and drizzle all the olive oil over the top. Shuffle the vegetables in the pan to make sure they all are in oil. Roast in the oven for 25 minutes.

As the vegetables roast, bring a pot of well-salted water to a boil and cook the pasta until al dente. Drain the pasta, return it to the pot and cover it with a lid to keep it warm.

When the timer for the vegetables goes off, remove the baking sheet from the oven and toss in the sun-dried tomatoes, olives, and artichokes. Mix in with a spatula and return to the oven. Turn the oven down to 350 degrees and continue to roast for another 10–15 minutes.

While still hot, use a silicone spatula to scrape all the vegetables along with the oil into the pot of cooked pasta. Scrape as much oil from the baking sheet as possible. Add the basil and gently toss until everything is incorporated in oil. Wait to season with salt until it has cooled to room temperature. Garnish with a sprinkle of parmesan or crumbled feta before serving.

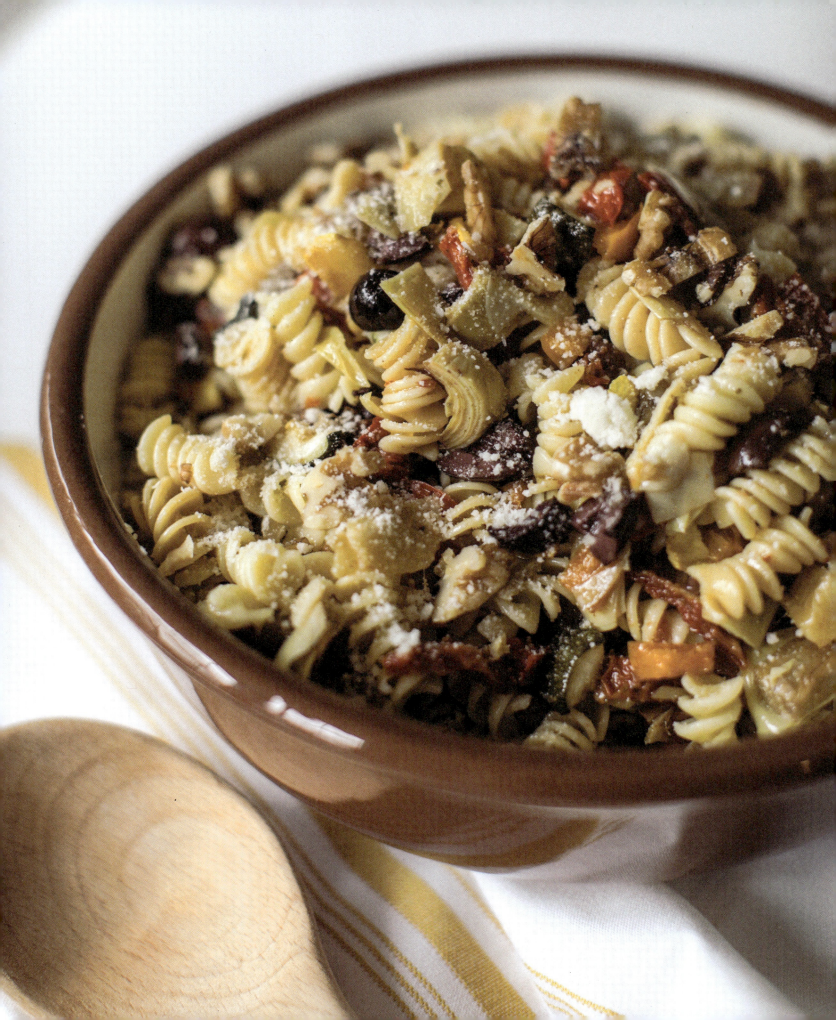

# CHICKPEAS WITH MEYER LEMON RELISH

*Makes 20 side servings*

Meyer lemons and blonde raisins give this dish a surprising sweetness. It is just as wonderful served at a summer BBQ as it is a complement to grilled fish for a dinner party.

1 Meyer Lemon Relish recipe found on page 178
3 15½-ounce cans of chickpeas
½ cup blonde raisins
1 bunch of scallions, sliced at a diagonal
2 teaspoons cumin
¼ teaspoon white pepper
¼ teaspoon kosher salt

Soak the raisins in a bowl of very hot water for 10 minutes. Drain and rinse the chickpeas and add to a large mixing bowl. Drain the raisins and squeeze out any excess water. Add the raisins to the chickpeas along with the additional ingredients and the Meyer lemon relish. Toss gently until combined and season with a pinch of Maldon salt if needed. Store in a sealed container for up to 2 days before your party.

**TIP:** This dish is best served at room temperature.

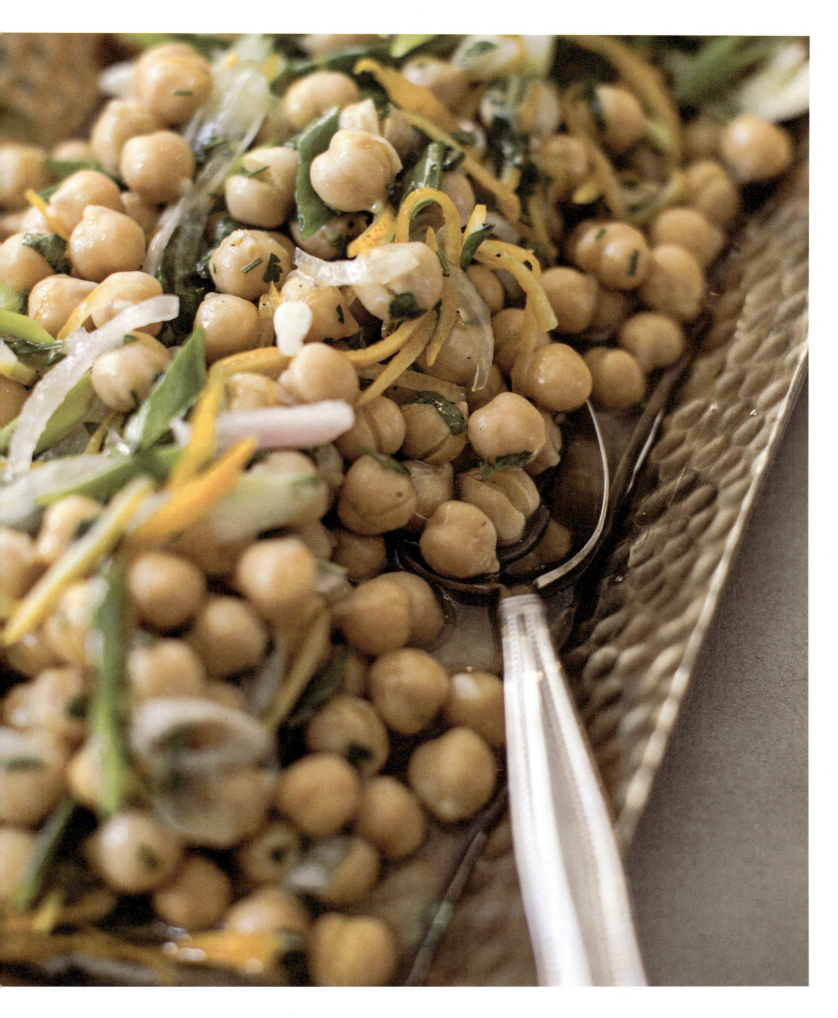

# FOUR BEAN SALAD WITH WARM TOMATO VINAIGRETTE

*Serves 10–12*

1 16-ounce can of navy beans
1 15½-ounce can of cannellini beans
1 16-ounce can of kidney beans
12 ounces of fresh green beans
1 16-ounce bag honey gold nibble size potatoes
½ cup walnuts, toasted and rough chopped
¼ cup crumbled Roquefort cheese (optional garnish)
1 Warm Tomato Vinaigrette recipe on page 177

In a pot of well-salted water, cook the nibble-sized potatoes whole, until a knife can be inserted with ease. Drain immediately and set aside to cool. Don't overcook the potatoes or they will fall apart. Gently combine the canned beans in a colander and rinse well. Cut the ends off the green beans and cut them in thirds on a diagonal. Blanch in well-salted boiling water for 1 minute, then rinse under cold water.

Combine the beans and the potatoes in a large mixing bowl, heat and whisk the tomato dressing and pour into the bowl. Gently toss and taste for salt. Pour onto a platter and sprinkle with toasted walnuts. Crumbled Roquefort makes a nice garnish sprinkled on top as well.

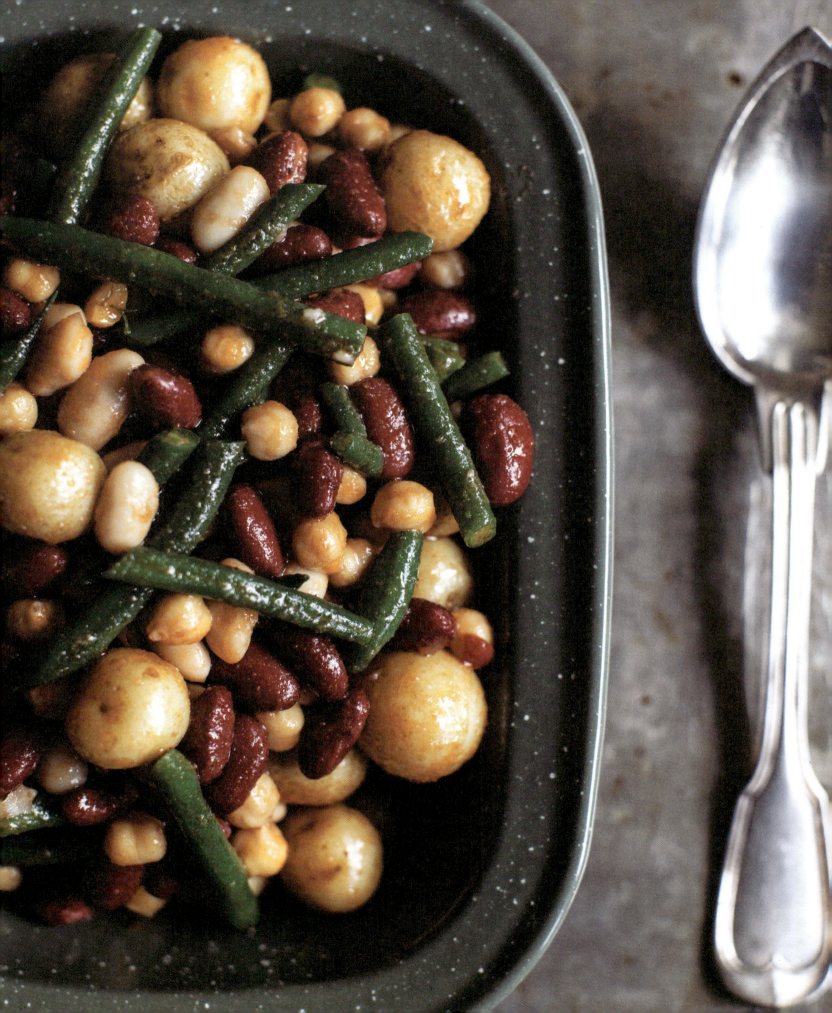

# COUNTRY POTATO SALAD

*Serves 6*

Growing up on potato salad, I have seen my fair share of interpretations, from deli-style to German. This is a recipe adapted from the one my mother used to make growing up as a kid. The hard-boiled eggs add a tremendous amount of body and the Dijon and capers give that little bit of zip to cut through the mayonnaise. I prefer a potato salad that is well coated with mayonnaise, but not swimming in it. If your preference is for a looser salad, you can always add additional mayonnaise.

4 large russet potatoes, skin on, washed, and cut into 1" pieces
2 scallions, rinsed and sliced at diagonal
2 hard-boiled eggs, roughly mashed
1 tablespoon fresh dill, chopped
½ teaspoon ground black pepper
½ teaspoon Dijon mustard
1 teaspoon capers, chopped
½ cup mayonnaise

In a pot of well-salted water, boil the potatoes just to the point that a knife can slide through them easily. Drain the potatoes and set them aside to cool. In a large mixing bowl, combine the scallions, eggs, dill, pepper, capers, Dijon, and mayonnaise and stir to mix. When cooled, add the potatoes and mix well, breaking up some of the chunks of potatoes until creamy. Season to taste with kosher or Maldon salt if needed. If the boiling water was salted well enough, likely, you will not have to add additional salt.

# FARRO WITH GRAPE TOMATOES AND ZUCCHINI

*Serves 10*

Farro is an ancient grain with a nutty flavor and meaty, chewy texture. I prefer to serve this simple, fresh salad as a side to a protein rather than complicating the flavors by mixing in more ingredients.

2 cups dry farro

10 ounces grape tomatoes, a medley of color

1 large zucchini, medium dice

1 shallot, minced

2 tablespoons fresh dill, chopped

¼ cup walnuts, toasted and rough chopped

½ cup feta cheese, crumbled

½ cup olive oil

¼ cup rice wine vinegar

½ teaspoon kosher salt

½ teaspoon black pepper

Cook the farro according to the package directions, until its al dente. Slice the grape tomatoes in half lengthwise. Combine the farro, tomatoes, zucchini, shallot, dill, and walnuts in a bowl. Pour in the olive oil and toss to combine. Sprinkle in the vinegar, salt, and pepper and toss to combine. Gently toss in the feta and serve.

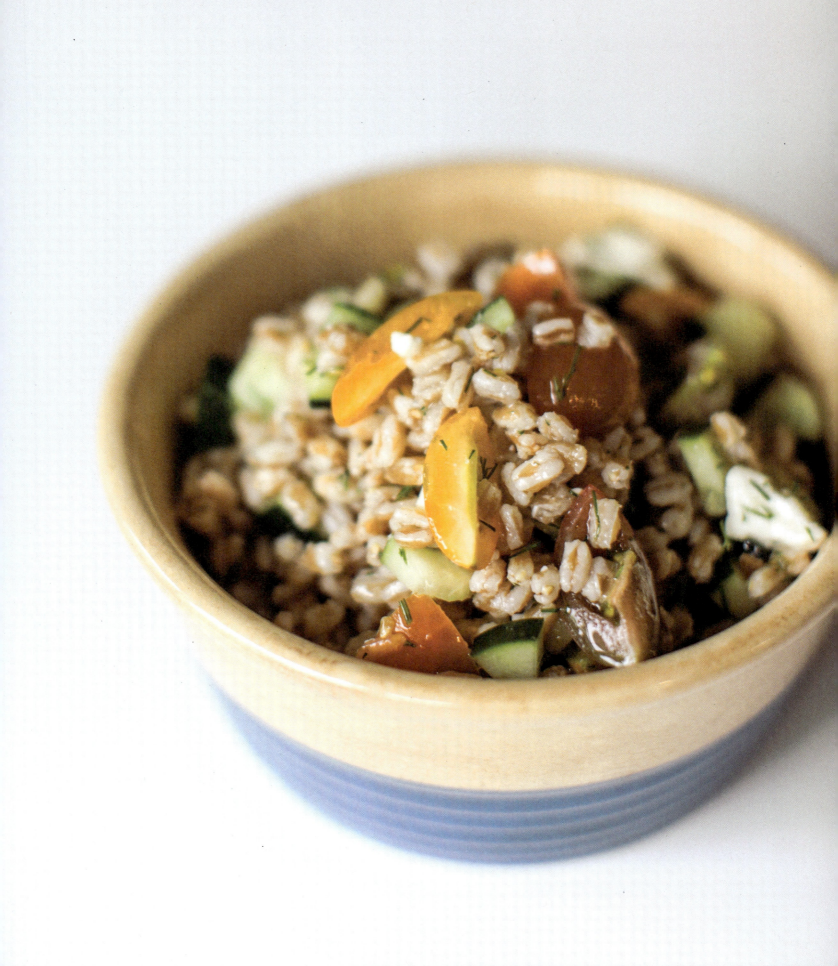

# SAFFRON RISOTTO WITH SEARED MUSHROOMS

*Serves 8*

The simple flavors of this risotto make it a perfect side dish to complement most types of meat, poultry, or fish. Consider making it a separate course for a seated dinner.

2 tablespoons olive oil

1 large onion, small dice

2 cloves garlic, minced

2 cups arborio or carnaroli rice

½ teaspoon kosher salt

5 cups vegetable stock

1 cup of water

Zest of 1 lemon, grated

1 pinch of saffron

3 tablespoons unsalted butter

2 cups grated Parmesan cheese

2 tablespoons grapeseed oil

2 pounds cremini mushrooms, sliced in half

In a small saucepan, heat the vegetable stock and water. In a 6-quart pot, heat the olive oil and sauté the onion until translucent. Add the garlic and the arborio rice and sauté for 3–4 minutes, stirring continuously. With the stockpot on medium heat, ladle 1 cup of hot stock into the rice and stir continuously. Add the salt and the saffron and continue to stir as the liquid gets absorbed. As it thickens, continue to add the hot stock ½ cup at a time while continuously stirring. Keep repeating until the rice is al dente. It should be creamy but loose, not thick. Remove from heat and stir in the lemon zest, Parmesan cheese, and butter until combined. Thin with some hot water if it gets too thick. Taste for salt and adjust if needed. Cover and set aside.

In a very hot skillet with 1 tablespoon of grapeseed oil, sear half the mushrooms on high heat until caramelized. Remove from the hot pan and sprinkle with some salt. Repeat for the other half.

Portion the risotto on a dish and top with some seared mushrooms. Garnish with fresh parsley and fresh cracked black pepper.

**TIP:** Successful risotto takes patience to cook slowly. It should have a loose, creamy consistency when it's served, as opposed to a thick, dense texture.

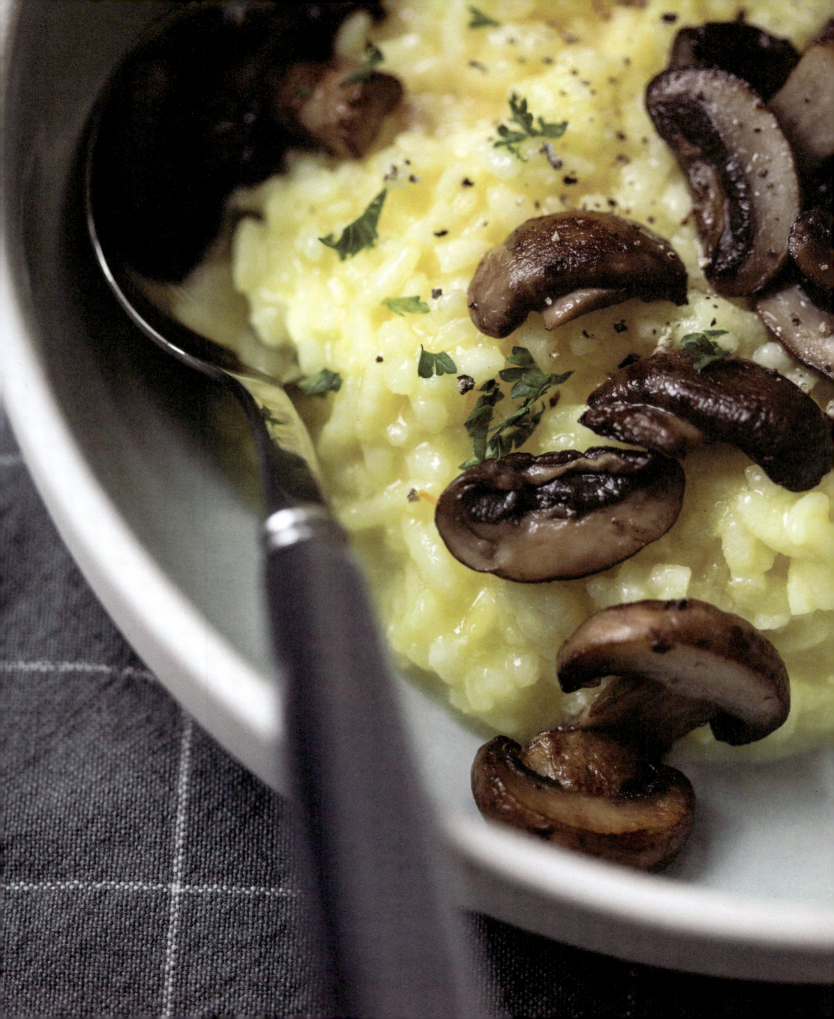

# HARICOT VERT WITH CHAMPAGNE AND LEMON VINAIGRETTE

*Serves 6*

**FOR THE VINAIGRETTE**

¼ cup olive oil

3 tablespoons champagne vinegar

The rind of 1 lemon, grated

½ teaspoon kosher salt

½ teaspoon black pepper

**FOR THE HARICOT VERT**

24 ounces Haricot Vert

1 large shallot, finely diced

2 tablespoon olive oil

½ cup pumpkin seeds

Maldon salt to finish

To prepare the vinaigrette, combine the ingredients in a mixing bowl and whisk until incorporated and set aside. In a small frying pan, heat 1 tablespoon of olive oil on medium heat and add the pumpkin seeds. Continuously shake the pan and toast until lightly browned and fragrant. Set aside.

Trim any stems from the haricot vert and quickly blanch until bright green, about 2 minutes. Rinse under cold water and pat dry. In a large frying pan on medium heat, sauté the shallot in 1 tablespoon of olive oil until translucent. Add the haricot vert, toss while sautéing for 2–3 minutes. Remove from heat and while still hot, toss with the vinaigrette and pumpkin seeds until fully combined. Transfer to a platter and serve.

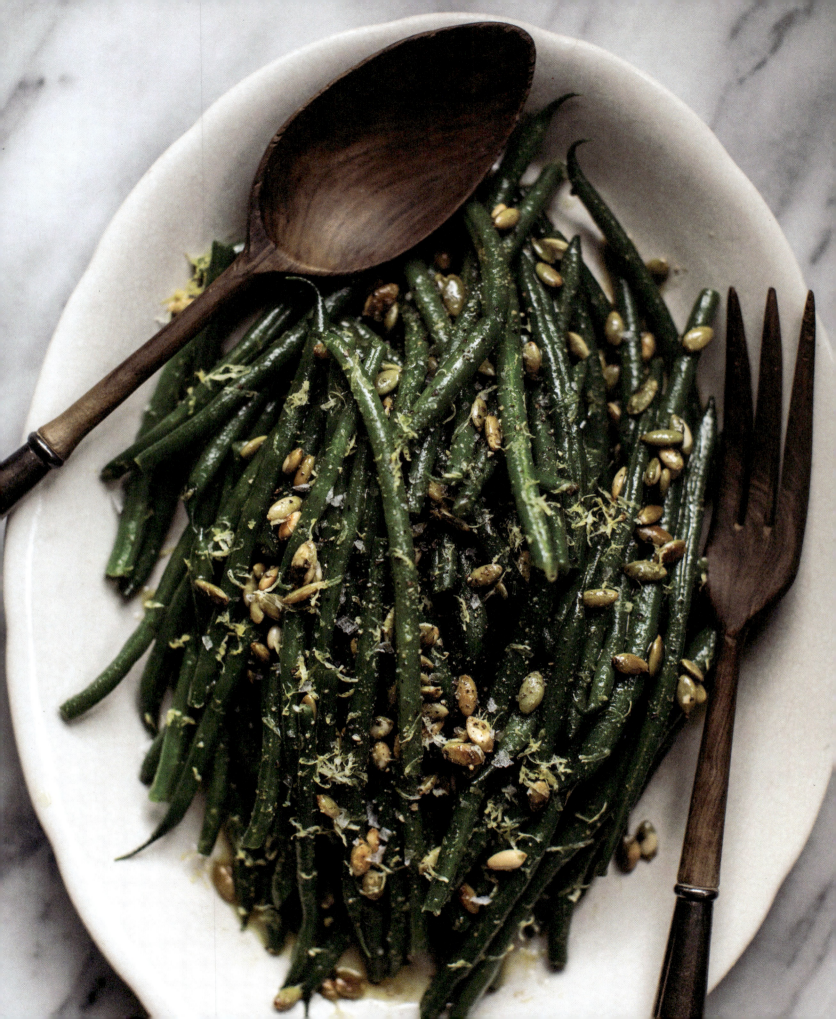

# BOURBON PRALINE HAM

*Serves 24 as an hors d'oeuvre*

This recipe is one I always serve at our holiday cocktail parties. The presentation is beautiful and always elicits an expression of amazement from the guests. I let them carve their own pieces to assemble on homemade biscuits with salted butter. This can also be prepared and assembled on small scones to serve as a passed hors d'oeuvre.

| | |
|---|---|
| 1 ham (7–8 pounds), bone-in | ¼ cup orange juice |
| 1 cup bourbon | ¼ cup water |
| 1 orange | ½ teaspoon lemon juice |
| 6 whole cloves | ½ teaspoon nutmeg |
| 3 cups sugar | 2 cups pecans, roughly chopped |

Preheat oven to 325 degrees. Trim some of the excess fat from the ham, leaving a thin layer only. Peel the rind from the orange using a vegetable peeler. In a small saucepan combine the bourbon, orange rind, and cloves. Heat over medium heat until very warm, but not hot enough to boil. Turn off the heat and allow the orange and cloves to steep in the bourbon until it has cooled. Place the ham in a large resealable bag and pour the contents of the saucepan over the ham. Seal the bag and allow it to marinate for 3 hours (or overnight). Remove the ham from the marinade, place it in a roasting pan, and cover with foil. Reserve the marinade and place the ham in the oven for 1½ hours. Remove the foil and allow it to roast for another 30 minutes. Remove from the oven and cover to keep it warm while you prepare the praline. Place a serving platter on the counter next to the roasting pan in preparation for the praline. Place the pecans in the warm oven until ready to use.

In a medium saucepan, combine the sugar, nutmeg, ¼ cup of the bourbon marinade, orange juice, water, and lemon juice. Swirl the pot gently to dissolve the sugar as much as possible. Clip-in a candy thermometer. Prepare a measuring cup with water and a pastry brush next to your stove. Using the wet brush, brush any crystals of sugar off the inside rim of the pot before turning on the stove. On medium heat, allow the sugar mixture to boil undisturbed. Do not stir while it boils and do not shake the pot, just continue to brush down the sides with a wet pastry brush to prevent any crystallization. When the candy thermometer reaches 295 degrees, take it off the heat and remove the candy thermometer. Quickly transfer the warm ham to the serving platter and remove the pecans from the oven. Using caution, dump the warmed pecans into the pot of caramel and swirl. Immediately pour the praline over the ham in a steady stream. If it should start to stiffen, place it back on the stove on medium heat to loosen it and continue to pour over the ham. Allow the praline to harden for a few minutes and serve immediately.

> **TIP:** If you are serving a large crowd, opt for making two half hams with their bone-in rather than a full leg of pork. Do not use a spiral-sliced ham for this recipe.

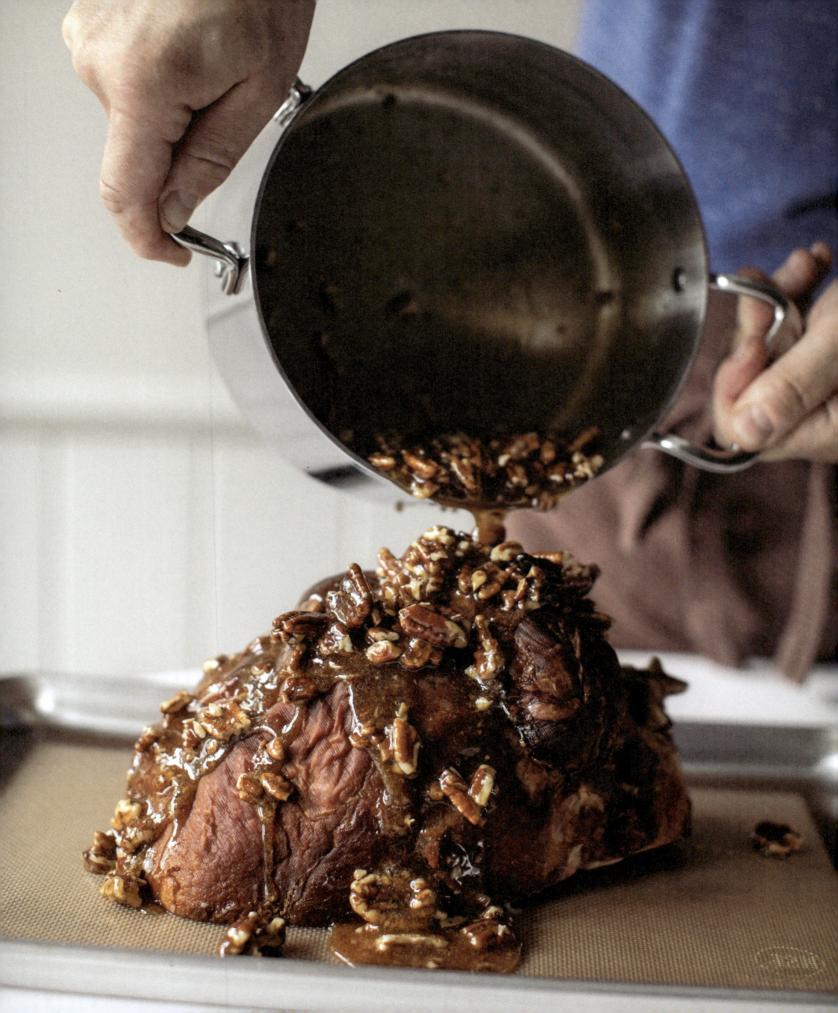

# TURKEY SPINACH MEATLOAF

*Serves 6*

I love meatloaf but never felt comfortable serving the traditional kind that is slathered in ketchup. I wanted a fancier version to serve at a dinner party. One that would pair well with mashed potatoes and parsnips or a corn soufflé.

2 pounds ground turkey, room temperature

1 pound ground sweet Italian sausage, room temperature

1 small onion, small dice

6 cloves garlic, minced

1 stalk celery

3 tablespoons olive oil

1 cup sliced mushrooms, roughly chopped

2 big handfuls of baby spinach

1 tablespoon fresh thyme

1 tablespoon mustard powder

2 large eggs

½ loaf of Italian bread broken into pieces, without crust (2 cups total)

½ cup whole milk

1 teaspoon kosher salt

½ teaspoon black pepper

¼ cup Parmesan cheese

1 tablespoon butter, unsalted

Preheat the oven to 350 degrees. Sauté the onion, mushrooms, garlic, and celery in the olive oil until onion and celery are translucent. Add spinach and toss to wilt. Remove from heat and let cool. Warm the milk slightly in a small saucepan and add the Italian bread. Allow it to soak up, then mash with the back of a fork. Add the eggs, thyme, mustard powder, salt, and pepper to the bread mixture and mix until combined. In a large bowl, combine both types of meat, the sautéed vegetables, parmesan cheese, and the bread mixture. Using your hands, combine everything until thoroughly mixed through. Taste and add salt if needed. Grease the insides of two loaf pans with the butter. Divide the meatloaf mixture between both pans, rounding the top with your hands. Bake for 40–45 minutes. Allow the meatloaf to rest for 5 minutes before turning out and slicing. Serve hot.

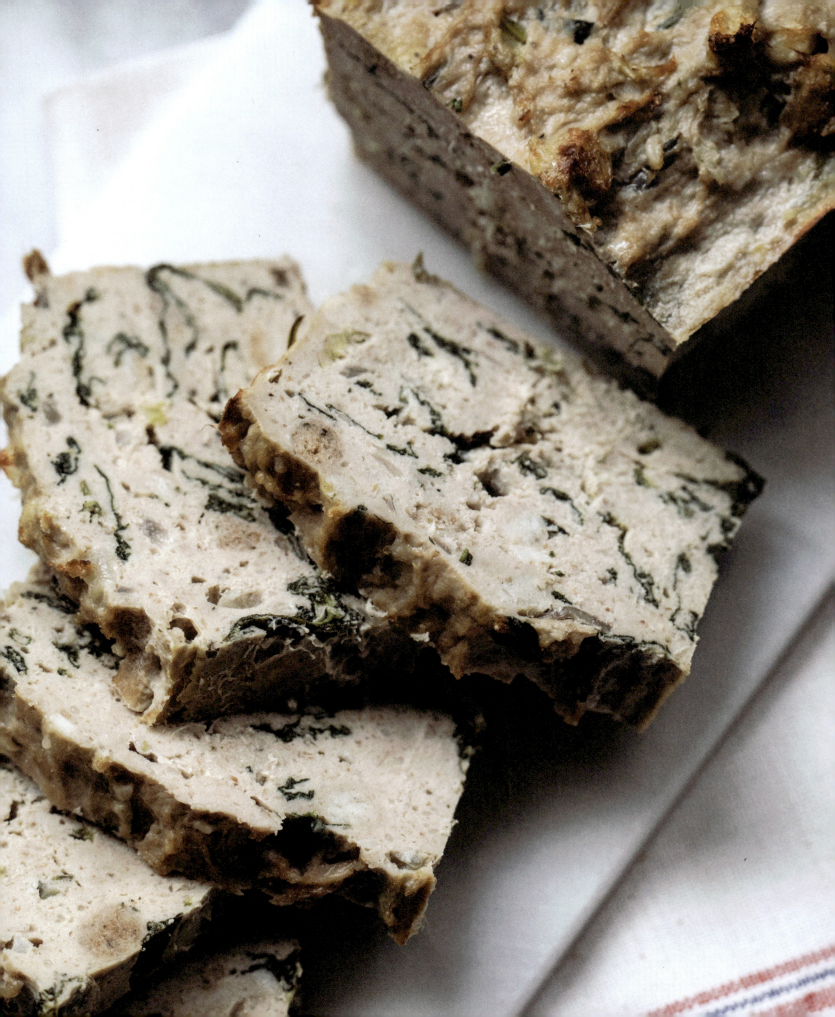

# SIMPLE LEMON GARLIC ROASTED CHICKEN THIGHS

*Serves 6*

Roasting chicken is a classic preparation that is welcomed by even the most finicky eaters. The scent of chicken roasting in the oven is like a welcome mat at your front door. Using chicken thighs guarantees a tender, moist dish. Paired with risotto or oven-roasted potatoes, it's an easy meal to prepare for a large crowd.

12 bone-in chicken thighs

14 cloves garlic, mashed

3 sprigs rosemary, removed from stem and minced

5 lemons

3 tablespoons olive oil

¼ teaspoon cumin

½ teaspoon black pepper

2 teaspoons kosher salt

12 small sprigs of rosemary

Zest 3 lemons and combine in a bowl with the garlic, minced rosemary, olive oil, cumin, and pepper. On a baking sheet lined with parchment, spread out the 12 chicken thighs, skin side on top. Pat dry with paper towels. Gently run your finger under the skin of each thigh to loosen it. Scoop some of the garlic mixture and rub it under the skin. Be sure to pull the skin tightly on the chicken and tuck under the bottom to keep it set. The garlic mixture should divide evenly between all 12 thighs. Sprinkle the kosher salt over all of the chicken evenly. Slice the additional 2 lemons into 12 slices and lay one on each thigh. Top with a sprig of rosemary. Cover the tray with saran and allow to sit for 1 hour before roasting.

Preheat the oven to 375 degrees and gently remove the saran from the chicken. Roast the chicken for 35–40 minutes. They should have an internal temperature of 165 degrees, although cooking them a little longer will not sacrifice their moisture. Serve hot.

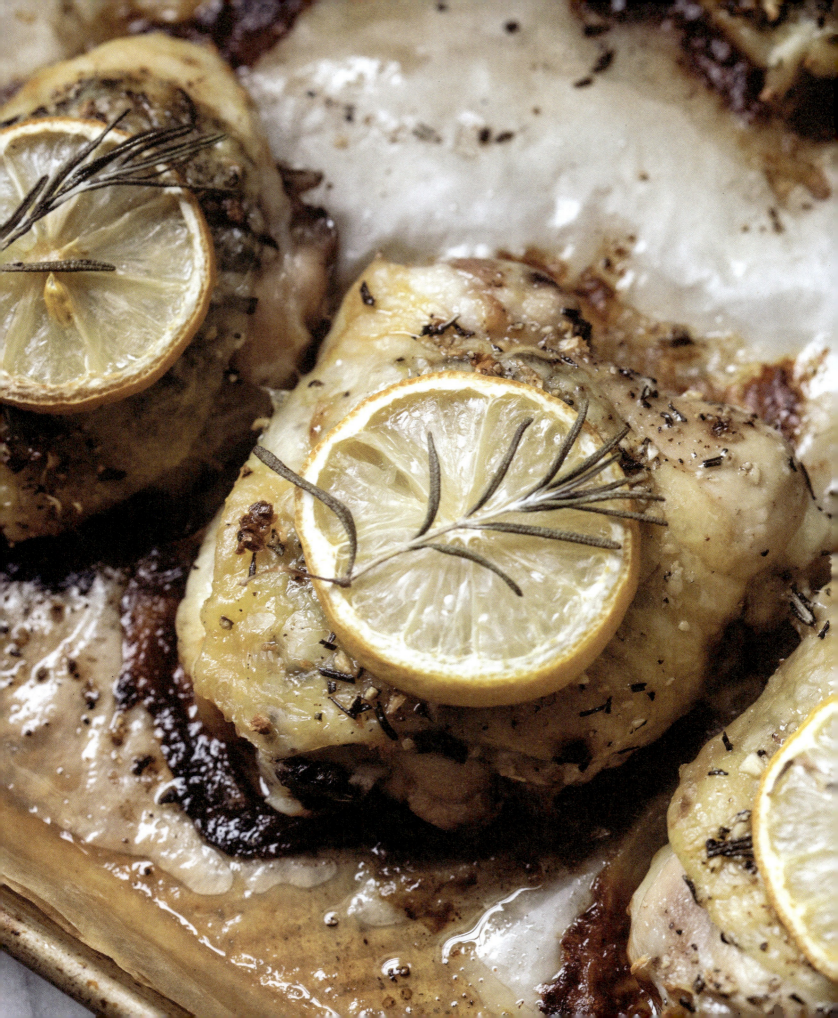

# DIJON-CRUSTED LEG OF LAMB
*Serves 10*

This Dijon paste is so flavorful and easy to prepare, I rarely cook lamb any other way. The paste forms a thin crust but retains its moisture so that it essentially doubles as a condiment. Boneless leg of lamb cuts down on the cooking time, but you can use this preparation with a bone-in leg or with chops.

  6-pound boneless leg of lamb
  2½ teaspoons kosher salt
  2 teaspoons black pepper
  8 cloves garlic
  2 tablespoons fresh rosemary
  2 tablespoons fresh oregano
  ¼ cup Dijon mustard
  4 tablespoons olive oil

Preheat the oven to 350 degrees. Trim any excess fat from the lamb—a thin layer is OK. Combine 2 teaspoons of kosher salt and 2 teaspoons of black pepper. Pat the lamb completely dry and season both sides with the salt and pepper mixture. Set aside.

In the bowl of a small food processor, combine ½ teaspoon kosher salt, garlic, rosemary, oregano, mustard, and oil. Process until fully combined, about 60 seconds.

Place the seam side of the leg down into a shallow baking dish. Spread the paste evenly over the top of the lamb. Roast for about 1 hour and 15 minutes or until a thermometer reaches an internal temperature of 140 degrees. Remove from the oven and allow it to rest with a piece of foil loosely tented over for 10 minutes before serving. Be careful not to smear the crust. Slice the lamb at a slight diagonal, about ¼" thick, and fan three medallions on each dinner plate.

> **TIP:** Allow the lamb to come to room temperature before roasting. To shorten the cooking time, slice the leg in half lengthwise to create two smaller legs of lamb.

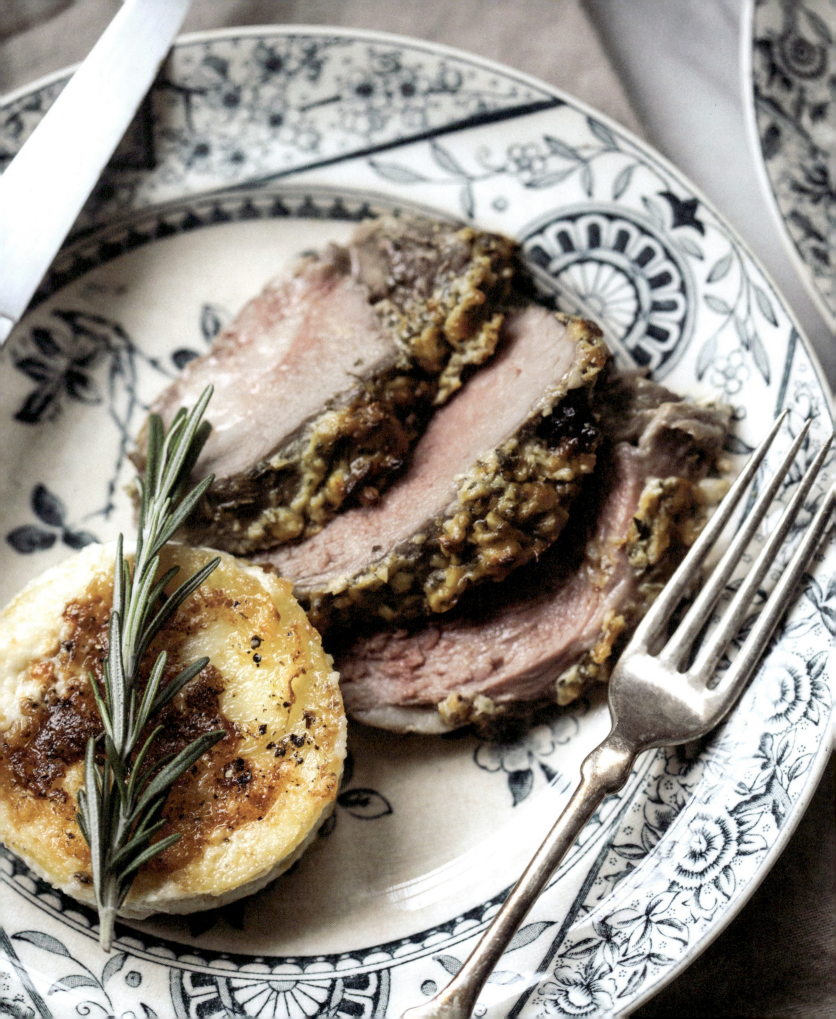

# MACARONI AND CHEESE

*Serves 10–12*

Mac and cheese has been a staple of mine forever. I set about to create an elevated version so that I could serve it at dinner parties. While using a variety of good-quality cheese is essential in making it flavorful, the fun begins when you start experimenting with different types of your favorite cheese. I have added Boursin, Brie, and Brillat-Savarin with much success. I do not give measurements for salt in this recipe because cheese varies in its saltiness. Carefully salt the cheese mixture pinch by pinch to taste before mixing with the pasta.

| | |
|---|---|
| 2 pounds of corkscrew pasta | 1 teaspoon black pepper |
| 7 tablespoons unsalted butter | 1½ quarts whole milk |
| ½ cup flour | 6 ounces Comte cheese |
| 1 large onion, small dice | 6 ounces Emmental Swiss cheese |
| 4 cloves garlic, minced | 8 ounces Monterey Jack cheese |
| ½ teaspoon nutmeg, freshly grated if possible | 8 ounces sharp cheddar cheese |
| 2 tablespoons fresh thyme | ½ cup plain bread crumbs |
| 2 tablespoons Dijon mustard | 2 tablespoons grated Parmesan cheese |

Preheat the oven to 350 degrees. Using the large holes on a cheese grater or a food processor, grate the cheese, combine, and set aside. Boil the pasta in generously salted water until al dente. Drain and set aside to cool, keep it loosely covered.

Warm the milk to a slight simmer in a small pot, do not boil. Turn off the heat and cover to keep warm. In a 6-quart pot or Dutch oven, melt 6 tablespoons of butter on medium heat and sauté the onions and garlic until translucent. With the heat still on, dump the flour into the pot and stir vigorously to create a roux. Allow it to cook for 2–3 minutes. Turn the heat down to low—while whisking with one hand, add the warmed milk in a steady stream with the other. Whisk until fully incorporated, then add in the nutmeg, Dijon, pepper, and thyme. Allow it to simmer for 5–6 minutes as it thickens while stirring constantly with a wooden spoon. Add the cheese a handful at a time while stirring until it's fully melted and thick.

Turn off the heat and test for flavor. Add salt one pinch at a time until the desired flavor is achieved. Toss in the cooled pasta until fully incorporated. Using 1 tablespoon of butter, butter a deep 9" x 13" baking dish. Turn the pasta out into the baking dish evenly, making sure to add all the sauce. Sprinkle on the bread crumbs and Parmesan cheese. Bake for 40 minutes uncovered until bubbling and evenly golden brown.

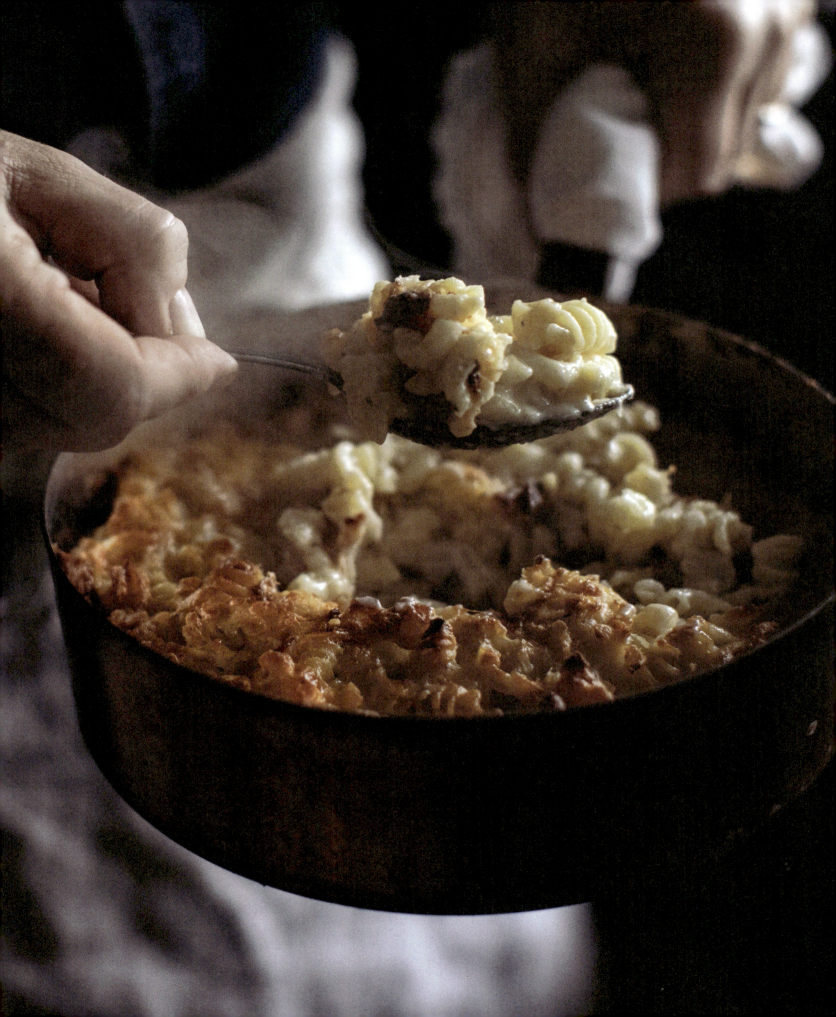

# LAMB FRITTATA
*Serves 6–8*

Any kind of frittata is wonderful to prepare for a gathering. Lamb and potatoes give a satisfying heft to this egg dish that is cooked right in its skillet. This recipe could be modified to make miniature frittatas that you can serve as an hors d'oeuvre at a cocktail party. Just layer the ingredients in non-stick, miniature muffin tins and reduce the baking time.

1 pound ground lamb

1 large onion, small dice

5 cloves garlic, minced

1 cup heavy cream

14 large eggs, room temperature

1 tablespoon Dijon mustard

1 teaspoon fresh thyme

1 tablespoon fresh oregano, minced

⅛ teaspoon grated nutmeg

½ cup crumbled feta cheese

¼ cup grated Parmesan cheese

2 tablespoons za'atar spice

1 tablespoon kosher salt

½ teaspoon black pepper

12 ounces nibble-style honey gold potatoes

Preheat oven to 350 degrees. Cut the small potatoes in half and boil in well-salted water until they reach a firm al dente. Drain and set aside to cool.

In a 12" cast-iron skillet, brown the ground lamb in one tablespoon of olive oil. Remove the meat and set it aside. In the same skillet, sauté the onions and garlic until translucent. Add to the reserved meat and allow it to cool completely.

In a large mixing bowl, whisk the eggs, heavy cream, Dijon, nutmeg, thyme, oregano, kosher salt, and pepper until well combined. Pour out any excess fat in the skillet and layer in the potatoes and the lamb/onion mixture. Top with the feta cheese. Set the skillet on the stove over medium heat and immediately pour in the egg mixture, taking care not to disturb the layered ingredients in the skillet. Sprinkle the top with parmesan and za'atar. Let the skillet remain on the stove for 4–5 minutes or until the egg mixture starts to bubble along the side. Carefully transfer the skillet to the oven and bake for 20 minutes. Turn the oven down to 325 degrees and continue to bake until the frittata is nice and puffed and golden brown on top. Let it set out of the oven for about 10 minutes before cutting into it.

**TIP:** For a heartier version, try layering in a cup of Sourdough Croutons (page 188).

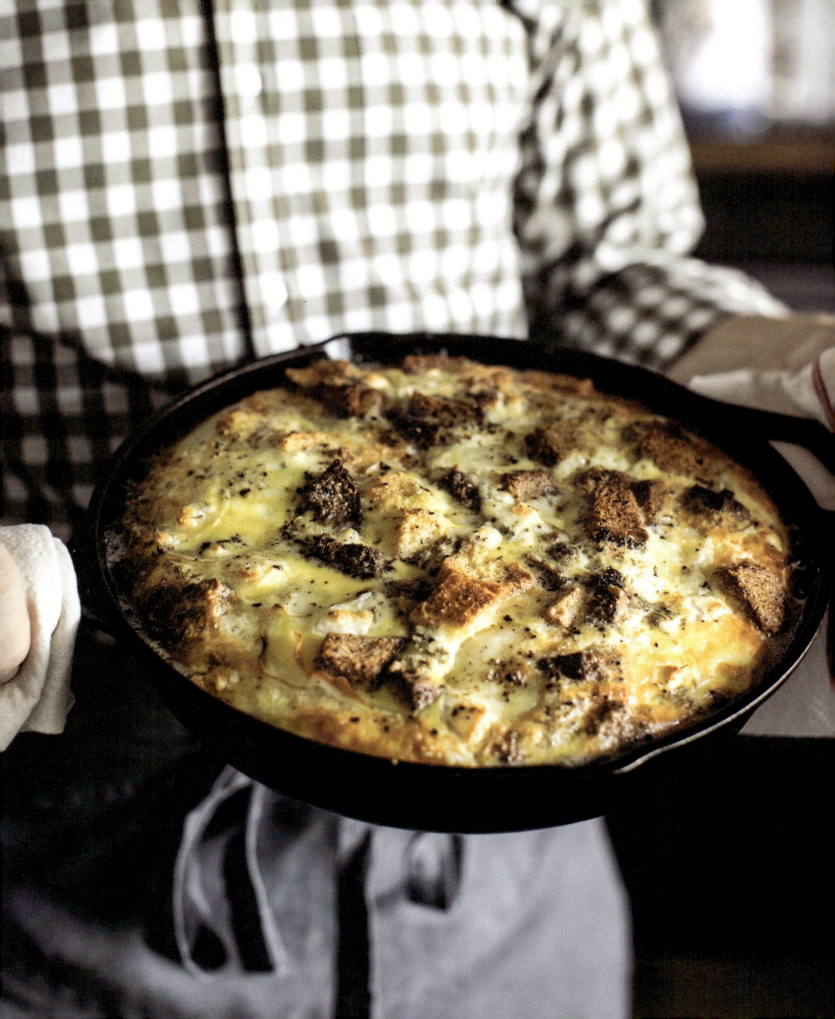

# SEAFOOD AND WHITEFISH IN A SAFFRON BROTH

*Serves 6*

A simpler version of a bouillabaisse, this easy to prepare dish will wow your guests during a seated dinner party. Meaty scallops and langostino compliment the tender white fish and buttery clams in a colorful, fennel and saffron-infused broth.

1 tablespoon olive oil
1 large fennel bulb
1 leek, sliced down the middle and washed
4 cloves garlic, cut in half
2 stalks of celery, cut in half
Rind from 1 lemon
2 pinches of saffron
2 bay leaves
1½ tablespoons kosher salt

8 cups vegetable stock
3 8-ounce bottles of clam juice
12 ounces passata
1-pound kingklip
1½ pounds rockfish or haddock
3 pounds littleneck clams
12 sea scallops
1-pound langostino meat

Soak the littleneck clams in a bowl of salty water (enough to submerge them) for 30–60 minutes. Drain, rinse and set aside in a bowl of fresh cold water. Remove the beard from the scallops and discard them. Cut each of the fish into 6 or more pieces.

Trim the fennel bulb of its fronds and reserve it for garnish. Slice the fennel bulb in half through the core. Lay each half down on a cutting board, cut off the core, and thinly slice the fennel into strips. In a stockpot, sauté the fennel and garlic in the olive oil for 3–4 minutes on medium heat. Add the whole leek, celery, lemon rind, bay leaves, saffron, salt, vegetable stock, and clam juice. Allow it to simmer for 20 minutes covered. Add the passata and simmer for an additional 10 minutes uncovered. Remove and discard the lemon rind, leek, garlic, bay leaves, and celery. Taste the broth and add salt as needed to flavor.

With the broth on a low simmer, gently add the fish and scallops. Cover and simmer for 4 minutes. Carefully add the clams and the langostino meat to the broth and simmer uncovered for an additional 4–5 minutes. The clams should all be opened. Remove from the heat and portion the fish and seafood amongst 6 bowls along with some fennel from the broth. Ladle in the hot broth and garnish with sprigs of fennel fronds and a little crack of black pepper.

**TIP:** Finish this dish just before serving by drizzling a small amount of good quality olive oil over the top.

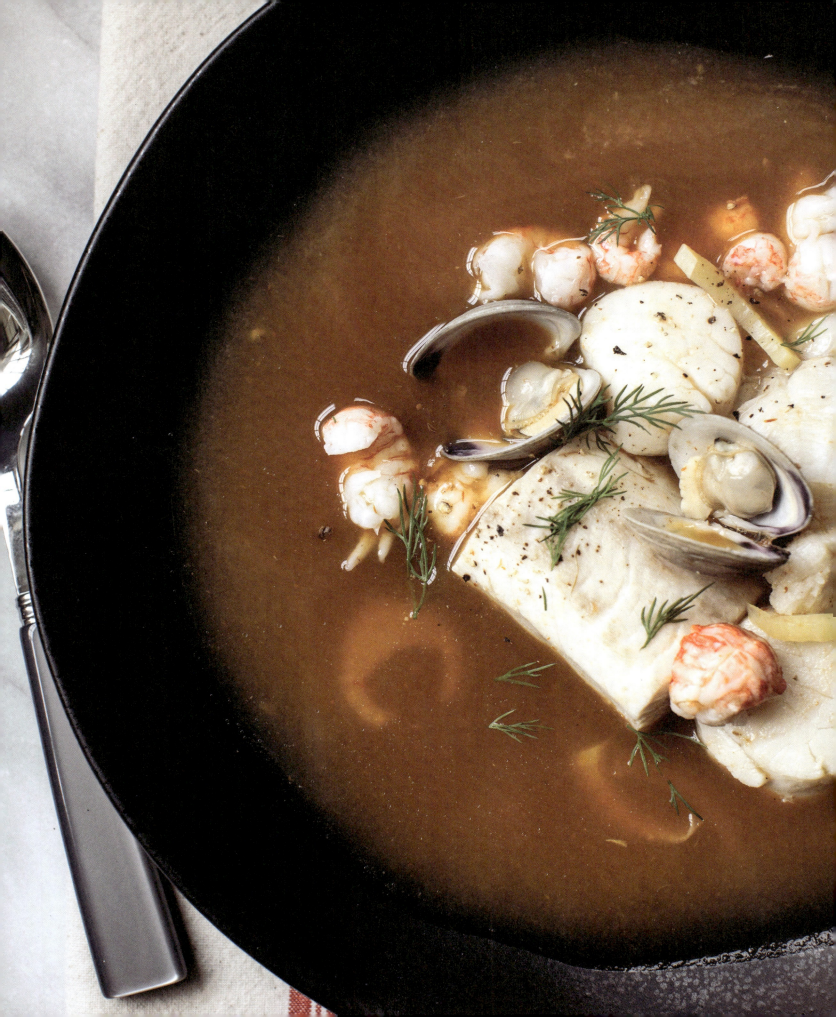

# ARTICHOKE LEEK QUICHE

*Serves 12*

This decadent deep-dish quiche is packed full of filling and can be served as a meal with a light salad, just as it can be served for a brunch. Artichokes and leeks make the perfect combination for this flavorful dish.

1 Rich Quiche Dough recipe on page 182
1 tablespoon butter, unsalted
3 cups chopped leeks
2 cups artichoke hearts, rinsed and chopped
2 shallots, small dice
4 tablespoons fresh thyme
¼ cup olive oil
½ teaspoon black pepper

2 teaspoons kosher salt
16 large eggs
2 cups heavy cream
⅛ teaspoon nutmeg
9½ ounces gruyere cheese, grated
3½ ounces Brillat-Savarin cheese, cubed
2 tablespoons grated parmesan cheese

Preheat the oven to 350 degrees. Butter a 9" deep-dish pie dish. Roll out the quiche dough to ¼ inch thick so that it is larger than the mouth of the pie dish. Gently lay the dough in the pie dish. Fit it in the bottom and up over the sides with ½ inch hanging over the rim. Working around the rim of the pie dish, turn the edge of the dough up under itself so that it rests on top of the rim. With your index finger and thumb, create a crimped edge around the pie dish, making sure the crust of the dough sits up on the rim. Prick the bottom with a fork and set it aside in the refrigerator to rest.

In a large skillet, heat the olive oil until hot and add the leeks, shallots, artichokes, and 2 tablespoons thyme. Sauté until the leeks are soft and the shallots are translucent. Set aside to cool. In a large mixing bowl, combine the eggs, heavy cream, 2 tablespoons of thyme, nutmeg, salt, and pepper, and whisk until fully combined. Add additional salt pinch by pinch if needed to adjust the flavor. It should taste custardy.

Take the pie dish with dough out of the refrigerator. Spread half of the gruyere cheese over the dough and spread the artichoke and leek mixture on top. Spread the remaining gruyere on top of the artichoke layer. Dot the top with the cubes of Brillat-Savarin. Slowly pour in the egg mixture until the pie dish is filled within ½" of the crimped dough. Sprinkle the parmesan cheese on top and carefully place it on the middle rack in the oven. Bake for about 1 hour to 1 hour and 10 minutes, until the top has puffed up and turned golden brown. The quiche is done when the middle is firm and springy but not wet and soupy.

Remove the quiche from the oven and allow it to sit for 20 minutes before cutting. The quiche can also be cooled completely, refrigerated overnight with a sheet of parchment laid over the top, and reheated the next day to be served.

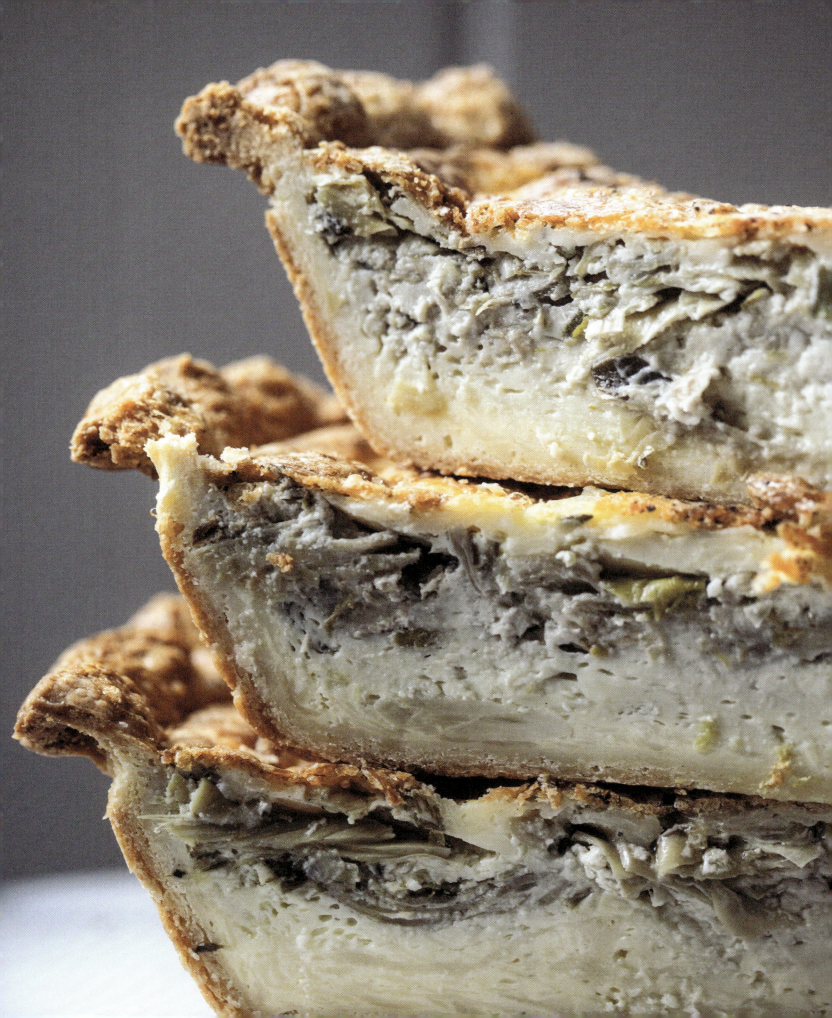

# PAN-SEARED TARRAGON SALMON

*Serves 4*

A quick and healthy meal to serve to friends and family. Pan sear just before serving for the best results. Consider drizzling some fresh arugula-parsley pesto over the top before serving.

> 4 7–8-ounce filets of salmon, bones removed
> 8 sprigs of fresh tarragon
> 2 tablespoons grapeseed oil
> Maldon salt or kosher salt

Sprinkle the flesh of the salmon with a hearty pinch of Maldon salt, crushing it between your fingers. Add the oil and sprigs of tarragon to a non-stick frying pan. Gently heat the oil on low for about 4 minutes to allow the tarragon to release its flavor. Turn the heat up to medium-high and allow the oil to get very hot to achieve a perfect sear. The oil will start to shimmy to the sides of the pan. Quickly place each piece of salmon flesh side down (skin side up). Allow the salmon to sear undisturbed for 4–5 minutes, being careful not to burn it. Remove the tarragon before it starts to burn. Adjust the heat slightly if needed. You want a nice dark sear to the flesh to create a crispy texture. Carefully flip the salmon over onto its skin and let it sear in the hot pan for 5 more minutes. Remove each piece from the pan and allow it to rest for 3 minutes. Using a spatula, gently pry underneath the flesh removing it from the skin and transfer to a plate. Serve immediately.

> **TIP:** Grapeseed oil has a higher burn temperature than most other oils and is best used for searing at high temperatures.

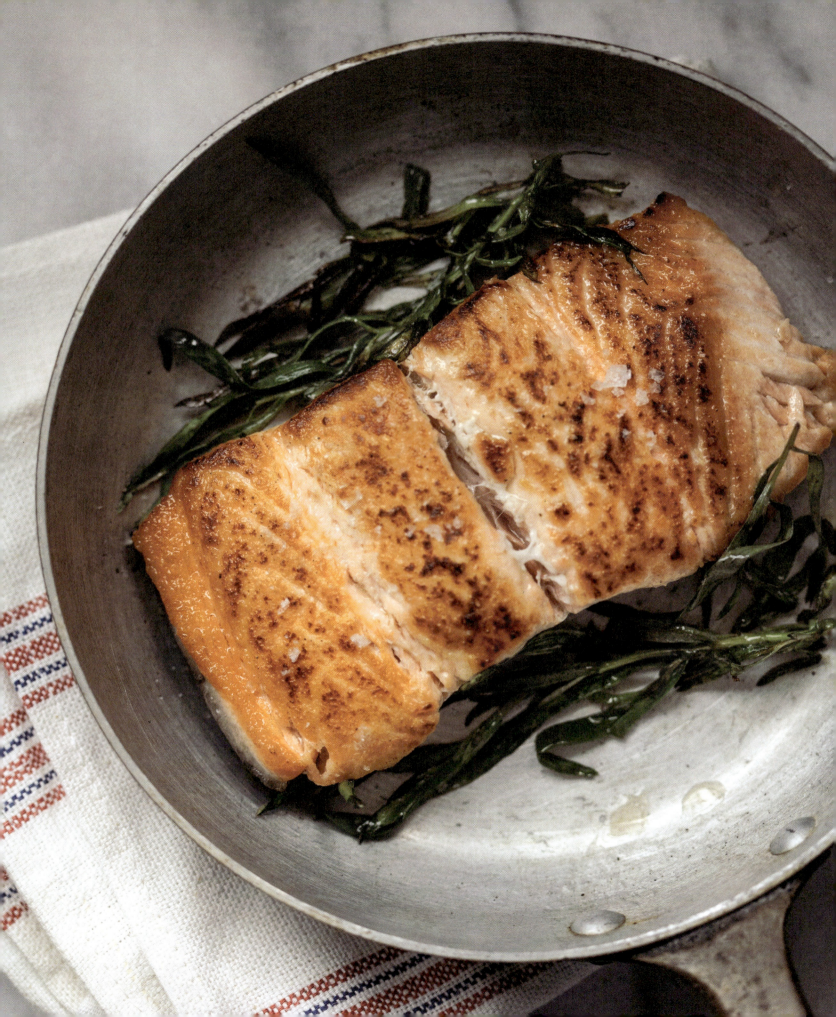

# BARBECUE SPARERIBS

*Serves 6*

St. Louis-style spareribs are meatier than baby back ribs and a full side weighs about 2½ pounds. They tend to have more fat on them, which renders a very tender meat. Don't reserve these for just a barbeque—they are deliciously served as an entrée at a casual dinner party as well.

2 sides of St. Louis-style ribs (about 5–6 pounds)
4 tablespoons olive oil
2 tablespoons kosher salt
2 tablespoons black pepper
2 tablespoons garlic powder
2 tablespoons onion powder
½ cup apple cider vinegar
1 ½ cups of Homemade Barbecue Sauce, found on page 180

Preheat oven to 225 degrees. Allow the spareribs to come to room temperature. Arrange two large pieces of aluminum foil on the counter side by side. Pat the spareribs dry with a clean paper towel and lay each side of the spareribs on top of the foil.

Combine the salt, pepper, garlic powder, and onion powder in a small bowl and mix well. Rub both ribs on both sides with olive oil. Evenly sprinkle the salt mixture on all four sides of the meat. Gather up the sides of the aluminum foil around each rib and evenly pour ¼ cup of apple cider vinegar into each one. Gather the edges of the aluminum foil and crimp them over the top of the ribs, creating a small tent. Transfer each rib in aluminum foil to a baking sheet and roast for 4½ hours undisturbed.

Just before the ribs are finished, heat 1½ cups of barbecue sauce in a small saucepan and keep warm. When the ribs come out of the oven and while still piping hot, slather on the hot barbecue sauce. Set the oven to broil and put the ribs under the broiler for 3 minutes for the barbecue sauce to slightly caramelize. Carefully transfer to a large white platter or wooden cutting board and section the meat into pieces that contain 2–3 rib bones for serving.

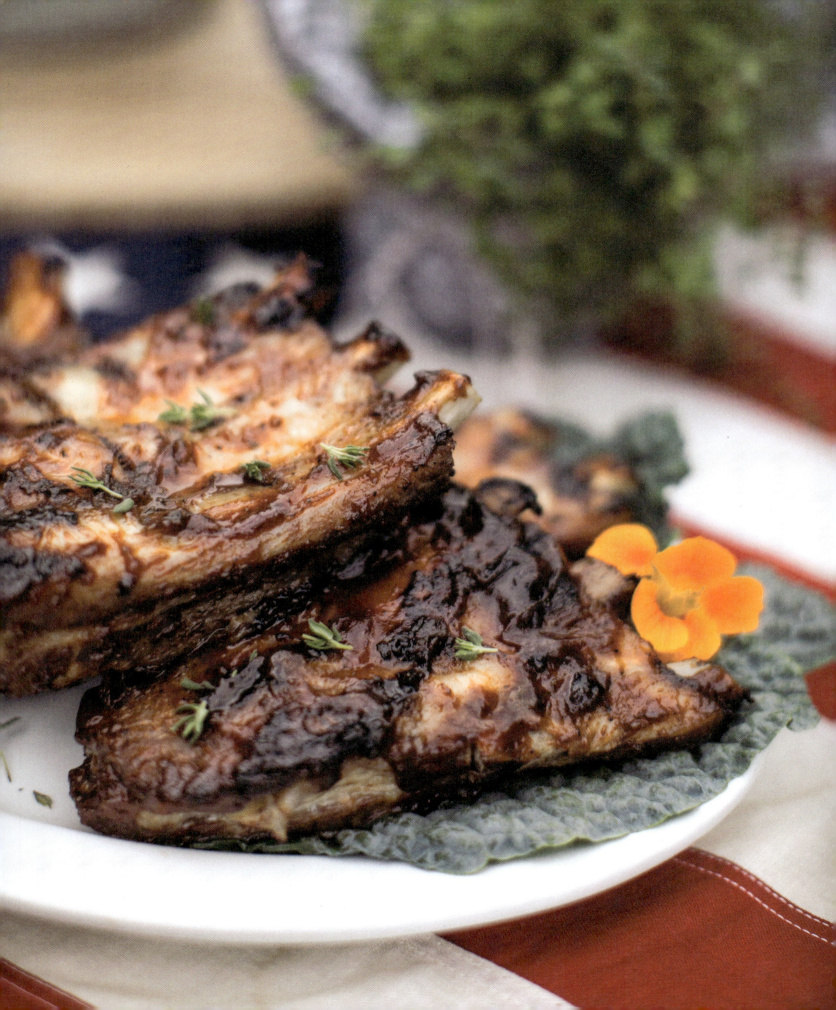

## A Sweet Ending

# WHITE CHOCOLATE PISTACHIO CHEESECAKE

*Serves 12–16*

This recipe comes from my good friend Helen whom I met when she opened her shop, *Helen's Fabulous Cheesecakes*, in Brooklyn, New York. To say this is a decadent cheesecake would be an understatement. Considering how dense this cake is, it is also remarkably light and creamy.

| | |
|---|---|
| 2½ pounds cream cheese—use good quality cream cheese | 6 large eggs |
| 16 ounces sour cream | 1 tablespoon butter, unsalted |
| 1 cup sugar | ½ cup Valrhona or Callebaut white chocolate |
| 1 tablespoon pure vanilla extract | 4 tablespoons pistachio paste |
| 2 tablespoons lemon juice | ½ cup shelled pistachios, chopped |

Allow the ingredients to sit out and come to room temperature before using. The cream cheese should be soft and easy to work with.

Preheat the oven to 325 degrees and butter the inside of a 10" cheesecake pan. Line the bottom with a round piece of parchment. Wrap the outside of the pan with two layers of foil, creating a tight skin all around. Turn down the top edges of the foil onto themselves and tightly tuck them under the outside rim of the cheesecake pan.

In a double boiler on low heat, melt the white chocolate and keep warm. In a stand mixer fitted with a paddle attachment, mix the cream cheese on medium speed until fully creamed and no lumps exist for about 4 minutes. Add the sugar and mix at medium speed until fully combined. Scrape down the sides of the bowl. On low speed, add the eggs one at a time until each one is fully incorporated. Allow the batter to mix for an additional 2 minutes on low. Scrape down the sides of the bowl and add the vanilla and lemon juice—mix on low until incorporated. Add the sour cream and continue to mix on low until fully incorporated, not more than 2 minutes.

Remove 1 cup of batter into a clean mixing bowl and add the melted white chocolate to it. Fold together with a rubber spatula, then return it to the batter in the mixing bowl and fold until incorporated. Again, remove 1 cup of batter to a mixing bowl and add the pistachio paste to it and blend. Fold that back into the mixing bowl of batter until it is fully incorporated and light green in color. Pour this batter into your cheesecake pan and stop 1½" from the rim.

Set the cheesecake pan into a large roasting pan (a disposable roasting pan that has been doubled for stability works well). Fill it with tepid water until it reaches halfway up the cheesecake pan. Carefully place the cheesecake in the water bath on a rack set in the middle of the oven being sure not to let the water splash.

Bake for about 1 hour or until the top becomes firm and spongy to the touch when gently tapped in the middle of the cake. The center should not be jiggly or wet. Check the cake after 40 minutes to be sure the outside rim is not cooking too quickly or turning brown. Reduce the heat in your oven by 5 degrees if it is. Keep a close eye on the cake after 40 minutes. The cake should have very little browning on the top. At the point that the middle just becomes firm to the touch, turn the oven off and allow the cake to remain in the oven for another ½ hour.

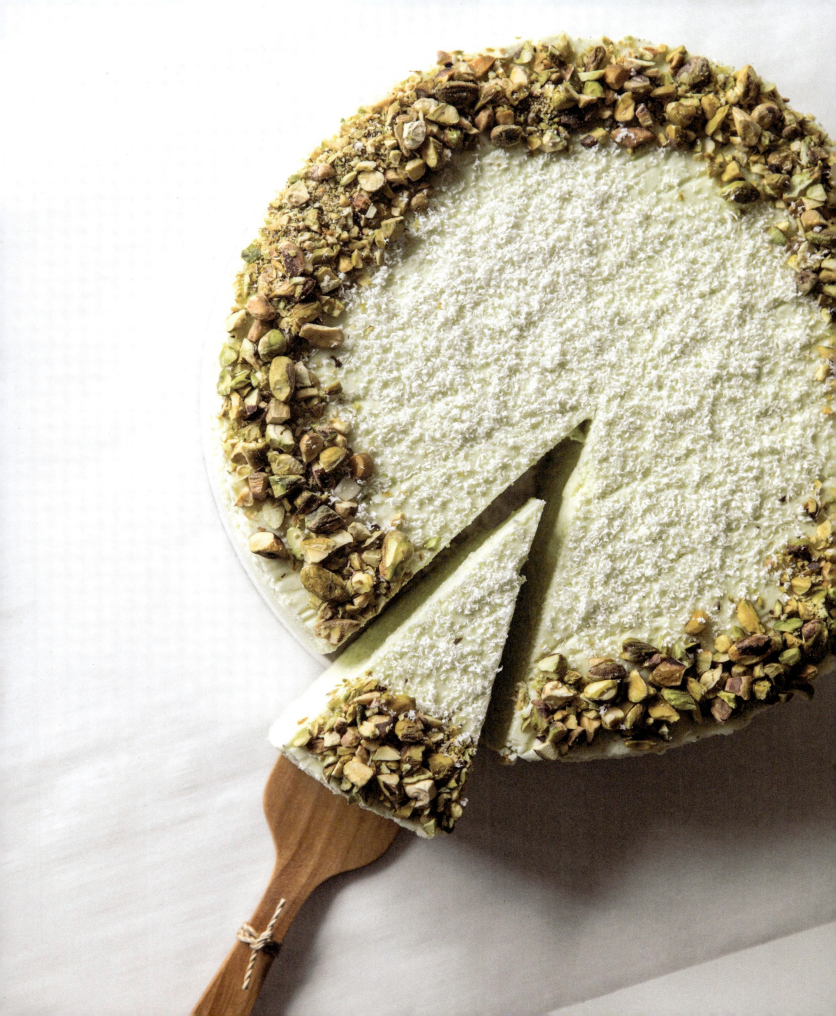

Carefully remove the cake and water bath from the oven and set it securely on the counter. Remove the cheesecake from the water bath, being careful not to get any water on it. Remove the foil from the pan and allow the cake to cool completely on a wire rack. Do not try to unmold the cake at this point. Lay a piece of parchment paper that's been cut to fit on top of the cheesecake and refrigerate it overnight.

While it is still cold, gently unmold the cake from the pan. Invert a flat dish over the top of the cake and flip it onto the dish so that the bottom now becomes the top. Using a sharp knife, gently pry the bottom of the pan from the cake. Remove the parchment.

Garnish the top of the cake with some shaved white chocolate and chopped pistachios. Serve chilled. To make clean slices in a cheesecake it is best to cut it with a knife that has been warmed, making sure to wipe it clean after each pass through the cake.

**TIP:** This recipe requires pistachio paste that is used for bread, pastry, ice cream, and desserts which can be ordered online. Find a brand that has a green-colored paste rather than one that's brown-colored.

# BROWNED BUTTER SPICE CAKE AND FIG TRIFLE

The nutty flavor and aroma of browned butter mixed with fresh pears and a mélange of spices creates a completely indulgent experience. Layered between a slathering of rich espresso cream and fig jam, this dessert is a showstopper. It takes some preparation in advance to make the cakes, but the assembly is easy and well worth it. The cake can be made and frozen two weeks in advance. I use square cake pans for this recipe because the cake eventually gets cut into 1" cubes.

## FOR THE CAKE
- 1 pound unsalted butter
- 7 Bartlett pears, very firm
- 6 large eggs, room temperature
- 3 cups brown sugar
- 3 teaspoons baking soda
- 1½ teaspoons baking powder
- 1½ teaspoons fine sea salt
- 2 teaspoons cinnamon
- 1 teaspoon nutmeg, fresh grated is ideal
- 1 teaspoon cardamom
- ½ teaspoon allspice
- 3 teaspoons vanilla
- 4 cups all-purpose flour
- 3 cups pistachios, shelled and roughly chopped
- Juice of ½ lemon

## FOR THE SPREAD
- 2 jars of fig spread
- Juice of 1 lemon

## FOR THE CREAM
- 1-quart heavy cream
- ¾ cup sugar
- ½ teaspoon vanilla
- 2 tablespoons instant espresso

## *For the cake*

Preheat the oven to 350 degrees. Lightly butter three 8" square cake pans (you can use round if you don't have square). Line the bottom with parchment paper. Lightly flour the sides of the cake pans and set them aside.

In a small saucepan, melt the butter. Once fully melted, turn the heat up to medium and cook the butter until it turns a medium golden brown, smells nutty, and has brown bits on the bottom of the pot. Immediately take off the stove and slowly pour out all of the browned butter into a metal bowl, being careful not to get any brown bits in the bowl. Allow the butter to cool.

Prepare a bowl with cold water and lemon juice. Wash and dry the pears—leave the skins on. Remove the core by cutting down along all four sides of it with a sharp knife, placing each piece in the bowl of lemon water as it's cut. Once all the pears are cut, remove each piece one at a time, and in a separate bowl, grate with the large holes of a grater. Squeeze the juice out of the grated pears with a piece of cheesecloth and set it aside.

In a bowl, sift the flour, baking soda, baking powder, salt, and all spices. In a mixing bowl on a stand mixer fitted with a paddle attachment, beat the eggs and the brown sugar on medium speed until light and fluffy. Drizzle in the cooled brown butter and vanilla. Mix on medium until incorporated. Turn the mixer down to low and add the flour mixture a cup at a time until just combined. Do not overmix. Add the pears and chopped pistachios to the bowl and mix on low until incorporated about 1 minute. Using an ice cream scoop or a 1 cup measure, evenly divide the batter between the pans. Bake for 25 minutes. Check the cakes after 20 minutes with a skewer pressed into the middle of the cake. It will come out clean when the cakes are done. When finished, transfer the pans to a cooling rack. Let them cool completely before turning out. Turn the cake out of the pan and remove the parchment. To store the cakes, wrap in saran wrap two times and refrigerate until ready to use. It's preferable when freezing to wrap each cake in parchment and then wrap in two layers of saran wrap.

### For the cream

Set the bowl of a mixer along with the whisk attachment and the quart of heavy cream in the freezer for 10 minutes. Pour the heavy cream into the bowl and add the instant espresso and vanilla. Stir to combine. Set the mixer to high and whip the cream. As the cream starts to increase in volume, steadily pour in ½ cup of sugar. Turn off the mixer and taste for sweetness. Adjust with the additional ¼ cup sugar if desired. You want to achieve a slight sweetness without having it be overly sweet. Continue to whip the cream on high until stiff peaks form. Keep cold in a refrigerator until assembly.

### For the spread

Combine the fig spread and the lemon juice in a small saucepan and warm until it becomes smooth and easy to stir. Remove from the heat and let cool. If it stiffens while assembling the trifle, simply put it on the stove for a few seconds to loosen it up without heating it too much.

### To assemble the trifle

If you've frozen the cakes, be sure they are thawed completely and slightly cold. Cut the cakes into ½" cubes. Line up your glasses and layer them with cream, cake, and fig spread. Create 2–3 layers in the glass and top with a dollop of cream. Use a small ice cream scoop to dollop the cream into the glasses to keep them neat and clean. Grate some dark chocolate on top to finish. Garnish with a sprig of rosemary or mint. Serve immediately.

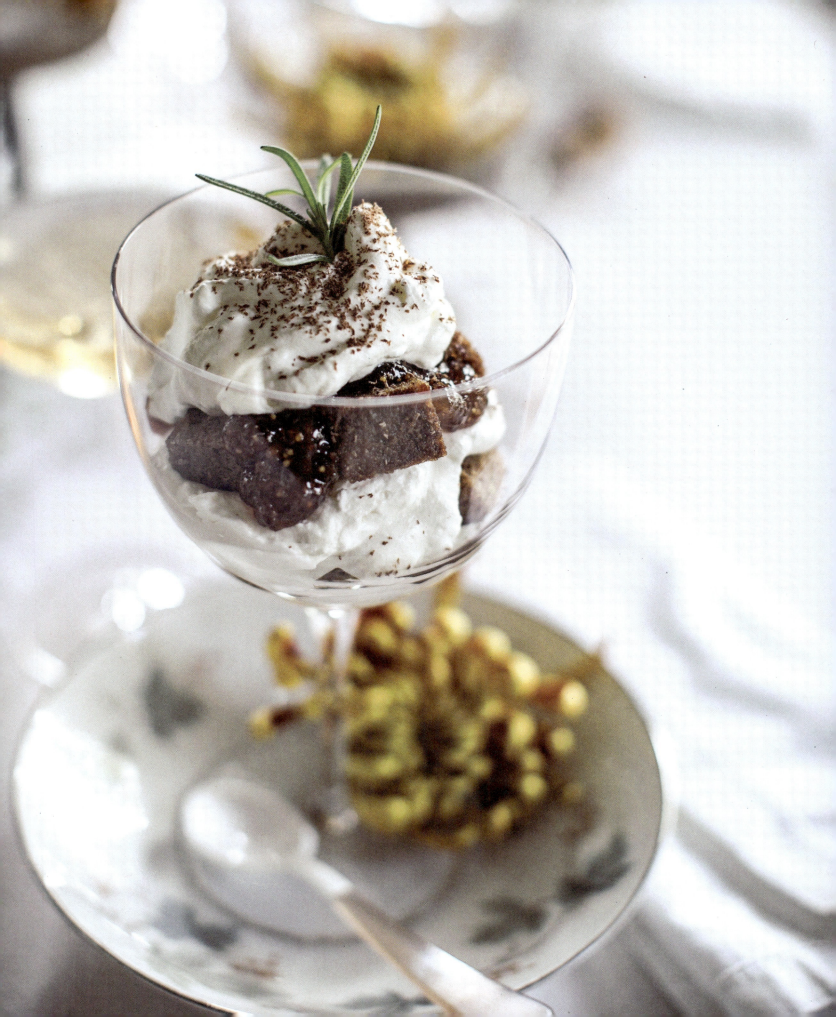

# CHOCOLATE MOUSSE

*Makes 24 4-ounce servings*

This easy dessert is a wonderful finish to any dinner party. It makes a beautiful presentation when served in small antique glasses.

¾ cup plus 3 tablespoons sugar, kept separate

4 tablespoons cocoa powder

6 tablespoons corn starch

⅛ teaspoon fine sea salt

2½ cups whole milk

4½ cups heavy cream

½ teaspoon instant espresso

2 teaspoons pure vanilla extract

12 ounces dark chocolate, at least 70% cacao

3 tablespoons butter, unsalted

Combine the milk, 2½ cups heavy cream, and vanilla in a bowl and set aside. Combine the ¾ cup of sugar, cornstarch, cocoa powder, and salt in a medium saucepan. Add 2 cups of the milk and cream mixture to the sugar mixture in the pot and whisk until the cornstarch is dissolved. Add the additional 3 cups of the milk and cream mixture and whisk until combined.

Place the saucepan on medium heat and cook, stirring with a wooden spoon constantly. Cook for 7–8 minutes until it thickens. Add the dark chocolate and continue to stir until the chocolate is fully melted. Remove from the heat and stir in the butter until incorporated. Pour the hot pudding into a bowl and lay a piece of parchment paper or saran directly on top to prevent a skin from forming. Allow it to cool, then refrigerate until firm, 5–6 hours.

Once the pudding is cooled and firm, add the remaining 2 cups of heavy cream to the bowl of a mixer fitted with a whisk. Add the remaining 3 tablespoons of sugar and set the mixer to high. Whisk the heavy cream until stiff peaks form, about 5 minutes. Gently fold the chilled pudding into the whipped cream until fully incorporated. Spoon the mousse into glasses and garnish with a raspberry. Chill in the refrigerator for 30 minutes before serving.

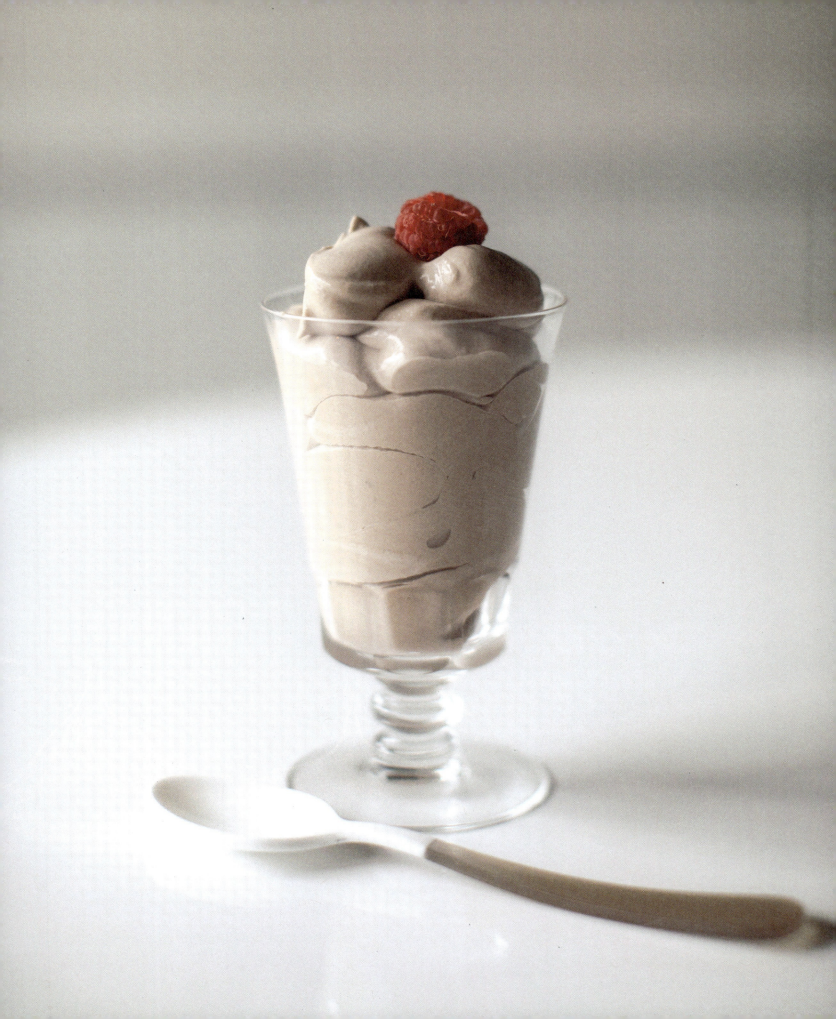

# AFFOGATO

I always wonder how something so simple can be so delicious, and even more so, how it could make such a big impression. Experiment with different flavors of ice cream, or even experiment with making your own. My go-to flavors are rich vanilla or decadent mocha. I simply use espresso pods in my Nespresso machine to make the espresso at the time of serving.

1 container of mocha ice cream
1 shot of espresso

Pre-scoop the ice cream into a glass with enough room to hold the espresso. Place in the freezer until ready to serve. Just before serving, pour one shot of hot espresso into the glass and serve immediately.

**TIP:** For an added presentation, serve the chilled ice cream to each guest, then pour the hot espresso tableside.

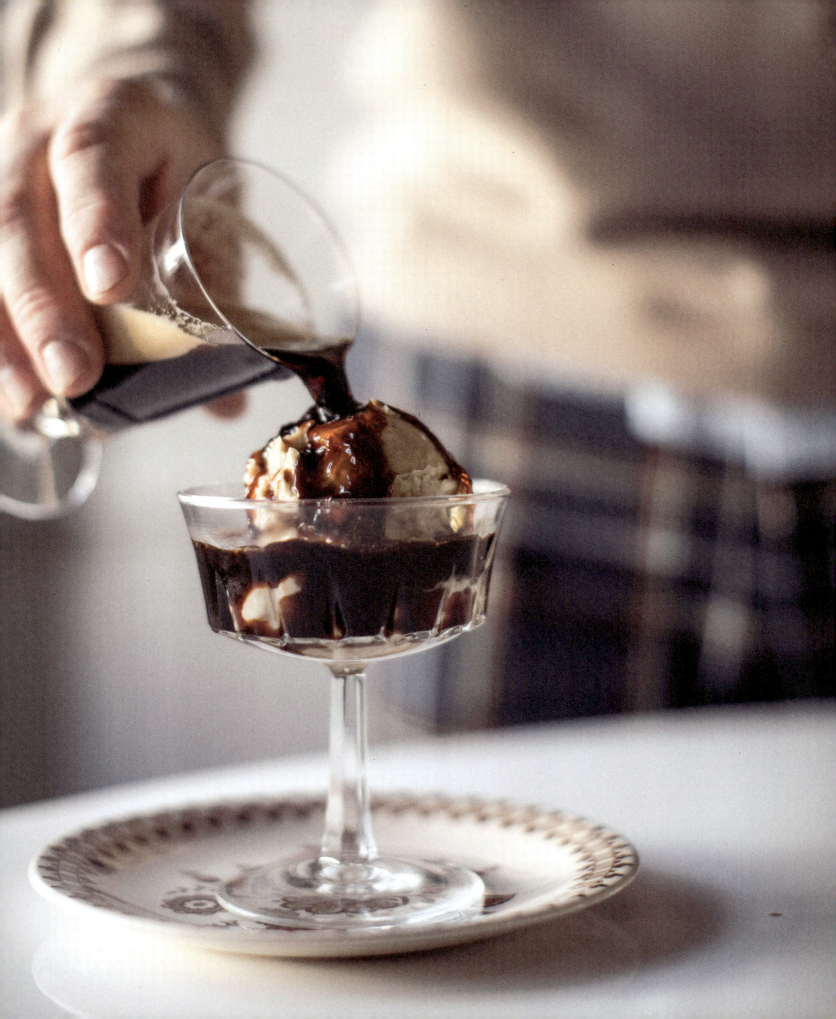

# SALTED VANILLA SHORTBREAD

*Makes 1 10" fluted tin*

This beautiful shortbread is moist, tender, and buttery. It was baked daily at my shop in Atlanta. The salty-sweet flavor combines nicely as a dessert when paired with a scoop of cherry-vanilla ice cream. For cocktail parties, serve the shortbread in small, bite-sized squares on a passing tray.

- 17½ ounces unsalted butter, cold
- 2 cups confectioner's sugar
- 4 cups all-purpose flour
- 2 teaspoons pure vanilla extract
- 1 teaspoon fine sea salt

You will need a 10" fluted tart tin with a removable bottom and a 2" round metal cookie cutter (you could substitute a 10" springform pan for the fluted tin). Preheat the oven to 350 degrees.

Cut the cold butter into chunks. In the bowl of a food processor, place the flour first, then the cold butter and the sugar on top. Add in the vanilla and salt. Process until the dough comes together and is smooth. Turn out onto a piece of parchment and give a few additional kneads by hand if any of the ingredients did not incorporate. Place the cookie cutter in the middle of the tin and divide the dough into pieces around it. Gently press the dough into the tin in an even layer, being sure to press into the grooves of the fluted tin. Make sure the dough is level and smooth. Do not remove the metal cookie cutter. Prick the dough with a fork and refrigerate uncovered for 20 minutes. Bake for 30–40 minutes until the top is a nice light golden brown. Allow it to cool completely before lifting out the cookie cutter. Gently twist the cookie cutter to loosen it before lifting it away from the shortbread. Cut the shortbread while it is still on the metal bottom of the tin and gently remove the shortbread from the tin.

# BUTTERSCOTCH PANETTONE TRIFLE

I love to serve trifles in individual glasses for a dinner party. They are easy to prepare, and the presentation is quite beautiful. I take advantage of buying discounted panettone during the holidays. Any variety of panettone can be used for this dessert. The richness of whiskey in the butterscotch pudding blends nicely with the mild flavors of panettone. It is so delicious, this large batch of the pudding can be kept in the refrigerator to snack on days after your party.

1 large panettone

**FOR THE PUDDING**
1 cup light brown sugar
4 tablespoons orange juice
2 tablespoons water
3½ cups whole milk
1 cup heavy cream
½ cup cornstarch
¼ teaspoon nutmeg
½ teaspoon fine sea salt

6 tablespoons sugar
6 large eggs, yolks only
6 tablespoons butter, unsalted
4 teaspoons pure vanilla extract
4 tablespoons whisky

**FOR THE WHIPPED CREAM**
1 pint heavy cream, very cold
¾ cup mascarpone cheese, room temperature
½ teaspoon cocoa powder
5 tablespoons sugar

Remove the crust from the panettone and slice into ½" cubes. Set aside in a covered dish.

In a large mixing bowl, whisk the egg yolks with the sugar until light and creamy. Add the salt and cornstarch and whisk until combined. While whisking, pour in 2 cups of the cold milk and whisk until incorporated. Set aside. In a small saucepan warm (do not boil) 1½ cups of the milk with heavy cream and the nutmeg, cover to keep warm. In a medium-sized saucepan, combine the brown sugar, orange juice, 2 tablespoons of whiskey, and water. Boil for 2–3 minutes, stirring to dissolve the sugar. Turn off the heat and whisk in the warmed milk mixture, whisking constantly. Turn the heat on medium and bring it just to a boil. Quickly remove it from the heat and slowly pour the hot milk mixture into the bowl of the cold milk mixture while constantly whisking. Make sure all the ingredients are fully combined. Add this back to the pot and set it on low heat, stirring constantly with a wooden spoon or silicone spatula. The pudding will thicken, and just as it lets out a few bubbles from the top, remove it from the heat. Using a whisk again, vigorously whisk in the butter, vanilla, and 2 tablespoons of whiskey until combined and smooth. Pour the pudding into a bowl. Press a piece of saran wrap directly on top of the pudding, making sure it is fully covered so skin doesn't form. Allow to cool completely before placing in the refrigerator.

## For the whipped cream
Chill the bowl and whisk of a stand mixer in the freezer for 10 minutes. In the chilled mixing bowl, whisk together the mascarpone, sugar, and cocoa powder until smooth. Scrape down the sides and add the heavy cream. At high speed, whisk everything until stiff peaks form. Keep cold in a refrigerator.

## To assemble the trifle
In a beautiful glass that's been chilled, create 3–4 layers of the pudding and panettone, until it reaches almost the top of the glass. Using an ice cream scoop, dollop on the whipped cream and serve immediately.

MASTERING THE ART OF ENTERTAINING

*It doesn't have to be perfect,*

*It should just be thoughtful.*

Notes

# — ACKNOWLEDGMENTS —

*So many people have been* instrumental in the creation of this book, from those who were completely hands-on—seeing it to fruition—to those who gave their gentle and continuous encouragement to leave behind a legacy that has long been a dream of mine. There have been many starts and stops along the way—sometimes doubts—but as with everything in life, I believe in divine timing. At the time of my dad's passing, I became inspired to sit down and put pen to paper. I know he is with me and seeing me through it. I'm so thankful for all those who have genuinely added to the fabric of my life, for without you I would not be who I am today.

First and most importantly, I wish to thank my husband, Tony, who has stood by my side every single step of this journey. Even when he couldn't manage one more moment on his feet helping me test recipes or clean up from photoshoots, he persevered, and he always made me feel so accomplished. He was involved with every aspect of this book, and I don't think it would be here today if it weren't for him. When he first told me he collected stemware, I knew it was love at first sight. Thank God we share a love for entertaining.

You rarely meet someone who can visually interpret your story in a single photograph. Heidi Harris, my photographer, has spent years artistically capturing the details of my life to bring this book to fruition. Through this journey, we have developed a wonderful connection dissecting the intricacies of life and bonding over our shared appreciation for the metaphysical side of it. If my words ever fail to express my thoughts, her images illustriously triumph.

A collective special thanks to my friends Marjorie, Paige, Jeff, Jamie, and Patty, who brought so much energy, style, and good laughs to our photoshoot. I'm also thankful to each of you individually for the nurturing and support that you selflessly give. To Katherine Snow Smith and Barrett Briske who, at different times of editing, masterfully kept my sentences correct, punctuation accurate, and voice consistent. To Brooke Warner and the team at Spark Press, thank you for your expertise in bringing this book together. Frances Schultz, your authenticity, gentle kindness, and encouragement will always remain in my heart. Ronda Carman, I am so appreciative of your sound advice reviewing my initial manuscript. To Suzanna Hamilton, who had a wonderfully strategic and informed path for the publicity of this book, and to Kendall Stowell for masterfully keeping me plugged into social media.

My heart is also full of gratitude for my close friend Pat who has been my number one champion since I started my business long ago in Connecticut. My dear friend Helen, you are an inspired cook, and I can't thank you enough for allowing me to include a few of your recipes in this book. To my French compatriot and friend Shawn, thank you for always encouraging me and believing in my talents.

Last and certainly not least, to my mother, Nancy, who, when I first started catering, would stay up until ungodly hours of the morning helping me prep for a party. Not only do I appreciate the free labor, but your dedication and generosity come forward in everything that you do. Through all my fitful moments and my occasional, unwavering OCD, you never lost your patience. As we continue to debate who taught whom how to cook, I will remain forever grateful for all that you've done to help make this book a reality.

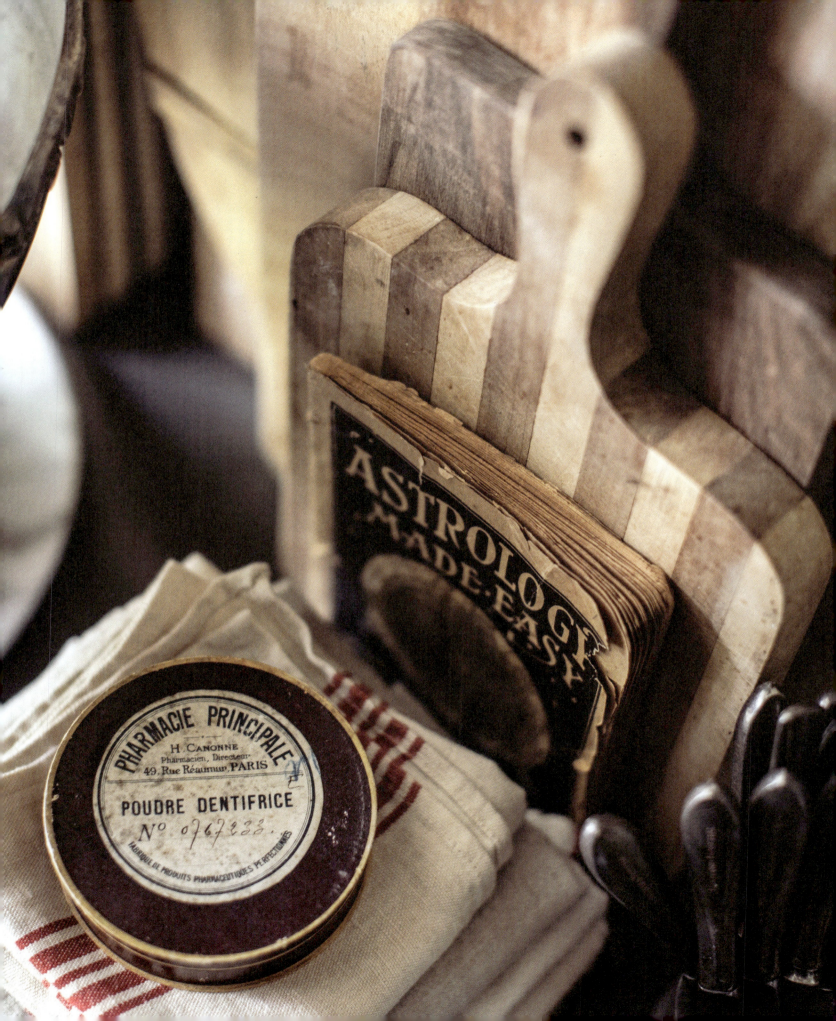

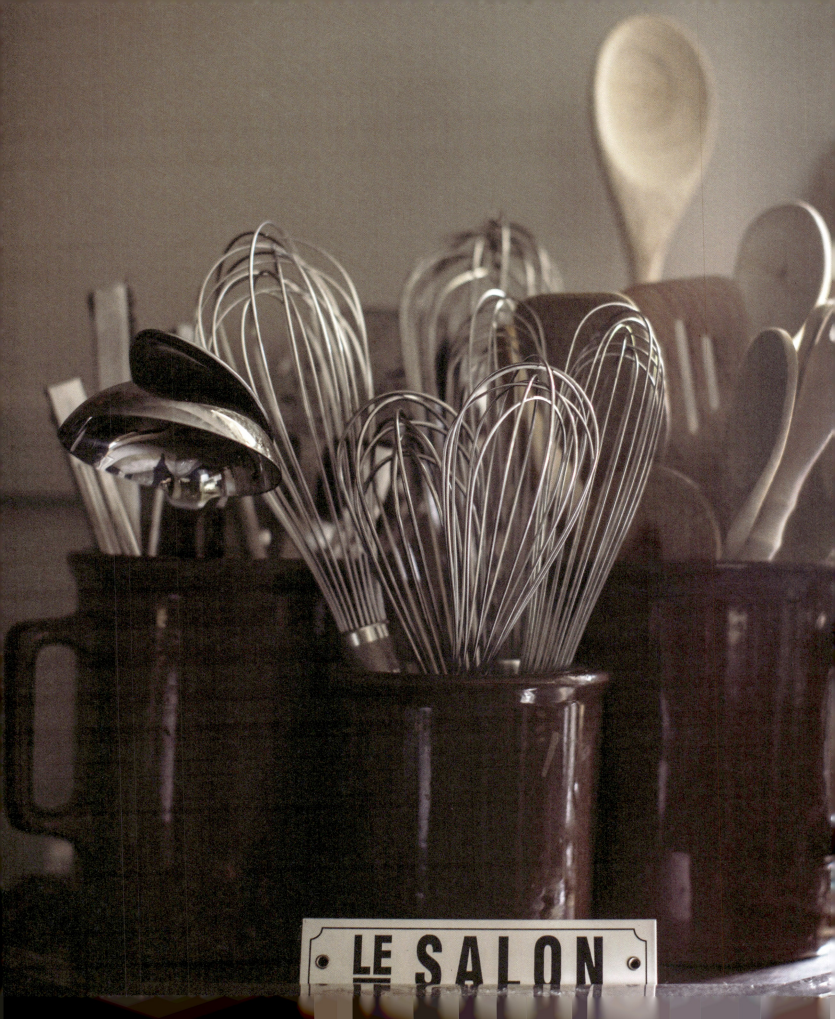

LE SALON

# — RECIPE INDEX —

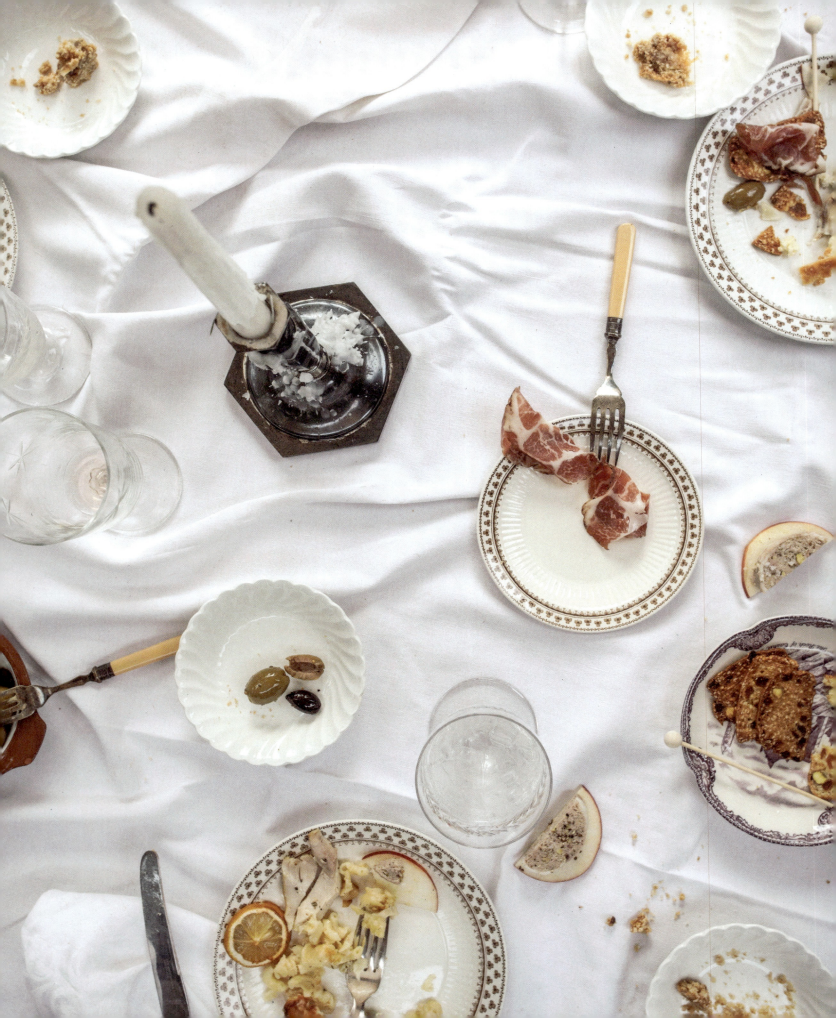

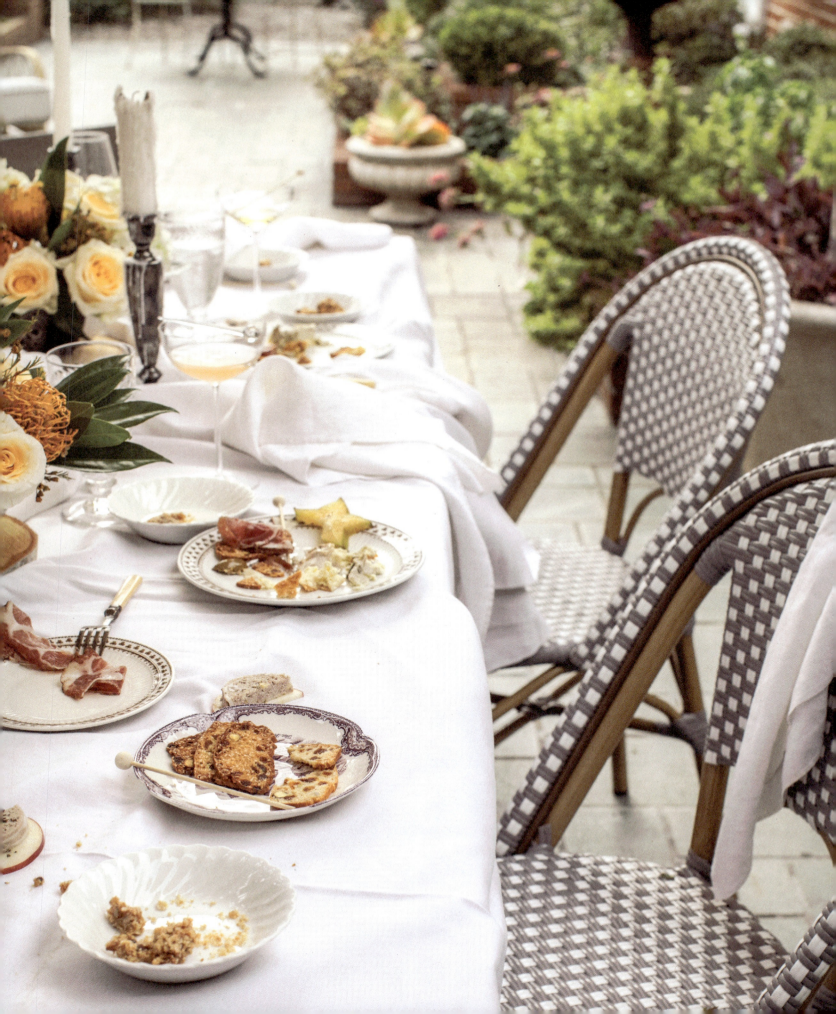

## — ABOUT THE AUTHOR —

*Joseph Marini* has been captivated with home economics since his first class in grade school. Since that time, he's honed his skills to include all aspects of creating an authentic, inviting social environment at home, and today he is renowned for his enterprising entertaining skills. Noted for his nod to etiquette, Joseph is an expert on how to host well, from serving the perfect canape to creating a tabletop prop closet to averting a conversation crisis at the dinner table. At the core of his teachings is the understanding that entertaining is about creating community and nurturing people through the intimacy of home. Joseph lives in Florida with his husband and their family of beautiful dogs.

## — ABOUT THE PHOTOGRAPHER —

 *Heidi Harris* is an Atlanta-based photographer specializing in editorial, lifestyle, and commercial projects nationwide. Her work centers on her close connection with her clients and her passion for visual storytelling. As an artist who embraces authenticity, she loves the scent of tea olives in the breeze, ladybugs, and her cherished friends. When she's not traveling, Heidi can be found spending quality time with her family and their spirited Irish setter.

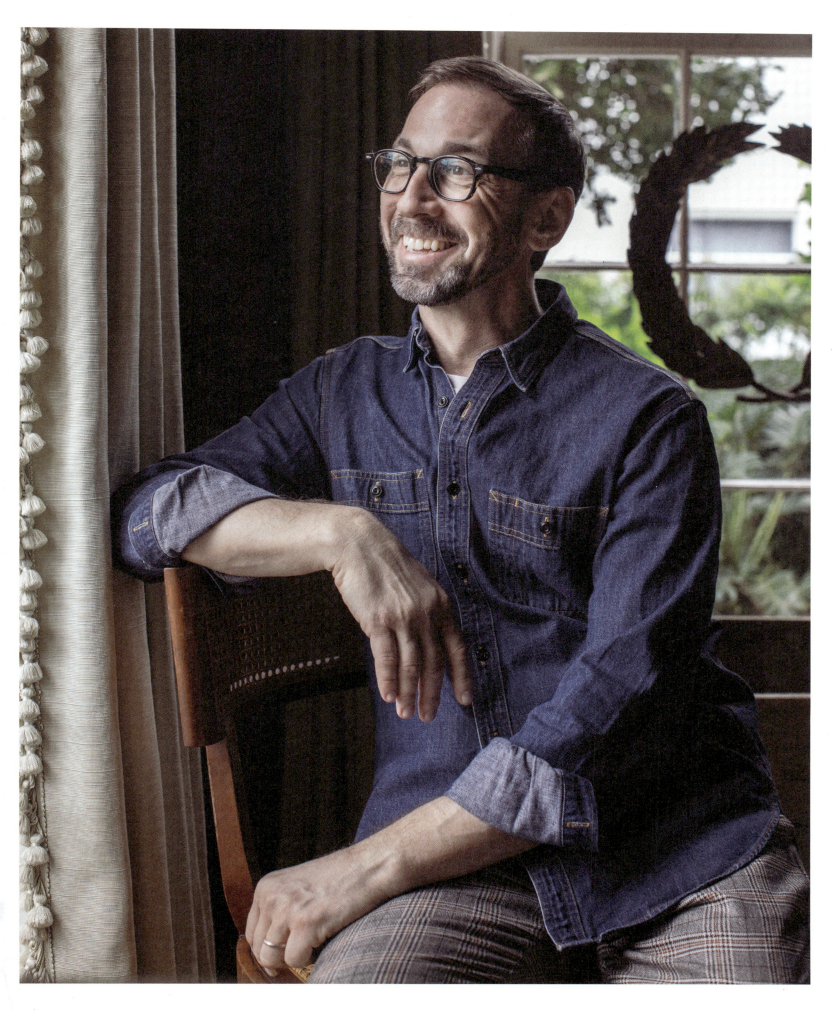